Shadows and Light

The Extraordinary Life of James McBey

Alasdair Soussi

First Published in the UK in 2022 by
Scotland Street Press
100 Willowbrae Avenue
Edinburgh EH8 7HU

All rights reserved
Copyright ©Alasdair Soussi

The right of Alasdair Soussi to be identified as the author of this work has been asserted in accordance with Section 77 of the Copyright, Designs and Patents Act 1988

A CIP record for this book is available from the British Library.

ISBN 978-1-910895-63-4

Typeset and cover design by Antonia Shack in Edinburgh
Printed and Bound by CPI Group, Croyden.

The wonder grows from day to day
How God can look after James McBey
When as the Bible says he oughter
He casts his bread upon the water
Lo! It returns upon the tide
Well buttered on the upper side.
When servants leave him, is he stranded?
No. God is much too open handed –
He takes two angels from the Host
And sends them via *The Morning Post*
No wonder France is still in debt
And baulked the Balkans fume and fret,
And trade is in a dreadful plight –
God has no time to put things right:
He's far too busy, night and day,
In doing things for James McBey.

E. Arnot Robertson circa 1920s,
source Aberdeen Archives, Gallery and Museums.

*To my North and South,
and in loving memory of my East and West.*

Contents

Acknowledgments	xi
List of Illustrations	xv
Foreword	xix
Chapter One – 'Ma'alesh'	1
Chapter Two – 'A stern flat land'	21
Chapter Three – The breadwinner	37
Chapter Four – Across the border and beyond	53
Chapter Five – 'The Arabian Nights'	73
Chapter Six – McBey's war	93
Chapter Seven – 1 Holland Park Avenue	116
Chapter Eight – Love and marriage stateside	138
Chapter Nine – Paradise	160
Chapter Ten – A war to forget	178
Chapter Eleven – 'Why can't I see the sun rise?'	199
Chapter Twelve – 'He is still taking complete charge of my life'	217
Afterword	233
Endnotes	239
Bibliography	275
Index	279

Acknowledgments

Much of this book was written in Glasgow during the height of the Covid pandemic and coincided with the deaths of my beautiful – and always supportive – parents, Judi and Ahmad, who tragically passed away within a week of each other in November 2021. If my wife, Eilidh, and my daughters, Flora and Iona, are my North and South, then my parents were my East and West, and the loss of their guidance and unconditional love is an untethering that will forever remain a source of deep sorrow.

It is my wife and children, and my late mum and dad, to whom this book is dedicated.

Indeed, no book is written in isolation, and if not for the support and co-operation of many people and institutions, this biography would never have come to fruition.

I am indebted to Marguerite McBey's nieces, Barbara Kehler, Joan Dickson and Kathleen Loeb-Schwab, for their unfailing help with my project from its uncertain beginnings to its completion. My gratitude also goes to Joan's husband, John Dickson, for sending me many wonderful images related to James and Marguerite McBey, some of which appear on these pages. Each of them always met my (many) emailed queries with kindness and genuine interest, and this book is a testimony to their involvement.

My sincere thanks and appreciation also go to:

Charles Catto, my greatly valued Aberdeenshire expert whose dogged research on my behalf provided me with the foundations on which to build many aspects of this book.

Griffin Coe, art curator at Aberdeen Archives, Gallery & Museums (AAGM), who went above and beyond to help me piece together McBey's life, especially during the difficult days of lockdown, and whose advice was always expertly, patiently and courteously given.

Helen Fothergill, service manager at AAGM, who – without hesitation – embraced my project and who kindly facilitated my grant on behalf of Aberdeen City Council.

Madeline Nehring, AAGM's lead art curator, whose leading role in the gallery's decision to hold a McBey exhibition inspired by the book's publication vindicated my own belief that the artist's extraordinary life and times should be made into a biography.

The staff at the mighty Scotland Street Press, not least my publisher Jean Findlay, who saw the book's potential and believed in me as a writer, and Antonia Shack, who devised and designed the book's wonderful cover. Every writer needs an editor, and I was very fortunate to have at my disposal the talents of Scotland Street Press's Catie Gladstone, who tended to my book with patience, precision and professionalism.

Lesley McDowell, who, in 2020, told me that I needed 'a good book idea and a grant,' and whose sage advice I followed, and James McGonigal and Alexander Maitland for their early encouragement.

Jennifer Melville, Jill Marriner and Edward Twohig for their selfless advice on all matters pertaining to art, and whose inbox I often frequented with questions and pleas for advice.

The wonderful staff at AAGM, Glasgow's Mitchell Library and Edinburgh's National Library of Scotland.

AAGM, Tangier American Legation Museum, Allinson Gallery, Inc., Marist College and others named as credits, for permission to publish artworks and photographs.

The Society of Authors and Aberdeen City Council for their generous financial support as I strove to meet my deadline.

And Jean McLean, my mother-in-law par excellence, who gave up her time to collate and compile many aspects of my work.

Only James McBey's incredible drive, talent, ambitions and subsequent legacy made possible this book, and though I will never know his views on it, it is my hope that I have done his life and times justice. Indeed, while this is a biography on her husband, these same sentiments apply to the late Marguerite McBey herself.

I finished writing this work on the beautiful Isle of Islay, surrounded by breath-taking scenery, the wind, waves and rain, and many fine people. The fact that my wife, whose love and support proved critical during this time away from our Glasgow home, agreed to (temporarily) relocate to the Inner Hebrides, at the height of winter, no doubt is a testament to her generosity – and a gesture for which I will always remain grateful.

My gratitude also goes to:

Michael Agnew, Simon Aitken, Daniel Albert, Jane Allinson, John Ansley, Kirsten Appleyard, Malcolm Archibald, Rachel Ashcroft, Phil Astley, Nicolas Barker, James Barr, Mychael Barratt, Stephen Bartley, Karim Benzakour, Jonathan Black, Angus Blakey, (Dr) Andrew Blaikie, (Professor) Andrew Blaikie, Claire Brenard, Jenny Brown, Stewart Brown, Hélène Bullen, Peter Bullen, George Cheyne, Rafael Cidoncha, Richard Conahay, Leslie Cotchett, Ronnie Cox, Tom Cumming, Christopher Davidson, John Davison, Allison Derrett, Charles Duff, Stuart Hadaway, Blanca Hamri, Sarah Harley, Colin Helling, (the late) John Hopkins, Mirrin Hutchison, Janet Jones, Katy Kavanagh, Malcolm Kinnear, Robyn Law, David Lever, Gerald Loftus, Ronnie MacAskill, Ronald Manzer, Georgina Martin, Lyndsey McLean, Robin McLean, Carl Mooney, Jr, Barry Moreno, Chris Murphy, Fiona Musk, Philip Neale, Malcolm Nicolson, Paul O'Pecko, Ben Peters, Mark Pomeroy, Sarah Putnam, Jennifer Rasamimanana, Christine Rew, Eugene Rogan, Amy Rose, Donnie Ross, Evert Schilder, Peter Semple, Iain Sime, Jan Smith, Jacqueline Spear, Jacqueline Speel, Mary Anne Stets, Nick Stroud, Peter Trowles, (the late) Gordon Turner, Alan Wilks, Jenny Wilks, Matthew Williams, Nancy Williams, Joe Winkelman, Aziz Zefri and Khalid Zefri.

The above help and guidance notwithstanding, it goes without saying that any mistakes – hopefully few and minor – are mine and mine alone.

List of Illustrations

1. Newmill cottage in Foveran, where McBey was born in 1883. Image courtesy of Jenny Wilks from a photograph taken circa 1900.

2. Foveran Parish Church, Foveran, Aberdeenshire. Photograph taken by Charles M. Catto.

3. *Portrait of the Artist's Grandmother*, by McBey, oil on canvas, 1901. Image courtesy of Aberdeen Archives, Gallery and Museums.

4. Today's cellar doors at 42 Union Grove, Aberdeen, in front of which McBey found his mother hanging. Photograph taken by Sarah Harley from Margaret Duffus Leasing.

5. McBey as a young man in 1910. Photograph courtesy of Joan and John Dickson.

6. *The Story-Teller*, by McBey, etching on paper, 1912. Image courtesy of Aberdeen Archives, Gallery and Museums.

7. *Grimnessesluis*, by McBey, etching on paper, 1913. Image courtesy of Aberdeen Archives, Gallery and Museums.

8. *Mrs Curtis, Esna, Upper Egypt*, photographic reproduction of one of McBey's paintings from 1917. Image courtesy of Aberdeen Archives, Gallery and Museums.

9. Photograph of McBey sketching the Mosque of Omar, Jerusalem, in 1918. Image courtesy of the Lowell Thomas papers, archive and special collections, Marist College, USA.

10. *Lawrence of Arabia*, a photographic reproduction of McBey's 1918 oil portrait. Photographed by the Imperial War Museum, image courtesy of Aberdeen Archives, Gallery and Museums.

11. McBey's London studio at 1 Holland Park Avenue, photographed in 1999. Photograph taken by John Dickson.

12. McBey's 1919 etching from the Middle East during the First World War, *Dawn: The Camel Patrol Setting Out*. Image courtesy of the Allinson Gallery, Inc.

13. McBey's friend and lover, E. Arnot Robertson, photographed with him and another young woman, along with Arthur Baylis Allen, aboard the *Esna*, possibly – according to the artist's diary – in 1923. Image courtesy of Gordon Turner.

14. *Santa Maria della Fava*, by McBey, dry-point on turquoise paper, 1926. Image courtesy of Aberdeen Archives, Gallery and Museums.

15. Photograph of Frances Gripper, one of McBey's lovers, in the mid/late 1920s. Image courtesy of Leslie Cotchett.

16. Marguerite photographed as a young woman in the mid/late 1920s. Image courtesy of Joan and John Dickson.

17. Marguerite and McBey photographed in 1931 shortly after their marriage. Image courtesy of Joan and John Dickson.

18. McBey with Marguerite and Marguerite's mother, Hortense, in 1931. Photograph courtesy of Joan and John Dickson.

19. *Approaching New York, No. 2, upright plate*, by McBey, etching on paper, 1934. Image courtesy of Aberdeen Archives, Gallery and Museums.

20. *Acrobats Marrakesh*, by McBey, oil on canvas, 1936. Image courtesy of Aberdeen Archives, Gallery and Museums.

21. Photograph of McBey at work in New York in 1944. Image courtesy of the Tangier American Legation Institute for Moroccan Studies (TALIM).

22. El Foolk, Tangier, photographed in 2000. Photograph taken by John Dickson.

23. Interior of El Foolk, Tangier, photographed in 2000. Photograph taken by John Dickson.

24. *Portrait of Marguerite McBey*, McBey, oil on canvas, 1950. Image courtesy of Aberdeen Archives, Gallery and Museums.

25. *Self-Portrait*, McBey, oil on canvas, 1952. Image courtesy of Aberdeen Archives, Gallery and Museums.

26. *Zohra*, McBey, painted in 1952. Photograph of portrait courtesy of Ayoub el Jamal. This image of the painting is courtesy of the Tangier American Legation Institute for Moroccan Studies (TALIM).

27. Pedro Villa Fernandez photographed circa 1960s. Image courtesy of Hélène Bullen.

28. McBey and Marguerite's nieces in Tangier in 1956. Photograph courtesy of Joan and John Dickson.

29. Photograph of Marguerite and McBey looking through his large telescope at El Foolk, Tangier, in 1959. Image courtesy of Joan and John Dickson.

30. McBey's grave and headstone on Cherifian Rocks, Tangier, photographed in 2000. Photograph taken by John Dickson.

31. Lady Caroline Duff, Marguerite's lover after McBey's death, photographed in Tangier circa 1972. Image courtesy of Charles Duff.

32. Marguerite and David Herbert in the mid/late 1970s. Image courtesy of Joan and John Dickson.

Foreword

I heard James McBey's voice for the very first time on 18 February 2022. It was a spine-tingling experience. I had been writing the story of his life for the previous eighteen months, but had yet to hear the soft, undulating Aberdeenshire accent so often described.

I knew that McBey, as a man of habit, would have marked the recording in his diary. And he had. Today this recording is a witty and whimsical throwback to a bygone age. It was Swede Leo Komstedt who dropped by the Scotsman's home in Tangier on 22 October 1959 with recorder and microphone in hand in a bid to draw the shy seventy-five-year-old artist out of his shell. As Komstedt himself noted on tape, it was not easy.

'When I hear my own voice, I feel just as though you were looking at photographs of myself taken naked,'[1] McBey stated during the twelve-plus minute recording, in which he soon relaxed.

As I listened, I counted myself fortunate that I had been given the opportunity to hear the voice of my subject, a privilege not granted to biographers of other, more distant, personalities, such as Abraham Lincoln or Jane Austen. (How wonderful – and enlightening – it would be to hear the former's delivery of the Gettysburg Address or the latter read from *Pride and Prejudice*.)

The recording reveals McBey's bashfulness, impressive intellect and amiable nature through his lyrical tones. Recorded in what was then the winter of his life, it divulged nothing of his myriad flaws, his deep-seated insecurities, his traumatic past and his intrepid adventures. McBey by that time held a place as one of Britain's most accomplished artists, having taken the creative world by storm decades earlier.

A bona fide artist-adventurer, McBey lived a life that was both cinematic and painfully real, from his birth in Scotland's Victorian north-east to his death in post-war northern Morocco. McBey reached a level of fame in his lifetime that saw him become a celebrity on both sides of the Atlantic, as the printmaking heir to the masters Rembrandt and Whistler, and as World War I's official war artist on the parched Palestine Front.

A compelling diarist as well as artist, his half-a-century of diary-keeping was ever-evolving and often visceral. But the artist was already being lamented as a forgotten great just a year after his passing in December 1959.

'Among a brief list of current exhibitions on the wall of a Tube station I happened to notice one mentioning James McBey,' wrote Frank Davis for *The Illustrated London News* on 10 September 1960:

> Many of the present generation will not have heard of him, so speedily do reputations fade. Enough, at this point, to note that by 1914 he had established himself as an etcher of far more than ordinary accomplishment and, during the quite crazy gambling boom in etchings in the 1920s, was recognised [...] to be in the authentic line of descent from [...] Rembrandt himself.

Three major institutions – Aberdeen Archives, Gallery and Museums, the Imperial War Museums and the Tangier American Legation Museum – are today largely responsible for promoting his international credentials as an etcher and painter. Each institution holds and displays vast collections of his work.

But James McBey's name and art have still not made their way into popular Scottish and British culture outside the borders of Scotland's north-east. Only in the north-east is he something of a cult figure. Had McBey been French, Russian or even American, a current acclaimed printmaker told me, a separate museum would almost certainly have been established in his honour.[2] It is a self-evident truth to anyone who has studied and appreciated McBey's work that he deserves to be widely hailed as one of the twentieth century's most gifted artists.

This is not a book about art, but rather one in which art features, it should be noted. Others more qualified can speak about McBey's artistic relevance, but this book as a biography, prioritises the lesser known aspects of the man himself over any wider discussion of his artistic merit. Yet, as with other greats from the modern art world, his life and work were inextricably linked and I do not shy away from illustrating this.

My telling of the Scotsman's life and times has been facilitated by access to the reams of McBey-related material at Aberdeen Archives, Gallery and Museums. It was a thrill to read and even handle the pocket diaries in which the great man himself confided his everyday thoughts and experiences. The sight of the piles of yellow-stained envelopes, each

meticulously prised apart by a letter opener (a largely forgotten tradition) was exhilarating. Each envelope hid a missive that more often than not added another intriguing piece to the James McBey puzzle.

Most of the letters, diaries and other source material referred to in the pages that follow have never been made public. What emerges from all sources is a man apart – a complicated being and genius artist intertwined. McBey, like explorer and missionary David Livingstone, poet Robert Burns and writer Muriel Spark, today stands as an international Scot for the ages.

CHAPTER ONE

'Ma'alesh'

'Damascus is simply an oasis – that is what it is. For four thousand years its waters have not gone dry or its fertility failed. Now we can understand why the city has existed so long.'

– Mark Twain, *The Innocents Abroad*, or *The New Pilgrims' Progress* (1869)

Sometime after the end of the First World War, T. E. Lawrence invited his former military colleague from the Middle East, Sir Ronald Storrs, to the Imperial War Museum (IWM) in London, to see the work of Irish artist, Sir William Orpen (1878–1931). The legend of the man dubbed 'Lawrence of Arabia' had already hit dizzying heights due to his swashbuckling role in the Arab Revolt against the Ottoman Empire. Storrs couldn't resist some light-hearted mischief-making at the one-time British intelligence officer's expense.

'When we came to his portrait by James McBey, I asked him to stand in front so that we might for a minute see him against McBey's vision,' recalled Storrs, writing after Lawrence's untimely death in 1935. 'In a flash the word went round the staff that Lawrence was here, and for the rest of our visit we were accompanied by the rhythmic beat of a dozen martial heels.'[1]

Lawrence's fame had taken on a life of its own in post First World War Britain. It was only appropriate that his portrait had been painted by the brilliant McBey. McBey's skill, fortitude and industry had made possible his presence as *the* man to capture Lawrence's sunken features in a chaotic Damascus. McBey's oil composition, the oldest known surviving portrait of Lawrence, remains one of the most evocative paintings of any wartime figure, as the work of an artist at the peak of his talents.

Both men had made their mark on the sun-beaten lands of the Middle East during the First World War in quite different ways. McBey was nearing the end of his time on the Palestine Front and would soon return to London – his home since 1911 – when he first met Lawrence in October

1918. Nearing thirty-five, the Scotsman had experienced much during his sixteen months in the Arab region as official war artist to the British-led Egyptian Expeditionary Force (EEF). He had tirelessly worked its battle-scarred landscape and had recorded it all, with painstaking brilliance, for posterity. This was the landscape where the Allied military campaign against the Ottoman Turks had erupted in late 1914, and two years later, the Arab Revolt had ignited. Now McBey was in Damascus, which, freshly liberated from the Ottomans, was in a state of flux.

The city's capture provided all-out victory for the Allies in the Levant. With most eyes on the mindless slaughter in Europe, where a whole generation of young men would lose their lives on the Western Front, the conflict raging in the Middle East was a little feted campaign. Even Lawrence would regard the Arab Revolt as 'a sideshow of a sideshow', but the relentless advance of the EEF, under the command of British general Sir Edmund Allenby, saw the Turkish Army routed in Damascus, with the Ottoman armistice coming at the end of October, and the European armistice itself following on 11 November.

McBey entered Damascus on the coattails of a conquering army, which included the EEF (British and Australian troops, among others), Arab irregulars and Lawrence himself. He now found himself in the centre of the coveted city, armed only with the tools of his more genteel trade, and laden with his own experiences of war. McBey had witnessed Allenby's onward march from Quneitra, which he would depict in his 1921 etching *Hermon: Cavalry Moving On Damascus*. The victorious anti-Ottoman figure of Emir Sherif Feisal, third son of the king of the Hedjaz and Allied Commander of the Arab Northern Army, longed to see Damascus as the capital of a great Arab Kingdom, with himself as ruler. The city was gripped by disorder with the Ottomans either dead or on the retreat, but McBey had a job to do. Having survived this far, fate would hand McBey one of his most iconic assignments yet.

A weathered Lawrence, driven by his equally weathered chief of staff, Walter Francis Stirling, had swept into the ancient Arab city in his stripped-down battle-wagon – a Rolls-Royce tender named 'Blue Mist' and commandeered the year before in Cairo – on the morning of Tuesday 1 October. Within days, 'McBey [had himself] reached Damascus and encountered T. E. Lawrence who had just occupied the city with some three thousand "Arab Irregular Cavalry" of the Howeitat, Rualla and Beni

Sakhr tribes.'² Lawrence, who had lived and fought alongside the Arabs for two years, was feeling troubled as his thoughts turned to the promises made to them for self-government in a post-Ottoman world that he had long known would not be fulfilled. Stirling, who later recalled that 'Dervishes danced around us [...] while from the balconies and rooftops veiled women pelted us with flowers'³ as they both entered the conquered city, also remembered that Lawrence's 'mind was too complex to permit of satisfaction for an achievement successfully carried out [... because] his moment of triumph was embittered by his knowledge that the [British] government wouldn't keep their promises to the Arabs.'⁴

Five-foot-five Lawrence, pensive and exhausted, presented himself to McBey on the forenoon of 3 October, at the Victoria Hotel. McBey, broader and six inches taller, was tasked with the duty of painting the victorious intelligence officer-turned-guerrilla fighter. The artist, on the face of it, had little in common with a man who had spent two years blowing up bridges and Turkish trains. Yet, they met as outsiders, both born illegitimately in late nineteenth-century Britain, McBey, the largely self-taught etcher and painter, and Lawrence, the enigmatic Arabist. McBey would recall the moving occasion when he sketched a motionless Lawrence, who, dressed head to toe in native robes of white and gold, greeted a steady stream of Arabs as they bowed before him and kissed his right hand in tearful goodbyes. Lawrence was given leave to depart the front the next day, having deemed his role in the war complete with the liberation of Damascus. Lawrence, now thirty years old, soon set sail for England, where the myth of 'Lawrence of Arabia' was born.

McBey's finished portrait remains an artistic triumph more than a century on. It is a composition which was later described by a clearly confronted Lawrence as 'shockingly strange to me.'⁵ The Arabist's 'face is as thin and sharp as a dagger, and his eyes [...] enormous and profoundly sad'⁶ in the sapping autumn heat of Damascus, where 'confusion, chaos, jealousies, and violence'⁷ reigned supreme. 'It is the face of a man worn out by danger, stress, responsibility, and disappointment.'⁸ McBey had captured Lawrence's troubled and bitter-sweet end to his Middle Eastern war with fleet of thought and typical panache. The portrait would help to fix Lawrence's enduring legend.

The Scot had embarked on his duties as official war artist to the EEF in the early summer of 1917. The many months leading up to the capture

of Damascus – 'the final prize'[9] of the Middle East campaign and, according to Lawrence, the 'climax' of the Arab Revolt – had not been for the faint of heart. The terrain and environment had been continuously hot, arid and capricious, and McBey's normally full head of hair had been cut to the bone. McBey now looked every inch the soldier in stark contrast to his more dapper demeanour as a young artist in pre-war Britain. Photographs from the time depict a steely-looking individual who seems nothing like a creator of delicately produced works of art. The harsh climate of the surroundings also impacted his compositions, which was a cause for concern.

McBey wrote to his Aberdeenshire friend, William Hutcheon, a journalist, in early 1918: 'Watercolour is getting impossible, and I'm a bit tired of the medium. We are comparatively free from dust, but the appalling heat dries the blod [sic] immediately it is put on the paper, and buckles it, and a wash is altogether out of the question, so I have written to [Charles] Masterman[10] for permission to paint in oils also. I hope he will grant it.'[11]

McBey began 1918 in Umm el Kelab, the site of Allenby's GHQ, close to Rafah, sixty-odd miles south-west of Jerusalem, which had been captured from the Ottoman Army by EEF forces in early December 1917. His first diary observations on New Year's Day opened with the words: 'Did not sleep well at all. Very hard on table.' There would be many more uncomfortable nights like this for the subaltern as he looked ahead to a full year on the road. January, like the months preceding it, was busy, his days and nights spent mixing with other Allied personnel, travelling and sketching the sights made famous by the Bible. 'The capture of Jerusalem [had] provoked an enthusiastic reaction in Britain that ignited War Office interest in the Palestine campaign'[12] – and even for a non-combatant like McBey, the British-led advance must have been cause for celebration. His official brief had been 'to make drawings of appropriate war scenes in Egypt and Palestine for the purposes both of propaganda at the present time and of historical record in the future.'[13] The junior officer was, as such, effectively part of the wider Allied war effort, and the EEF's battlefield triumphs made his own job easier to realise.

McBey worked in and around Jerusalem during the early part of that first month. Unbeknown to all involved that month would herald the final year of the First World War. It was winter, and the artist, ever the hardened Scotsman, would have been familiar with the inclement

weather which often played havoc with his work schedule. His work was not made any easier by his lack of permanent transportation. Forced to get rides when he could, on 2 January he was left exhausted after his vehicle for the day tried to navigate a road which was 'a treacherous swamp on which boulders distributed. Car stuck. Walked and stumbled along.' Four days later he took to reading William Makepeace Thackeray's *Vanity Fair* such was the misery of the day where the rain fell 'all the time.' He was forcibly reminded that a bloody war was being waged, later that month, when, accompanied by a group of Americans, he made a field trip north of Jerusalem to Nebi Samwil, a past battleground on the line of the November 1917 advance towards the Holy City. 'Very hot walking until we struck Samwil plateau,' he recorded in his diary. 'Horrible sights: hands sticking out of the earth and bodies not buried. Woman and dog and child.'[14] In the afternoon, after bad weather forced the group to seek shelter at the home of a 'Mrs. Larsson', he 'saw Hole's book on the Holy Land for the first time.'[15] William Hole (1846–1917) was 'an artistic pilgrim to Palestine'[16] – and McBey was almost certainly referring to his early twentieth century work, *The Life of Jesus of Nazareth*, featuring eighty of Hole's Gospel-themed illustrations. By warranting a mention in his diary, the book must have struck a chord with him for both artistic and religious reasons. It was possibly owned by Edith Larsson, an immigrant of Swedish descent who had settled in Jerusalem years before with her evangelical father to join a Christian utopian commune known as the American Colony. McBey would have been familiar with dogmatic views such as Hole's, having been born and brought up within the unbending confines of Scotland's Presbyterian north-east. McBey's family's library at his childhood home in Aberdeenshire extended to little more than the Bible, a book on Protestant reformer Martin Luther and an old, engraved atlas in two volumes.[17] Jarring in its racial slights, the opening passage of Hole's book reads:

> In the backwaters of civilization, where the current of time flows past, leaving the manners and customs of a people unchanged, it is possible so to re-create the past, that pictures representing it may lay claim to a certain amount of historical accuracy. And thus it is in the land of Palestine, where observation of the primitive life of its inhabitants impresses the conviction that, in

this respect at least, nothing of importance has been changed; but that as it was in the days of Jesus Christ, so it is to-day.[18]

The artist might have reflected on his boyhood days reading the Bible to his beloved grandmother before bedtime as he flicked through the pages of the book and studied Hole's Biblical impressions. As a child and youth in Aberdeenshire, McBey could little have imagined that he would one day be visiting the very places made famous by the Gospels, let alone in a time of war. Before January of 1918 was out, he had called on the likes of Mount Zion and Bethlehem, where a visit to the Church of the Nativity saw him sketch a kilted Scottish sentry standing before the silver star, later turned into the hauntingly evocative chalk and watercolour, *The Star of the Nativity: in the Church of the Nativity at Bethlehem, where the silver star marks the birthplace of Jesus*. McBey had befriended John D. Whiting, a multitalented man who worked with Jerusalem's American Colony, and watched him deliver a lecture on 'Bedouin life' in mid-January at Jerusalem's Russian Hospice, originally constructed to accommodate that country's pilgrims. Interestingly John D. Whiting had begun serving as an intelligence officer for the British in 1918. At the Russian Hospice McBey met the son of an Aberdeen librarian – a taste of home he found 'Extraordinary.'[19]

Around McBey the EEF continued to make war. The Ottoman Army may have lost Jerusalem, but they were far from out. Allenby telegrammed a colleague at the end of 1917: 'I hope to operate against Hijaz railway during wet season, and while waiting for my railway to overtake me, as there are still 20,000 Turks south of Amman.'[20] However, a retrospective report by the EEF commander-in-chief made clear his position as it pertained to the start of 1918: 'Any further advance northwards on my part was out of the question for the time being,' wrote the imposing general, known to his troops as 'the Bull':

> Besides the construction of roads and the improvement of communications in the forward areas, stores of supplies and ammunition had to be accumulated. Until the railway had reached a point considerably nearer my front, this was of necessity a difficult task, and one rendered still more difficult by frequent spells of wet weather. Moreover, before a further advance could be made, it was necessary to drive the enemy across the River Jordan to render my right flank secure.[21]

Much intrigue surrounded the war effort at the start of the new year. Lawrence had suspected that a traitor had infiltrated the ranks of the Allies' Arab contingent and was feeding back information on their 'plans and whereabouts'[22] to the enemy. Lawrence hired a bodyguard of trusted Arabs to keep him from being targeted, aware that the Ottoman Turks had put a bounty on his head, which had risen in price as his reputation soared. In early January 1918, the diminutive guerrilla fighter, remembered by one colleague as 'a small bedraggled figure',[23] watched his fleet of armoured cars come under stinging rifle fire through his binoculars from a hill overlooking a plain. This counterattack followed a mobile assault on an Ottoman position which was defending a section of railway.[24]

McBey too was on the move while Lawrence pushed on. On 22 January, he packed for a two-week excursion, leaving Allied-occupied Jerusalem for Egypt, which had been under British occupation for the past thirty-six years. It was a taxing journey – early on the car in which he was travelling got a puncture – but three days later he was wandering about the sweaty streets of Cairo under a warm sun. A sun that, within months, would really start to burn. Like many of the Allied ranks in the bustling Egyptian metropolis, second lieutenant McBey called in on Shepheard's Hotel – 'the social mecca of British Army officers.'[25] Shepheard's – founded as a caravan tavern in 1841 – had long proved the ideal meeting spot to plot or simply gossip. Indeed, 'As a place from which to watch the world go by, [its] open-air terrace [...] was said to have no rival. Here [tasselled] fezzes greeted solar topis, peaked caps toasted pill-box kepis, and skullcaps attended top hats while bushwhacking wide-awakes bent over their beer.'[26] One British officer, Wyndham Deedes, lamented that the free-spirited nature of the hotel, with its 'broad stairways and wide halls, resplendent with divans, cushions and palms,'[27] made the Middle Eastern conflict appear 'more like a carnival than a war,'[28] while another bemoaned 'the very undesirable state of affairs now existing in Cairo [where] crowds of idlers in military uniforms throng the streets from morning to night.'[29] McBey probably more than held his own in the company of the hotel bar's hard drinking clientele as stories of war were exchanged amid the noise and smoky breath that made thick the atmosphere.

McBey took a donkey ride not long after, to the ancient Egyptian capital of Memphis, lying just beyond the southern edges of today's Cairo.

He also visited the age-old burial ground of Saqqara, which had served as the necropolis for Memphis for more than three thousand years. On 28 January, he left for Upper Egypt by train. 'Uneventful and pleasant journey,' McBey wrote in his diary. 'Very restful to my eyes the green after the desert and the barren rocks. Slept part of the way.' He explored Luxor for the next few days, drawing and visiting the ancient sites, but he felt weighed down by a consuming sadness. On the last day of January, he almost broke down as he watched the sun set, and he was clearly glad to bring his time in Luxor to an end when he left on 2 February.

McBey's melancholia was likely connected to Isa Curtis, who met him for a few minutes at Esna after his 'damnably nervous' train journey from Luxor on his way to Aswan.[30] She looked 'very pale', which was probably due to her pregnant state, the result of their affair.[31] He had started a passionate relationship with the married Briton in 1917, and their very brief meeting at Esna, located on the west bank of the Nile some forty miles south of Luxor, was awkward. At the station, he handed her a copy of *The Bystander* and, after shaking hands with her from his carriage window, tried to take her photograph 'but she was turned away.'[32] (One surviving snapshot depicts Mrs Curtis, dressed in white and wearing a wide-brimmed sun-hat, with her back to the camera walking towards an official building signposted 'Esna Railway Station' in Arabic, which is likely the image in question.) Their meeting had been arranged by letter, with Isa earlier writing: 'If you intend doing Aswan too, let me know what day you'll be leaving Luxor and I *may* see you as your train passes through Esna Station,'[33] adding in a further missive: 'And if I'm *not* alone at the station, please *don't see* me – I shall *trust* you to do this for me.'[34]

Early February proved challenging for McBey. He developed a sore throat, and it became painful to swallow. One morning he took to drinking a cold glass of beer to soothe the pain. At Aswan, a doctor lanced a quinsy and he began running a fever – and days of discomfort ensued. After heading back to Cairo, he spent three days in hospital, where clearly benefiting from time away from his hectic schedule, he recovered well enough to resume his duties. This was the first time he had needed bed rest since getting his tonsils removed several years before, he noted in his diary. From the Egyptian capital, he wrote happily to Isa and continued sketching, making a field trip to the Pyramids of Giza. Later that month, he was back in the Holy Land, and was delighted to discover that he had

been allocated his own car, a Ford, and driver. 'Ought to do good work now,' he wrote.[35]

Meanwhile the various factions which made up the Allies continued to make life difficult for the Turkish Army. A jubilant McBey received his vehicle on 19 February, and set off to explore Jaffa, the site of the 1192 battle between the army of Muslim general Saladin and the Crusader forces led by England's King Richard the Lionheart. While McBey was in Jaffa, Allenby's 60th Division took El Muntar, Arak Ibrahim and Ras et Tawil, as 'the Bull' moved on the Jordan Valley. Within days, Jericho, a bridgehead into the Valley, fell to the EEF's combined British, Australian and New Zealand forces. The artist shortly afterwards sketched this fertile strip of land from the safety of a 'very high hill.'[36]

Now with his own mode of transport enabling him to keep up to the front, he stepped up the pace. At the beginning of March, he returned to Nebi Samwil and found it less horror-strewn than before – 'Place tidied up'[37]– and a week later he drove to Ramallah, where he heard shells bursting in the distance. On 23 March, and clearly enjoying his new-found freedom, he journeyed to the Dead Sea after making an early morning sketch at the Mount of Temptation.

'It was delightfully buoyant, but my eyes stung badly,' he recalled of his swim in the landlocked salt lake:

> The sun was the only substitute for a towel. I had just begun a drawing when two large cars drove up. In the first was the duke of Connaught and General Allenby, and in the other, Staff Officers. The Commander-in-Chief stopped and said, 'Making a survey?' (I was working on a survey plane table.) 'No, sir. Sketching.' 'Who are you?' 'The official artist.' 'What, McBey? I did not recognise you.' No wonder, for the Dead Sea water, drying on my face, had left a thick deposit of salt, giving me the appearance of Lot's wife.[38]

His chance encounter with Allenby and the duke of Connaught, formerly Governor General of Canada, and the seventh child and third son of Queen Victoria, involved extricating the commander's heavy vehicle, which was sunk up to its battered axles in a quagmire. 'I proposed different route and acted as pilot in sandy wadi switchback,' he wrote of their testing departure. 'Got them safely over worst at which I was greatly relieved.'[39]

Springtime saw Allenby forced to deal with some military setbacks which threatened to derail his progress to Damascus. Two botched attempts to take Amman between March and May would result in Allied deaths. The War Office now informed Allenby of its plans to remove troops from the EEF to cover heavy Allied losses sustained on the Western Front following the German Spring Offensive. 'You will adopt a policy of active defence in Palestine as soon as the operations you are now undertaking are completed,' Allenby was told.[40] McBey had noted (in his diary) the EEF's first lot of Amman troubles, but it appeared to have little impact on his own work schedule. On 9 April, he was again in Jaffa, where he edged towards the front line. The next day, he 'watched from signal station shells bursting up coast' and then, on a hillside, opened a letter from Isa, written from the Egyptian city of Alexandria. She informed him that she had given birth, but that their child had died, writing obliquely: 'I am still here. My reason for wanting to go to Alexandria came here on the 26th but only stayed four little days.'[41] It was McBey's first experience of fatherhood, and the loss was hard to take. Returning to Jerusalem, he again reflected sadly 'on Isa and the little one'[42] but carried on his artistic duties in the following days, visiting the Mount of Olives and Herod's Gate. Later, he 'went up to Zion Gate and sketched sentry, very impressive, and also kids – little boy with goat.'[43]

McBey was at the Jordan Valley in early May, and spring temperatures were sizzling ahead of the oncoming summer meltdown. 'It is only with an effort I can write in a sober fashion this morning,' he wrote to Scotsman, William Hutcheon:

> as I feel I have now thoroughly got the better of the touch of the sun I got in the Jordan Valley. What a sinister place that is! It is like being in a vast white oven with, for a lid, the sky resting on the Moab mountains on one side and the Judean hills on the other. By all accounts no human being can spend a summer there and live. I am going to have a rake through the Bible to-morrow, as I am inclined to think the Hebrew idea of Hell on which we were brought up took shape from their living on the edge of this furnace.[44]

Allenby had sent upwards of sixty thousand men and officers from the ranks of the EEF to Europe in response to the War Office's orders. Dispatched to replace them were 'Indian regiments [...] and, while the

cavalry arm was no worse for the wear, the infantry and specialty troops were seriously weakened. Signalmen, normally requiring two years of training, were forced to become proficient in just two months.'[45] Required to bring his new influx of partially trained recruits up to speed, 'the Bull' enforced a new training regime as he sought to resume his campaign. 'The principle adopted in the infantry was to brigade one British battalion to every three Indian battalions right through the divisions,' noted one member of the Egyptian Camel Transport Corps, 'and this acted very well indeed, for the white troops provided just that leaven of steadiness lacking in the young Indians.'[46]

McBey was at his most prolific in the final few months of the war. But he spent time with Mrs Curtis in June (and then again in August) amid the blistering heat of an Egyptian summer before his early autumn push towards Damascus, alongside the EEF. Isa was likely still reeling from the death of her new-born in Alexandria when McBey caught up with her in Cairo, and his enigmatic diary entries could well have been a reference to the baby (boy) she had lost – 'She told me about him' (12 June) and 'Told me more about him' (14 June). Cecil House, a hotel in the city, was deemed an appropriate place in which to resume their illicit love affair. It was intense, and a visit to the pyramids even saw them become sexually intimate by the Great Sphinx of Giza, after which they both caught a breezy tram ride home. Following their daring tryst in the shadow of the ancient monument, the couple may have been too consumed with each other to notice that day's hubbub on Cairo's twenty-two-year-old tram system, which often saw 'hawkers of meats and drinks and curios [...] plague you with their constant solicitation [and] boot-boys carry on their trade furtively between the seats.'[47] Cairo's cinemas, such as Salle Kleber and Obelisk Cinema, which were often frequented by battle-hardened British and Australasian troops from the front line on R&R, also provided the couple with entertainment during the balmy evenings. Before parting from Isa, and heading back to Palestine, he made time to sketch another portrait of his married lover, following his first of her one year earlier. He worked meticulously on getting the picture just right for several days, and on 27 June, he kissed her goodbye before heading back to the Holy Land.

McBey likely had Isa on his mind as, tired and reflective, he returned to his day job. Their relationship was not purely physical, suggested by his confiding in her the painful nature of his mother's death, which he felt

moved to do days before they parted. Mrs Curtis' surviving letters reveal a tender and heartfelt concern for his welfare also: 'I'm *trusting* you to be very careful of yourself, to keep well and strong, and to dodge shells and bullets'[48] and 'Please don't start working too hard until you're *quite* fit again'[49] (after learning of McBey's stay in hospital following his quinsy). Isa's missives were often searching, sometimes revealing, but never lacking in pangs of emotional longing: 'But all this dreadful week your face has haunted me. I must give you relief somehow, and no matter by what means [...] Be happy now. Make things worthwhile to me.'[50]

McBey's biggest assignment during that period came when he was given permission to paint a portrait of 'the Bull' himself. McBey's portrait of Allenby gives a window into the artistic processes he employed, and the painstaking means by which his final work was achieved. The 'physically large and confident'[51] Briton first sat for McBey on 25 July at GHQ, now located at 'Bir Salem, near Ramleh, on the Jaffa-Jerusalem road',[52] and again on the twenty-sixth, after which he spent the next several weeks fine-tuning his composition. On one particular day, he laboured at Allenby's 'tunic and sleeve and right arm'[53] from 5 a.m. We can imagine him stood before his canvas, doubtless with a cigarette clutched between his lips, frowning in concentration. Even when he returned to Cairo in August to see Isa for their last meeting of the year, he continued to work away at the portrait of the man he referred to as the 'C. in C.' in his journal. Back at GHQ, he painted himself into exhaustion after toiling 'like the devil at portrait',[54] and doing so in between bouts of sickness. Following visits by Allenby and his wife, Lady Adelaide Allenby, who both cast a critical eye over his work in progress, he successfully completed his composition, finding for it a gilded frame. He unveiled the oil on canvas portrait to the EEF chief himself on 12 September – having gone through four botched canvasses before he cracked it at the fifth attempt. As Britain's official war artist, McBey must have sweated on Allenby's sober judgement. Thankfully, McBey's brief diary entry, in all its understated Britishness, appeared to reflect a satisfactory outcome – he 'thought very well of portrait.'

McBey re-joined the action having completed Allenby's portrait, and now began to stalk the front line. The outcome of the EEF's 'September operations [would leave] the Turks depressed in morale, and so greatly reduced in numbers as to be almost entirely deprived of power to resist

the northward sweep of the cavalry.'[55] McBey watched a dramatic early morning bombardment, at Mulebbis, near Jaffa, on 19 September, and when 'dawn came in, with it the sky was sprinkled with bursting shrapnel.'[56] After he had eagerly climbed to the top of a hill for a bird's eye view of the barrage, McBey witnessed the first shots of the decisive Battle of Megiddo, where 'For a quarter of an hour, up to 1,000 shells a minute rained down upon the stunned Ottoman defenders on the Plain of Sharon. Waves of British and Indian infantrymen followed closely behind this surprise bombardment.'[57] In 1920, McBey would publish his plate of the bombardment, *Zero: A Sixty-five Pounder Opening Fire*, a powerful depiction of a field gun, and its male operators, two of whom can be seen covering their ears as it fires. Allenby wrote to his wife later that day predicting: 'I am beginning to think that we may have a very great success.'[58]

That day McBey also encountered 'Turkish prisoners' and a dressing station where he came across the grisly sight of 'many dead Scots and camels.' The 'dead Scots' were from the First Battalion Seaforth Highlanders and the Second Battalion Black Watch, who had joined that first wave. A 1925 account of the Black Watch's participation described how they 'went into action in shirt-sleeves, tunics being left behind. Sun helmets were also left and steel helmets worn. To lighten the weight, haversacks were not taken. Each man carried a bottle of water-sterilizing tablets.'[59] After the EEF had successfully punched holes through the shell-shocked Turkish defences, Allied casualties were light. But McBey would have likely seen twenty-one-year-old Seaforth Highlander, Private Thomas Meiklejohn, born in Fife, and Private James Smeaton of the Black Watch, married to Annie, and father to two girls, from Auchterarder, Perthshire, among the dead.[60] It must have pained the Scotsman to see men from his native land lying bloodied and lifeless after being cut down in battle. On the same day, he heard the distant rumble of a Handley Page aeroplane in the chilly evening air as he camped down for the night. He had previously seen this British biplane bomber complete a bird-like landing back in August.

The ruin inflicted on retreating Ottoman lines by the Allies later resulted in McBey's oil on canvas *Tul Keram: A Retreating Turkish Column Bombed and Machine-Gunned by Airmen in the Defile at Tul Keram*, which features dead Ottoman troops, a decimated column of wheeled carts,

and a slain horse in the foreground. It is a wasteland where death litters the bare landscape, as bleak as any seen on the Western Front. On 20 September, the skies gently broke as the first drops of autumn rain fell. McBey kept up his sketching from his front row seat to the action, capturing even the most innocuous scenes, such as water pipes being laid through no man's land at Mulebbis. As an assignment, his was intense, dangerous and unpredictable – but he met head on the challenges as he watched and recorded the region change before his eyes.

McBey was in Nablus two days later. He arrived there at noon – 'Place dead and alive, all cholera and dust.' He continued north, spending time with some Scots soldiers on a hillside camp and witnessing a 'mob of Indians fighting for water.' McBey had been fully aware of the influx of Indian soldiers to the ranks of the EEF, and he depicted them in his work. In watercolour and ink he created *The Wells at Samaria: Indian Troops Fetching Water during the Advance*, on 22 September 1918, the same day he had observed the thirst-starved Indian troops. The creation showed a much more ordered scene than the clashes he had in fact witnessed and noted. That same month he also made a full-length chalk and watercolour portrait of an Indian Army soldier sitting side-on in the desert, pictured with rifle and steel helmet.[61] Again in September, and in the same medium, he created a half-length portrait of an Indian infantryman on desert sentry duty. Standing, he wears a steel helmet, with a bayonetted rifle by his side.[62] Who knows whether these men survived the war, but McBey was present to document their commitment to the Allied effort, as well as the contribution of the Allies' other non-white troops. Intriguingly, the 'dispiriting effect'[63] upon passing Indian cavalry and companies of Arab irregulars, from the brutal destruction at Tul Keram, was also noted by the war artist. Lacking any further explanation on McBey's part for their dismay, we can find the reason in one writer's observation, that 'it is not too far-fetched to imagine these non-white [groups] reflecting that if the British could unleash their annihilating airpower on the Turks, they could just as easily do again in the future on any other non-white opponent who had attracted their wrath.'[64]

McBey saw the first rains on the Plain of Esdraelon on 26 September. Esdraelon, which stretches from the Mediterranean coast to the River Jordan, had been painted by American expatriate artist John Singer Sargent thirteen years earlier. Described in the Bible, Esdraelon was the location

of a battle waged between Saul and the Philistines. McBey and most of the war's participants knew the huge significance of these ancient Arab lands now shaking under the weight of heavy gun fire. One eyewitness to the war on the Palestine Front, a machine gunner, later wrote:

> Battlefields, named in the Bible, had been crossed over by British forces, British cavalry had galloped across the actual field of Armageddon, and occupied the sacred place of Nazareth. Armageddon, overlooking the great plains of Esdraelon, southwest of Nazareth, was the battlefield where Barak defeated the Canaanites, and Gideon the Midianites: there Saul was slain by the Philistines, and in 1799 Napoleon defeated the Turks on this same battlefield.[65]

Lowell Thomas, the US journalist-filmmaker who would soon make T. E. Lawrence a global star, wrote of his meeting McBey at a camp on the Plain of Esdraelon. McBey was part of a four-member team covering Allenby's onward march to Damascus. Thomas recalled that McBey was unassuming, but impressive and curious too.

'They were [...] two reporters, a photographer and an artist,' wrote Thomas in his autobiography, *Good Evening Everybody: From Cripple Creek to Samarkand*. 'The paucity of their number was astonishing enough – four men to cover a war involving hundreds of thousands of diverse troops and about to reach its climactic moments! – but it was their attitude toward their assignment that later made it clear I virtually had the field to myself.'

'Fergus Ferguson', a reporter from Reuters, 'had long since ceased to be moved or even terribly interested in anything that' was happening. The other reporter, 'William A. Massey', appeared largely 'concerned with dry facts and oblivious to the romance and colour of a modern war in the ancient lands of the eastern Mediterranean.' And the shooter, 'Harold Jeap', lamented Thomas, 'didn't seem to know which way to point his camera.' Thomas also claimed that, quite incredibly, the growing legend of Lawrence was also his alone to exploit.

'Had they heard about Colonel Lawrence and his Arab irregulars? I asked Ferguson and Massey,' Thomas recalled in his 1976-published memoirs:

> Yes, but it had all been a diversion. No one would ever hear of Lawrence again. Had they tried to get his story? What! Travel halfway

across the Arabian desert to some godforsaken water hole? For what – to see a bunch of Bedouins on camelback? Wasn't Esdraelon bad enough?

'The exception in this fog of indifference was James McBey, Allenby's official artist,' he added:

> He was a Scot from dour, gray-granite Aberdeen [...] and with his bulk and loping walk could have passed for a professional wrestler. In fact he was as gentle a man as I've ever met, soft-spoken, full of whimsy, and so sensitive to the drama of this war in the desert that the floor of our tent and the sand outside were forever strewn with his sketches.[66]

Thomas' observations were unduly harsh on Ferguson, Massey and 'Jeap' (who also suffers the indignity of Thomas' misspelling – Harold's surname was, in fact, spelled Jeapes, and he was the official war cinematographer in Palestine and Egypt during Allenby's campaign). Indeed, Fergus Ferguson, on his death in 1948, was described as the 'doyen of diplomatic correspondents', while Massey published books on the Palestine Front following the end of the war, such as *Allenby's Final Triumph*. Thomas' dismissive attitude of Massey is again highlighted by another sloppy error: it is not William A. Massey, as the filmmaker insists, but William Thomas Massey. As for Jeapes, this 'gnome of a man'[67] who apparently 'found these new surroundings so alien',[68] Thomas required some of his footage for his own post-war show extravaganza, *With Allenby in Palestine and Lawrence in Arabia*, which the American might have been humble enough to acknowledge. Still, Thomas, who 'was more of a showman than a reporter',[69] was evidently taken with McBey. Thomas clearly felt that McBey's blend of unpretentious intellect was worth recalling decades after the fact.

By the close of September, the Battle of Megiddo had been won by the Allies and it was game on for Damascus. McBey knew that his services would be required in the city, but first he had to return to Jerusalem for some essentials. On 1 October, as the beaten Ottomans retreated from Damascus, he was back on the road racing to meet his own date with destiny. 'Started off in early morning and made good timing,' he recorded in his diary that day, after his desert-hardened Ford had burned across the crumbling roads, leaving a trail of thick dust in its wake:

> Passed Jenin, El Fule, Nazareth where got hard boiled eggs. Pushed on through Tiberias, where had tea in hotel and

thorough good wash. On through the plain into the hills, through Rosh Pina, overtook lorries and at night crossed Jordan Bridge. Hot and moist. Mosquitoes. Lightening all night.

McBey saw a shimmering Damascus emerge from the smoky air at about 3 p.m. on 2 October, and witnessed long lines of Turkish prisoners and the streets littered with the dead. The following day, he was able to explore the city at first light in all its battle-scarred glory. Soon, a buoyant British press were able to inform readers about the successful conquest. Newspapers waxed lyrical about the fall of the city for days afterwards, and William Thomas Massey offered his own eyewitness account of the victorious arrival of the Allies: it was, he breathlessly claimed, a day hailed by the native inhabitants 'as the greatest in the four thousand years of the history of Damascus.'[70]

Sadly, for reasons unknown, McBey leaves blank his diary from 4 October to the twenty-first – and so his immediate impressions of Damascus remain a mystery. In the newly liberated city, Allenby, lieutenant general Sir Harry Chauvel – Australia's Commander of the Desert Mounted Corps – and Lawrence were just some of the power players trying to take control of the vacuum. The lithe and bearded figure of Emir Feisal was another, who, soon after his own arrival amid the chaos, began plotting the future of an independent Arab state around Damascus, despite the existence of the notorious Sykes-Picot Agreement, a 1916 settlement of duplicitous nature cooked up by Britain and France, which agreed to carve up the region into colonial spheres of influence. Sir Mark Sykes MP, who had forged the agreement in conjunction with French diplomat François Georges-Picot, wrote a poetic account of the liberation of Damascus for *The Observer* on 6 October. In this account he predicted 'the beginning of a new and wonderful era in the history of the Near East.' Sykes, whose racist views of the Arabs had earlier been illustrated by an entry in his 1915 book, *The Caliphs' Last Heritage* – 'Arab character (see also *Treachery*)' – had his own reasons for celebrating the Allied victory. Within several months he would be dead, taken by the Spanish flu in a Paris hotel room. The pact would be his dubious legacy, sowing the seeds of conflict and division in the region for generations.

Politics aside, McBey was presented in Damascus with a portrait painter's dream. McBey, after shadowing the main thrust of the EEF, would first lay eyes on the mysterious Arabic-speaking Briton T. E. Lawrence

in the city's volatile surrounds. Lawrence sat for him 'for only a couple of hours.'[71] In a letter to Lowell Thomas dated 9 March 1954, the artist elaborated on this atmospheric encounter with Lawrence thirty-six years earlier.

A seventy-year-old McBey wrote to Thomas from his home in Tangier, Morocco:

> During the sitting one after another of those bearded chieftains gently opened the door of the room where I was working, tiptoed across to Lawrence and kissed his right hand as it lay on the arm of the chair [...] Tears were on the cheeks of some of them. These tears may have been [...] part of a farewell ritual (I have seen the technique used here on occasions). Nevertheless it happened, and I saw it. Lawrence showed no reaction, but kept his pose for me admirably.[72]

McBey also captured the dashing figure of Feisal in 1918 Damascus. Lawrence, recalling his first meeting with the Emir in October 1916, gave a hint of the man whom the artist would himself meet, albeit after a further two years of desert warfare:

Feisal looked very tall and pillar-like, very slender, in his long white silk robes and his brown head-cloth bound with a brilliant scarlet and gold cord. His eyelids were dropped; and his black beard and colourless face were like a mask against the strange, still watchfulness of his body. His hands were crossed in front of him on his dagger.[73]

McBey would have his own story to tell, beginning when he 'saw a galloping horse approaching from the horizon' during an evening after the fall of Damascus.[74] 'As it got closer the Arab horseman pulled up so sharply that the horse reared and seemed to slide the last few feet in a cloud of dust.'[75] Feisal, he was informed by communiqué, would sit for him at noon the very next day.

'I was piloted to the end of a crowded room where Feisal was holding audience,' he noted later:

> He greeted me smilingly, and spoke to the interpreter, who translated: 'His Highness wishes to know where you wish him to sit to be photographed.' Tell him he is going to be painted, not photographed, and that he will have to sit steady for an hour, perhaps two. I half expected a refusal, but Feisal merely shrugged his shoulders, and uttered the Arabic 'Ma'alesh' (it

does not matter). I lured him into a small room, away from the crowd. Feisal sat wonderfully steady for about five minutes, then he suggested lunch, and we adjourned. To my surprise, the many Arab Chieftains, lunching with Feisal, at an enormously long table, sat in European style, used knives and forks although the food was Arabic. A huge Abyssinian negro, with swords, knives, and automatic revolvers hung around him, stood immobile behind the Emir's chair.[76]

When Feisal returned, McBey placed him on a Savonarola (a chair with an X-shaped frame) on which the Emir sat squirming for the rest of his pose. After the sitting was complete, it turned out that the object of his discomfort had been a loose doorknob, which the Arab leader picked up and hurled across the room in disgust.

After the war, McBey was interviewed by author Kenneth Hare, for his gossipy tome, *London's Latin Quarter* (1926), in which a stylish portrait of the Scotsman, composed by artist Dorothea St. John George, is included. McBey, described by Hare as 'burly' with a resemblance to Beethoven, recalled the Emir as 'the worst sitter I have ever had.' 'He was a bag of nerves and seemed quite unable to keep still for two minutes together,' he added, speaking with the frankness of a man who was clearly relishing sharing the years-old episode:

> When I told the interpreter that he must tell the Emir to sit still, it dawned on me that the wretched creature was too frightened of his master to pass on my message correctly [...] What the interpreter actually said on these occasions God knows. He probably observed that I kissed the ground before the feet of His Majesty the King of Damascus – on whom be peace – and ventured to suggest that the weather was seasonable for the time of year.[77]

McBey's Damascus portraits of Lawrence and Feisal would be followed by one of the muscular Afro-Arabian bodyguard, and another of Mohammed Ali-el-Mauyed El Aden, a proud and gnarled Arab veteran of sixty-five, who 'insisted that the word "fighter" should be written on the drawing before he would allow it out of his sight.'[78]

McBey's war was not yet over. These had been some of the most thrilling encounters of his commission – but other towns and cities in the Arab region remained unexplored and un-sketched. He was a man at the

top of his game, but the years leading up to this moment had not been without hardship and pain.

CHAPTER TWO

'A stern flat land'

'Nature was sparing in her gifts to Scotsmen. She gave to Scotland a poor, sterile soil as a rule, and compelled them by constant and painful toil to extract from her rugged bosom even a humble subsistence.'[1]

– Neil Macnish, *A Sermon preached at St John's Church, Cornwall, on the 26th November 1893, before the Sons of Scotland* (1894)

At James McBey's birth, just two days before Christmas Day in 1883, the dusty deserts of Arabia were a world away. While vast expanses of the Middle East were under Ottoman Empire control, Britain was in the twilight of the Victorian age. McBey would never forget his native north-east Scotland, where he came squalling into the world at 4 a.m. in Foveran, Aberdeenshire. It was, he recalled, 'a stern flat land fringed by rocks and sand dunes, sparsely punctuated by small villages and farms and inhabited by survivors'[2] who worked the hard soil for their frugal hand-to-mouth existence.

He was illegitimate, his mother, Annie Gillespie, having given birth out of wedlock at twenty-two. Annie, striking, and with chiselled features, was the daughter of blacksmith William Gillespie. 'He was an erect, powerful man with a black square beard'[3] who had toiled at his smithy for forty years by the time McBey emerged into the cold, winter gloom of late nineteenth century Scotland.

McBey would not find comfort in his mother's arms. Even as a tiny child, he sensed domestic unease. He wrote in his 1883–1911 autobiography, *The Early Life of James McBey*:

> My earliest recollection goes back to when I was three years old and is that of an irate grandfather upbraiding my mother in the little garden in front of the house. Dimly I sensed that the discord was connected with me and that he was angry on my behalf. My mother, in a huff, seized my arm and dragged me

to the barn, where, seated on a pile of straw, she and I finished eating a bowl of brose she had in her hand.[4]

Annie, unmarried and responsible for a child she had likely not intended to conceive, did not take to motherhood. Her crippling misery and fragile mental health impacted McBey from the moment he formed the most basic of childhood memories. In his brilliant, but all too brief, memoirs, first published (posthumously) in 1977, the artist reflected:

The relationship between my mother and myself was unusual. She had never shown affection towards me or kissed me and I had been brought up to address her and refer to her as 'Annie', never as 'Mother'. Her attitude seemed to become more and more harsh.[5]

McBey blamed his mother's ever-increasing severity on a mysterious eye condition from which she was beginning to suffer. By the time of her late twenties – when he himself had just turned school age – an ominous haze was beginning to descend over Annie's world. Such a development must have been frightening, even for a young woman used to the hardship of working-class life in Victorian Britain in a parish on the edges of the icy North Sea.

But before Annie's sight started to fail her, her father William died in April 1888 at the Foveran home that he, Annie, Annie's mother Mary, sister Jane, and four-year-old McBey shared. McBey at this young age might have been unaware of the unbearable pain William probably endured as he slowly died from cancer – a disease that a labouring nineteenth century Scot would have had little chance of overcoming. Just two months before William expired, he became consumed by what his death certificate records as 'anasarca' – an extreme form of edema – which would have seen the sixty-nine-year-old's body swell with fluid, before he passed away in the house which he had lived in since a young man. McBey recalled his grandfather with a certain fondness – he had once damaged his little finger and William had used 'his blacksmith's tongs' to pull 'the flattened edges of my finger back into shape.' A procedure which McBey bravely bore until he was made to immerse his hand in bone-chilling water, and his resilience turned to shrieks of pain.[6] But with William's passing he, his mother, grandmother and aunt moved from the blacksmith's cottage, which adjoined the smithy (the buildings known collectively as Newmill), to a tenement in Newburgh, a village also falling within the Parish of Foveran.

Newburgh, where McBey's new home was located, was within walking distance of the smithy – which continued to clang with hammer on metal when William's appointed son George Gillespie took on the business. But the young McBey had never seen this side of Aberdeenshire and vividly described his first childhood impressions of these new sights as his very small world expanded.

He wrote:

> The springy turf of the square mile of links, redolent of aromatic thyme, was so strange and wonderful to me, as hitherto I had seen only tilled fields. Through the gap in the sand dunes lay the sea, flat, crouching, and angry, thrashing itself on the sand to the edge of the world. Its steady muttering drone was the background of sound against the silence in which we all lived.[7]

Yet, while McBey's childhood move to Newburgh clearly threatened to overwhelm his febrile senses, the 1886 publication of *Slater's Royal National Commercial Directory of Scotland* put it in more prosaic terms:

> The parish of FOVERAN extends four miles in length from east to west, and about two in breadth, and comprises 10,537 acres [...] The soil varies from sand to a rich loam and strong clay, the whole of which is arable. The [River] Ythan, navigable for about three miles, forms the boundary on the north [...] At the mouth of the river is the small village of NEWBURGH, in which a considerable trade is carried on in grain, lime, bones and guano [...] Population of the parish in 1881, 2,042.

Annie's faltering vision was a focus of McBey's young life. Annie began taking the horse-bus to Aberdeen Royal Infirmary to be examined by specialists. In late nineteenth century Aberdeen, the Royal Infirmary was located at Woolmanhill, in the centre of the city. By the time Annie was attending consultations at the Infirmary, beginning in the summer of 1889, the Jubilee Extension Scheme was making way for the provision of new surgical, medical, pathology and laundry blocks as the expanding institution cemented its role as a dominant health care provider in Scotland's north-east. (Because the nineteenth-century middle classes often enjoyed the luxury of being visited at home by physicians, voluntary hospitals such as this were built to help serve the needs of the poor across Victorian Britain.)[8]

From the 1860s, the city of Aberdeen and its 'immediate suburbs' were serviced by the horse-bus[9] – a convenient, if not altogether comfortable, mode of transport. Much of Annie's adult life was punctuated by her use of their dark and jolting carriages as she travelled to and from hospital, taking the omnibus from Newburgh to Aberdeen and back again, the carriage wheels clattering across the filthy and manure-covered thoroughfares to and from the city. Arriving in Aberdeen, Annie would then reluctantly enter the Infirmary. At a time when hospitals had not long 'ceased to be houses of death and instead had become houses of healing',[10] she was surely racked with nerves as she sat in the large waiting room before her consultations, worrying about her fate. If Annie had been deemed an interesting or complicated case, she might have been referred to a consultant,[11] such as James Mackenzie Davidson, Argentinian-born Scotsman, and University of Aberdeen graduate, one of the Infirmary's most prominent doctors in the late nineteenth century. He had been appointed ophthalmic surgeon at the Infirmary in 1886 – and would become a pioneer in British radiology when London's bright lights came calling eleven years later. It is possible that Annie would have crossed paths with this specialist as an outpatient, who was described in his 1919 obituary as 'very popular, being kind and courteous.'[12]

Ophthalmology was one of the more advanced branches of medicine during the Victorian period, particularly in terms of diagnostics. The invention of the ophthalmoscope – credited to German physician and physicist Hermann von Helmholtz in 1851 – and its subsequent modifications meant the interior of the eye could be examined in a way that few other parts of the body then allowed.[13] But, leeches, an antiquated remedy, were prescribed for Annie's eye troubles, and it fell to the young McBey to administer the bloodsuckers. What quickly became a gory night-time ritual in their village tenement had him work a wine glass to extract one of these 'loathsome animals'[14] from its jar of water to place on his mother's temples as she rested her head on a cushion. Annie must have willed the creatures to relieve her distress and restore her failing eyesight as they latched on to her taut flesh and inserted anticoagulants through their saliva. Leeches retained a (dwindling) place in the late Victorian period as a remedy for reducing swelling and inflammation. Records show that Annie's first visit to

the Infirmary, on 19 July 1889, resulted in a diagnosis of 'old iritis & H.'[15] – suggesting that inflammation of the iris, the coloured portion of the eye, had been present in the recent past ('H.' is likely an abbreviation for 'Hypotony', the term for very low intraocular pressure).[16] 'Leeching [...] (three or four to the temple),' stated an 1889 medical textbook, 'sometimes has a good effect on the pain [of iritis], though it has little influence on the course of the inflammation.'[17] Annie likely had problems in both eyes, which would cause blurred vision, photophobia and excessive discomfort. McBey, battling his disgust as trusted applicator-in-chief, repeated the leeching process on Annie every two or three weeks. Leech-holes soon pockmarked both sides of Annie's forehead as the invertebrates routinely fattened themselves on her blood, offering scant benefits to her condition in return.

McBey likely remembered his childhood in the context of the Kirk and its all-consuming Presbyterianism. McBey's 'short, stout, and kind'[18] grandmother, Mary Gillespie, to whom he would become particularly attached due to rejection by his own mother, often had him read aloud from the Bible. Against the deathly silence of Newburgh, fourteen miles north of Aberdeen, McBey would read a chapter as bedtime loomed, usually choosing one of the shortest ones. Not one to be hoodwinked, however, Mary soon made him read an extra chapter. He:

> Then [...] fell back on the genealogical chapters of the first book of the Chronicles and haltingly read to her from the listed posterity of Abraham, Jesse, Caleb, etc., the chief men of God, the stock of Saul and Jonathan and the catalogue of David's mighty men. She listened for only a few minutes to the rocky cacophony, then her patience invariably broke and she freed me with the remark, 'You do seem to get the folk with the queerest names to read about. Maybe we have had enough of them for tonight. You'd better go to bed.'[19]

Writing his autobiography just after the end of the Second World War, McBey's abiding affection for his grandmother is clear. Her commitment to the Bible, as the revealed and literal truth, gave him pause for thought and sometimes prompted light-hearted reflection. One such memory concerned Mary's divine conviction surrounding the collapse of the Tay Bridge in violent storms on Sunday 28 December 1879, which took

with it an Edinburgh to Dundee locomotive, five passenger carriages and one luggage van, killing everyone on board. As the gales raged, McBey's grandmother had gone out to inspect possible damage to her own home and surrounding property. Asked by her grandson why the bridge had given way, 'her grave and serious explanation was that the train crossing it at the time was full of sinners, because they were journeying on a Sunday.'[20]

Villagers descended on Foveran Parish Church each Sabbath for 'a grim and solemn ritual'[21] to connect with their feared Creator. McBey and his family joined farmers, blacksmiths, fishermen, domestic servants, shoemakers and the like as they walked the mile or so distance to hear the three-quarter of an hour sermon. 'One of the peculiarities of [the] Scottish religion had been its intellectual character and suspicion of emotion. Its worship was very staid and in private life those who were strict discouraged any display of emotion.'[22] McBey could still recall the palpable constraints that Sundays placed upon his own (unhappy) life as a child several decades later, by which time he had enjoyed love affairs, marriage to a beautiful American and international artistic success. They were 'days of restraint, inertia and suppression'[23] when playing childhood games, whistling or indulging in mirth of any kind was considered sacrilegious. Even in the big cities, the Sabbath was a 'dismal ordeal for the younger generation' when 'all newspapers and books of a secular character were carefully put out of sight',[24] according to one late nineteenth-century observer in Glasgow. Nineteenth century philosopher James McCosh, who became the eleventh president of America's Princeton University after leaving his native Ayrshire, summed up the emotional self-control that pervaded life in Victorian Scotland.

He wrote:

> I confess I have often been repelled by the cool manner in which Scotch people, after long absences or in critical emergencies, often meet with each other. I remember going up to a most excellent man to comfort him when he was trying to restrain his tears as he hung over the body of his son, just deceased. I was chilled when all that he could utter was, 'This is a fine day, sir.'[25]

It was against this stern and rigid backdrop that McBey lived out a childhood that was almost suffocating in its 'seclusion.'[26] While his uncle George toiled hard at the smithy, trying to continue the legacy of his

father, and his other uncle, William, worked as a coachman, driving horse-drawn carriages, his septuagenarian grandmother kept body and soul together by fixing austere dinners for him, his mother and aunt. Food was limited – but available – and, while 'not to be enjoyed',[27] was, it seems, enough to keep their bellies full.[28] During the long winter months, when a glacial North Sea chill gripped Aberdeenshire with a biting severity, a basic sustenance that included boiled beef, turnips, cabbages, potatoes and fireside stewed tea was routinely counted on to insulate against the bitter cold which seeped in through the cracks and gaps of their tenement building. By 1891, the family's neighbouring tenants included an elementary teacher, a domestic servant, a baker, a quay labourer and a midwife. Newburgh village was an unexciting little place for a young boy such as McBey, who, even then, was almost certainly dreaming of greater horizons. But he would have seen the lively comings and goings of all these busy villagers who made an honest living from their tiny community's needs and wants in both good times and bad.

While the seasons turned, and the harsh Aberdeenshire winter would lift, Annie's detached and unsympathetic treatment of her son remained, as did her propensity to thump McBey across the back of the neck with a closed fist as punishment. However, an important piece of the family jigsaw was revealed to McBey through his mother. McBey one day accompanied Annie for a 'walk across the Foveran Links.'[29] We can recreate the scene. McBey is still just a little boy when Annie abruptly beckons him to follow her from their village tenement. It is a Sunday afternoon, and perhaps Mary is reading passages from her Bible as befitting this day of rest and worship. It is another eerily silent Sabbath, but then there is Annie striding out in front of her young son, McBey's small legs struggling to keep pace with his impatient and irritable mother, who is already in the throes of despair due to her failing eyesight. McBey takes up the story:

> In the distance, a solitary man was seated on an isolated boulder. He stood up as we drew close, and Annie engaged him in conversation. He was tall, thick-set, with dark moustache and close-cropped side-whiskers. Frequently during the ten minutes he and Annie talked, he regarded me with his grey eyes in a curiously penetrating manner, but he addressed no word to me.[30]

'That', Annie mutters to McBey on their walk home, and in tones all too familiar, 'was your father.'[31] Other than learning his father is also called James McBey, the boy is left none the wiser.

Intriguingly, the 'penetrating manner' of James' stare was not, it appears, a piece of fiction employed by McBey to embellish his past recollections. Available photographs of James, captured by Aberdeen's W. B. Anderson, then operating out of the city's 26 Union Terrace, portray an imposing individual. James is seated with a book on his lap and with his legs crossed looking at the camera with a steely gaze. Such a gaze once seen in person, would have been difficult to forget. He has a large head with receding hair and a bushy moustache, and wears trousers, creaseless and with a perfect seam, partially hidden by a long, buttoned jacket. He looks proud, stern and determined; little given to compromise.

How Annie and James met is not completely certain, but both Gillespie and McBey families lived in Foveran at the same time and were of a similar class. William Gillespie took up the reins at Newmill smithy in 1843 when in his early twenties, taking over from blacksmith John McConachie. Previously William had worked at a blacksmiths' forge in Aberchirder, nearly forty miles north-west of Foveran. The 1851 census shows him married to his wife Mary and father to two young children, William (Jnr) and Jean (later known as Jane). As William's family grew to include Alexander, John, James, Mary, Annie and George, the smithy also expanded as employees and domestic servants were hired. Blacksmiths could find rewarding but hard work in farming communities around them, such as 'repairing machinery for the local farmers, but also shoeing horses, and possibly modifying or manufacturing machinery as well.'[32] But the years were not kind to the Gillespies, and they suffered hardships, as did many other working-class families in Victorian Britain. By 1883, the year of McBey's birth, William's family had been reduced, through early death, to his two surviving daughters, Annie and Jane, and his sons Alexander, William (Jnr) and George. Alexander Gillespie was by this time living in Australia, having last been recorded as a nine-year-old living with his family in Foveran in the 1861 census. He is next recorded in an 1875 marriage certificate in Victoria when he ties the knot with Australian-born Annie Munro. How or indeed why Alexander made his way to the southern hemisphere is unclear – but it appears that his family

were aware that his departure had led him to live in more exotic climes than the British Isles.[33]

The family of Alexander McBey, a horse dealer and farmer, earlier residing in Echt, Aberdeenshire, settled at the farm of Mains of Foveran in 1864 after taking on the full lease when the tenancy of the previous occupier (interestingly, Alexander Gillespie, William Gillespie's father) expired. James Wyllie McBey had been born to Alexander and his wife Martha (Stephen) in Echt, fourteen or so miles west of Aberdeen, in the early 1850s. The 1871 census details James as a seventeen-year-old farmer's son, his farmer father at that time employing two men. Alexander McBey led a colourful life in the courts being pursued by creditors and defending himself against charges of bankruptcy prior to his death in Aberdeen sixteen years later. William Gillespie's will suggests that Newmill smithy had long enjoyed business with the Mains of Foveran McBeys,[34] who, according to the Aberdeenshire Ordnance Survey Name Books of 1865–1871, were living and working 'on the Estate of Foveran – the property of Miss McKenzie of Glack.' Perhaps from an early age James had run errands on his father's behalf to Newmill for work to be undertaken; and perhaps there, amid the smell of molten iron, he came into contact with a young and pretty Annie, who, while hardened, was not yet consumed by the misery that her son would come to know so well.

What is clear is that a sexual encounter took place between James and Annie around March 1883, when James was nearing thirty and Annie just twenty-two. This liaison could well have been the totality of their relationship – but on Sunday 23 December, both were welcoming, or perhaps dreading, the birth of their son at the Gillespie family home in Foveran. On that day the latest *Aberdeen Weekly Journal*'s front page was advertising steam ship passages to 'all parts of America', and at that time Scotland accounted for 'one of the highest levels of emigration in Europe.'[35] Only two years earlier, the 1881 census had recorded James McBey senior as a twenty-seven-year-old farmer, with both parents still alive at seventy years old, though retired from tending to their sizeable lease holding at the Mains of Foveran overlooking the vast blue basin of the North Sea. The census records James as presiding over 443 acres, ninety-three of which were arable, and, like his father before, employing two men. Annie, on the other hand, was living simply as a master blacksmith's daughter with her parents, older sister, Jane, and blacksmith brother, George. Two years

later, she was giving birth amid the winter gloom of a Sabbath morning, and bringing a new life into a hard and harsh world.

Giving birth during the Victorian era was fraught with danger – and the risk of death for mothers and babies was high since the majority of births occurred within the home. But McBey's arrival was, it seems, without incident. Yet, could Annie's new role as a mother be the reason for her descent into melancholy – perhaps what we today would call postnatal depression? Depression that from the moment the young McBey was old enough to recall, became the dominant feature of her life as a mother?[36] Apart from anything else, it is not difficult to understand why an unwed mother in the late nineteenth century, who surely longed to marry the father of her child, might be fearful of the future. The onset of her sight loss would, as we will see, heap further misery upon her. But Annie's cold and indifferent attitude towards her son suggests real mental health difficulties which, writing decades afterwards in late middle age, McBey himself had not yet fully appreciated nor understood. Today, Annie's clear psychological turmoil might receive sympathetic medical intervention and treatment, from counselling to medication, if it were spotted and correctly diagnosed. Back then though, there were few options open to a severely depressed but functioning, working-class Victorian woman, whose dark and volatile moods even chilled her own mother. While Aberdeen Lunatic Asylum (present-day Royal Cornhill Hospital) had opened its doors to patients in 1800, Annie's slow spiral into mental anguish would never have been deemed a recognised cause for admittance without her being demonstrably disturbed. As it was, she suffered in silence until she could bear it no longer.

McBey was an illegitimate child, as his birth certificate records, although it is clear from his signature that James immediately acknowledged his son. But McBey did not enjoy his father's presence in his Aberdeenshire childhood other than meeting him once as a boy. While we today often perceive Victorian attitudes towards children born outside marriage in terms of shame, and even outright condemnation, the truth was a lot more complicated. When McBey was born in 1883, around eight per cent of Scottish births were illegitimate. But, 'in the [Victorian] north-east countryside [...] between a fifth and a quarter of all births were illegitimate, making having a bastard child a normal part of the life course for many women.'[37] Moreover, 'local cultural traditions made [illegitimacy]

less deviant [...] in a village [...] than allowed by dominant discourse, legal frameworks and national political and ecclesiastical authorities.'[38] Indeed, Aberdeenshire farmers put great stock on female fertility, to the extent that marriage may sometimes have been delayed so the woman could prove the ability to conceive through pre-marital intercourse.[39] The Kirk deplored any form of sex out of wedlock, but, from the perspective of the common people in the rural north-east, 'single mothers and their children were not only tolerated but actively incorporated into the community.'[40] While it is not known if Annie was involved in any sort of 'fertility testing', her giving birth illegitimately had many precedents in her rural home.

Yet, tucked away in the archives at the National Records of Scotland in Edinburgh is proof that Annie and James were censured by Foveran Parish Church for pre-marital sex and conceiving an illegitimate child. On 2 February 1885 – some fourteen months after their son's birth – both were hauled before the Kirk Session (church court) where:

> Annie Gillespie [...] confessed that she had born an illegitimate male child on the 23rd of December, 1883. The accused James McBey, farmer, Mains of Foveran, as the father of said child. The accused being present, acknowledged the paternity. They were directed to come back on the first Monday of April for further discipline.

Both complied and, on 6 April, it was recorded that 'at a former meeting [they] had pled guilty to the sin of fornication with each other. They were suitably rebuked and admonished and restored to church privileges.'[41]

On each occasion, meetings were signed off by the minister and the session clerk. By this period, the established Church of Scotland lacked the authority to compel parishioners to undergo Kirk Session discipline, which, 'From the 1870s [...] became largely restricted to unwed mothers, who wished to have their children baptised or be considered of "reformed character" in order to qualify for charitable relief.'[42] McBey was baptised at Newmill on 14 November 1885 at nearly two years old by the very same man, Rev. J. S. Loutit, who had reprimanded his parents just months earlier. This suggests the motive behind their decision to appear before the session was to secure his baptism, and might also explain the time taken between McBey's birth and his parents' punishment. Whether Annie's personal experience of church discipline contributed to her

fragile mental state is hard to say, but it seems unlikely that, in the Scottish north-east, where illegitimacy was common, she would have been cast as a social pariah. Indeed, Annie's 1889 visit to the ophthalmological ward of Aberdeen Royal Infirmary came via the good offices of Loutit himself, who acted as her 'recommender' for treatment. Why James and Annie didn't marry we simply cannot know, but it is perhaps pertinent to point out that James remained a single man up until his death in 1927.

McBey's illegitimacy soon did give him cause for introspection. The first time he was forced to think about his family pedigree came after he was leaving church one Sunday afternoon and was walking back to the village with a group of friends. 'One of my companions, a year older than myself, said to me, "I suppose your mother was married but just kept her maiden name?"' he later recalled:

Being less than eight years old, I had never given the matter a thought, so had no reply to his implied question, but it mystified and perturbed me as to why my mother should be Annie Gillespie and I, James McBey. A total lack of affection or sympathetic understanding between us kept me from asking Annie to explain and I somehow hesitated to ask my grandmother about a matter so personal.[43]

T. E. Lawrence was, as already noted, also illegitimate, being born to parents who lived together as husband and wife, but were, in reality, unmarried. 'Lawrence's illegitimacy,' wrote one historian, 'was not a direct source of guilt or shame at least until after his character was formed'[44] even if, according to another, 'there is no doubt that the permanent atmosphere of pretence, caution and suspicion that was engendered in the family by this scandalous subterfuge [...] contributed to Lawrence's highly complex persona.'[45] While McBey's illegitimacy seems to have had little practical bearing on his own Victorian childhood, in terms of his place within the community, his parental origins and dealings with his father, James, would, as we see later, remain a source of emotional baggage as he negotiated young adulthood.

Life expectancy (at birth) in Scotland, for those born between 1881–1890, remained less than fifty years for both men and women, and McBey as a child would lose close family members. In October 1892, McBey was playing in the village when he was ordered home to visit the death bed of his spinster aunt, Jane. Nearing forty-three, Jane Gillespie, who, like her sister Annie, was working as a dressmaker,

developed shingles, according to McBey's autobiography, and died. Her death certificate paints an altogether grimmer picture, revealing the obvious torment of Jane's final months as she suffered from 'spinal congestion' followed by paralysis. She had been under the care of two doctors and had even been the recipient of '16 weeks lodgings and sick-nursing at 10/- per week'[46] but to no avail. Now McBey only had his mother, Annie, and his grandmother, Mary, left, and he came to rely entirely on Mary for the affection and comfort he so craved. McBey's relationship with Mary and Annie was a study in opposites. Mary Gillespie, formerly Mary Torn, had known much grief as a wife and mother – and took solace in her faith for her litany of bereavements. Annie was still young, but clearly ageing before her time. While Mary treated her grandson with a hard-bitten, but always kindly, manner instilled from her own long life as a woman from bleak and weathered rural north-east Scotland, Annie adopted a more uncompromising attitude. McBey recounted tales from his young life of his grandmother's gentle ways – her making of a mustard sauce for mealtimes as a simple extravagance or her wise and pithy proverbs that were often on hand to sum up any of life's challenges. But he also described his mother's unpredictable and angry outbursts. Once, McBey remembered, after tripping and spilling a pitcher of milk he had purchased from an adjacent farm, he was forced to admit the incident to Annie. His mother was incandescent with rage and made to thrash him for the accident. But, after he grabbed hold of an iron poker, Annie backed off. From that day onwards, McBey's beatings at the hands of his troubled mother ceased for good.

By the time he was on the cusp of his teenage years, McBey's life had been coloured by illegitimacy, bereavement, frugality and a troubled and sometimes violent relationship with his gravely depressed, and increasingly blind, mother. He loathed school, where his attendance was a torment and where Latin and arithmetic held no appeal. Friendships were few, too, such was the uninviting homelife fostered by Annie, who, it would seem, had very few friends of her own. Aberdeenshire had a bleak countenance of unending acres of farmland, grimy blacksmiths and tough fishing grounds with its hardy 'fisherfolk, living in a string of historic villages.'[47] But when the yearly Flower Show was held at the Village Hall one summer month, this

countenance broke to reveal to this lost and lonely schoolboy an altogether more enticing vision.

Knockhall Castle, a 'rather plain looking tower house of three storeys',[48] was built by Lord Sinclair of Newburgh in 1565, and had once hosted James VI of Scotland for a single night in 1589. It overlooked the mouth of the trout-rich Ythan, which flows some thirty-nine miles towards the North Sea. Knockhall Castle would prove to be the unlikely spark that ignited his passion for art. It all began when Willie Murray, the local grocer, offered a small monetary prize at the show to anyone who could charm him with their illustration of this local ruin. McBey accepted the challenge and, after memorising the centuries-old antiquity, he ventured home to draw his representation of the building. On cartridge paper, he sketched from his mind's eye the stonework, shape and structure of Knockhall. And, like he was to do for the countless etchings and paintings he would compose during his lifetime, he proudly signed his name on his work before offering it up for due consideration. He didn't have to wait long. He won, and, for his efforts, received the 2s. 6d. in prize money – 'which meant wealth to me.'[49] His piece, endowed with a striking rosette, was hung on the wall for the start of the show. No matter that his had been the only entry, his first artistic effort quickly proved a critical success. Local bigwigs, who had never before bothered with the fortunes of this unassuming only child, suddenly offered kind words of praise, and, for that moment at least, life was sweet and full of promise. That his mother made no mention of his triumph was a bitter pill to swallow for McBey, who, despite everything, still craved the maternal affection that Annie wouldn't – or simply couldn't – give. What would life have been like had his father been present to witness successes of this kind? McBey lacked a father at home, and did not even have a father figure after his maternal grandfather had died in 1888. Perhaps he seldom missed what he never had, but encouragement proved hard to come by.

However, some encouragement came when Nellie Mackenzie, the daughter of a well-to-do tenant farmer, who had seen his entry at the show, and shared an interest in art, invited the youngster to watch her paint in oils. He 'was shown into an upper room at the farm [...] and the peculiar and characteristic smell of drying linseed

oil greeted and thrilled'[50] McBey. The bright colours of the paint tubes made for a dazzling sight, too, and he was also introduced by Nellie to an altogether more cultured variety of food – cured ham – for high tea. From reading McBey's memoirs, one could be forgiven for thinking that Nellie was a young woman – in fact she was just three years older than the schoolboy. McBey delighted in being taken into the confidence of a relatively prosperous local girl, enjoying the teenager's company at her home of Linnhead Farmhouse – 'Across the burn from the church'[51] – then occupied by her father, a farmer, Alexander Mackenzie. Mackenzie's 1901 household would include Nellie (real name Helen), then twenty-one, and six servants. Writing in *The Aberdeen Press and Journal* on 30 January 1933, the forty-nine-year-old McBey recalled that placed on the easel on which the girl worked 'was a sheet of "opal" glass and beside it the "copy" – a lithograph of a spray of flowers [...] All that sunny afternoon I watched breathlessly whilst she relentlessly imitated those flowers on the opaque glass.'

This new immersion into the art world, however slight and however fixed to his hard surroundings, sent his imagination reeling. His childhood, for so many years lived in monochrome, was now filled with an array of luscious tones that, while exciting, he dared not admit for fear of ridicule. But disregarding the fact that painting was an unusual hobby for a local working-class boy from rural Aberdeenshire, he devoured copies of the *The Boy's Own Paper* for their articles. He became familiar with the Dutch artist Rembrandt (1606–1669) from these periodicals. Soon he cycled the fourteen hard miles to Aberdeen. While bicycling, the wind would have blown through his emerging crop of sweptback hair (hair that would lend him his dashing looks as a young adult). The city – with its imposing architecture and 'clatter and shrill grind of the iron-shod traffic on the granite setts of the streets'[52] – was a far cry from sleepy Newburgh where freshwater pearls, today thought extinct, serenely populated the waters of the Ythan. It was the first time he had travelled to the Granite City alone, and his goal was now the shop of James Stephen & Sons at 49 and 50 Woolmanhill, which was opposite the Royal Infirmary, where his mother had placed so much faith for so little return. There he purchased an exciting array of artistic goods, such as tubes of oils, brushes, linseed oil and canvas boards. He revelled in the heady chatter and urban racket of the wide,

open spaces of Aberdeen, as he gazed spellbound through the large shop windows and passed scores of businessmen and busy city ladies. While in the city he also bought – and ate for the first time – bananas and tomatoes, his experiences growing richer and his tastes expanding. His 'return journey', he recalled, took 'three hours, as I stopped frequently to open the new acquisition and feast my eyes on it.'[53] The urban lights of the city had shone brightly – and McBey knew that another life, outside his own, was possible.

But, for now, he had to return to the inertia of village life where, settling down to paint with his brilliant new colours, he once again faced the bleak reality of a lonely childhood. 'On one canvas board I painted an old umbrella-mender,' he recalled decades later, '[and] on the other a musician blowing a large brass wind instrument, both copies from coloured lithographs in some periodical. My grandmother thought they were wonderful, but Annie was now too blind to see them.'[54]

CHAPTER THREE

The breadwinner

'And wisdom and knowledge shall be the stability of thy times.'
– Isaiah 33:6.

> I looked and thought, 'All is too gray and cold
> To wake my place-enthusiasms of old!'
> Till a voice passed: 'Behind that granite mien
> Lurks the imposing beauty of a Queen.'
> I looked anew; and saw the radiant form
> Of Her who soothes in stress, who steers in storm,
> On the grave influence of whose eyes sublime
> Men count for the stability of the time.

– Thomas Hardy, *Aberdeen (April: 1905)*

It was no easy task being a Victorian blacksmith. True, there were more hazardous professions or environments to which a working-class nineteenth-century Briton could be exposed, but, in an era when scant attention was given to work welfare, labouring at a smithy was all physical toil, burning heat and little rest. McBey's uncle, George, who had succeeded his master blacksmith father, William, at Newmill following his death in 1888, knew this as well as most.

Each morning, as dawn broke, George Gillespie would wake in his blacksmiths' cottage to the sound of horses' hooves on the street outside as life in Foveran stirred. By the time he roused his aching body from just a few hours of sleep, his family's young domestic servant would have already lit the fire to ready porridge for breakfast. By 1891, twenty-seven-year-old George and his twenty-five-year-old wife Helen had three very young children – a family which like other families of the era, would increase substantially by the turn of the century – and were employing a teenage girl as a live-in housemaid, whose role would have been to help the Gillespie's burgeoning brood deal with the monotonous tasks of day-to-day Victorian living.

Once up, dressed and fed, George would enter his shop, light the fire in the forge and prepare for the long, sweaty hours ahead. His days at the smithy could see him fashion horseshoes, nails and iron gates, and fix tools for nearby farmers as the heat rose, the sparks flew and his muscles strained. He became blacker from the soot that hung in the fetid air of his yard, which banged, clattered, hissed and spewed like a steam engine, and his day would end in exhaustion, his calloused hands in pain. George's smithy would also have doubled as a place of gossip. 'The political centre of the village is the blacksmith's bench,' remarked one Victorian journalist. 'If there is a chance idler, he comes here to pore over the newspaper that by noonday is always black with the smoke and cinders from the forge, and marked with the thumb-prints of many readers.'[1]

As the century began to close, so too did McBey's schooling as his family spied the opportunity to exploit his money-making potential. While he could have followed in his uncle's footsteps at a smithy, fate dealt a surprise hand. Though each side of his immediate family were mostly farmers and blacksmiths (and one great-grandfather had been a shipmaster), a much more middle-class profession beckoned for McBey. Not for him would be the hard toil of hammering and fabricating like George, but instead the more genteel role of bank clerk.

Now in his teens, McBey was learning to navigate his mother's emotional outbursts, which sprung from her mental anguish at her degenerating eyesight. He had also developed a passionate interest in a pursuit few other boys of his age had contemplated. His young mind was already sketching the local sights as he prepared to emulate the great figures of art about whom he was reading in his periodicals and as he longed to find an escape from a turbulent and unhappy homelife. There was George's heat-filled smithy, which enjoyed regular business from nearby farmers and labourers; the horse-drawn carriages that rattled across the ragged streets and roads on which villagers from the parish also pounded; and the salt-bitten fishermen whose lives were often at the mercy of the sea in which they plied their trade. Soon, all of this, and more, would provide him with the inspiration to indulge an artistic longing that so crowded his imagination. But first, he would say goodbye to a life that had been 'a daily ordeal'[2] for as long as he could remember.

McBey's school years had been one long endurance test. In his memoirs, he railed against the burden of homework and lamented his

status as an only child who was forced to face 'the mysterious workings of equations' and 'the intricacies of Latin tenses and declensions'³ alone. 'I had no one to help me,' he remembered sadly, 'and had to stumble along laboriously far behind the average.'⁴ Yet, by the time he was attending school in the late nineteenth century, much about life as a Victorian pupil – or 'scholar' as per the censuses of the time – had changed. Andrew Findlater, one-time editor of *Chambers's Encyclopaedia*, reflected on his own less than stellar days as a pupil in an Aberdeenshire parish school in the early nineteenth century.

> 'I do not think that I ever heard Mr Craik (the schoolmaster) ask the meaning of a word or sentence, or offer to explain the one or the other [...]' he recalled forlornly of his schooling. 'In the curriculum of the Aberdour School neither grammar, history nor geography formed a part.'⁵

McBey's schooling was not as rudimentary as that of fellow north-east coaster Findlater, even if large elements of those austere days remained. The 1872 Education (Scotland) Act was intended 'to bring a degree of order to the perceived chaos of Scottish education in the later nineteenth century [... and] had far-reaching consequences for the parish framework of schooling.'⁶ But fear still ruled supreme in the classroom as the twentieth century approached. 'In the schoolroom we were seated on forms behind long desks and faced the schoolmaster who stood out on the "floor"', McBey wrote, 'holding in one hand a six-foot wooden "pointer" as though it were his sceptre and in his other hand his leather "tawse" like the sword of an executioner.'⁷ The tawse struck fear into the hearts of a great many nineteenth-century school children. From the Scots word for the thongs of a whip, this leather strap – with one end split into two tails – was used by schoolmasters across the land to punish bad behaviour and poor performance. And in an age when physical assault was not deemed inappropriate in the home, few Victorian parents would have objected to its use in the classroom.

Yet, while he thought himself behind the curve at school, McBey excelled at geography – a subject that he little knew then would become part of his future as his artistic travels took him across Europe, America and, as we know, the Arabic-speaking world. It was a topic in which he had 'a shy confidence'⁸ and which provided some welcome relief from other subjects in the curriculum, not least the daily torture of the Shorter

Catechism. Such was his fear of this lesson, which demanded individual recitations to questions such as 'what is required in the eighth commandment?'[9] that he took to 'digging my nails into the joints of my middle fingers; and snipping off with my sharp teeth the roughnesses I thereby raised.'[10]

For all of his protestations of being a struggling student, however, he entered a competition to secure a £5 bursary on the basis of his proficiency in grammar, composition, arithmetic, geography and history – and won. On top of his success at the Flower Show with his artistic impression of Knockhall Castle, his success at school proved a further morale boost, not to mention a financial one. According to McBey's letter of confirmation of March 1897, his bursary could only be redeemed on the provision that his 'progress [was ...] satisfactory and attendance at school regular.'[11] His first solo visit to Aberdeen, which had briefly freed him from the bleakness of his family, and which saw him purchase the oil colours, brushes and canvas boards from James Stephen & Sons, appeared to be carried out courtesy of this first instalment.

McBey received his Scotch Education Department Merit Certificate from Newburgh Mathers Public School in the spring of 1897. He would remain at that school until it was time for him to enter the world of work. It was his mother who first informed him that he would be interviewing for a clerking job at the North of Scotland Bank. She had arranged this through a family friend, who used his influence as a senior official there to schedule him in for an assessment. A sensitive and imaginative boy, with simmering artistic desires, McBey was acutely aware of his own mind, which oscillated between the coldness of his mother and the warmth of his grandmother in the relative desolation of his upbringing. He baulked at the prospect of joining a bank – seeing how a cousin of Annie's, John Torn, despite being 'a natural engineer',[12] was wasting his talents as a lowly tenant farmer – but McBey passively submitted to her demands and attended the entrance exam at Ellon, several miles up-river. Ellon, where the nearest bank branch to Newburgh was located, was described as a village 'pleasantly situated on the Ythan which is crossed here by a handsome bridge [... and where its] monetary affairs [...] are facilitated by three highly respectable banking establishments [...] the Union Bank of Scotland, the Aberdeen Town and County Bank, and the North of Scotland Bank.'[13]

McBey's father may have been playing on his mind as he cycled to his appointment. Annie had earlier made him write to his father, James, to notify him of his potential prospects at the bank. Having moved from Aberdeenshire, James had now settled in south-east England, leasing the farm of Beddlestead in rural Surrey. In the 1901 census, McBey senior would be recorded as a farmer living with his thirty-seven-year-old domestic servant, Annie Hendry, a Scotswoman from Strachan, Aberdeenshire. How James and this particular Annie met, or what kind of relationship they were conducting behind closed doors, will likely remain a mystery. Judging by James' succinct response to his young son's correspondence, the emotional self-control, which characterised many Victorians from Scotland's north-east, was still very much part of his demeanour, despite his long move south.

'Dear James,' the perfunctory 19 December 1898 dated note ran, 'I received your letter some time ago. I am glad to hear that you are likely to get into a Bank. If you are successful I will try to help you. I may call on you soon. With kind regards. Yours faithfully, J. McBey.'[14]

Was it a thrill to receive a letter back from a father who had barely featured in the course of his young life? And, if so, was the brevity of his response a grave disappointment? We will never know, but McBey could have been forgiven for wondering what kind of 'help' he could hope to receive from a man who was now living at the other end of Britain, a world away for a boy barely travelled.

When McBey arrived for his examination at the bank, he was made to wait. If he was nervous, he doesn't reveal it in his memoirs. Whatever tensions lay between himself and his mother, Annie had likely made sure that he looked the part. As a young child, McBey was forbidden by Annie to wander outside barefoot in the summer – as other children from the village did – and she appears to have taken great pride in making certain that he was clean and respectable. In comparison with her aloof, severe and sometimes violent ways, this seems curiously out of character – but could be viewed as an attempt to express a deeply repressed maternal love. However, as the minutes ticked by, he was not so much thinking about his home life as he was the private suite in which he found himself. There were leather-bound chairs and a large bookcase packed with weighty tomes – but what really arrested his senses was a small oil painting filling a space on the wall. It was his first encounter with a serious piece of art,

and it was dwarfed by the lavishness of his surroundings. Still, it was the only object to which McBey was drawn, and his eyes studied the figures which, in his feverish imagination, seemed to come alive. So absorbed was he by the painting that he had to be, he recalled, repeatedly beckoned by the inspector, John Innes. He must have been most captivated by the painting's brushstrokes because he claimed Innes even tested his hearing 'by the ticking of his watch at various distances'[15] before examining his competency in dictation and basic arithmetic. Whether or not McBey's account of this hearing test was true or simply a mischievous literary embellishment intended to demonstrate his early passion for art is a moot point because soon afterwards he was offered the position of bank clerk – with an apprenticeship that would last for five years.

McBey had now succeeded in getting gainful employment in addition to his artistic success and £5 bursary award – no small achievements for an illegitimate Victorian with a volatile homelife. However, while 'village life' attached 'considerable prestige'[16] to the banking trade, he still loathed the very idea of playing dogsbody in a city bank. His apprenticeship would require his leaving the rural setting of Newburgh for the urban racket of Aberdeen, complete with its booming granite industry. At this time, the family was largely living off money which Mary and Annie had inherited after the death of William in 1888 and Jane four years later. Now McBey was to be the family's breadwinner – and swift arrangements had to be made. According to the Scotsman's autobiography, the discussion at home concerning their change in fortunes was a moving one – but, clearly, one that was difficult to speak of plainly.

'Annie said to my grandmother, "Jimmy and I will have to live somewhere in Aberdeen. Are you willing to come with us?",'[17] he recalled. It is not known if Annie used McBey's nickname of 'Jimmy' at all frequently during her lifetime, but it is nice to believe that it was a genuine, if fleeting, term of affection for her son, and surviving letters reveal that she often referred to him as 'Jim'. The question, however, hung in the air with a suspense that McBey could barely stand. While he struggled with the notion of Mary – 'the only friend I had'[18] – not living with him and his mother in Aberdeen, his grandmother let slip buried emotions that hitherto had been tightly bound up in her Presbyterian demeanour. Maybe it was the prospect of being left behind – or being separated from her grandson – that almost moved her to tears. Or perhaps she was just

glad to be asked. But as her aged eyes welled up, there could only be one answer – and her agreement was enough to break the tension. The truth was – however fraught, uncomfortable and even miserable their lives were together – they needed each other. Annie could now barely see, and as sight loss made her more vulnerable, she couldn't hope to live without her family's companionship. Mary was nearing eighty and was likely thinking about her own mortality, having already lived many years longer than the average Victorian Briton. McBey was expected to carry the burden of his family's fortunes on his shoulders, though just a child who still sought the love and affection that only his grandmother could give.

McBey made no long, drawn-out goodbyes to Newburgh. He travelled with Annie to Aberdeen the next day to settle into his new life. The Granite City was now a city on the rise, having long felt its northerly isolation, unlike Glasgow and Edinburgh in the central belt. 'In the course of the nineteenth century, Aberdeen grew outwards from its historic centre around the Castlegate and the harbour and expanded along the channels marked out by the new streets and their hinterland.'[19] Such redevelopments necessitated the clearance of slums as matters of public health were considered towards the end of the Victorian era. Shuttle Lane was one of the worst slums and played host to poverty, squalor and criminality in equal measure. By the mid-nineteenth century 'there was a public house and a penny theatre for every ten families in the area, and even at the end of the century, after city improvements had removed many of the worst slums from Aberdeen, Shuttle Lane remained bare, bleak and crowded.'[20] But McBey would be spared the grimier elements of the city's downtrodden excesses. He moved in with a Newburgh widow on Aberdeen's Urquhart Road at the same time as Annie rented a three-roomed tenement at 42 Union Grove, then recently built, in anticipation of the family's new beginnings. Before Annie returned to Newburgh to prepare for the short, if significant, move south, she bought McBey 'a grey suit with long trousers, six white dickeys, six pairs of white cuffs, a hard black ugly-looking bowler hat and a pair of shoes.'[21] Whatever the complexity of her feelings towards him, something motherly remained.

McBey could barely sleep the night before his big day. It was the first time he had lived away from his family and, as he tossed and turned in his new lodgings, where he would stay for the next two months, he

was gripped by fear: what if he failed at the bank and had to return to Newburgh a disappointment? Worse still, maybe, what if he succeeded and spent the rest of his days as a pen-pusher? He was not even twenty miles from home – but home felt further away than it had ever been. On 15 March 1899, he stirred from an uncomfortable slumber. He was fifteen years old, nearing 5'11 in height, and looking more and more the man he would soon become. McBey was now a respectable young gentleman, and, though he would not know it then, he had taken his first important step towards realising his dream of becoming an artist.

If McBey caught his reflection on his first walk to the arresting four-columned building that was head office of the North of Scotland Bank, he would have thought himself a most curious sight. It was springtime, and if it was bright, the granite facades of the city would have been lit by the early morning sunshine as a cool breeze, blowing in from the North Sea, would have given a slight familiar feeling of home. The building's sparkling interior – with its 'marble, plate glass, brass, and mahogany'[22] – was quite unlike anything he had seen. It stood in sharp contrast to the grimy blacksmiths' shop of his uncle who would now be sweating from the heat of his forge. On arrival at the bank, McBey was immediately given orders to report to an agent at the bank's George Street branch. In true Presbyterian style, there was no time for small talk.

McBey's first impressions of banking must have occupied his thoughts as he struggled to navigate the maze of streets which surrounded him. He had, to his amazement, been addressed as 'Mr'. The pace of life in the finance trade seemed frantic, frightening even. When he met with Mr Saunders, the agent to whom he was sent, he saw a man who – middle-aged, balding and nicotine-stained – had probably known little else but the daily monotony of officialdom. McBey might have seen his bushy eyebrows and bushy moustache as an interesting subject for a future painting had it not been for Saunders' questions which, relating to his complicated upbringing, threw him off guard. Illegitimacy may have been somewhat more pronounced in the north-east – particularly in the rural areas – but he was now a respectable city gent, at an elevated social status, and he had to sidestep Saunders' close probing.

In his memoirs, McBey goes to great lengths to describe his early days at the bank, where he would use a telephone for the first time. It was all balances, cheques, bags of silver coins and busy bank clerks. McBey

attempted to grasp the responsibilities that came with his duties amid the confusion. He spent his first day running around Aberdeen handing back bounced cheques to their bank of origin, and by the time he had finished and was returning to his lodgings, it was evening. He was drained, his legs like lead and his mind weary. The demands of the next day would be heavy too.

Still, he made time to write to Annie, doing so on the sixteenth. Addressing her as 'mother' (and not 'Annie') he penned:

> I am getting on fine as yet. I had a headache on Wednesday morning, but it wore off before nine o'clock [...] We have no dinner hour, we just take a piece with us in the morning for lunch and eat it in the office [...] I feel quite at ease in my long trousers, and like them better than the knickerbockers [...] I am your loving son, James McBey.[23]

'Those early banking days were a nightmare and haunt me still,' a middle-aged, successful and more candid McBey reflected in the *Aberdeen Press and Journal* in January 1933. 'The bank was run, very soundly, on strictly economic lines, and the youngest apprentice in each branch had to end his exhausting day by delivering between 20 and 100 letters to clients, this to save postage.'

But it didn't take him long to acclimatise to his new role. Soon, he was tallying up accounts with ease, and rubbing shoulders with the other young clerks, who scurried between tasks to help keep Aberdeen's financial centre ticking over from morning until the close of business.

McBey was reunited with Mary and Annie on 15 May, when they made their long-awaited move from rural Newburgh to Aberdeen's Union Grove. His grandmother took up her old role as home-maker, but his mother's eyes had deteriorated so much that she withdrew further into the gloom of her vision loss and 'sat hour after hour immobile and silent.'[24] 'She could no longer go out alone,' McBey remembered, '[and] every evening at dusk I walked with her a mile or so along one suburban street after another. We did not converse during those outings.'[25]

There is a photograph of Annie as a young woman – almost certainly taken before her journey into motherhood – in which she looks attractive, doe-eyed and proud. Her hair, tightly pulled back, sits neatly on her head, as a delicate wisp touches the top of her left ear. She radiates health – with a nose and mouth perfectly aligned – and it is easy to see why

James must have been (however briefly) smitten. Some two decades later, and another photograph – which captures her seated by the fireplace in her Union Grove tenement – portrays Annie in steep decline. Sitting side on, hands clasped, with her right arm perched on a cushion, it is difficult to make out her facial features, but a close look reveals a woman much older than her years. She appears tense, drawn and disengaged as she stares off into the distance surrounded by pictures and ornaments she can now barely see, due to an eye condition no doctor can cure.

As ever, it was McBey's grandmother who supplied the more homely aspect of the family's life in the city. After a hard day's graft at the North of Scotland Bank, where he worked reluctantly but diligently, McBey could always count on his grandmother to fill the ever-widening gap between him and Annie, who was now an invalid in an era which little cared for the unproductive, weak and infirm. Despite her move from rural Aberdeenshire to north-east Scotland's largest urban centre – with a growing population of around a hundred and fifty thousand hardy and wind-swept residents – Mary continued to eat seaweed as a preventative cure and routinely finished off the empty shells from boiled eggs 'to cut up any hairs that might be in the stomach.'[26]

McBey's days at the bank were long, his weeks demanding, and he lived for the all-too-brief moments he could lose himself in his art. He joined the city library, where he studied books on painting and sketching, and took to copying images he found in pencil, pen and ink. When the Aberdeen Artists Society put on an exhibition near the end of 1900 at the Art Gallery, he attended. When he spotted the opportunity for night-school tuition at Gray's School of Art, he enrolled. He even managed to secure a (modest) grant of 5/- for evening classes at Gray's, where he studied and was examined in 'Freehand' and 'Light and Shade', receiving a second- and first-class award in each respectively.[27] It was there, on the evening of Tuesday 22 January 1901, that McBey's instructor announced the death of Queen Victoria, whose iconic sixty-three-year reign had included a long love affair with Aberdeenshire. In his autobiography, McBey wrote that her funeral took place three days later – which is mistaken. In fact, Queen Victoria was granted a state funeral in London on 2 February. Given an unexpected day off work for the sombre occasion McBey cajoled his grandmother into sitting for a portrait.

Now seventeen, and on the threshold of manhood, McBey stood over his easel as he set to work trying to capture Mary's likeness. His grandmother had lived through the reigns of George IV, William IV and Victoria – and would even outlive Victoria's comparatively short-term successor, Edward VII. She had grown up the hardy daughter of farmer John Torn and had borne her late master blacksmith husband, William, at least eight children. Her face, arranged on a large head, was wide, open and wrinkled, while her sunken lips betrayed years of teeth-loss that had long caused her to chew with her gums. McBey adored her and – despite her limited capacity to display easy affection – she clearly reciprocated. Now, during this particularly poignant period of change, when the British state was in mourning for their queen, Mary was sitting for her strapping and artistically gifted grandson simply because he had asked her to.

He worked at her portrait for three hours, during which time she displayed an 'amused, slightly perplexed, benign tolerance.'[28] His first draft complete, he showed it to Mary, who announced, 'It is as good as a photograph,'[29] delighting McBey. Viewing the finished artwork more than a century on, it remains an impressive composition, a testament to an innate ability that he had honed in just several years of childhood graft. Indeed, McBey elicits Mary's kind, but stoic, features as she peers straight out of the canvas, every inch the gentle matriarch. Days afterwards, McBey caught Annie standing before the portrait of Mary. She was sad, lost and alone in her thoughts. Annie's sorrow at not being able to make out the picture made her utter one single sentence of regret, before she remembered herself and turned her frustrations on her son, warning him against being distracted from his job at the bank.

Annie soon asked McBey for a similar portrait. But, self-conscious about her eyes, she made a reluctant subject. Despite McBey's assurances that she looked fine, Annie's obvious unease is clearly captured in a pencil sketch, which, subtly rendered, has the haunting effect of evoking his mother's wide-eyed vulnerability as the forty-year-old 'stares intently out of the picture space'[30] with a high forehead, unkempt hair and pursed lips. But there is poise in the subsequent completed oil painting of his mother, who, captured in profile, with her hair in place and a high-collared neck, retains her dignity amid the strain, by virtue of McBey's composition skill. The painting took pride of place above the mantelpiece at Union

Grove as can be seen in a photograph of Annie, even if she sadly was unable to see the painting for herself.

McBey was by this time already two years into his work at the bank and had never stopped looking for ways to improve his artistic talents. He soon spotted another opportunity when he came across an advert from John A. Hay in the evening newspaper. Hay was an art teacher, based at 115 Union Street, which, many decades earlier, had once belonged to a Harris Rosenberg and Company, a furrier and 'importers of foreign skins', and his tuition amounted to £1. 1s. every quarter. During each visit, the aspiring artist would have spied the forty-five-metre-long Ionic façade – erected in 1830/31 at a cost of £1,460 – on the other side of Union Street and, despite his hardships at home, he must have felt some sense of belonging to his adopted city. Today the façade stands incongruously opposite a McDonald's restaurant and a string of other modern outlets, but then it would have been a proud monument at the epicentre of the busy city.

McBey's banking salary together with his first 'commission' (the landlady of their tenement had paid him £5 – some £600 today – to paint a portrait of her own daughter after seeing his of Annie and Mary) had long since freed him from the limitations of his childhood. But feeling conspicuous as the only male student in Hay's class full of young women, McBey was then ill-at-ease in the company of the opposite sex. Still, he set aside his shyness, which, as it pertained to women, would not last much longer, and wowed his 'thin and lanky'[31] tutor with every brushstroke. After several lessons, however, his natural talent became too much for Hay, who refunded McBey's tuition. The teacher, noted by McBey in his autobiography as fifty-something (he was, in reality, in his early forties), could teach his teenage pupil nothing. For McBey, his 'bridge to freedom'[32] had been removed by an unwanted act of kindness, but the truth was that he was outgrowing the Granite City, even if he had yet to realise it himself.

McBey may have felt himself cut adrift – but he was now an unstoppable force, who quickly turned his attentions to etching. It was a skill that he longed to understand – yet knew very little about. While many of his contemporaries would study at the best art schools in Europe, this future master etcher began the most important phase of his learning pouring over an Aberdeen library book. It was, to be exact, *A Treatise on Etching*,

first published in French in 1866 by Maxime Lalanne (1827–1886), a leading light of the French etching revival. McBey would become the darling of the etching revival in Britain in later years, but he was unaware that his first brush with Lalanne could have such profound consequences for his own life and future career. The text McBey had borrowed from the city library was the translated version, composed by S. R. Koehler, a German-born editor and print department curator at the Museum of Fine Arts, Boston, in 1880. He had long shunned dreary texts on the finer points of banking law relating to his day job. As he got to grips with 'M. Lalanne's pleasant little book', to quote Koehler himself, it became clear that the 'teasing, temper-trying, yet fascinating art'[33] of etching would be unlike any other medium he had tackled.

Having proved himself a quick learner as both an aspiring professional artist and an unwilling bank clerk, he studied the etching process forensically. It necessitated a copper plate being covered with a wax ground which could be drawn through with a sharp etching needle to expose the metal beneath; the copper would then be immersed in dilute acid until the lined areas of the plate unprotected by the ground had been bitten or eaten away; once etched to the required depth and the varnish and wax cleaned and degreased, the copper would then be ready for printing; a printing press would subsequently yield the desired result onto paper.[34] Urs Graf (c.1485–1529), the Swiss Renaissance goldsmith, painter and printmaker, is regarded as having created the earliest dated etching, *Girl Bathing Her Feet*, in 1513. By the time McBey was pursuing his own passion, the medium was hundreds of years old – yet 'for the century and a half that followed the death of Rembrandt the art of original etching was little practiced and less understood.'[35] In Britain, etching occupied a minor place among the art establishment during the early nineteenth century, until flamboyant expatriate American, James Abbott McNeill Whistler (1834–1903), helped to spark a revival in which McBey himself would soon star.

The young clerk wasted little time in taking to the field with his newfound knowledge, only hesitating to consider the ridicule that might come his way should he be spotted in public by one of his colleagues from the North of Scotland Bank. On one bright Saturday afternoon in July 1902, he settled down to etch at Point Law, a stretch of land between the River Dee and the Albert Basin, and not two miles' walk from Union

Grove. As the summer sunshine set the water's surface aglow, he turned his back on a scene of moored fishing boats, and began etching them from a mirror, which he had hooked over a penknife thrust into a wooden crate.[36] It was a thrill to pursue his latest interest – but he had to force himself to relax as his body threatened to overwhelm him with excitement. Returning home, he submerged his plate into a diluted bath of acid and watched and tinkered as his maritime scene appeared in the copper. But the final part of the process required its printing onto paper, which, without a press, could not be achieved. He decided to use the family's mangle in the basement, which delivered the result he sought. He quickly settled into a rhythm, especially during 'those precious hours of daylight before the bank demanded my daily presence at 8.45 a.m. This continued for years, the bank, etching, and study compelling me to lead a life of comparative isolation.'[37] Further etchings, including a touching plate of three boys fishing, followed, but the basement was poorly lit and not fit for purpose. He sought the help of his uncle, George, to develop better print making equipment. George had relocated with his family to Aberdeen to try his hand as a city blacksmith, after he was unable to make a profit at his smithy at Foveran. George knew his way around complicated metal contraptions and, by 1903, they had together succeeded in assembling a functioning printing press composed of materials that had included 'the discarded steel piston rod of a marine engine,'[38] which, following a confrontation with his mother, McBey stored at home.

The atmosphere at Union Grove simmered. Nearing twenty, McBey had confidently defied his mother by placing his machine in the parlour, and if he had not yet left Aberdeen – and his family home – in body, he had certainly done so in spirit. A two-week break, in July 1903, with distant relations in Portsoy, some sixty miles north-west of Aberdeen, confirmed this as he happily whiled away the hours sketching by the harbour, before returning to the grim surrounds of his tenement where Annie sat morose and broken. Three years later, McBey was earning more money, had passed his apprenticeship, and had even spent time in Edinburgh, where, briefly seconded to work in the North of Scotland Bank's new branch at 20 Hanover Street, he etched when time permitted. There he lived at 44 Queen Street, only about a mile's walk from Edinburgh Castle. He had placed a request for lodgings in the *Edinburgh Evening News* only weeks after his arrival in the city in September 1904, looking for somewhere he

could work away at his Edinburgh plates privately and without disturbance. It is tempting to wonder whether this 18 October *Evening News* advert, with its subtle indications, was the advert in question: 'Lodgings wanted by clerk in quiet house and neighbourhood – parlour-bedroom or parlour and bedroom – 4328 News Office, Stockbridge.' By January 1906, one of his prints, *Old Torry*, an accomplished depiction of Aberdeen fishing smacks, was hanging at the Royal Scottish Academy exhibition, and later that year he was able to rent loft space above 22 Justice Mill Lane, from where he secretly painted in oils and etched in the early evenings. It was his first real artist's studio – a gratifying and seminal achievement.

Although in McBey's autobiography he aches for a motherly love seldom given – and there is no reason to doubt that his written recollections were anything but genuinely felt – correspondence in Annie's own hand reveals a side to her little mentioned in the Scotsman's memoirs. While we know she showed a keen interest in her son's job prospects and attire, surviving letters to McBey paint a still more tender portrait. Beginning missives with 'Dear Jim' and ending with 'I remain your affectionate mother', Annie, writing during those occasions when McBey was working away from the north-east, finds her maternal voice. Sentiments such as 'If it's raining when you come to Aberdeen take a cab if you can get one'[39] and 'try and not get cold'[40] are interspersed with her hopes that he write again and another warning him against attending the local baths due to cases of small pox. Perhaps it was easier for her to express herself in writing than in person, but her final expression of emotion would be her most tragic yet.

As Christmas 1906 approached, a 'fancy goods store' on Union Street was advertising its gift range on the front page of the *Aberdeen Daily Journal*, and the cold and wintry city was looking forward to the festive season. But alienated from the festivities, sometime during Tuesday 11 December, Annie decided to satisfy an urge she had doubtlessly considered for years. She had likely rehearsed it repeatedly in her mind as she lay in bed at night or sat up in the parlour until the early hours, close to her old prescriptions for atropine sulphate and other ineffective medications. When McBey returned home from his studio at 9.30 p.m., all was quiet. His grandmother was already tucked up against the winter chill, but Annie was probably lying alert, rigid and still, and must have heard her twenty-two-year-old son ready himself for sleep. When nothing

stirred, she slipped out of bed, and felt her way by touch as her sightless eyes – now ravaged by repeated bouts of iritis, resulting, almost certainly, in some or all of secondary optic nerve damage, cataracts and glaucoma[41] – gaped like two black holes from a face of frown-lines and sorrow. She opened the tenement door to the landing and delicately made her way down the stone stairs – and into the basement. If she had practised her route in times past, she would have known where to find the rope, which part of the ceiling she could most easily reach and how many steps to take. Tying one end of the cord around a rafter, and the other around her pale neck, she drew her weary body upwards, and pulled the noose tight. We will never know if she hesitated before she let herself drop, but her resolve to end her torment was surely not without struggle as she likely wriggled and twitched like a fish on a line until death overcame her. She was forty-five and had finally taken control of her life by choosing how and when to end it. But now, hanging lifelessly in the cold, she was alone in the dark once more.

CHAPTER FOUR

Across the border and beyond

'Nothing can dwindle to nothing, as Nature restores one thing from the stuff of another, nor does she allow a birth without a corresponding death.'

– Titus Lucretius Carus (c. 99 BC–c. 55 BC)

McBey might have felt the crushing isolation brought on by years of estrangement from his mother, but he had made one close friend in Aberdeen whom he had met at Gray's School of Art.

Henry J. Rennie, described in the 1901 census as a 'photographer's pupil', had accompanied McBey 'up dark sleety Union Street in silence'[1] following the news that Queen Victoria had died on 22 January that year (which had triggered the school's temporary closure), and a close bond between the two soon formed. McBey, in his memoirs, noted that Rennie was forced to use a crutch, on account of an unspecified disability. As he got to know him better, McBey realised Rennie was 'of a studious and argumentative nature.'[2] McBey was somewhat curious about Rennie's disability – the bespectacled Rennie was 'lame'[3] and 'had a stiff knee'[4] – but he found true stimulation in conversing with his intelligent friend.

Their meeting of minds quickly developed into meaningful Sunday walks when they would thrash out the issues of the day, particularly debating on matters of faith and the Church. 'What may have fostered a tacit understanding between us was his physical handicap [...] and my spiritual one,'[5] recalled the only child, who almost certainly found in Rennie a brotherly connection.

It is easy to imagine them wandering deep in conversation amid the gravestones of St. Nicholas Kirkyard (the 'Mither Kirk'), many today rendered illegible due to the passage of time. A gentle Sabbath hum would have echoed off Union Street and in through the central archway of the Ionic façade near where travelling shows of 'giants' and 'dwarfs' once performed for a paying public prior to its construction.[6] The bookish-looking Rennie, three years older than McBey, but shorter and slower

on his feet, was profoundly thoughtful, and the aspiring creative recalled feeling somewhat inferior in the presence of his better read, and more pious, companion. Still, they conversed passionately on many aspects of contemporaneous spiritual interest, including 'the inter-denominational rivalry'[7] of Scotland's Presbyterian places of worship.

The 'late nineteenth century [had been] the high water mark of competitive rivalry [...] when the three leading Presbyterian denominations were well established across the country, and sought through vigorous competitive activity to maximise market share.'[8] After the Disruption of 1843, which had seen some ministers and members of the Church of Scotland leave to form the Free Church of Scotland, there followed a battle for the hearts and minds of Scottish churchgoers, which also involved the United Presbyterian Church. In 1900, the Free Church and the latter amalgamated to form the United Free Church of Scotland. That union was not endorsed by a small minority of worshipers, who elected to continue the Free Church of Scotland.

The relative merits of each denomination were almost surely debated during their hours-long strolls; and it is certain that all were namechecked, every musing leading to another until they bid each other goodbye, and McBey returned to his grey tenement of solid pointed granite. This tenement, erected in 1890, today bears a plaque in McBey's honour. 'Sceptical by nature,' he later wrote, referring to a subject which he would often revisit, 'I was searching for an unassailable belief – a faith to which I could adhere and which would carry me through life, come what may.'[9]

Whatever faith McBey possessed by December 1906 is unclear; but when Annie was laid to rest beneath the sodden turf of Foveran Kirk graveyard, surrounded by the acres of farmland which remain a fixed part of the landscape still today, the minister's solemn words at the graveside must have echoed in his ears. McBey's writings show he took pains to make certain that his mother's tragic suicide remained a closely guarded secret so as not to prevent her being buried on holy ground. It was his 'last act of loyalty'[10] to a woman who had suffered, and caused McBey, a young man turning twenty-three that very month, to suffer enough.

We know that he found it difficult to put the discovery of Annie's cold and lifeless body hanging from the basement ceiling out of his mind. He was sleeping soundly when his grandmother slipped into his room bearing a candle, and shook him awake in the mid-morning blackness. Mary

told him that Annie was not in bed, and, having checked the parlour, where Annie often stayed up late and alone, accompanied him to explore the rest of the tenement.

The deathly silence must have screamed amid the bitter winter chill as both grandson and grandmother crept down the stairs of their tenement building and into the basement. As the cold stung McBey's exposed skin, and his icy breath vanished into the gloom, 'There, in the dim light cast by my candle, stood Annie fully clothed.'[11] Mary called out to her, but, as McBey inched closer, the remaining shadows parted to reveal his mother's lifeless form. 'Suddenly the hairs of my body stood up',[12] and he ushered his grandmother back upstairs. Returning with his penknife, he cut Annie's silently swaying body loose, after which she fell hard on the ground.

Aberdeen's newspapers often reported the city's tragic suicides and attempted suicides during the era of Annie's own passing. Drinking acid, cutting one's throat and hanging were common methods by which some troubled north-east coasters chose to take their own lives, with trawler fishermen, gilders and wives of salesmen among their roles. 'Suicide was not in Victorian and Edwardian times, and is not now, a crime in Scots law and neither was an attempt at suicide,'[13] but 'self-destruction was imbued with theological implications.'[14] Accordingly, at a time when many of the city's more devout onlookers would have viewed Annie's suicide as a grave mortal sin, McBey was keen to keep the nature of her death out of the press. After McBey had cycled to the station to report his mother's sudden passing, police officer Inspector Wilson, assigned to the case, co-operated in deterring the curiosities of local reporters, by helping him carry Annie's body upstairs to the parlour, and pledging to 'mislay' the charge book. 'No words that I knew could have expressed the gratitude I felt towards [the] Inspector,'[15] wrote McBey of Inspector George Wilson, a kind and middle-aged husband and father.

He was surely replaying his mother's suicide and the subsequent days over and over in his mind, as the horse-drawn hearse, followed by a carriage which carried him and his two uncles, rattled its way along the wet and filthy roads on 15 December from Aberdeen to Foveran, where Annie had been born forty-five years earlier. He had probably considered his grandmother's death a more likely eventuality than his mother's and probably feared it more too. He now found Mary, though well into her

eighties, both an able and comforting companion. With McBey's lead, both had gone to great lengths to conceal the true nature of Annie's sudden passing, settling on a heart attack as the purported cause of death. And, according to McBey's autobiography, he was greatly helped by the undertakers who prepared her body for burial. Her neck, deeply, and visibly scarred from the rope, needed to be covered before anyone could pay their respects, and a wide frill was applied. When the neighbours dropped by, including perhaps eighty-two-year-old Stirlingshire-born Janet Duncan, formerly at 42 Union Grove, now living at 116, they, as tradition dictated, placed their hand on Annie's forehead, suspecting nothing of the tragic reality. Writing as an older man, McBey could still remember the peaceful features of Annie's lifeless face. He also recalled his own creeping elation at what her death, as shocking as it was, now meant for both him and his grandmother. By taking her own life, she had freed herself from torment, but had also freed her adult son. McBey later speculated 'it was possible that by leaving as she did she felt she would be making life less difficult for me.'[16]

The days following the funeral at Foveran Kirkyard, located on the right bank of the east-flowing Foveran Burn (the scene of a 1912 etching by McBey), saw life resume a more normal pattern. Naturally letters of condolence were received, including one black-rimmed missive expressing the heartfelt sentiment that 'The removal of a dear mother by death is the greatest loss any one can sustain.'[17] Just as Mary had made porridge for both her and her grandson the very morning of Annie's death, she continued her duties of keeping house. It is hard to know exactly how Mary herself felt after the death of her daughter, her third daughter to die since her first and her namesake succumbed to pneumonia at age fifteen in 1873. It is easy to assume that the enduring hardships of the period made dealing with bereavement altogether more tolerable; but pangs of loss and grief must have gripped her during her long days alone at Union Grove, especially during the dark winter months as she waited for her grandson to return home for high tea in the evenings.

McBey was grateful for his grandmother's presence and care, which must have made his days at the bank more tolerable. Yet, after the funeral, he struggled to get back to his art meaningfully in the weeks following Annie's death, such was the demands on his time from relatives. Fear gripped him when alone in his loft studio as the dark evenings

brought with them memories of his mother hanging, cold, in the basement. Naturally distressed by the grim discovery of Annie's asphyxiated body, he would have to wait until spring before the longer days granted him more daylight and, with it, a more congenial atmosphere in which to work. But he 'never again felt at ease in that silent building.'[18]

Art was not central to McBey's life again until well into 1907. A change in work studios, swapping 22 Justice Mill Lane for an upper floor space on 220 Union Street, when his lease ran out, would have helped him move on and refocus on his art. Operating out of a room situated on the city's most prestigious artery must have been a thrill, a sign that his fortunes were changing, even if he remained reliant on his day job at the bank. If he stood at the window during his time at his art studio, he would have seen Aberdeen in all its urban glory. Aberdeen's trams were pulled initially by horses in the late 19th century before electrification came about in 1902. McBey's lofty studio would have given him a fine birds-eye view of life in the Granite City: from the tram-cars trundling their way through Union Street to cyclists and horse-drawn carriages competing for space, and the bobbing heads of busy Aberdonians in top hats, flat caps and bonnets bustling amid this busy traffic. Photos from the time portray a packed Union Street which, according to Aberdeen's daily newspapers, was often the scene of accidents, injuries and deaths. In 1903, a young hotel worker was struck on the shoulder and injured by a tram car as he made to cross the thoroughfare; two years later, an apprentice plumber was thrown off his bike when he collided with a dog; and in 1907, a middle-aged labourer under the employment of the city's electrical works fractured his skull after inexplicably falling backwards as he was about to lay underground electric cables. He was taken to his granite tenement on Union Grove, just several doors away from McBey and his grandmother, but sadly succumbed to his injuries, leaving behind a grief-stricken widow and a grown-up family.

McBey, during his daily trips to work and stints at his art studio, which was perched above The Northern Plate Glass Insurance Company, managed to avoid injury as he traversed Union Street (the Granite Mile), dodging the traffic emerging from connecting roads – such as Holburn Street, Bon-Accord Street and Castle Street – to get to where his business took him. Working like an automaton at an urban bank was a mind-numbing experience for a restless creative like McBey, and he

found his city-centre studio a haven where 'all round me came the faint friendly sounds of civilisation which at the same time gave me a sense of comfort.'[19]

He had, by this time, cultivated a neat moustache. One photograph, captured at Aberdeen's Duthie Park, by the banks of the River Dee, pictures the young bank clerk-come-artist in confident mood, betraying no hint of the trauma from months earlier. However, photographs can – and often do – lie, and he must have been hiding deep reservoirs of complex emotions. Perched on a bowing cane, with one leg across the other, and his left hand thrust into his trouser pocket, he leans into his friend, Rennie, who, standing centre, has his arms around both McBey and another acquaintance, George Dawson. McBey immediately draws the eye; taller and more handsome than his two companions, he wears a slight smirk under a flat cap.

In many ways, Annie's sudden death had made McBey feel somewhat re-born, so much happier was his home life. But, he had yet to taste life outside Scotland. The opportunity to travel beyond the border came when his bank entrusted him and a colleague with escorting a major cache of excess gold bullion to London. This mission was a bi-annual event which many clerks in the office believed took place with an attending inspector carrying a pistol. By the time McBey was writing down his early life story in post-war Morocco, he was a well-travelled man, his name a regular feature of passenger manifests, yet he recalled his wide-eyed naivety at this assignment with a disarming frankness.

"'This is a special consignment, the biggest we have ever sent,'" he remembered being told by the head of securities, and which he recounted in *The Early Life of James McBey*. "'I see, but shouldn't I have a revolver?'" McBey enquired. "'Do you know how to use a revolver?'" he was asked. "'No, I have never even had one in my hands,'" McBey replied. "'Then you are probably safer without one [...]'" the securities chief retorted, who further asked him whether he had ever visited London. "'Heavens, no, I have never been outside Scotland,'" stated McBey.[20]

McBey, who was widely-known by his friends for his sense of fun and mischief, must have smiled while composing his autobiography as a famous artist, not least when penning the account of his December 1907 journey south of the English border. Such was the significance of his first London-bound passage, by night train to Euston Station, that it is worth

noting his memories as he recalled them decades on. 'When dawn broke grey the landscape that sped past us was very different from the Scotland we had left the previous evening,' he wrote with the elegant economy of words that would characterise his memoirs. 'The undulations were much softer, the countryside more intimate, and the trees and foliage sylvan instead of sturdy. We felt we had entered a foreign land.'[21] His sense of England as a 'foreign land' was understandable such were the many hundreds of miles which lay between Aberdeen and his destination of London. By visiting the Big Smoke of London, he was, for the first time, entering the beating heart of Britain, a small island nation which still then retained a vast Empire of colonies and dominions. He had never been as close to the Palace of Westminster, where the country's prime minister, Glasgow-born Sir Henry Campbell-Bannerman, was in the last months of his premiership (and his life).

He had purchased a guide to London prior to his departure from Aberdeen, and anxiously followed the map therein as he and his co-worker travelled with the £120,000 consignment by horse-drawn wagon from Euston Station to the Bank of England, founded, whether McBey knew it then or not, by Scottish merchant William Paterson 213 years earlier. As he related in his own memoirs, but given more dramatic effect by Kenneth Hare in *London's Latin Quarter*, the clerks had been forced to get public transport after their promised police escort failed to arrive.

And 'as the bullion-waggon had never repaired to the station as arranged, it was always possible that the van which he had procured as a substitute might be there by design [...]' reported Hare, revelling in McBey's earlier innocence. 'What if they were tricksters conducting him to the river with intent to push him in, having first dealt him a good swinging blow on the head?'[22]

Fortunately, he arrived safely at the Bank of England in Threadneedle Street, which, by noon, when he had completed his business, would have throbbed with traffic and noise. His senses would have been absorbed by horses pulling canvas-covered carriages steered by hauliers and tradesmen, and buses adorned with ads, such as those for Bovril and Lipton's Tea. McBey would have found the commotion in London similar to that in Aberdeen, but he would never before have countenanced the sheer scale and noise of Britain's largest city. With several million inhabitants, London rocked with a force of energy that made it one of the most

dynamic urban centres on earth. Indeed, McBey's London visit coincided with the city's cinema boom, which, between '1906 to 1914, and particularly around 1909 to 1910, [effected] a remarkable transformation [...] across the face of London.'²³ The year 1907, for instance, saw the release of silent films such as *The Anarchist and His Dog* and *Dreamland Adventures*. Watching motion pictures would soon become a genuine passion of McBey's, but he had higher priorities on this first London visit. The Scotsman, who, after making good on his delivery, was granted close to a week off from the bank, primarily viewed London as the gateway to the European art world. And he wasn't about to let the opportunity, however fleeting, slip through his grasp.

He took a train from London Bridge Station to Newhaven on England's south coast, and then a night ferry to Dieppe. Perhaps his vessel was the *Arundel, Brighton IV, Dieppe IV* or *France*. Then he took a train to Paris, following the well-known route of many early-twentieth-century British holidaymakers. Newspapers from the time often advertised trips to the Continent, such as that in a July 1909 edition of *The Bystander*, which announced that a 'Special fourteen-day excursion to Paris, Rouen, and Dieppe has been arranged by the Newhaven and Dieppe route from London [... where] a restaurant car will be run on the train from Dieppe to Paris.' He had departed one great capital city, which had given the world such titans of art as J. M. W. Turner (1775–1851), to reach another great capital, the birthplace of French Impressionist Oscar-Claude Monet (1840–1926). Monet was at that time living some fifty miles away from Paris in Giverny, on the banks of the River Seine.

McBey doesn't say which hotel he checked into in Paris – only that it was 'a small hotel close to the Gare St. Lazare'²⁴ railway station. The Hotel Océanique and Hotel Terminus were lodgings with global connections close to that railway station so it is possible he stayed at one of these two hotels. In a June 1901 edition of *The Gentlewoman*, an ad reported that '[English travel agency] Messrs. Henry Gaze and Sons [...] proprietors of the Hotel Océanique (opposite Gare St. Lazare), are further improving this popular hotel.' And in June 1898, US art dealer and collector Edward Guthrie Kennedy had just left the Hotel Terminus when a letter had to be forwarded to him from James Whistler concerning his work, *The Little London Sparrow*.²⁵ By simply making his way from London to Paris, and stepping off the train at Gare St. Lazare, McBey had experienced

more cosmopolitan sights and sounds in a single day than he had over the course of his life. And, he was determined to explore some of the wonders of the art world which were now within reach, eyeing visits to the Musée du Luxembourg and, of course, the Musée du Louvre.

'The streets were full of men with black eyes, olive skins, and delicate black beards, all of them rather small but very alive and excited,'[26] remembered the eagle-eyed McBey as he navigated his way through the streets of Paris, stopping at a café where he drank some unidentified alcoholic beverage before reaching the entrance to the 1750-established Luxembourg, Paris's oldest public museum. His visit, he claimed, was conducted in a kind of haze on account of the 'bitter and warming'[27] drink he had consumed at the café – probably a French apéritif going by his vivid description – yet he instantaneously recognised Whistler's prized, *Arrangement in Grey and Black: Portrait of the Painter's Mother*. McBey would one day be described 'as the greatest etcher of our time after Whistler' by US filmmaker Lowell Thomas. Seeing Whistler's creation, he might not have been aware of its colourful history prior to its arrival at the Luxembourg. Whistler's portrait of his mother was completed in 1871 and hung in the house of his brother, William McNeill Whistler. At one point it required the artist's intervention to prevent it being seized by William's creditors, and later the artist also used it as security for a loan. The Luxembourg took receipt of the work in 1891, and it continued to travel around France during McBey's own lifetime, making its way to the Jeu de Paume in 1922 and then the Louvre three years later. Since 1986, it has remained primarily at the Musée d'Orsay, being loaned out on occasion, for example to the Louvre Abu Dhabi in 2017.[28]

After studying the Luxembourg's other works, such as those of the Impressionists, he completed his cultural immersion in Paris by taking in a production of Richard Wagner's *The Valkyrie* at the opera followed by a trip to the Louvre the next day. The whole experience was, perhaps, too demanding for McBey's depleting energy levels because he struggled to stay awake during the operatic performance, but after a fitful night's rest, he made the most of the Louvre on the day he would return to Britain. The Louvre, long known for its unrivalled collection of art, must have been a site to behold for McBey, who probably caught sight of the *Mona Lisa*, which would later be stolen by three audacious Italian thieves in August 1911. The portrait, prior to the theft, 'was not widely known

outside the art world.'[29] Painted by Leonardo da Vinci (1452–1519) in the early 1500s, 'it wasn't until the 1860s that critics began to hail it as a masterwork of Renaissance painting. And that judgment didn't filter outside a thin slice of French intelligentsia.'[30] Accordingly, McBey, with countless other masterpieces vying for his attention, might have given the *Mona Lisa* limited regard had he looked upon it during his hurried visit. Indeed, a period photograph of the Salon Carré du Louvre,[31] the gallery in which the *Mona Lisa* then hung, shows that the small 77 x 53 cm portrait was surrounded by paintings such as *Portrait of Baldassare Castiglione*, by Italian High Renaissance painter Raphael (1483–1520), and *The Meal at the House of Simon the Pharisee*, by Paolo Veronese (1528–1588), and a host of other sensational works. Enormous in scale, Veronese's exquisite-looking oil on canvas landscape stretched the width of seven works below it, which were dwarfed in comparison.[32] McBey's head must have spun viewing such a collection of masterpieces.

Returning to London, he had just enough time to see the National Gallery and explore more of the British capital – where, by 1909, some thirty-six thousand Londoners would own a car – before reuniting with his colleague, who had stayed on in the city after their Bank of England delivery. Travelling north, they finally reached a dark and wintry Scotland where after just 'a few hours under the cold grey sky of Aberdeen, Paris and London were but the precious memories of a dream.'[33]

McBey's imagination must have been stirring in excitement after his return from London. He began the next phase of his life in haste, having observed some of the greatest works of art in the world, and been close enough to touch them. A new start was precipitated when he came home one afternoon to find his grandmother, Mary, on the floor of their tenement. She had taken a dizzy spell and collapsed – but was otherwise fine. Nearing ninety, however, the time had come for her to be looked after full-time, and, having disclosed to her grandson that she had fallen many times before in the past without his knowledge, it was decided that she should live with her eldest son, William, and his family at 20 Viewfield Road, west of Aberdeen City Centre. Latterly, Mary had made his life a happy one, but the granite-built Union Grove, with its memories both good and bad, had served its purpose, and it was time for McBey to move on.

McBey found new accommodation for himself at 154 Union Street, about two miles away from Viewfield Road, pledging to visit his grandmother each Sunday. He rented a room a minute's walk from his studio, alongside several other lodgers. He still worked at the bank, but was, by now, a well-known face around Aberdeen art circles. He had exhibited at the twelfth Aberdeen Artists Society show, and Robert Watt, a branch manager of the bank, had commissioned McBey to paint his portrait for the princely sum of £15 (about £1,900 today). McBey was so pleased with the resulting composition of Watt that he entered it, alongside three etchings, to the thirteenth Aberdeen Artists Society show. All four submissions were accepted and were even the subject of relatively positive reviews in the local press that he nevertheless thought 'faint praise.'[34]

Though McBey makes little mention of his association with the city's Northern Arts Club (NAC) in his autobiography, this link helped to power his creative ambitions in the north-east. Prior to his London trip, he had purchased from a second-hand shop on Aberdeen's Marischal Street what he some years later claimed was one of the original death masks of Napoléon Bonaparte, cast by François Carlo Antommarchi, the former French Emperor's physician. Initially uncertain as to the mask's true origins, McBey had the bronze figurine hung at the 1907-established Arts Club for members there to examine. We know that he is first mentioned in the NAC minutes, briefly, on 8 February 1908, and that he exhibited there between 1909–1919 as a member.[35] His time at the NAC put him into contact with other like-minded creatives and immersed him further still in the world of art, as his profile continued its ascendancy. His connection with the NAC was reasserted in 2020 when Australian artist David Lever bought a work at a Sydney auction. Delightfully, this turned out to be a portrait of one of the founders of the institution, William Yuill, painted by McBey in 1909. Curators at Aberdeen Archives, Gallery and Museums had no idea the work existed, or, of course, how it managed to make its way from north-east Scotland to Australia's south-east coast. But its 'discovery' shed more light on McBey's close connections to the Arts Club, and one of its founders.

McBey's composition captures an affable-looking Yuill sitting side on, with his left arm placed across the back of a chair. His (visible) left ear is large, his eyebrows arch upwards, his nose is strong and his white beard points downwards. It appears to be a spontaneous work intended to

capture the jovial nature of the sitter, who had been painted by Scottish artist John Pettie (1839–1893) seventeen years earlier. On the reverse of the portrait, written on cream-coloured paper, is an enclosed addendum with the inky words, 'Caricature sketch of me done by James McBey at the Northern Arts Club Aberdeen in 1909, W. Yuill.' Intriguingly, McBey has painted in at the top left-hand corner a coiled black snake with gold stripes and a protruding tongue. One can only assume that the enigmatic serpent is a private joke between sitter and painter,[36] who, by 1909, had clearly reached a level of proficiency – and confidence – in his art that made producing informal works of this quality possible.

The emergence of the portrait reveals a glimpse of McBey's artistic activity prior to his decision to be a professional full-time artist, and also highlights Aberdeen's links to the wider world at that time. In the 1921–22 edition of the *Aberdeen University Review* is Yuill's obituary, which, given its rich content, and its illustration of a life well lived, deserves to be reproduced:

> Mr. William Yuill (alumnus, 1860–62), residing at 29 St. Swithin Street, Aberdeen, died at a nursing home in Aberdeen on 17 May, aged seventy-eight. He was the eldest son of the late Rev. James Yuill, for many years Free Church minister at Peterhead, and a brother of the late Mr. George Skelton Yuill (alumnus, 1864–66), the well-known Australian merchant, who founded the Yuill Scholarship in Chemistry in the University [...] He was educated at the Gymnasium, Old Aberdeen, under Dr. Alexander Anderson, his maternal uncle, and later attended classes at the University, but did not take the complete Arts course. He received his training as a civil engineer in Aberdeen, and was engaged on the South Breakwater and other important harbour works then being carried out under the late Mr. Dyce Cay. For some years Mr. Yuill was in India as a railway engineer, and, returning to this country, he set up practice in London and gained an important connection as a sanitary engineer. He subsequently went out to Australia, and after spending a number of years there he retired and took up his residence in Aberdeen. During the war Mr. Yuill rendered very useful service in connection with the moss dressings depot, and for a time took charge of the sublimating or sterilizing plant at Gordon's

College. Keenly interested in art, he was one of the founders of the Northern Arts Club, and young and aspiring artists always found in him a warm patron and friend.

Precisely how the portrait came to arrive in Australia remains unclear, but the above death notice gives a clear indication of why it did. William and his brother, George, both spent time in Australia – and George's obituary, published in a November 1917 edition of the *Pastoral Review*, likely explains why the picture found its way to Sydney specifically.

'By the death of Mr. George Skelton Yuill, which occurred in Sydney last month, Australia loses one of her most prominent commercial men [...]' went the solemn, but notable, announcement.

[He] was an owner of racehorses in China and Australia, and latterly won many races with the well-known horses *Gallipoli, Clydeside, Gadabout, Rushford, Malkin*, and *Harvestress*. He was born in Aberdeenshire [...] and was 67 years of age at the time of his death. His only daughter [Winnifreda] married the Earl of Portarlington in 1907.

In 1909, the ambitious McBey, perhaps foreseeing his would be a life of adventure, began keeping a diary. Little did he know it then, but he would diarise up until his death fifty years later. Confiding his thoughts, feelings and experiences in diary form would compel him to devise a cypher for his more personal exploits and sentiments, and on 11 January, he made his first coded entry. It was of a romantic nature – 'Kissed Miss Lumsden she was willing' – and would set the tone for the next five decades of entries. In 1909, the year he made a return journey to London on bank business, 'Miss Lumsden', 'Eva Whitehouse' and 'Susie' would all feature as romantic interests in between scribbled notes and reminders concerning his art work – 'canvas, blotting paper' – and general housekeeping – 'pay coal'. He also that year recorded a visit to the House of Commons, where '[David] Lloyd George's proposals were being debated.'[37]

McBey began to plot his future plans for success at his new lodgings on Union Street. While there, he once became ill with pleurisy and, rather comically, got his head stuck in between the brass bars of his bed. His landlady had applied an iodine solution to the left side of his chest and back – which had been burned by a hot poultice she had applied the previous day – causing him to lurch upwards. Yet, by 1910, he presented as a healthy male in the prime of life, who was now ready to take a leap of

faith he could barely have imagined just a few short years before. Over the course of his eleven years at the bank, he had made nearly £500. And, having risen through the ranks as a loyal bank clerk, he was now earning £80 per year. But he wouldn't settle for a life of predictability, and unashamed mediocrity. He had saved £200 (just over £25,000 in today's money), and a life less ordinary beckoned. He wrote, 'I had not the slightest cause to imagine I might be able to earn a livelihood as an artist, but to founder quickly on the high seas appealed to me as a better fate than to decay slowly in the harbour.'[38]

The only tie McBey felt to the land of his birth was Mary. She remained his rock, and was certainly the first woman he had ever truly loved, but, born in 1820, she was in the deep winter of her life. Happily for her grandson, however, she appeared settled with William and his family. By 1911, she would be living quietly alongside her son, still a coachman, his wife, Margaret, and Mary's nineteen-year-old grandson, John, himself a bank clerk. It had been years since McBey had painted Mary's portrait at Union Grove, and one can picture her whiling away the hours by the fire of her home barely changed, save for the deepening wrinkles of her face, which came alive each Sunday when McBey visited and shared his news. It is not known if he discussed with her his intention to leave the bank, but he would likely have found little resistance from a woman, who, in her own quiet way, had long been his greatest champion. Together they had been through much – Annie's death most of all – but the boy she had seen grow up was now a handsome young man with an eye for the ladies and they for him.

A photograph taken in 1910 portrays McBey as the consummate artist in a suit and waistcoat; a spotted bowtie is perched neatly below a wide chiselled face, while his swept-back hair sits above a moody expression flawlessly composed for the occasion. His look perfected – the die was cast. In July that same year, he clerked at the bank for the last time, having handed in his notice weeks earlier. He recalled it in his autobiography as Saturday 10 July, but the tenth of that month fell on a Sunday, and his diary entry – 'left Bank today' – pencilled in down the side of the page almost as an afterthought confirms it as Saturday the ninth. On that day, American aviator Walter Brookins made history as the first pilot to fly higher than a mile – over Atlantic City, New Jersey – in his Wright Model B biplane. McBey's own piece of history may have seemed pale by

comparison – 'Everyone was much too busy to waste time bidding goodbye so at 1.10 p.m. I quietly walked out'[39]– but he was now a professional artist, who would succeed or fail entirely on his own merits.

That weekend, McBey embarked on his first assignment as a self-employed etcher and painter – a work trip to the Netherlands. 'No man who is instinctively an etcher,' wrote one Victorian and Edwardian art critic, 'can keep himself for ever [sic] absent from the great flat lands, that inspired Rembrandt.'[40] The city of Amsterdam had been the scene of Rembrandt's death 241 years earlier, and the Dutch master had been one of the great artists McBey had first read about in his boyhood periodicals, and he longed to visit. He caught the *St. Sunniva*, a 966 grt vessel that had been built in 1887, and sailed down the coast to Leith. The ship's modest speed of up to 15.5 knots would have given McBey ample time to survey Scotland's arresting eastern seaboard, passing the likes of Stonehaven, the ruined medieval fortress of Dunnottar Castle, perched high above the crashing waves of the North Sea on a rocky outcrop, Montrose and St. Andrews before heading into Leith docks. From this busy Edinburgh port town, where, in 1910, John Gibson's Caledonian Cycle Works at 109 Leith Walk was turning its hand to designing and manufacturing biplanes, he hopped on 'a small cargo steamer in which I was the only passenger'[41] and made his way across open sea to Amsterdam. McBey does not say which steamer he took, but George Gibson and Co., Leith, then owned various active vessels, which, according to the 1908 *Encyclopaedia of Ships and Shipping*, maintained 'regular services between Leith and Rotterdam, Amsterdam, Harlingen [and] Antwerp.' It took 'two days and nights'[42] to reach Ijmuiden canal, during which time he watched a stable of tethered horses slip and slide across the well-deck as the steamer battled south-westerly gales. Some of the battered horses perished during the crossing. From Ijmuiden, he spied farmland and windmills, before, 'in the grey distance, the church spires of Amsterdam serrated the base line of the sky.'[43] As a tug guided the hardy vessel quayside, he recalled that but 'for the anachronous presence of a steamship here and there we might have been entering the eighteenth century.'[44]

To McBey, the Netherlands appeared oddly quaint at first sight, like the scene from a chocolate-box. He watched a gathering 'of Dutchmen each with wooden clogs on his feet and a cigar in his mouth'[45] crowd the weathered harbour, all subjects of Queen Wilhelmina, whose reign had begun

the previous century. Like his journeys on foot across London and Paris, the artist navigated his way by map through the streets of Amsterdam to what he described as 'the address of the minister of the Scottish Church.'[46] He had been directed to this minister by a banking friend at what was now McBey's former place of employment. The minister was almost certainly the Rev. William Thomson, another Aberdeenshire native, who had been serving at the Scots Kirk, Amsterdam, since 1895, having earlier assisted at a church in Aberdeen itself. He agreed to find McBey somewhere to lodge, taking the fledgling artist to the home of the Kamp family on the city's Bosboom Toussaintstraat.

The following morning, after McBey's first undisturbed sleep in days, Amsterdam and its unexplored spaces lay before him like a giant canvas. His widowed landlady had two sons, the youngest of whom agreed to show their intriguing new guest the sights by bicycle. The Dutchman, Jan, who had a decent grasp of English and was around the same age as McBey, appeared to revel in his role as tour guide, and the pair clearly clicked. A visit to Zaandam, with its windmills turning in the summer sunshine, was followed by an excursion to Wijdewormer. Both locations epitomised the gentler pace of life which McBey clearly craved after years in the banking trade. Indeed, the Kingdom of the Netherlands, a constitutional monarchy for generations, presented the young Scotsman with his first taste of unabashed serenity, if his memoirs are to be believed. And when he and his companion cycled to Volendam and he witnessed artists 'working in the open and unashamed',[47] he was moved to wonder if he had found paradise at last.

Nothing would shatter this contentment during the next two months of his Dutch adventure. With the tools of his trade to hand, he set about Amsterdam's streets and canals observing and sketching, dealing with the attentions of passers-by and absorbing the sights and sounds of another one of Europe's historic places. He made a trip to the city's Rijksmuseum, as he had Paris's Luxembourg and the Louvre three years before, where he studied diligently the works of Rembrandt and saw *The Night Watch*, 'the show-piece of the museum', 'hanging alone in a special chamber.'[48] American travel writer John U. Higinbotham, reflecting on his early-twentieth-century sojourns in the Low Countries for his book, *Three Weeks in Holland and Belgium* (1908), elaborated on his own visit to

the Rijksmuseum, which he described as 'comprehensive in its scope.'[49] 'It has a large collection of objects,' he reported:

> These include the uniforms and armament of Holland in all ages. A stack of stone cannon balls reminds one of the first years of gun-powder. Many models of locks, dikes and dock yards show where a large portion of Holland's brains and energy are expended to this day.[50]

But, like the Scotsman, he gravitated towards the Rijksmuseum's 'fine gallery of paintings.'[51] 'The best known, and strange to say, the best executed, is *The Night Watch* by Rembrandt,' agreed the author, as starstruck by this Dutch marvel, completed in 1642, as McBey was.

> The management has been wise enough to give it a separate room and it richly merits the distinction. In the handling of light and shade and in the animation of the figures it is a masterpiece. It tells a story and tells it plainly and you do not need to be told that you are looking at one of the triumphs of art.[52]

McBey also spent time at the Frans Hals Museum in Haarlem, named after another one of the celebrated Dutch masters, admiring more of the great compositions which his boyhood journals and the city library in Aberdeen had first brought to his attention years earlier. He had started to collect blank antique paper on which to reproduce his etchings, and bought a beautifully bound volume of ancient leaves in Amsterdam which he years later claimed was once owned by Rembrandt. He explored the city's Jewish Quarter, much to the concern of Mrs Kamp, and then checked in to the Hotel Spaander so he could sketch the town of Volendam and nearby villages. The late-nineteenth-century-established Spaander remains a storied, art-inspired hotel in Volendam, some thirteen miles north-east of Amsterdam, which American and British guests had started visiting by the turn of the twentieth century. 'Artists were mainly enchanted by the quaint red-roofed timber cottages and by the local costume [... And] images of Volendamers in wing-tipped hats and baggy trousers became so prevalent in the Western world that the indigenous costume was soon identified with'[53] Dutch traditions.

McBey was pleased to take advantage of a preferential rate for struggling artists at the Hotel Spaander. A fuller (and more romantic) account of the Spaander is given by the jovial Higinbotham, who takes a steamboat ride on the *President Roosevelt* from the Dutch fishing village of

Marken (then an island, but today a peninsula) to Volendam, 'the resort of painters.'[54] 'Many a poor artist has been allowed to partake of [the hotel's] generous hospitality and to pay in promises, maturing when his ship should come in,' observed the American.

> And notwithstanding the hundreds of ships that do come into Volendam so few of them belong to artists that his only pay in many cases takes the form of pictures. And so [the] hotel is filled with paintings, some of them good, and all of them interesting. Some are on canvas and others are on the plastered walls. Few artists who have studied abroad have failed to visit Hotel Spaander, and many whose ships have come in laden with fame and gold hung their earlier efforts on its walls.[55]

At Spaander, the Scotsman met and befriended Alida Spaander, the daughter of the hotel's founder, Leendert, and both would begin a correspondence that would last for decades. Alida would assume the business from her father in 1919, and a promotional leaflet, pocketed by McBey during his 1910 visit, lauds its 'large collection of pictures, sketches and drawings given by artists [...] of different Countries who have visited Volendam.'[56] Indeed, during his stay at the Spaander, on the banks of the IJsselmeer, the artist was, as he himself asserted, part of an international clientele. Fortunately, the hotel retains the guestbook from the period which corroborates his account. When McBey checked in, he did so alongside a host of Europeans and Americans, whose elegant (and often fancy) signatures remain a testament to their patronage. There was the mysterious-sounding Madame Delon from New York, philanthropist and hospital reformer Sir Henry Burdett from London, and a Friedrich Leiter from Vienna.[57] McBey also recalled an 'elderly' artist from the US, who had a voracious appetite belying his slim appearance, and was the first American he had ever encountered. Again, he does not name the individual, but the artist was likely, looking at August guest records, Massachusetts painter Melbourne H. Hardwick (1857–1916), a middle-aged naturalised American originally born in Canada, who 'studied in both Boston and Europe [...] and frequently returned to such locales as Holland, England and Nova Scotia later in his career'[58] prior to his death in 1916. Another American painter who was lodging at the hotel that month was Connecticut-based Harry L. Hoffman (1871–1964), but, at thirty-nine, he was surely too young to be the artist in question.

At least two remnants of the artist's stay at the Spaander survive to this very day. First, of course, is his inky guest book signature, scratched onto the thick paper above his (studio) address given as '25 Crown Street, Aberdeen, Scotland.'[59] Another, naturally, is a painting, which, like the five hundred or so other works at the hotel, remains on display. Dated 17 August 1910, and dedicated to Alida, it is a portrait of an unknown Dutch girl of fair complexion, wearing a white wing-tipped hat, with her right hand resting on her cheek. The subject matter is hardly imaginative, but the girl's sullen look and curled mouth are subtle, arresting flourishes.[60]

On 2 September 1910, he left the Netherlands for Scotland, and within days was back amid the cold granite confines of Aberdeen, carrying his sketches. Having recently exchanged his studio on Union Street for his Crown Street address, he began work on his Dutch etchings, which would become, among others, *A Volendam Girl*, *The Mill*, *Zaandijk* and *Hoorn Cheesemarket*, all delicately-produced and skilled compositions belying his self-taught status as a printmaker. As a working artist, however, he knew that he needed to sell and so started to explore the prospects which existed outside Aberdeen. Of the dealers he met in Glasgow and Edinburgh, none appeared bowled over by his plates, but George Davidson Ltd., situated on Glasgow's bustling and famed Sauchiehall Street, was the most encouraging, and McBey had, at least, cause to feel hopeful when he managed to leave some prints for sale in both cities. Yet, he became aware that he would have to leave the Granite City, and Scotland itself. He had been across the border and beyond, and now it was London, to which many Scots from the past had flocked to seek their fortune – 'high in hopes and ambitions'[61] – that became McBey's promised land.

Since he had left the Netherlands, he and Alida Spaander had swapped letters. Like with many of the women he would meet over the course of his life, he had clearly made an impression on her, and she on him, and such was their bond that the twenty-nine-year-old felt able to confide in him her innermost feelings: '[...] poor boy, I don't know what you must thought [sic] of me, but don't blame me when I have not been to you like always,' she wrote shortly after his return to Scotland. 'I can not [sic] tell you wich [sic] thoughts always aren't through my head and after all I loved you as ever.'[62] In October she wrote again: '[...] when I am alone I am longing to have my good friend again with me, o [sic] why must good friends always part, I often wonder.'[63]

Whatever the true nature of their relationship, and McBey's 1910 diary (followed by an entry one year later) suggests that an intimate encounter had taken place between them,[64] it is clear that, sensing some vulnerability on his part, she was keen to impress upon him that she would remember him always: '[...] if I did try to forget you [...] it would not help [...]' she penned.[65] Yet, when she wrote again, on 26 December, wishing him a 'happy and bright new year', she appeared unaware of his plans to 'emigrate to London.'[66] In 1911, he prepared for the move of his life, packing up in the spring, just as census enumerators had recorded him living at his Union Street address alongside two music hall performers. On 25 May, and with a heavy heart, he bade Mary farewell, and the following day took the train south, stopping off at Stirling, where he visited its ancient castle overlooking the River Forth. He looked out over the ramparts to where William Wallace had defeated the English at the Battle of Stirling Bridge in 1297, and where Robert the Bruce had triumphed over King Edward II at Bannockburn seventeen years later. It was 26 May and, faced with the magnitude of his relocation to England, he pencilled in his diary 'Turning point', also noting the time as 6.45 p.m. and writing in code, 'O God Keep Me.'

And like a bird released from its cage, he was free to fly.

CHAPTER FIVE

'The Arabian Nights'

> 'I would be sitting pretty, but for my curiosity.'
>
> – *The Arabian Nights,* also known as *The Thousand and One Nights*

What was on McBey's mind as his train hurtled southwards across the Victorian-built tracks on 29 May? He would have had plenty of time to contemplate as he sat back for the eight or so hours it would have taken him to reach the British capital from Scotland's central belt.

Might his dead mother have consumed his waking thoughts or, if he managed some sleep, his dreams?

Habitually reflective, as his fifty years of diary keeping testify, it seems likely that he was looking back on the past. A couple of years before Annie took her own life, McBey had been offered the chance to swap his job at the bank for work at a tea plantation in Ceylon (today's Sri Lanka). McBey had told his mother of this unexpected opportunity, which would have seen him earn £300 per year as opposed to the paltry £55 he was making as an overworked bank clerk. Annie, McBey credibly claimed, did not meet the news positively, so clearly frightened was she about being left behind, and he himself was naturally torn about the move. According to McBey's autobiography, it was an old coin that he had earlier found at Foveran Kirkyard which decided his fate. In a story which sounds suspiciously apocryphal in nature, he flipped the coin seven times, five falling with the thistle side, his choice for remaining in Scotland, facing up. Reading between the lines, the offer had come just too soon and, not ready to throw in his lot with some faraway job opportunity, he 'was relieved to come to a decision [...] by subterfuge.'[1]

Could it have been this episode that he replayed in his mind as he made for England, or was he recalling the rose and kiss he received from a Jeannie Gordon in July 1904 at Insch, Aberdeenshire, where he had spent a short time clerking at the village branch of his bank?[2] Or was he, instead, fretting about his eyes – fearing that what had happened to Annie

might happen to him? As a boy, he had discovered that he had trouble reading the clock on Newburgh's Holyrood Chapel from afar. He had tried on Annie's eyeglasses, much to her fury, and discovered that he was, in fact, short-sighted. In adulthood, and while working at the bank, he took to wearing spectacles, and was terrified that he had 'inherited some incurable defect.'[3]

He was leaving the Scottish north-east somewhat under a cloud, in respect to his relationship with his uncle, George, but McBey would have argued that the disagreement was not instigated by him. It was on a matter connected to his mother, and McBey's complaint that George, in a letter written to his nephew within weeks of Annie's burial, had demanded money from her estate. Annie had left no will, but this did not deter George, who, clearly resentful of McBey's leverage in the matter, had been eager 'to hear what way my sister's money has been divided.'[4] William, the oldest Gillespie sibling, had warned McBey that George had visited him to ask his collaboration in seizing all of Annie's assets. He had given his younger brother short shrift and advised McBey to do the same – which he did. McBey had long become the go-to man of the family. Only months after George had invited McBey's scorn, his wife had begged a loan to help 'cure' her daughter, Maggie, of her stammer. She had been 'very much ashamed' at having to ask – 'you will think I have a good cheek' she wrote to the clerk from her then home near Ballater on 8 April 1907 – but it was clear that her husband had been in no position to pay the £1. 10s fee.

Whatever his thoughts during his journey, McBey arrived in London just in time to see an art exhibition at Shepherd's Bush. Prior to his leaving Aberdeen, he had responded to an ad in *The Studio: An Illustrated Magazine of Fine and Applied Art*, published monthly and produced at London's Leicester Square, which offered space to rent for the annual sum of £40. He had written to Mrs Schupp at 8 Wharfedale Street, Redcliffe Square, who had offered the let – a 'charming studio [...] with] top light, side light, service inclusive'[5] – and they soon agreed terms. Mrs Schupp was thirty-eight-year-old German Paulina Schupp, who, together with her German husband, Matthew, a railway worker, would rent out their top floor space to McBey at their south-west London home. It was a diverse household that also included three Irish lodgers as the 1911 census records. Early-twentieth-century London was a cosmopolitan place hosting thousands

1. Newmill cottage, Foveran, Aberdeenshire. Birthplace of McBey. The cottage adjoined the smithy where McBey's grandfather, William Gillespie, and his uncle, George, worked as blacksmiths.

2. Foveran Parish Church in Aberdeenshire today. Both McBey's troubled mother and much-loved grandmother are buried in its kirkyard. During his trips back to his native north-east Scotland, he would often take the opportunity to visit Foveran Parish Church and the graveside of his mother and grandmother (buried together along with other family members).

3. McBey's 1901 painting of his grandmother, Mary Gillespie. After the death of Queen Victoria, McBey was given an unexpected day off work for her funeral, and persuaded his grandmother to sit for a portrait. On seeing the first draft, Mary said, 'It is as good as a photograph.' In this impressive composition — which he created at just seventeen — McBey elicits Mary's kind and stoic features.

4. The cellar doors in the basement at 42 Union Grove, Aberdeen. McBey discovered his mother hanging from a beam in front of the doors. His grandmother, Mary, called out to her daughter, but, as McBey inched closer, the remaining shadows parted to reveal Annie's lifeless form. 'Suddenly the hairs of my body stood up' — and he ushered his grandmother back upstairs. Returning with his penknife, he cut Annie's silently swaying body loose, after which she fell hard on the ground.

5. McBey as a young man in 1910. He would that year quit his job as a bank clerk to pursue his artistic ambitions.

6. McBey's 1912 etching, *The Story-Teller*. Created in his London studio from sketches and memories formed in Tetouan, Morocco. It depicts 'a tall figure wearing a graceful djellaba' bewitching his audience, who, 'huddled against the city walls [of Tetouan]', are held spellbound by his tale.

7. McBey's 1913 etching, *Grimnessesluis*. A result of the Scotsman's second visit to the Netherlands. A mysterious backwater in Amsterdam's Jewish quarter is depicted. Some have suggested that the ghostly face on the right of the picture is a small portrait of McBey's hero, Rembrandt, rather than a Jewish woman as the artist himself claimed.

8. A representation of McBey's 1917 painting of Mrs Isa Curtis during the Scot's commission as official war artist on the Palestine Front. McBey and Isa Curtis met in Egypt, where Isa's husband, William, was working as an engineer in Esna, Upper Egypt. They began a passionate love affair, with Isa giving birth in Alexandria to his baby, who survived only a few days. Despite the work's title, *Mrs Curtis, Esna, Upper Egypt* it was in fact painted in Cairo.

9. McBey sketching the Mosque of Omar, Jerusalem, in 1918 during his stint as Britain's official war artist on the Palestine Front. McBey's war commission in the Middle East would see him witness the Allied capture of Jerusalem and Damascus; meet and paint T. E. Lawrence; and indulge in a passionate affair with a married British woman.

10. McBey's 1918 painting of T. E. Lawrence, better known as Lawrence of Arabia. This is thought to be the oldest known surviving portrait of the enigmatic Lawrence who sat for McBey at the Victoria Hotel in Damascus. Lawrence later described the picture as 'shockingly strange to me'.

11. A photograph of McBey's London studio at Holland Park Avenue with two of his paintings displayed. Shortly after the war, T. E. Lawrence came to visit McBey at Holland Park, but 'thought he heard voices' and left without entering. The artist took possession of the residence in May 1919, and after his death in 1959, his wife, Marguerite, kept the property as a shrine to his memory.

12. McBey's 1919 magnum opus, *Dawn: The Camel Patrol Setting Out*. This etching formed part of his 'First Palestine Set' and became a much sought-after print at auctions on both sides of the Atlantic, causing its value to skyrocket. The plate portrays nine Australian riders heading out towards a vast expanse of rolling desert in the Sinai Peninsula during World War I.

13. McBey (centre) aboard the *Esna* with his friend and lover E. Arnot Robertson (right) and two friends, including fellow artist Arthur Baylis Allen (behind). The *Esna* was the first boat that McBey owned. He loved to sail and would later trade in the *Esna* for another vessel, the *Mavic*.

14. McBey's 1926 drypoint, *Santa Maria della Fava*. A single impression of this Venetian plate fetched $2,560 USD at an American auction in 2021.

15. Frances Gripper, McBey's American lover, whom he met in London on her twenty-sixth birthday on 29 September 1928. She was engaged to Robert Oliver Schad, and after her fling with the Scotsman, returned to the US to marry her fiancé.

16. Marguerite was a strikingly beautiful woman. McBey met her in Philadelphia in late 1930, and they married in New York in March 1931.

of Irish and Jewish immigrants, among others, with the latter's population there having 'doubled between 1850 and 1880, especially as people fled pogroms in central Europe, Poland and Russia.'[6] To McBey, with ambitions of greatness, the capital must have fizzed with life and edge. He felt far from home, however, in the giant swell of such a pulsating city, to which he had yet to acclimatise. 'Spent the day unpacking,' he scribbled in his journal on Wednesday 31 May in his spacious tin-roofed attic room. The following day he fired up his printing press, shipped from Aberdeen. 'Felt dreadfully weary or homesick, I do not know which. Sight of my poor little possessions upset me completely.'

McBey began a correspondence with his grandmother just as soon as he was able – and Mary's sweet and caring letters must have been a comfort to him in those early few weeks and months. 'Dear Jim, I am glad you got my letter and could read it so well,' she wrote on 15 June in a progressively more shaky hand.

> I hope you will forgive my spelling. I am always in good health but very stiff. The weather is not so warm now [...] I hope your new clothes will please you. You will need to be careful not to go out at night without changing them [...] Be sure and write me where ever [sic] you are. I remain your affectionate Grand Mother [sic] Mary Gillespie.

He had committed to his new life, and in the Big Smoke his social scene expanded, largely extinguishing pangs of loneliness. Campbell Lindsay Smith (1879–1915), another Scottish artist who had ventured south to make a name in London, introduced the young artist to the Chelsea Arts Club. McBey already knew Lindsay Smith, having met him in Aberdeen. The Chelsea Arts Club had been founded in 1891 by an artistic collective, which had also included James McNeill Whistler, and was based (as it is today) at 143–5 Old Church Street. Smith, born in Angus in 1879, grew up in Aberdeen, where, like McBey, he also took classes at Gray's School of Art. The same year that McBey arrived in London, Smith was boarding at an address in Chelsea. Lindsay Smith would later die in Belgium during the First World War as a member of the Gordon Highlanders. In June 1911, McBey became a 'temporary honorary member' of the Club after Smith proposed him. A 10 June letter, which was posted to his new address, and must have been a thrill to receive, was signed by the honorary secretary and entitled him 'to full use of the Club.' A later document,

dated 16 July, shows his first full year's membership (as a so-called Town Member), which, for the period 1911–1912, cost £3. 8s.

McBey had been in London for just six weeks but was already mixing with the creative classes. And just as London had been the gateway to Europe for him in 1907, so the city again allowed him to leave British shores. But, this time it was Spain, not France, which attracted him. He linked up with Douglas Ion Smart (1879–1970), a London-born landscape watercolourist and etcher who was four years his senior. In contrast to McBey, Smart had studied at the Royal College of Art and was himself the son of painter Charles Ion Smart (1842–1932). With such a companion, McBey must have travelled with the intention to not only see for the first time some of the sights of the Iberian Peninsula, but also to learn from someone who had benefitted from a more formal artistic education. He left London with Smart on 18 July, just two days after he had been officially welcomed into the Chelsea Arts Club, and headed to Spain at a cost of £5. 19s. Both men spent time first in Paris on the nineteenth, and broke their train journey up at Poitiers, western France, bathing and sketching, before crossing the Franco-Spanish border at Hendaye as dawn broke on the twenty-first.

As one modern-day writer has noted:
> The beginning of the [twentieth] century was a turbulent period in Spanish history both politically and socially. The loss of the last colonies in 1898 was a major blow to the national self-esteem [of] a nation fumbling for stability and longing for the greatness of times past.[7]

McBey makes very detailed diary entries of his Spanish trip, a highlight of which was repeated visits to the Museo Nacional del Prado – The Prado Museum – in Madrid. There, he was captivated by the work of Seville-born Diego Velázquez (1599–1660), and:
> He spent eight days copying [Velázquez's] arresting portrait of the dwarf Don Diego de Acedo, nicknamed *El Primo* and although later on in his career McBey certainly was influenced by more modern artists, [Velázquez] and Rembrandt remained his benchmark.[8]

In Fuenterrabia, and later on the outskirts of Madrid, he also took in his first bull-fights. 'At the beginning of the [nineteenth] century the popularity of bullfighting was such that it interfered with work [...] and

it was suggested that bullfighting [...] take place on Sundays instead of Mondays.'⁹ The high regard in which bullfighting was held by the Spanish public had little dimmed by the time McBey arrived in 1911. And it proved a prime spectacle for this young and vigorous creative who was clearly looking for subject matter to convert into his most dramatic works yet. 'The rush of the bulls at full gallop into the cells awaiting them when the trap doors are closed is said to be almost as fine as the fighting itself,' noted one writer of a 1910 Spanish bullfight.

> Out into the fierce sunshine the creature rushes, for one moment blinded by the light, the colour, the crowd, the clash of trumpets; then the multitude burst forth into loud cries and applaud his first wild rush and onslaught, which is repeated [...] until he lies prostrated at the feet of his antagonists.¹⁰

McBey recorded similar scenes in his diary. On 23 July, for instance, in a 'nice little bull ring' in Fuenterrabia (Hondarribia in Basque), he was privy to the bloodlust that saw 'four bulls and three horses killed.' Following his and Smart's return to London in September in the wake of a cholera epidemic, he produced multiple plates, including seven dry-points (a form of printmaking in which no chemicals or acids are required) of a bullfight. McBey and Smart's journey had been a truly intrepid tour of Spain: forced to sleep rough due to a lack of funds following visits to Toledo and Valencia, they had also been twice detained by the police. This would not be McBey's last run-in with the law.

In October McBey made a sketching trip to Carmarthen, Wales, with a girlfriend known only as 'Susie', where he took time to attend two Sunday church services (he had also attended church while in Spain). The next month McBey's first London exhibition was held. The pressure to impress on the biggest stage of his career so far – the prestigious Goupil Gallery – must have been great. 'Few attended, disappointing,' he noted glumly in his diary on 21 November, the first day. That evening, perhaps disconsolate, he might well have reflected on his last few months – which had surely passed in a blur – and all he had left behind as he continued to battle a lingering gloom that had still to leave him since his arrival in England. Winter nights in an attic studio in London must have reminded him of his cold and lonely nights in Aberdeen. He had abandoned his boyhood city because, in part, he considered his talents and ambitions to be little understood by the people who lived there. Prior

to leaving, he had exhibited twenty-five prints in the Granite City on the third, fourth and fifth of May. By the close of the exhibition, at a gallery on Diamond Street, he had sold just five, which had 'justified' his 'decision to quit Aberdeen.'[11] Yet, he must have taken heart from a 4 May report in the *Aberdeen Daily Journal*, which had lauded the rapidity of his success and his forthcoming move to London. His future dealings with Goupil's were also then noted. He had sent a number of his etchings to Goupil's prior to his move, some of which, by the time he was in London, had even managed to sell. He had, from an artistic perspective – if not from a familial one – much for which to thank his native land. In the early part of 1911, Aberdonian Alice E. Macdonell, a patron of the arts, had asked Campbell Lindsay Smith, who had painted her portrait – a 1910 oil on canvas – to introduce her to McBey at his Aberdeen studio. She had brought her husband, William R. Macdonell, and, recognising his budding genius, had bought nine of McBey's prints at a cost of £14. 3s. 6d. Alice's influential father, John Forbes White, had written entries on Velázquez and Rembrandt for the *Encyclopaedia Britannica*, and her endorsement no doubt provided more than just a financial boon.

Any concerns he may have had about failing in London before he had barely begun evaporated two days later when Goupil's sold twenty-nine of his prints. By 6 December, it would sell seventy-seven. The press gave the newcomer their overwhelming seal of approval. The art critic of London's *Morning Post*, Scottish-born James Greig, was so taken with McBey as a prodigious 'etcher new to us' that, he ventured, 'we are prepared to follow him on the long way he is sure to go.'[12] The *Aberdeen Daily Journal* of 22 November also gave an enthusiastic assessment of McBey's show, by way of the writer of the paper's 'London Letter' column.

> Hurrying away from the incessant hum of the busy Strand, I passed into Messrs Goupil's galleries this afternoon, and found myself in an atmosphere thick with refreshing Scottish accents. A young Aberdeen artist, Mr. James McBey, is showing there 50 or so of his etchings. Many Scotsmen and their lady friends have been coming and going all day [...] This is Mr. McBey's first London show, as he quitted Aberdeen only a few months ago [...] The fruits of his Spanish tour are seen in 17 'dry paint' pictures that hang on the walls. Judging from the frequency

of the matador sketches, the artist was greatly impressed by the bull-fights. In one of them, *The Ovation to the Matador*, Mr. McBey conveys the impression that a Scottish football crowd falls very far short of the wild enthusiasm of the bull-fight audience.

And in a brief nod to McBey's penchant for collecting antique paper, the *Daily Journal* added: 'I believe the paper on which the etchings are printed is over 300 years old. A well-known art collector of London who chanced to visit the galleries purchased three of the pictures this afternoon.'

McBey must have been delighted with these notices, and no doubt was also delighted that, in such a crucial introduction to London's art scene, his name had been spelled correctly. Back in 1906, when his etching, *Old Torry*, was successfully exhibited at the Royal Scottish Academy, his surname had been listed in the Aberdeen press as 'McBee', an error which the RSA had likely caused. In his autobiography, he had noted this infuriating slip, but any frustration (and there must have been some) was tempered by the fact that he was now an RSA exhibitor – 'armour against the sarcasm I feared might come from my fellow clerks'[13] – which had emboldened him to send two etchings to the Royal Glasgow Institute show. Both were accepted and hung, and were unexpectedly bought by a visitor – a feat that had even impressed his mother.

As a rising star of the printmaking world, McBey was operating in a small but competitive field. Among his rivals were fellow Scotsmen, such as David Young Cameron (1865–1945) and Muirhead Bone (1876–1953), both from Glasgow and both, by virtue of their earlier births, long established. Soon, McBey, Bone and Cameron would be known worldwide as the 'Big Three', but for now, McBey, as the new kid on the etching block, was playing catch up. Cameron, who would often sign his work 'D.Y.C', was the son of a minister. He became a student at Glasgow School of Art in the early 1880s, after which he secured a place at Edinburgh School of Art, 'where he was encouraged to take up etching because of the strength of his pen drawings.'[14] Bone, eleven years DYC's junior, was the son of a journalist father, and left school at fourteen, having lost his mother to tuberculosis four years earlier. He completed a three-year apprenticeship at a small architectural firm in central Glasgow but was encouraged to attend evening classes at Glasgow School of Art, which he did between

1892 and 1894. He 'eventually decided to forsake the possibilities of an architectural career, in favour of continuing with his own art as a full-time occupation'[15]– and in or around 1898, he began to pursue the art of printmaking. Scandinavian sensation Anders Zorn (1860–1920) had long been wowing art lovers with his own plates, having started life in rural Sweden as, like McBey, the son of an unwed mother (and German brewer father). Thus, by the time McBey had left the bank, and had found his way to London, Zorn, DYC and Bone had been headlining for many years.

Following his success at Goupil's, McBey soon settled into life in the capital. He had already witnessed King George V's coronation procession on 22 June 1911 from Hyde Park Corner, after the death of George's father, Edward VII, on 6 May 1910. At the Chelsea Arts Club, he met William Hutcheon, the Aberdeenshire-born journalist with whom he would swap letters in the Middle East, some of which would be included in a post-war column, 'An Artist's Wanderings', in *The Graphic*. He was also introduced to artist and art historian Martin Hardie (1875–1952), later Keeper of the Department of Prints and Drawings at the Victoria and Albert Museum. These were heady times for the talented Scotsman, and encouraged by Hardie to do so, he applied for election as an associate of the Royal Society of Painter-Etchers and Engravers (today the Royal Society of Painter-Printmakers). DYC had been elected an associate in 1889, becoming a Fellow in 1895, although he had resigned his membership in 1903 over an internal dispute. What McBey might have thought a formality proved to be a serious assessment. On 4 December 1911, he wrote to the institution enclosing several prints – including *Omval* and *A View in Wales* – which were to support his submission. One day later, Hardie dropped him a postcard wishing him luck. 'I am writing to shout about it,' he penned, clearly optimistic about McBey's chances. On 8 December, however, Hardie told him he had been unsuccessful and, on the ninth, the Royal Society informed him officially when sober arrangements were made to return his work.

Afterwards, Hardie wrote again, this time offering his sympathies. No one had been elected, he explained, and McBey had, along with another, been the closest to success. Later, in a 1925 catalogue, *Etchings and Drypoints from 1902 to 1924 by James McBey*, which was compiled by Hardie, the art aficionado remembered the Scotsman's early London triumph at Goupil's, relating 'that soon after the exhibition opened, McBey woke

to find himself famous and – a sound antidote to pride – doomed for many days to work like a galley-slave at heater, jigger and printing-press.' By 1925, McBey had put any disappointment far behind him, but, in December 1911, the Society's rejection had been his first rebuff from any art institute. He would have the chance to cast his own judgement upon them and other art establishments some years later.

As 1911 gave way to 1912, he resolved to pick himself up. He spent Christmas and New Year in Aberdeen and Aberdeenshire – and on Boxing Day he visited his mother's grave. One can imagine him visiting his grandmother and regaling her with details of his travels in London, Spain, Wales and his overwhelming success at Goupil's, perhaps skipping over the fact that at the hands of the Royal Society he had tasted bitter rejection. On his way back to London, he called at Glasgow, where he visited art dealer George Davidson, whom McBey had met while still living in Aberdeen. Back then, Davidson had quietly admired his work, and he now wanted to host a full exhibition. The Glasgow show was soon held, and again McBey was successful. 'Letter from Glasgow ordering 49 [prints], making 89 since Monday, and asking regarding my future work,' he noted in mid-February.[16]

The rest of 1912 proved equally fruitful. After his arrival in London, McBey had met artist James Kerr-Lawson (1862–1939) – another Chelsea Arts Club member. Kerr-Lawson, a London resident since 1900, had been born in Scotland, but had emigrated with his family to Canada, where he was raised in Hamilton, Ontario. Kerr-Lawson's father, William, had suffered injuries as a sailor after being shipwrecked off Cape Horn and was of poor health, forcing his mother, Jessie, to shoulder the heavy burden of her large family. This she did admirably, becoming a successful writer, and making something of a name for herself in both Scotland and Canada during her lifetime. Here, surely, was a man with whom McBey, also shaped by the women in his life and with a similarly dramatic backstory, would have an affinity. Older than McBey, and with a stellar art education that stretched to the Ontario School of Art, the Academy of San Luca in Rome and the Académie Julian in Paris, Kerr-Lawson was very much a veteran and perhaps the first 'father figure' to mentor McBey's fledgling career.

McBey visited Sandwich, Kent, in April, where Kerr-Lawson had a studio. He stayed at the George and Dragon and spent almost a month in

rural south-east England. McBey had, up until this point, explored little of England's countryside. He travelled around by bicycle, and, overcome with the delicious sights of a Kentish spring, felt moved to write Hardie a hastily written postcard: 'What a stuff is here! Surely centuries of etchers fashioned this land! I cannot make up my mind where to begin.'[17] McBey's resulting plates, including *The Skylark*, *The Shower* and *Ebbesfleet*, were a triumph. Hardie, who called the works 'a song of spring',[18] later remembered that McBey's travels among these English 'pastures new' resulted in the creation of 'fresh achievements which revealed a mastery [...] over the beauty and mystery of line and space.'[19] The influence of Rembrandt's 'atmospheric skies and low horizons'[20] are readily apparent in these prints, and McBey, having studied and worshipped the Dutch virtuoso as a boy, was now beginning to emulate him as a man.

On 27 May, McBey confided in his diary more feelings of isolation (and guilt) – 'Felt frightfully lonely. Wonder if I be paying too much for my success.' In the summer, he returned north, where the scenes from his childhood remained little changed, and where the memories came flooding back. He visited his grandmother, who was still being cared for by his uncle and aunt, William and Margaret, in Aberdeen and was becoming increasingly infirm. From this trip, he produced two etchings, *The Foveran Burn*, after likely sketching within sight of the graveside of his late mother, and *1588*, his impression of a Spanish galleon careering onto the shore at Collieston, near Newburgh. The ability of the north-east to inspire McBey, artistically at least, persisted.

In late November, McBey joined Kerr-Lawson for his most exotic trip yet, sketching and painting in Morocco. The elder artist had himself frequently wintered in Morocco since he first set foot there in 1888, and the journey was almost certainly at his behest. In fact, on the eleventh of that month, and suggesting that both men had been planning the trip for some time, McBey noted in his diary: 'K. L. came up. Says his wife has returned for Canada. Will know in a few days about [Morocco] [...] Am very fond of him.' There was, indeed, much to like about the gentle Kerr-Lawson. On his death in 1939, a long-time associate would recall a man 'as delicately fastidious as his art [... and] the least self-seeking of friends, and that was why he made so many in every rank of life wherever he was and wherever he went.'[21]

The intoxicating sights of North Africa, especially Tangier, for centuries Europe's gateway to Africa, had long been a draw for many artists. On 26 November, McBey and Kerr-Lawson departed Southampton for Morocco on the *Prinses Juliana* of the Amsterdam to Dutch East Indies (Indonesia) line, a huge hulk of a ship at 8,085 grt. Also in second class were Lionel Roberts, a twenty-eight-year-old chauffeur, who would be disembarking at Genoa, and sixty-two-year-old chaplain John Hackett, who, like McBey and Kerr-Lawson, was Morocco-bound. It is intriguing, even now, to wonder what had prompted Roberts and Hackett to leave England, the latter temporarily, the former, according to the passenger manifest, for a life in Italy. McBey's (and Kerr-Lawson's) motives for heading to the top of Africa were clear, however. Like the artists Sir John Lavery (1856–1941), William Kennedy (1859–1918), Joseph Crawhall (1861–1913) and Arthur Melville (1858–1904),[22] McBey would soon make his own mark on this Arabic-speaking land, but, in November 1912, as he made haste around the western edges of the Iberian Peninsula, his most pressing objective was for now just to survive.

'We should be off [Cape] Finisterre just now, but Heaven and the skipper alone know where we are,' he wrote mid-voyage to the Bryce family, which included the London-based artist Alexander Joshua Caleb Bryce (1868–1940), whom he had met in the capital.

> If you cannot make out the writing don't blame me, for we are driving through a frightful blizzard and the ship is sliding down one green mountain to bury half her length in the next. We have had a devil of a time [...] You let go of your plate for a moment and down it slides to the bottom of the table. The other people let go of their own to seize yours and back come the whole lot. Past you they go like a regiment of cavalry and disappear over the end of the table. The amount of crockery broken on this trip must be colossal [...] An English girl got shot out of her chair and landed in a corner amongst a smother of plates, knives, tumblers, soup, potatoes, petticoats and screams [...][23]

Referring to Southampton Mayor Alderman Henry Bowyer, who was a Trinity House pilot and lieutenant-commander of the Royal Naval Reserve, he added:

We are passing steadily the lights on the Spanish coast and a very dramatic moon is showing off theatrical clouds [...] Have just heard that we have still aboard the Mayor of Southampton who was our pilot down the Solent. He could not get back to his own boat so had to come with us for the whole journey.[24]

He continued: 'Friday 1.20 p.m. Just now was the first meal when there was a decent muster. Some of the lassies are no' bad looking now that the greenish pallor has worn off [...]'[25]

He had been offered plenty of tips before he departed as he recounted to a journalist in March 1913 after his journey. 'One thing they told me was not to carry a revolver. That was the only piece of advice I adopted, yet sometimes I admit I afterwards wished that I had disregarded it.'[26]

The Moroccan interior was not regarded as foreigner friendly. English journalist Lawrence Harris described his own trip to the country in the ugly racist imagery of the times in his 1909 travelogue, *With Mulai Hafid at Fez: Behind the Scenes in Morocco*, writing:

> The Mogreb or Land of Morocco is the most glaring example in the world of a country of degenerate mankind [...] The brutal Arab is opposed to the cunning Moor, who is again terrorized by the violent Berber. They are all fleeced by the oppressed Jew, and these, with a few renegades – the scum of Europe, having a compound of all the vices – make up the population of this benighted country. European traders in the coast towns are tainted by close contact with this vicious life.[27]

McBey and Kerr Lawson's trip there coincided with a period of great political flux. French artist Henri Matisse (1869–1954) had also visited Morocco earlier in 1912 and would again in the winter of 1912–1913, shortly after McBey and Kerr-Lawson landed. When McBey and Kerr-Lawson arrived, the Treaty of Fez, establishing Morocco as a French protectorate, had been agreed eight months earlier. Civil unrest had followed when Moroccan soldiers turned on French commanders in Fez, an inland city located north-east of the Atlas Mountains. French troops responded with force, claiming the lives of some eight hundred Moroccans, thirteen French civilians and nineteen French servicemen.[28] In late spring, Berber tribesmen besieged the city, and once again the French colonial authorities brutally repelled the assault, at the expense of about six hundred Berbers and several French soldiers.[29] The day after

the *Prinses Juliana* had sailed from a wintry southern England, and as it was listing its way towards the Maghreb, the Franco-Spanish Treaty of Madrid was also being ratified, resulting in 'France [accepting] the right of Spain to exercise her influence in a clearly defined Spanish zone along the Mediterranean for about two hundred miles, with a hinterland averaging sixty miles',[30] as the two European powers feasted on Morocco like vultures on a rotting carcass.

On 30 November, McBey pencilled in his diary: 'saw my first sight of Africa at 3 p.m. Cape Spartel.' The two artists first looked to settle at the north-central city of Tetouan, the designated capital of the Spanish protectorate, but, as McBey recalled, it was 'a difficult place to get at.'[31] 'It is 45 miles from Tangier over the mountains, and there are no roads, only bridle-paths. Then no big boats reach it by sea,'[32] he remembered. From the *Juliana*, passengers 'descended the ladder' and jumped into a 'little eggshell of a boat' which made for land amid torrential rain. Another boat took them to a 'small steamer' where they were all treated to 'a supper of eggs and sweet tea.' 'Too wet to sleep, we went on deck where we watched the men getting up the anchor. Soon we plunged and raced past the *Juliana*, through the Straits, and into the quieter waters off Ceuta, then South for another fifteen miles or so' before halting.[33]

'The Dutch steamer on which I was a passenger [was] eight miles from Tetuan, and lay a mile from the shore,' he continued. 'How we were to get off I was unable to conjecture, for the sea was white with mountainous breakers.'[34] It was midnight when the ship anchored, and passengers had to wait until early morning before they could disembark. When it came, 'a beautiful fresh morning, cold, with a touch of Scotland in the air',[35] McBey observed a small launch heading towards them 'from the tiny pier', which he half expected to be toppled by the heavy waves. It made several valiant attempts to reach the steamer 'but was beaten back time and again' – and only when the steamer had flooded the swirling surface with oil could it approach. Passengers, faced with a gap of about eight feet, which, as both vessels pitched in the swell, 'often [...] looked like 20 feet', were forced to jump across the void to continue their journey.[36]

Once on dry land, McBey and Kerr-Lawson took to mules to reach Tetouan, a journey which proved just as dramatic. McBey was uneducated in the ways of this mysterious land in comparison to Kerr-Lawson.

His trips to France, the Netherlands and Spain may have equipped him with some valuable experiences of foreign travel, but this was an entirely different proposition. A sea, this time of mud, lay before him, thick and 'averaging in depth from two to eighteen inches.' Reaching Tetouan, via a trip of seven to eight miles, on which they 'passed a semi-Spanish semi-Moorish sentry', McBey was struck by 'strange smells' and exotic sights, which, on traversing the narrow cobbled streets with Kerr-Lawson and his Arab guides, greeted them like the echo of a distant past. The 'little shops' housed their Arab owners in a manner akin to 'an idol in a shrine', he noted, and 'refuse of all terrible kinds' littered the way. The first phase of his journey ended as he arrived at his lodgings, along with his half-pound stash of tobacco, which he had craftily spread between his luggage and clothing to deter the prying eyes of local customs agents.[37] In 1912, there were several hotels operating in Tetouan, where 'sanitary arrangements [were] primitive and defective',[38] and both men found rooms at the Hotel Dersa. 'Splashed with mud from hats to soles, we sought our hotel, where everything rose and fell for three days till we managed to find our land legs,'[39] he later wrote to William Hutcheon.

McBey was unaware that this first experience of Morocco would ignite a life-long love affair with the country. But his initial impressions, displaying an impressive intellectual capacity to understand his surroundings, betrayed a captivation that was clearly all-consuming. 'What a place this is!' his letter to Hutcheon enthused of Tetouan.

> All between Asia Minor and the Atlantic has been compressed and distilled, and the essence collected and pressed within four ramparts in Jibbel Dersa, and called Tetuan. Since we came we have done little but stand, with mouths agape and codfish eyes, whilst the *Arabian Nights* have been unrolled before us.[40]

What he swiftly found were scenes of infinite artistic possibility, but the 'fear it would take years to tap'[41] these scenes almost threatened to overwhelm him. Veteran landscape painter Kerr-Lawson began capturing Tetouan's ancient topography, while McBey, 'a lover of action, chatter, gossip and humour',[42] set to work sketching its (mostly) Muslim residents, which proved a daunting prospect. 'What furnishes the most formidable obstacle,' he wrote to Hutcheon:

> is the existing hatred between Mohammedan and Christian.
> In Holland, in France, in Spain, and in almost every European

country, I suppose, a smile, a word, or a nod is at your call; but here, where there is no frown, there is an unblinking cunning stare, or they pass you with averted face.[43]

In Tetouan, then 'with a population of about 10,000, 3,000 being Jews',[44] he saw diseased beggars, their faces disfigured by leprosy. He befriended two British residents of the city, landscape and portrait painter Henry Bishop (1868–1939) and the acting British vice-consul, 'an eccentric named Miller',[45] who found for McBey a local boy to act as a minder and guide. Shaib had 'the face of a fiend and the manner of a panther',[46] and McBey, ever the wit, took great pleasure in investing the Moroccan with the 'Order of the Paint-Box' in his hotel room.

The ancient medina of Tetouan, today a UNESCO World Heritage Site, is fortified by a historic wall of some three miles. McBey and Kerr-Lawson walked round this historic wall not long after their arrival. 'The whole of the Old Testament might have happened here and most of the New also, except, perhaps, Revelation,' wrote McBey to Hutcheon, once again evoking his upbringing. Clearly warming to his Biblical theme, he went on:

> The voices of Laban and Jacob were raised in dispute; Naaman, the Syrian, was cleansing himself in the River Jordan; Hagar was wending her sorrowful way between the cactus hedges, with the little Ishmael slung on her back; and through the keen, cold air came the skirl of bagpipes – David was rehearsing his Psalms.[47]

In 'this land of much prayer', McBey opined, most of the people were made up of the 'lame', 'halt' and 'withered';[48] the variety, mystery and physicality together forming perfect subject matter for this young artist with endless ambitions. The locals looked on with prying eyes while he worked the streets, but their curiosity soon became a problem. 'Tetuan and the neighbourhood teems with matter for brush and pencil, and everyone displayed great curiosity in what I was doing,' he remembered in his 1913 press interview, adding that the local children proved the trickiest of the lot to deter.

> With the utmost sang-froid they would approach and poke their noses – and their fingers if they could – in everything. The Riff youth, however, who carried my materials proved useful for keeping the inquisitive youngsters at a safe distance. His modus

operandi was ingenious. The young [Riffian] had a long stick, bound with thick wire at intervals [...] and he had no hesitation in throwing this dangerous weapon at children who came too near.[49]

Working as an artist on the mean streets of Tetouan proved a steep learning curve. He witnessed 'a fine looking Arab taken to be tried for murder [... with] a rope around his neck and the ends [...] held by two guards.'[50] McBey longed to sketch the cemetery, which lay outside the walls of the medina, and though he anticipated trouble, he went ahead. He was fully cognisant of conservative Islam's aversion to pictures and images, and often worked covertly when he required human subjects. No sooner had he settled to begin sketching the cemetery than he was surrounded by an armed group of 'fierce-looking' locals. Their 'antique flint-lock' firearms were cocked, and McBey watched as they:

became restless, shifting their guns from hand to hand and craning their necks to see what I was doing. Then, with alarming suddenness, they began to talk. Not a sentence was intelligible, but their demeanour spelled trouble. Their voices grew louder and harsher, and their gesticulations more threatening.

He sensed danger, and hastily packed up and left, boldly pushing his way through the crowd until he was back within the medina. 'What would actually have happened had they caught me deliberately sketching in this sacred place I do not venture to say,' he recalled, 'but life is cheap in Morocco.'[51]

To modern eyes, his final comment seems crass, and whether or not his life was, in fact, in peril, one has to remember that these particular words were for media consumption, and added 'colour' was to be expected. That said, his encounters were exotic and strange, and some of them he experienced alone when his companion returned to Britain just days into 1913. Why Kerr-Lawson headed back before McBey is unclear, but the Scots-born Canadian had been painting the sights of Morocco for years. In September 1890, a report of a show in Glasgow had lauded his ability to make 'artistic capital out of Moorish gateways and market places [...] shining in sunlight under deep blue skies' – and, now middle-aged, he was likely content to return home.

McBey saw him off on 5 January, both having spent the festive period with Miller and Bishop, and a sunny Christmas Day at the consulate.

He watched his friend depart in a 'diligence' coach – an 'extraordinary contraption [...] constructed of two packing cases lashed together with string and resting on four supports resembling wheels' – steered by a 'Spanish driver.'[52] While Kerr-Lawson made his way back home via Gibraltar, McBey returned to his art in Tetouan, which, he lamented, was changing before his eyes as the Spanish authorities had already started 'to alter the beautiful old shops around the market and soon they will erect hideous houses.'[53]

McBey painted the poorly paid Miller, and received what later turned out to be a valuable China hen as payment. Miller became something of a constant during the artist's time in Tetouan. According to records, the consular official was 'acting' vice-consul because the permanent vice-consul, a W. S. Bewicke, had died of heart failure at a hospital in Gibraltar in August 1912. Miller was not just a diplomat, claimed McBey, but 'agent for vacuum oil and breakfast foods, a dentist, a doctor, and a kind of missionary. He was always annoyed when a British ship came into harbour, as that meant that he had to hoist the Union Jack, which he normally used as a bed cover.'[54] There is evidence to suggest that he was the very same (William) Miller who had previously been British Postmaster in Tetouan, and, as a member of the Bible Society, had proselytised the Christian religion across parts of Morocco.

Kerr-Lawson's departure had left McBey somewhat bereft of company, and so he speedily made plans to head to Tangier, some forty miles away on Morocco's northern coast. Before he did, he bid Tetouan a touching goodbye. 'Took a walk round by the river in the afternoon,' he scribbled in his journal on Sunday 12 January, 'and at 7 minutes to four plucked flower at point farthest from home I have ever been.'[55] This custom of plucking a flower (or leaf) from locations which had moved him became lifelong, as would hoarding mementos of all kinds.

Morocco, 'where bandits ruled the bridle paths',[56] and where a French naval bombardment had, in August 1907, shelled the city of Casablanca, causing death and ruin, was a volatile land. McBey knew that this next trek, across mountainous terrain, would involve exposing himself to more danger, and, before he left, he wrote to Hutcheon, sprinkling his note with black humour. 'If you do not get a [post-card] from Tangier within the next four days or so, you had better buy my etchings quickly. This is known on the Stock Exchange as "inside information".'[57]

He had been warned by Miller and Bishop not to risk it – and to delay 'til the next caravan.'[58] Mountain tribes had revolted, they said, and it was too dangerous to travel. A Reuters press report from January 1913 noted the enduring instability in the North African country, revealing 'that considerable unrest prevails in the neighbourhood of Alcazar, where the Djebala tribesmen are preparing for hostilities against the Spaniards' – but McBey boldly decided to press on. With 'a negro muleteer and four laden mules', he departed Tetouan. 'That night,' he recalled, 'we halted to sleep at a place high on the side of a mountain [...] Our bedroom was four mud walls, with no roof. When we entered it was already occupied by armed Riffs with their mules and horses. I was the only Christian in the motely crowd.' His local guide was not, he remembered, very talkative – but, 'in a voice that could be heard by everyone', he suddenly told McBey to be ready to leave for 8 a.m. the next day. Shortly after the Scot had fallen asleep, 'a stealthy hand passed over my face [...] and shook me by the shoulder.' In the early morning gloom, the muleteer indicated that, while sunrise was still hours away, it was time to move on.[59]

The guide later divulged to McBey that he had feared 'treachery' on the part of their Berber sleeping companions, and he had decided to extract his European Christian traveller from the scene as quickly as possible. 'It was a weird experience, and my nerves were on edge all the time,' McBey recounted. 'The mules kicked the soft earth, the ropes creaked as we tightened the packs, and the sleeping Riffs stirred restlessly.' The 'inky' black night and steep inclines made for an uncomfortable journey, but soon McBey, bruised and muddied, was delivered safely to Tangier.[60]

The port city of Tangier held a strategic position at the mouth of the Mediterranean, with a population of 'at least 20,000 to 30,000, of which 7,000 are Jews, 6,000 Spaniards, with 5,000 to 7,000 Moslems, and over 10,000 more living in huts outside the city, and a few thousand Europeans from various nationalities.'[61] The 'spaciousness' to work that existed in Tetouan wasn't to be found in Tangier. McBey checked in to Maclean's Hotel in the Soko. There he met Helen Russell Wilson (1872–1924), who had been elected a member of the Royal Society of British Artists in 1911, and had been 'a student at the Slade and at the London School under Frank Brangwyn [1867–1956], and afterwards studied Japanese painting at Tokyo.'[62] She was English, but lived in Tangier (where she would also die) on the Old Mountain Road. McBey went sketching with her and even

visited her home, which he found striking, remarking on the 'Splendid view [and] garden.'[63] His familiarity with the property would not end there, but, by early 1913, and having spent his twenty-ninth birthday in Morocco, he was ready to leave Tangier, which, in contrast to Tetouan, he found more 'Europeanised' and where 'lovely girls with dark eyes and white spats exercised a most disturbing influence.'[64] On 5 February, he joined such travellers as a clergyman and a barrister in second class and journeyed on the 1900-built Dutch steamship *Koning Willem III* to Southampton, remarking, 'am writing at 1.20 p.m. and just seeing the last of Africa […] Feel very sad. Goodbye Africa.' This passage, which had commenced in Indonesia, was less dramatic than his outward journey, save for a day when his liner was 'rolling tremendously' with 'Huge waves coming side on',[65] and he whiled away the hours reading Rudyard Kipling and writing letters.

He set to work in his London studio with the rich and absorbing sights he had sketched and memorised in both cities. His resulting etchings, such as *The Story-Teller*, *Beggars, Tetuan No.2* and *Gunsmiths, Tetuan*, were an atmospheric tour de force. In the first plate, McBey evokes Morocco's age-old custom of story-telling, a tradition which was strong in his native Scotland, too. *The Story-Teller* depicts 'a tall figure wearing a graceful djellaba' bewitching his audience, who, 'huddled against the city walls [of Tetouan]',[66] are held spellbound by his tale. *Beggars*, in contrast, elicits a more haunting portrayal of the ancient city, with a hooded figure to the left of the plate casting a menacing eye out of the picture space.

His etchings were more an impression of his experiences than an accurate portrayal of scenes, and therefore originated from 'his own memory of the atmosphere, action and feel of a certain place and time.'[67] The etching process had, already for McBey, become sacred. 'When the artist himself prints,' he was later to remark, 'the printing may be regarded as actually a continuation of his etched work, the combination of both culminating in the finished proof. A certain freedom, therefore, must be allowed him to give expression to what is in his mind.'[68]

While a talented etcher, and, by 1913, an etcher with the world at his feet, his Moroccan tour also gave rise to his adoption of another medium. 'As I was leaving the house for Morocco, a bottle of oil, which was insecure in my sketching bag, needed wedging, and I seized the first object that came to hand,' he later recalled. 'This happened to be a palette for

watercolours; and although I had no intention of working in wash, when in Morocco, I found it very fascinating to put colour over my pen drawing. This is how I came to produce watercolour drawings.'[69]

He would continue with this watercolour technique, using 'the colours to wash over his pen-and-ink drawings' rather than actually painting with them. From his Moroccan adventure, he produced an assortment of compositions, in various mediums, including thirteen plates. 'Was it to defy superstition that McBey made his Moroccan Set thirteen in number [...]?'[70] posed Martin Hardie. McBey was brilliant, witty and daring, but also complex. Long freed from the shackles of his Presbyterian upbringing, he would continue to go his own way.

CHAPTER SIX

McBey's War

'If I forget you, Jerusalem, may my right hand forget its skill.'

– Psalm 137:5–6

McBey arrived back safely from Morocco in early 1913 with plates to make and stories to tell. He remained productive, curious and, most importantly of all for a creative, in demand.

He had an active social life and was surrounded by many successful friends and acquaintances, including some London-based Scots. Aberdeen-born Mary Murray, better known as Mollie, and her doctor husband, William, also an Aberdonian, were one such pair who found the artist appealing company, especially Mollie, with whom McBey would become close romantically. According to the 1911 census, twenty-eight-year-old Mollie lived at her fifteen-roomed Chelsea residence at 95 Cadogan Gardens with her husband, her four children, her stockbroker clerk brother-in-law, and seven servants, who included a German maid and a Yorkshire-born governess. Dr Murray was the eldest son of Aberdeen Art Gallery chairman James Murray (who would be knighted in 1915), a Liberal Member of Parliament for East Aberdeenshire between 1906 and 1910, and a friend of womanising Liberal politician David Lloyd George, who would assume the British premiership in 1916 during the height of World War I. McBey had first been introduced to the whole Murray family through James Murray after he bought some prints from McBey during his first London show in 1911, getting the artist himself to choose them on his behalf. James Murray, a staunch supporter of women's suffrage, often 'did things in the grand manner. For the opening of the new Aberdeen Art Gallery, he invited a large group of museum directors from Europe to a weekend in Aberdeen, paying their expenses and supplying a special train, food and abundant drink.'[1]

McBey's London success in 1911 had heralded his arrival as an artist. He was now coming to define himself by his actions as a man. In July 1912, he had noted in his diary feeling 'rich for first time in my life'[2] after

receiving a cheque for £195 (worth more than £23,000 today). He increasingly took delight in surrounding himself with women, both married and single, such as Belgian-born artists' model Miss Jeanne Christians and Alexander Joshua Caleb Bryce's wife, Maude, both of whom appeared drawn to the Scotsman like moths to a flame. To Maude he even wrote of his heartbreak when his short summer romance with Jeanne came to an abrupt end in 1912: 'I still feel very keenly the loss of my little girl but today I have been better than at any time since the disruption [...] The worst of it is, there is something about her I cannot fathom.'³

With 'the Edwardian West End at night [...] the world's largest flesh market of that or perhaps of any other time [...] [with] its streets after dark [...] almost entirely given over to sexual commerce',⁴ McBey was probably not averse to using prostitutes, writing partially in code, on 17 October 1912: 'Am getting desperate for a girl. Walked up Regent St. at night.' Despite such dubious activities, this illegitimate son of a farmer father and blacksmith's daughter from Aberdeenshire was seamlessly etching, painting and charming his way into the upper echelons of London society. And why not? He had the talent, intellect and connections, which would take him further still.

As an artist with a rapidly burgeoning reputation, he exhibited three of his Moroccan etchings at the Royal Scottish Academy: *The Grain Market, Tetuan*, *Door of a Café, Tetuan* and *Jews Buying Fish, Tetuan*. The 10 May 1913 *Aberdeen Daily Journal* described them as 'three clever etchings by James McBey who went from Aberdeen to London, and who is now rapidly making his reputation in the south.' That summer, McBey paid a second visit to the Netherlands, where his professional career had begun, bringing back water-colours and executing at least one arresting plate, *Grimnessesluis*, depicting a mysterious backwater in Amsterdam's Jewish quarter with the reflection in the mirror of a 'Jewess' looking straight back at the artist at work. 'Have got Jewess on plate – face you see in dreams,' McBey later wrote Hardie of this etching. 'Hope she will print to-morrow, but she is awful delicate.'⁵ Others have suggested that the face is in fact a small portrait of his hero, Rembrandt, looking through the picture frame window of a house.

On this second Dutch visit McBey went to Overschie, then between Rotterdam and Delft, today part of the former. 'The kindness of the people here towards us would be creditable to any place,' he wrote to

Hutcheon, 'and is almost incredible for Holland, which looks on strangers with an aloof curiosity [...] Yesterday we sketched a little girl and a boy fishing, and everyone enjoyed it immensely, the models, half the village, and ourselves.'[6] But he did not make a return visit to the Hotel Spaander in Volendam, with McBey's old friend, Alida Spaander, lamenting as much in her letter of 22 December. 'So near and not to come,' she wrote in reply to a festive missive from McBey, 'and we should have been so glad to see you with us.'

McBey had by now been in London long enough to have both personal and professional concerns. He had recently switched art representation from Goupil's to Messrs P. & D. Colnaghi and Obach, after the former establishment had objected to his Glasgow show in 1912, and was also considering moving studios. His social scene included not just the Murrays, but the Inglises and the Jaffreys, all of whom had connections to Scotland's north-east. The Inglises were Lady Louisa Ann and her daughter, Miss Mary Louise, residing at 28 Holland Park Avenue, in west London. They were the widow and daughter respectively of the late Sir James Charles Inglis, who, on his death in December 1911, was general manager of the Great Western Railway. Sir Charles, born in Aberdeen and educated at its university, had been knighted by King George V at St. James' Palace on 23 February 1911, but only managed to enjoy this great honour for ten months before he passed away at sixty. The Jaffreys were Thomas Jaffrey, actuary of Aberdeen Savings Bank, who would himself be knighted in 1920, and his Aberdeenshire-born wife, Margaret, who was living with the Inglises at Holland Park while her husband worked in Aberdeen, travelling between there and London at intervals.

Much of McBey's life in 1913 and 1914 would be taken up with his relationship with Mary Louise. McBey first met her on 10 May 1913 when she and Thomas, her ward, called in at his Wharfedale Street studio. Four days later, after Thomas had arrived back in Aberdeen, he wrote to McBey stating that:

> The young lady, Miss Inglis was anxious to take another opportunity of calling at the Studio along with her mother, Lady Inglis, and also Mrs. Jaffrey [...] I do not think they will occupy much of your time and I hope it will be quite agreeable to you to see them.

McBey was young, free and single, with chiselled looks, sexual charisma and a 'gentle but resonant voice [...] with the Scottish accent of his birthplace',[7] which would prove time and again irresistible to women. He must have sensed that any 'anxieties' on Mary Louise's part were, in fact, a crush. Had she gone away from meeting McBey with her heart pounding, resolving to come back as soon as possible? McBey was no pen-pushing bureaucrat – as an artist he was outside the norm and dangerously different – and with Mary Louise herself an aspiring artist, a match was clearly being encouraged by interested friends. On 17 May, he wrote her. 'Any time this next week would suit me, except Thursday and Friday, and any hour of the day is suitable, tea time specially so,' he penned, remarking that he was 'delighted' at the prospect of seeing her again.

Existing images of McBey's Wharfedale studio give an insight into what visitors might have experienced when they stepped inside. First would have been the smell – if McBey had recently been painting in oils, guests would have detected the rich scent of fibres in the cotton or linen which made up the canvas, and the variety of aromas in the paints themselves. Another scent present would be that of linseed oil, used to mix the paints, the very same natural compound that McBey had detected when he visited Nellie Mackenzie's home as a boy many years earlier. The colours would almost certainly have included chrome yellow, a favourite of Dutch artist Vincent van Gogh (1853–1890), vermilion and Prussian blue, with any stray blobs having hardened over time.

In his studio, where 'It was cold in the winter, noisy in the rain and so hot in the summer that he sometimes worked almost naked',[8] he made art, ate, entertained, charmed and slept, surrounded by a printmaker's paraphernalia – flat scorpers, dry-point needles and an engraver's magnifying lens on a pivoting stand. On show too would have been a hammer, files for bevelling the edges of his etching copper plates and various burins (engraving tools) and, of course, the great starwheel of his etching press and its gears.[9] We should imagine him working at all hours with a cigarette in his mouth as he stood before his easel or dipped his plates in dilute hydrochloric acid during the etching process, the smell of damp paper high in his nostrils from the moment he roused himself from sleep. Mary Louise, turning just twenty-three in 1913, would have discerned these peculiar studio aromas, layered with the odour of tobacco, and spied his rich stash of artistic wares. She would also have noticed his collection of

books, antique furniture and hanging pictures, together with the death mask of Napoléon he had picked up in Aberdeen as a bank clerk, and which now peered eerily from a wall to the left of a corner mirror.

After McBey and Mary Louise first met – and then met again – a relationship formed. Mary Louise was slim and pretty, and McBey tall and unconventional. Mary Louise's father's obituary had described him as 'warm-hearted' and, when such things were considered complimentary, 'an Imperialist in the highest sense of the word.'[10] As McBey and Mary Louise saw more of each other, his journal quickly became a place in which he could record his romantic angst. Mary Louise's mother, Lady Inglis – or as McBey often referred to her in his diary, 'Lady I.' – was a central source of difficulties in their romance.

Lady Inglis, aka Louisa Ann, was then in her late fifties, and became a firm fixture of McBey's social calendar along with her daughter, and Louisa Ann's friend, Margaret Jaffrey, also middle-aged. McBey enjoyed tea and socialising with the group as a whole, but part of McBey's price for seeing his romantic interest was coming into too frequent contact with her older overseers. His time with Louisa Ann in particular became fraught. In the autumn of 1913, McBey joined the family as they travelled to England's south-west coast (taking in Plymouth, Lady Inglis' birthplace), where McBey spoke to Mrs Inglis of his mother's suicide. 'She listened impassively to all,' he noted on 6 November. He next recorded a tetchy encounter in which she questioned his intentions with Mary Louise – 'Came into my bedroom and asked if it was for her money.'

Lady Inglis' domineering personality continued to hound the artist into the following year. When McBey found a new studio, the widow was not best pleased with his choice, and told him as much. He had outgrown

> Wharfedale Street, Earl's Court, [his] large unkempt looking room at the top of the house, where he had ensconced himself on his first arrival in London, with the printing press he had brought from Aberdeen, and where he had welcomed his first rush of success with amused incredulous amazement.[11]

McBey now had money to spend, and his extravagances that year would include his purchase of some Rembrandt etchings, not least the Dutch artist's 1652 *David in Prayer*. He longed for digs to match his upward career trajectory. He found a potential studio and residence at 11 Oak Hill Park, Hampstead. This address belonged to the family of artist William

Rothenstein (1872–1945) and his wife, Alice. William, now balding and bespectacled, had been born into a wealthy German Jewish family in Bradford, and, after studying at the Slade School of Art in London and the Académie Julian in Paris, he swiftly became an outstanding painter of portraits and landscapes. In 1912, the family purchased Iles Farm, Far Oakridge, Gloucestershire. They 'still kept their spacious pied-à-terre in Hampstead and went to London – Alice more frequently than William – as opportunity and temptation offered'[12] – but for William any day away from Iles Farm was a day wasted.

On 23 February 1914, McBey negotiated a lease with Alice – 'she wished to retain 3 rooms and pantry' he noted in his diary. He told Lady Inglis about the arrangement, who was not amused. That same day she wrote him a hurried note, revealing just how involved in the artist's affairs her family had become, which the Scottish artist received the following morning.

'The more I think about your taking that House, under the conditions you mention, namely, a married woman coming to town occasionally without her Husband and sleeping in the House – I feel convinced that you are running a severe risk,' she wrote on cream-coloured notepaper.

> If nothing else people you know will talk. As you are cautious with Englishmen would it not become you to be the same with Englishwomen. I feel as a mother and knowing you so well – that you will understand my writing to you today. I myself would not advise a son of mine to do likewise. But to take the House clear and himself choose the people who should live with him.

When McBey received the missive on the twenty-fourth, he bolted round to Holland Park. '[Lady Inglis] spoke against my taking house, and asked me if I cared for girlie,' noted the Scotsman that day – 'girlie' being his occasional diary moniker for Mary Louise. 'We talked all day, with break [...] Came back and we talked again. She said "when Greek meets Greek".'

'When Greek meets Greek, then comes the tug of war', to quote the proverb in full, was a fairly accurate prediction of the troubles ahead. Indeed, it would not be the last time that Lady Inglis and McBey would butt heads, but this time at least, it would be the artist who would prevail. He pursued the house, and, after some tweaks to his initial settlement

with Alice, prepared for his short move north to Hampstead. 'This my last day at Wharfedale Street,' he wrote on 24 March. Prior to his departure from Aberdeen, he had arranged for his disassembled printing press, his etching paper, furniture and bicycle to be shipped south. This latest move would be easier to carry out – but his new premises would be quite unlike anywhere else he had lived. The first post he received there was a letter from artist, journalist and critic Malcolm Charles Salaman (1855–1940), who was an influential figure McBey had earlier met, and a missive from the Murrays asking him to lunch at The Ritz. He met up with Mrs Jaffrey and, of course, the Ingleses, and accompanied them to the Coliseum. It was 26 March 1914, and he found himself living in an eleven-roomed London dwelling. He had been invited to dine at a luxurious hotel that was hosting the great and the good, had been to the theatre, yet, in many ways, he felt as lost as he did his first night away from home, in 1899 Aberdeen, prior to his starting as a bank clerk. 'Returned and dined alone,' he wrote in his diary that evening. 'Feel very strange in new place. So big. Hope I shall not feel lonely.'

Work, as ever, proved a partial antidote to loneliness, and, just weeks before he moved from Wharfedale, he had secured a prestigious portrait commission. Sir Herbert Raphael, then a Member of Parliament for Derbyshire (South), hired McBey to paint his wife, Lady Raphael, buying a print into the bargain. The Liberal politician, who had also practised as a barrister, had indicated that more commissions would be forthcoming should McBey's portrait of 'Lady R.' turn out well. (Both his prints and emerging portrait commissions were now giving him an annual income of £1,000 – more than £120,000 today.)[13] He would begin painting the 'vivacious' Lady Raphael in May. Until then, trying to hold on to Mary Louise's affections, while juggling his other work projects, was of utmost concern. In a relationship that could be termed somewhat chaste, McBey felt moved to note on 11 April that Mary Louise had sat on his knee for the first time, just one day after awkward declarations of love had been exchanged. When she travelled to Italy with her mother seven days later on an Easter break, McBey was left behind to ponder his life, resume his work, socialise (including at The Savoy) and wait, like a smitten teenager, for her letters. Outwardly, the near-six-foot, burly-looking artist may have appeared robust, but inwardly, he was riddled with melancholic self-reflection. 'Short walk on Heath, but terrible,' he diarised on 29 April. 'Had

not been since [Mary Louise] was with me.' And then on 10 May: 'It was a year ago today since Jaffrey brought [Mary Louise] to studio.'

However, her travels gave him a chance to catch up with others he knew in London, such as Aberdonian Dr James Laing Salmond and his vocalist wife, Irene Foster, and fellow Aberdeenshire man James Torn Reid, McBey's second cousin on his mother's side. Jim, as McBey referred to him, might have only been in his early twenties, but he had long been an important fixture of the artist's social circle – and a crucial familial link to his Scottish childhood.

McBey and Mary Louise's romance resumed on her return from Europe. But he left London for another trip to Scotland on 30 August, just after Britain's declaration of war on Germany. McBey had, by this time, raised the stakes with intimations of marriage to Miss Inglis. Her mother, it seems clear, was testing his resolve and commitment – 'Told her I would not stand interference after marriage etc. She says [her daughter] wishes to have studio, 3 servants etc.,' he had noted on 1 June. His visit to Scotland only seemed to inflame his passions. Between catching up with old friends from home, and visiting his grandmother, he continued a desperate correspondence with her. McBey even designed an engagement ring and wrote extensively in his diary of the love affair he longed to make a permanent union. Being briefly detained as a German spy by the coastguard, after he had raised his arms to stretch following a period sketching on the Aberdeenshire coast, received only a passing mention.

McBey made his move once back in London, on 20 October. He visited Lady Inglis and 'told her her daughter was to marry me.' She reacted with indignation, telling McBey that she had been 'deceived' and that she would not be announcing any engagement. Never mind, said McBey, 'it would announce itself.'[14] Three days later, he returned. Number 28 Holland Park was rocking, and the dapper creative arrived to find Miss Inglis 'looking unwell.' Her mother 'ordered girl out of room and told me about Inglis family,' he later noted. 'Thought her very friendly, but suspect her now of duplicity. Home, cannot sleep. Frightful headache. Miserable.'[15]

What did Lady Inglis tell McBey about the family? And what was so sensitive that even her twenty-four-year-old daughter couldn't be present to hear it? We will, of course, never know, but it could have likely related to the Inglises' own, highly intriguing, background. Sir James (then just

James) was working as a civil engineer in Plymouth when he met labourers' daughter Louisa Ann Full, who, on 9 October 1890, gave birth to Mary Louise. Her birth, however, was not registered as Inglis, but Full, with a simple pen strike making clear that the father was not known. Just months later, however, the 1891 census records mother and daughter living as Grey, while Sir James was residing elsewhere in Plymouth under Inglis. By 1901, they were all at 28 Holland Park, where mother, daughter and Sir James were all living under Grey (now spelled Gray), while Sir James retained his real name, Inglis, on the electoral roll. At what point did the composite family officially become Inglis, and what was the full story? On both counts, it is hard to say with certainty, but if Louisa Ann had known about McBey's complicated family background, she might have thought him able to understand theirs.

Lady Inglis likely left out of their discussion that the noble Sir James had, in fact, succumbed to general paresis, also known as general paralysis of the insane – a result of late-stage syphilis – which would have seen his mental capacities grimly deteriorate until he expired. Yet, a breaking point had been reached, and not even the intimacy of a September 1913 holiday with Lady Inglis and Miss Inglis in Scotland, where he had showed both mother and daughter his birthplace, could forestall the inevitable. After lunch, on 24 October, he received an 'Express letter' from Mary Louise ending it all. He was shocked but unsurprised. 'Of course wrote her saying I agreed,' he wrote that day, confiding in his diary that he wept. 'What a pity she has no backbone. Wish I could kiss her again.'

His ongoing sense of failure in being unable to contribute to the war effort on account of his poor eyesight must have been compounded by this failed love affair, the ending of which led him to seek comforting words from friends. His diagnosis of astigmatism, just days before he parted from Mary Louise, had 'floored' him, and a double blow of this nature was likely emasculating. He was at a low ebb, but his established life in London made any heartbreak more tolerable. On 9 November, McBey received from Mary Louise all the letters he had sent her over their courtship. 'Your letters are returned as requested. Had you loved me as you said – you would have given the promise I wished. Now whatever you said – I feel I could never believe you again. Mary.' The unspecified 'promise' seemingly unfulfilled, her note was emotionally charged, like

other letters of their relationship, but cold, detached – and final. And with that, McBey could finally move on.

The ending of McBey's relationship with Mary Louise may have been a wounding and unsettling experience, but in his artistic profession there was more stability. Before he had been barred from the River Thames, due to the onset of World War I, notable plates of the waterway had included *The Lion Brewery* and *The Pool*. McBey soon produced the likes of *Sea and Rain*, a depiction of the north-east fishing town of Macduff from his trip to Scotland. At the start of the year, he had already announced his arrival as a watercolourist after an agent from Colnaghi and Obach had earlier spotted his Moroccan watercolours lying unloved on his studio floor. Colnaghi and Obach held an exhibition of them (and many others) in London in February 1914, with most selling during the first week alone. Malcolm Charles Salaman, whose wedding McBey attended that spring, and whose reception he even hosted at his own home, had written of the artist's works:

> that the manner of these drawings differs materially from the modern accepted idea of water-colour painting, will not be surprising to those who have already recognised the outstanding individuality of this very interesting young artist. McBey never seems to do anything like anybody else; not from any striving after originality, but because he must simply be himself, because all that he knows about art he has discovered for himself, and a frank expression of his own conception, his own vision, in his own way, is the only thing that would ever occur to him as worthwhile.[16]

McBey's most profound experience of 1915 was his grandmother's passing. Mary had been confined to her bed for over a year, and this hardy farmer's daughter and blacksmith's widow from Aberdeenshire finally succumbed to the flu on 28 November at 10.50 p.m. at the age of ninety-five. When McBey heard of her death, it shook him like little else before. 'Felt dull blow. Terribly sad. Frightened,' he confided in his diary after being informed by wire the following day. 'Poor old girl,' he noted on the thirtieth after he had packed to travel north for the funeral, 'she was loyal to me. Would have liked to have been holding her hand when she went. Wonder if she was thinking of me.' After his arrival in Aberdeen on 1 December from London Euston, he headed straight to

his uncle Willie's house, where she was being prepared for burial. 'She looked beautiful – not more than 50 – her skin transparent and the little hands just as I knew them so well,' he wrote in his diary later that evening.

> They were so cold and I wanted so much to kiss her. Wanted to pluck out white hair on her chin, like I had so often done [...] The last link that holds me straight is broken [...] The only friend I have ever had. Funeral to churchyard in motors. Only about 10 there [...] There were no flowers. Buried simply, as she had lived. I lowered her left side. On quiet days she may hear the anvil at the Smiddy.

The last time he had spoken with his grandmother was during his previous years' visit to Scotland. He had, however, managed to make a hurried sketch of the nonagenarian, composed in ink, and timed and dated, 5.15 p.m., 15 October 1914. The woman who McBey had first painted back in 1901 was this time captured more simply, but no less affectionately, with nightcap and fragile hands, with a postscript from the artist recording it as 'the last time I saw my grandmother' alive.[17] She would be the seventh (and last) Gillespie to be buried under the weather-beaten family gravestone first erected in 1871 by William and Mary in memory of their teenage son, John, at Foveran Kirkyard.

No sooner had Mary been laid to rest alongside her husband and children, than McBey was again at loggerheads with his uncle, George. On 12 January 1916, he wrote to George in response to his letter concerning Mary's will. We can discern that George was unhappy about the settlement of yet another family estate, years after he took issue with his sister Annie's own legacy. 'First you must understand that in regard to my grandmother's estate, I am acting as Trustee as a favour,' he wrote abruptly on headed notepaper, which included his phone number of 4075, 'and if there be a recurrence of the letters you wrote me in 1907 I shall wash my hands of the whole thing.' McBey's reply included paying tribute to Maggie, the wife of his other uncle, William, who had cared for Mary during her final years: 'Personally I feel indebted to her, but that is my own business,' ending with: 'If you feel you must write me again, I must ask you to do it through your lawyer, else I shall take no notice of it whatsoever.'[18]

In his letter, written at the height of a war in which he had yet to participate, he had told George that he 'may be called away' at any time.

McBey's prediction came true when, after a series of snubs that, in the autumn of 1914, had left him 'tired out at rejection',[19] he was handed a war commission on 24 January 1916. It was as a second lieutenant with the Army Printing and Stationery Services (AP&SS) in France. He received his vaccinations, had a brief and uneventful meet-up with his father (of whom more later), wrote a will, bid his farewells, got a haircut and on 3 February he woke to a packed-up house 'at 6.30 a.m. Home strange and bare. Fire lit. Don't expect I shall ever see it furnished again.' That day he sailed across the English Channel to Boulogne.

The AP&SS, formerly known as the British Expeditionary Force Base Stationery Depot, began life in France in 1914 with staff of only a handful of men. A global conflict as all-consuming as the First World War required services of this nature to be carried out away from home, and the Depot's 'brief was to liaise with local printers who would produce army regulation books and forms, which would then be sent out to troops',[20] as well as more covert publications. The department soon needed to expand. By 1918, there were nearly one thousand men working for the AP&SS, which had offices in France, Africa and the Middle East.[21]

When McBey arrived in France, AP&SS units had been installed with their own printing presses in Le Havre and Boulogne. It was 'a secret but unexciting job',[22] and he was glad to meet up with Martin Hardie, now an army field censor. Hardie 'for a moment [...] failed to recognise' his artist friend, who entered a Boulogne smoking room on 15 February 'with cropped hair, trim moustache, and uniform spick and span.'[23] After reconnecting, both men went to find digs, deciding on rooms at a 'sinister hotel overlooking' Boulogne's Quai Gambetta 'for the sake of their outlook.'[24] Army regulations prohibited any kind of sketching, but McBey wasn't about to let protocol obstruct his artistic ventures. It was an irony surely not lost on someone as individualistic as McBey that his official work at the AP&SS was 'the very centre from where red tape was issued.'[25] His maritime scene, *The Quai Gambetta, Boulogne*, as observed from the Richmond Hotel, 'was done easily and without subterfuge, from the window of our upper room,' Hardie, eight years older than McBey, later recalled. 'Eagerly I watched every line of it drawn on the plate in the acid bath.' Other prints required more cunning, such as *A Norman Port*, *The Crucifix, Boulogne* and *The Sussex*, for which he 'had to depend on thumbnail notes, and on small sketches made in the palm of the hand, and

even inside his pocket.'[26] The beached cross-Channel passenger steamer, *Sussex*, proved an arresting subject for a plate, having been torpedoed on 24 March 1916 by a German U-boat which had believed it to be a mine-laying vessel. The unprovoked attack on the *Sussex* caused some eighty casualties, but the boat did not sink.

> Night after night [he] went to look at her tragic hull, and gradually, after making endless local notes and composition studies at home [...] he evolved what is one of the noblest, most spiritual of his plates [...] Where another might have made that scene with the setting sun behind the tortured wreck, flamboyant and spectacular, McBey was content to give a subtle, restrained impression, at once solemn and beautiful, strangely moving in its effect.[27]

In McBey's Boulogne, 'bets, practical jokes [...] visits to brothels, a great many letters home and a few mild grumbles' also took place 'behind the lines and within earshot of the slaughterhouse'[28] of the front.

The Scot, evidently unconcerned about being apprehended on a charge of spying should he be discovered blatantly disregarding the rules on sketching, had now turned rebel printmaker.[29] And when he was given orders to head to Rouen in July, he continued to make art. In September, he was laid low by a bad throat, as he would again be during his trip in the Aswan in early 1918, and took matters into his own hands when, confined to bed on the seventh, he attempted to burst a quinsy with a shard of wood. 'Succeeded partly. Much mucus. Very painful.' Just days later, he was granted leave, and on the eighteenth, he was back in England. Leave didn't last long, and from his return a week later until early the following year, he was based in France. In November, McBey was dispatched to Le Havre, located at the mouth of the River Seine, and on the twenty-ninth heard from Jim Reid news of his battlefield injury, and his transfer to a hospital in Chelsea, which left the artist feeling 'most desperately lonely.'

He found solace and stimulation in his art in between his repetitive war commission duties at the AP&SS. He must have been taken back to his former life as a reluctant bank clerk in being assigned to work on 'indents' (orders for materials from military units). From Le Havre on 7 December, he made the short trip 'to munitions factory at Harfleur and sketched workers in firelight. Hope I shall be able to do something with it. Prayed first in Catholic Church at Harfleur. Dark damp day.' Religion

and God recur often in McBey's diary entries at this point, and, having casually mooted converting to Catholicism earlier in the year, was it poignant that the Presbyterian-born artist found succour in a place of worship in Catholic France? He clearly needed spiritual guidance, but when Christmas Eve arrived, he sat out the service at Le Havre. McBey had, and would continue to have, a very personal relationship with God. In 1904, he had shocked his pious superior when, on secondment at his bank's newly-opened branch in Edinburgh, he revealed that he believed in prayer, but had 'never felt the necessity for an intermediary'[30] in the form of the Church. His convictions had somewhat softened in the intervening years, but, like everything else in McBey's life up until then, he conducted his faith strictly on his own terms.

His sketches from Harfleur would soon be put to good use just as he had hoped. From his visit to this historic town in Normandy, which the English army of King Henry V had laid siege to hundreds of years earlier, the Scotsman would create the glorious 1917 dry-point, *France at her Furnaces*, where 'half-naked workmen with long iron rods are seen hauling shell-casings from blazing'[31] ovens. Here, at the Schneider Munition Works, labour, heat and industry were combined to produce an image of hell's kitchen – a 'veritable workshop of war.'[32] Similar in style to *Zero: A Sixty-five Pounder Opening Fire*, his dry-point depiction of the deadly opening salvo of the Allied offensive of September 1918, *France at her Furnaces* would become, with its bursts of shadows and light, one his most famous wartime creations, as evocative today as it was back then.

McBey was again granted leave at the beginning of 1917, and this time he secured permission to visit the Somme on a sketching tour to record the desolation brought about by its past horrors. In February, he journeyed by train and car and explored Amiens followed by Albert. On the eighteenth, he travelled 'along in fog road from Albert and in mist made sketch.' There, he 'saw fearful mess of the earth. Terrible. What an awful thing is war. Ground like a whitish grey earthquake.' The mud, perhaps reminiscent of when he first made landfall in Morocco, repelled him, and later German shelling, shaking the ground beneath his sludge-soaked feet, came too close for comfort. He would produce five plates from this perilous field trip, including the sardonically named *Spring, 1917*, evoking a scorched landscape of trees stripped bare by war.

In March, another directive came, requiring him to return to Britain and to the War Office in London, where, on 27 March, he recorded in his diary that his new posting 'was for job in Egypt.' The 'job' was as official war artist with the Egyptian Expeditionary Force in the Middle East, on the recommendation of Campbell Dodgson, Keeper of the Department of Prints and Drawings at the British Museum. 'I can think of no artist more suitable for drawing in Egypt than James McBey,' wrote Dodgson in his January 1917 missive to the chairman of the War Artists committee. 'He is a Scot, from Aberdeen; aged about 35, I believe. He has made a considerable reputation as an etcher, and also as a water-colour artist. As a draughtman he first attracted attention by a fine set of drawings of Morocco in pen and ink outline and watercolour.'[33] His time as an artist in North Africa had no doubt identified him as a suitable candidate to the powers that be, but it was almost certainly true that McBey's London connections had helped. Furthermore, the fact that his work had also been exhibited in America had likely not gone unnoticed.

The British subaltern would not sail for Egypt until late May. But McBey's love life during his time in France had been an active one. With Mary Louise history, McBey's next significant squeeze had been violinist Phyllis Allan. He had first met Phyllis in December 1914, when another brief love interest brought her to his London studio. Phyllis was just a teenager, and she soon became smitten with the thirty-one-year-old Scotsman. Three days after Christmas Day, she visited his studio to play the violin for him, and on 1 January 1915, she declared her love for him. McBey soon made his own position clear, even purchasing an Amati violin for £60 as a way into her affections. At sixteen, Phyllis was young and immature, but in the eyes of the law, she was a consenting adult, with whom McBey had a tactile relationship, a relationship which also saw him paint her portrait. When McBey left for his posting in France in early 1916, it was clear that both felt a mutual attraction. They exchanged letters, and Phyllis' attentions were a reassuring constant presence during his time away. McBey enjoyed other, more brief wartime dalliances, including with the very married Irene Foster Salmond, who, as a mezzo-soprano, was helping to entertain Allied troops in France, and whom he had looked up during his stint there, but he had maintained correspondence with Phyllis during his French posting. On 2 May 1917, and just weeks before he left for Egypt, he reveals in his diary what appears to be their

first full sexual encounter, on Hampstead Heath, followed by several other intimate trysts. At eighteen, the winsome young girl whom McBey had painted two years before was now a young woman – but his affair with the teenager clearly has unsettling parallels with Pablo Picasso's (1881–1973) today-much-frowned-upon affair with French model Marie-Thérèse Walter, who became his mistress at just seventeen, when he was forty-five.

On 18 May, Phyllis saw him off at the station to Southampton. Always one to check for signs and signals in others, he noted that she 'could not wait as she had an audition at 12. She left about 11.15 and I kissed her goodbye once in station. She did not look back as I saw her through a pile of men. Seems significant.' McBey would have little time to dwell as he was soon to begin his role as official war artist on the Palestine Front. He sailed from Marseilles on the twenty-sixth, and whiled away the hours on the *Saxon* sketching. He took with him the books on religion he had purchased at London's Charing Cross Road. He also amused himself by scribbling on the back of each sketch. On the reverse of *The Arrival in Port*, he wrote:

> Egypt at last! The destroyers, having nosed ahead like dark ferrets all the way from France, stop, and, as the transport passes them, are seen alongside for the first time. From the crowded decks rousing cheers are given for the gallant [...] bluejackets as they drop anchor.[34]

At Alexandria, on 31 May, he shrugged off the attentions of an 'Egyptian, fat and grinning', and made for Cairo by train. The following day, McBey, a desert fox newly arrived, saw the Egyptian capital for the first time, in daylight, and sizzling under a summer sun. 'Wonderful town Cairo,' he wrote on 1 June. 'Strange to feel the Moorish smells again.'

The month of June would be a steep learning curve for both artist and the large multinational force he had been sent to shadow, observe and record. On 28 June, Allenby assumed command of the EEF from General Sir Archibald Murray, whose leadership had been deemed unsatisfactory by the War Office. Jerusalem was in their sights, and British prime minister David Lloyd George wanted the Holy City taken from the Ottomans by Christmas. McBey must have been aware of the enormous privilege and importance of his task. He had been allocated a salary of £500 per year plus expenses, and, as an official war artist, was in esteemed

company. Muirhead Bone, Britain's first official war artist, had arrived in France in August 1916 at the peak of the Somme offensive. He returned home at the end of 1916 but was back the following year 'concentrating [his efforts] on towns and villages ruined in bombing raids.'[35] William Orpen was another official war artist. The Dublin-born creative, given the rank of major, was documenting French battlefields from April 1917 until March the following year. Orpen, particularly prolific, would be knighted for his services to the war effort in 1918 – and, like McBey, would also paint T. E. Lawrence, doing so at the Paris Peace Conference in 1919.

McBey, however, would initially have the entire Palestine Front to himself, only being joined by another war artist, Thomas Dugdale (1880–1952), towards the close of 1918. McBey was required to hit the ground running from his arrival, travelling, sketching and eating on the hoof – 'a plate of onions at 6 a.m.'[36] His lack of an allocated vehicle would soon prove troublesome. In July, he was in the Egyptian Sinai Desert with the Imperial Camel Corps (ICC). Established in 1916, the ICC had enlisted their first companies from Australian troop battalions returning from the disastrous Gallipoli campaign, but later included British and New Zealand detachments. During summer in the Sinai region, the heat and dust combined to brutal effect. McBey woke at sunrise and regularly cooled off in the Suez Canal. He also rode a camel for the first time: 'Hurriedly packed stuff in cool blue morning. Camel at door. Little bit nervous, but after mounting felt alright. Does not appear so far from ground as I thought it would.'[37] He revelled in the 'wonderful' desert landscape where 'shadows [came] like big waves slowly over the sand.'[38] He 'happened to be on the spot when the [ICC] was sending its patrol of Australians across the Sinai Desert in expectation of a further attack on the Suez Canal'[39] – and accompanied them on reconnaissance, which gave rise to his magnum opus, *Dawn: The Camel Patrol Setting Out*, included in his 'First Palestine Set'. With its haunting imagery and 'characteristic economy of line',[40] the plate portrays nine riders heading out towards a vast expanse of rolling desert, depicted by McBey's masterful use of space. Its genius would be recognised in January 1926 when a single impression fetched at the American Galleries, New York, $2,200 (some $33,000 today) – then the highest figure ever paid at auction for an etching by a British artist.[41]

McBey began his love affair with Isa Curtis in August 1917. He met her in Cairo and must have been instantly attracted to the slim and enchanting-looking expat because on 8 August, just three days after he first mentioned her in his diary, they kissed. For the rest of the month, as the sun beat down on this ancient Egyptian metropolis, McBey and Curtis were inseparable – frequenting a café founded in 1909 by Swiss chocolatier Giacomo Groppi, for 'ices.' By the time she 'helped to pick off the words "War Correspondent" from my green badges' on 2 September, they had been sexually intimate. That day, McBey left for Palestine, and, as his train departed Cairo, he noted his melancholy at watching his lover, likely wearing her favoured wide-brimmed sunhat and black velvet choker, vanish from view. 'A white figure passes out of my life forever I fear. One that I would most willingly of all have retained.'

It would not, we know, be their last rendezvous, but what do we know of the enigmatic Curtis? Evidence suggests that she began life as Isabella Hempseed. Born in Thayetmyo in central Burma (Myanmar) in 1885, she was the daughter of Scotsman Richardson Hempseed, of the Royal Scots Fusiliers – a career soldier – and Mary, a former widow, also of Scottish heritage. Both emigrated in 1909 to Canada, where they would spend the rest of their lives. In April 1907, seven years before the First World War began, Isabella married Briton William Henry Curtis in Cairo, where, at the time of her marriage, she was living in the British Army barracks at Kasr el-Nil, likely with her half-sister, Martha (née Quegan) and Martha's serviceman husband, Richard Lumsden, of the Royal Inniskilling Fusiliers, who was also a witness at her wedding. William was an engineer, attached to the Egyptian Civil Service, who was working in Esna, where they both were living when Mrs Curtis began her affair with McBey.[42] The Upper Egyptian city had little strategic importance during wartime, and William may have been there to ensure the functionality of the Esna Barrage[43] – a barrier constructed by the British in 1908 to control the water of the annual floods. Indeed, the existence of a William Curtis who was made a Member of the Civil Division of the said Most Excellent Order in 1920 on the instructions of King George V for his engineering services to the Esna Barrage[44] strongly suggests that both were one and the same.

McBey had wasted little time in sketching his new romantic interest, doing so in Cairo on 22 August. Isa was required to travel the hundreds

of miles north from Esna to the capital to meet the artist for their steamy encounters. McBey, we know, was already well versed in the art of passionate love affairs, and Isa would not be his last. But when he reached Palestine on 4 September, he could not help but think of his paramour back in Egypt. Home also seemed distant: 'England and especially Scotland seem so far away now,' he noted two days earlier. With gunfire now echoing nearby, he was closer to the action than ever before. On the seventh, he observed from afar 'Gaza for first time. Wonderful. Greatly impressed. First time I have seen Bible town.' With shells bursting around McBey, the war was real and close at hand. As Allenby's EEF plotted its third attempt to take Gaza – having failed twice before under the leadership of Allenby's predecessor, Murray – the Scotsman knew he had to keep up to the front. But 'unable to obtain motor [...] transportation [he] had, like the infantry, to resort to walking to keep up with the advance, an exhausting job which left him little energy for drawing'[45] and meeting his remit. From Palestine, he wrote to William Hutcheon that he was 'looking longingly on Gaza' but complained of being 'bothered by [...] venomous snakes.' As a remedy, a war colleague had suggested raising 'the camp-bed on tent-pegs driven into the sand [...] I now envy his secure slumber just as I envy the faith of Roman Catholics, or that of the very righteous in Scotland.'[46]

Without a vehicle, McBey was forced to learn horsemanship. 'The second time I was on a horse's back I had a huge, flashy-eyed, nervous brute, modelled on the giraffe,' he later penned.

> I went up to an observation post, and all went well until I got about half a mile on my way back, when two heavy shells burst within a hundred yards simultaneously. The animal simply bounded into space. The earth went down and came up three times before the next two fell in the same place, by which time these three leaps had taken us beyond the range of the splinters.[47]

Another time McBey reported being followed by two marauding armed officers for four miles who, he ventured, suspected him of being a spy or an interloper. Sporadic turns on a horse were getting him nowhere, and when he missed the fall of Gaza on 7 November, he wrote to his superior, Charles Masterman, in London, in despair: 'The finest material of the whole time I have been here is around me and near me but completely

out of my reach.'[48] He did make a break for Gaza after he learned of its fall to the Allies, and he noted after his arrival in the bombed-out city, 'What a mess the Turks have left it in.'[49] He wasn't going to allow a repetition by missing the Allied capture of Jerusalem. Some kind of distressing message from Isa, maybe telling him that she was pregnant with his child,[50] passing Turkish prisoners, illness, mosquitoes and copious letter writing, including to Mrs Curtis, all served as a prelude to his arrival in the sacred city in December.

'Nearly every nationality and every mode of transport walking up the road to Jerusalem,' he observed on 6 December, and, in the days following, neither rain nor bad roads could stop his progress. Jerusalem was in the hands of a Christian-led army for the first time since the Crusades, newly seized from the clutches of the Ottoman Turks, who had abandoned this religious and historical epicentre in the cool December air without a fight. The Allies, including Allenby and T. E. Lawrence, ceremoniously entered the city on the eleventh on foot, and McBey was there to see and sketch the procession, remarking in his diary that there was 'Great excitement. Crowds began to form outside Jaffa Gate.' He had chosen the balcony of the Grand New Hotel, then converted into a hospital of 250 beds, to watch Allenby, walking tall and straight, lead a line of Allied officers and military attachés through the Old City at noon. Excited spectators lined the streets, peered from windows and gathered on balconies in the glare of the winter sun. 'We saw the procession, the proclamations and the sheiks' presentation, which I thought most picturesque,' he remarked. Bertha Spafford Vester, a leading light of Jerusalem's American Colony, recalled being ushered away from the front of the balcony to make way for the burly Scotsman. 'Of course I minded,' she recalled in her 1950 book, *Our Jerusalem*, after being forced to witness history over McBey's shoulder, 'but I could not refuse the official artist a good place to make the sketches for his famous painting of the historical entry of General Allenby.'[51] His subsequent oil on canvas work, *The Allies Entering Jerusalem, 11th December 1917*, with its use of space and falling shadows, did indeed become famous, even if its artist thought the Allied handling of the surrender of the city itself 'absolutely lacking in spectacular effect.' 'Not without reason are we believed to be the most unimaginative of the civilised races,'[52] he opined. Yet, the seizure of Jerusalem provoked much jubilation back home, as one reader of *The Manchester Guardian* attested.

Evoking General Allenby as 'master of the Holy Places', J. E. C. Welldon of The Deanery, writing in the newspaper's letter-to-the-editor column, described the city's capture as 'one of those dramatic events which touch the imagination of the world.'[53]

McBey first met John D. Whiting, a member of the American Colony, in Jerusalem, on the balcony of the Grand New Hotel, and it was he who ensured the Scotsman had prime spot for his sketches. A friendship was quickly struck between them, and they spent time together on McBey's thirty-fourth birthday on 23 December. On this occasion, McBey was almost moved to tears after receiving a gift of a Roman glass from some local children. They also spent Christmas Day together, when McBey sat beside Whiting's mother and enjoyed a 'tremendous' turkey dinner. On 30 December, he discussed with his war colleagues the concept of second sight – 'a [claimed] special psychic ability of having prophetic visions'[54] that had a great tradition in his native Scotland – and must have lovingly namechecked his late grandmother, Mary, who professed to possess such powers.

As the Allied advance moved, he moved with it too, and by the time Damascus was taken in October 1918, McBey had earned his stripes. He was spotted on 1 November by Hector Dinning, an officer with the Australian Light Horse. By this time, the Ottomans had unconditionally surrendered to the Allies. Dinning recalled that the artist 'passed and was hailed, and [he] haled [sic] back. [McBey] had just descended, and was making hot foot for Baalbek with a car full of kit and sketches and artist's gear [...] Aleppo he was making for ultimately, before the winter rains caught him.'[55] McBey pushed on to present-day Lebanon – taking in Beirut and Tripoli – after his memorable artistic encounters with Lawrence and Feisal in a newly-liberated Damascus. In today's Lebanon, he also explored Baalbek's ancient ruins, where he saw 'dead Turks, throats cut and heads battered in all over the place.'[56] The modern-day Syrian cities of Aleppo, Hama and Homs followed, and on the fourteenth, he again ran into Dinning. The Australian saw McBey perched by a 'petrol dump' deep in a sketch, his right hand doing what it did best. The officer, in his 1920 book, *Nile to Aleppo: With the Light-Horse in the Middle-East*, marvelled at the Scot's abilities:

> He has amazing powers of concentration on the business in hand [...] behind his glasses, moving his empty pipe energetically at

high frequency from corner to corner of his mouth, his large, delicate hands work with great sureness and rapidity. But the curious thing is that he can carry on a conversation with you at the same time – and a not-disconnected conversation. I think he must have two minds; perhaps it is with his subconscious mind he converses.

As an artist, 'McBey has a way with sitters that would make them do anything for him', Dinning observed. As for his manner, he added that the second lieutenant was:

not courteous in words (as a fact, he is somewhat gruff in his commands for a change of position), but very, very kind and courteous in the relation he contrives to set up between himself and the sitter. He puts himself on an equality with the lance corporal who is sitting – so that the victim feels, for the time being, he is his friend. When all is over, he thanks the corporal with a grace that puts him under the delusion that not himself but McBey is the debtor; a strange, but a charming, inversion.[57]

McBey had a swagger and stage presence in all he did. British artist Gilbert Spencer (1892–1979) had been serving with the Royal Army Medical Corps in Egypt when his attempt to prepare for an art exhibition at Port Said was 'over-shadowed' by the arrival of the Scotsman 'complete with servant, and a green armlet, to make some etchings of our hospital.'[58] Dinning also opined 'that perhaps the only occasion [in] which the Commander-in-Chief [Allenby] was not the dominator in Palestine was when he sat to McBey at Bir Salem.'[59]

By the time his tour of the Middle East was coming to a close, McBey had sent scores of drawings back to Britain for public consumption. As a December letter indicated, he was still keen to go the distance: 'I badly want to see England, naturally, but I should like to know that my record was complete.'[60] But delays, and a general failure by the British authorities to take advantage of the artist's 'prodigious output', led to disappointing coverage of McBey's time in the desert. On 16 August 1917, for instance, he delivered sixty-eight pictures to Cairo, but, by late October, they had still to arrive in London. 'A volume of *British Artists at the Front* devoted to McBey was planned, but never produced, although arrangements went ahead to the point that it was discussed who should write the introductions.'[61] Yet, once home, his astonishing artistic legacy on

the Palestine Front would be secured, and include images of not only the Allies' many British and Antipodean participants, but their Indian and, of course, Arab counterparts as well.

As for McBey and Isa, circumstances had conspired against them. He wrote to her on 29 December 1918 from Egypt feeling dejected. He had taken a Port Said-bound steamer to Egypt after returning first to Beirut. She replied, couching her bitter regret at losing him to the end of the war in humour: 'have you thought how cold it will be in England? And the rain and the sleet and the snow, biting winds and strikes? And you probably won't get a frightful lot to eat, not like here anyway [...] You'd better change your mind about going don't you think?'[62]

It would not be the last time their paths would cross, but their relationship, like the war itself, had run its course.

CHAPTER SEVEN

1 Holland Park Avenue

'Why, Sir, you find no man, at all intellectual, who is willing to leave London. No, Sir, when a man is tired of London, he is tired of life; for there is in London all that life can afford.'

– James Boswell quoting Samuel Johnson, *The Life of Samuel Johnson* (1791)

McBey's first studio, at 22 Justice Mill Lane, Aberdeen, had been a ramshackle old place. But when he had first seen the 'to let' sign nailed to the outside of the loft, overlooking a stable, he couldn't help but fantasise about swapping the parlour at Union Grove, which had twinned as his workshop for several years, for a studio he could call his own. Smitten, he paid £8 for one year's rent from the autumn of 1906. The loft was large, and (sparsely) lit, and, with the fireplace walled in, was more icebox than studio as the colder months brought shorter days and longer nights.

He worked by the light of a single flame, wrapped up against the wintry weather in gloves and jacket, as biting winds from the North Sea chilled Aberdeen and its inhabitants to a shiver. He painted and etched in silence, save for the creaking floor boards and the ghostly rattle of the 'irregular-sized panes of obscured glass' that looked out towards the back streets.

There was barely any distance between his studio and Union Grove, where he lived with his blind mother and elderly grandmother. In fact, it would have taken him barely five minutes to walk the 'winding lane' of his loft address to his upper-floor tenement. Justice Mill Lane runs parallel to Aberdeen's grandest road, Union Street. When he left his studio at a little before 9.30 p.m. on 11 December 1906, he knew nothing of the events that would soon come to pass. He descended the building's wooden staircase, which led to the stable, where a 'horseless carriage' belonging to a Gordon Highlander lay in storage. He took a familiar route home that night: west along Justice Mill Lane, passing to his left

Justice Mill Brae, before crossing Holburn Street and onto Union Grove where, by morning, his mother would be dead – and he would be freed.[1]

Now, in January 1919, McBey was preparing to leave a restive Middle East, where, for countless months, his studio had been its war-torn towns and cities. Sun-kissed, flushed with success and infused with the sights and sounds of war, McBey was a very different man to the one who had made that short and unassuming walk to his upper-floor tenement home.

McBey's months on the road had left him tanned and lean. He had once filled out his Army-regulation military fatigues, but now they buttoned up loosely against his scrawny frame, giving his long, bony fingers the appearance of proboscises. On 3 January, the Scotsman was back in Jerusalem. The war may have been over, but his artistic commission continued as he re-visited those ancient parts of the Palestine Front which now featured often in his sketching pad. But, as preparations for the Paris Peace Conference on 18 January began, bringing representatives from the victorious nations to the negotiating table, he knew his own assignment was winding down. He took in Nebi Samwil, Haifa and El Afule, among other places, but was back in Port Said on 2 February. Two days later, at 2 p.m., McBey's ship, *Norman*, began its journey out of the Suez Canal as a band played on the bridge. 'Went down to my cabin for something and found a letter from [Isa], enclosing 2 pansies […]' he noted in his 1919 Army book on 4 February. 'How strange, it is as though Egypt had flung the flames to me as I went away. Feel very sad at leaving this place of sun. Went up on boat deck and watched Port Said getting fainter in the mirage. At 4 p.m. it had disappeared.'[2] He killed time reading, playing (a lot of) chess and peering through his binoculars at passing sights – 'Watched the lights of the light houses until they faded astern'[3] – before the ship docked at a 'bitterly cold' Marseilles on 10 February. He travelled on via Paris, Rouen and Le Havre, where he spent time (as he wrote in code) 'with little blonde girl.'[4] In the early afternoon of the fifteenth he was back in London. But, after travelling under the bleak skies of southern England from Southampton, he did not get the welcome for which he was clearly hoping. 'Arrived at Waterloo about 12.45 after nearly two years absence,' he noted that day. 'Nobody to meet me. Felt it a bit.'

McBey arrived back to a post-war Britain reeling from the death and destruction. Of some six million men who had mobilised, an excess of seven hundred thousand had been killed, a number that also included

more than a hundred thousand Scots. His artist friend, Lieutenant Campbell Lindsay Smith, had been one of the fallen Scots, cut down in 1915 at the age of just thirty-six, sadly only several months after he had married. The global death toll from the First World War would later be estimated at some seventeen million soldiers and civilians, and such was the trauma visited upon a victorious British nation that in a speech on 24 November 1918, the country's wartime leader, David Lloyd George, had promised 'to make Britain a fit country for heroes to live in.'

As it was, McBey's own homecoming remained an underwhelming experience. 'Got a lot of letters and went to call on [CODE – Phyllis],' he wrote. 'Found them both laid up with influenza.'[5]

Phyllis Allan and her mother were likely suffering from a bout of the Spanish flu which would claim at least fifty million people worldwide over 1918–1920. Consumed by self-pity, McBey appeared to give little thought to their welfare as he sulked and skulked about London.

'Came away and dined, feeling very forlorn, at club,' he confided in his Army journal on the sixteenth after re-visiting the ailing Allans and failing yet again to rouse their enthusiasm. 'Perhaps I should never have expected any welcome at all, but the disappointment of it all shook me.'

McBey would soon snap out of his depressed state. He had made his wartime contribution and come back unscathed and even enhanced. Gone were the frustrations of his failures to enlist, due to his poor eyesight. He had, during his posting, been a powerhouse of art production – 'Of all the official war artists he was the only one to approach Bone's prodigious output, executing 299 drawings, watercolours and oils'[6] – but the wartime etchings that would make him famous in the years following his return from the Middle East had then still to be realised. McBey, to be sure, was one of the fortunate ones – and not only because he had survived. While many returnees from the war would be forced to pursue a life of grinding unfulfillment after their battlefield heroics, the artist would be able to continue in the same rich vein to which he had long become accustomed.[7]

McBey's fortunate position enabled him to consider buying a new home. No sooner had he re-entered civilian life than he was eyeing up 1 Holland Park Avenue as his new London residence after Martin Hardie drew his attention to its availability. In the 1911 census, this West London address, located 'on the main Uxbridge Road, near Notting Hill Stations

on the Tube and Metropolitan Railways',[8] was occupied by a Blanche Lilian Sauter – formerly Blanche Lilian Galsworthy, the sister of English novelist, and 1932 Nobel Prize laureate, John Galsworthy – and her two servants. Developer James Brace had built this elegant Georgian residence in 1820, which Lilian's father, John, later purchased for his daughter and her German artist husband, Georg Sauter (1866–1937). For his son-in-law he had specially 'converted the upper part into an enormous studio in which Georg could practise his art and Lilian live the social and artistic life of a painter's wife.'[9]

Their son, artist Rudolf Sauter (1895–1977), recalled his home as a magnet for the glitterati, hosting,

> painters like Whistler, who was very fond of my mother [...] the American etcher, Joseph Pennell [1857–1926], tall and thin, joyously disputing with everyone [...] Mark Twain, discussing philosophy, religion, and Survival with my mother [...] [artist] Prince Pierre Troubetzkoy [1864–1936], humanitarian and bestman at my parents' wedding in 1894 [...] Ezra Pound and Richard Aldington, fresh from contributions to the magazine *Blast* blasting everything and everybody, including John Galsworthy for having bourgeois opinions. Then there were Gilbert Murray and his wife (of whom my mother was particularly fond), full of his current translations of Greek Tragedy into English poetry, of whom my mother related that the beauty of his reading made Greek almost comprehensible, even to one who knew no Greek [...] and Joseph Conrad, bearded and swarthy, with his great head sunk into his shoulders – for all his shortness, apparently a little over life-size – and Jessie, whose crippled knee tended so much to cripple their lives.[10]

With such history, 1 Holland Park Avenue was just the kind of place for a celebrated artist to put down some permanent London roots – and brandish his success. But initially, it appeared beyond even McBey's financial reach. In reclaiming his expenses during his tour of the Middle East, he produced 'a document worthy in its precision of an ex-bank clerk, and quite typical of McBey in its modesty: for [twenty months] of continuous work he claimed £37. 5s. 10d. for materials and, for the transport of self, paintbox and luggage throughout the Holy Land, £2. 1s. 6d.'[11] This was hardly enough to secure an eleven-room London 'artist's house', which,

standing 'well back from the road', included two reception-rooms and five bed and dressing-rooms. To realise his purchase, he convinced his art dealer, Colnaghi's (which had recently dropped the Obach part of its name), 'to buy the remaining fourteen years of the lease'[12] at £100 per annum in return for 'his handing over to them his private collection of his own etchings.'[13] On Saturday 31 May, he took possession of the residence. The following year, he would receive a loan from George Davidson, the art dealer on Glasgow's Sauchiehall Street, which would allow 'him to purchase a further 999-year lease at a peppercorn rent.'[14] On 12 July, this 'wonderful Scot' who was a 'quiet, soft-mannered, Doric-speaking Aberdonian' with 'raven black hair' and a 'twinkling eye' finally moved into 'one of the very finest studios in London.'[15] It would remain his English home for life.

McBey's sequence of watercolours from his summer 1917 trip in the Sinai Desert, *The Long Patrol* series, had been exhibited in London between January and February 1918. The series included *Breakfast*, *Strange Signals*, *Noon*, *Bivouacs* and *Nightfall*. On his return from the front, he set to work producing three separate lots of his Middle Eastern plates. McBey's 'First Palestine Set', published in 1919, consisted of seven etchings, six of which evoked his time with the Australians and their ships of the desert under a blistering sun. *Dawn: The Camel Patrol Setting Out* was joined by *Strange Signals* to become two of his most celebrated works from the period. The 'Second Palestine Set' followed in 1920, and included his unforgettable *Zero: A Sixty-Five Pounder Opening Fire* and another, *The Moonlight Attack, Jelil*, in which Allied troops lie camouflaged on the desert floor awaiting the start of the Battle of Megiddo. His 'Third Palestine Set' followed one year later, completing his story of war, and included *The Dead Sea* and *Hermon: Cavalry Moving on Damascus*. All three sets proved a sensation. Hardie, McBey's friend, fellow artist and art historian, observed:

> McBey saw and studied the movement of war in Egypt and Palestine with a mind and eye as sensitised as a photographic plate; but what he has given us is not a photograph of facts and places, but their spiritual essence [...] He shows the vastness and tragedy of the Desert, the irresistible movement of an Army[16]

As Hardie makes clear, McBey's etchings of the Palestine Front were richer than any photograph. His style, swift and improvised, evoked 'the impulsiveness and emotion of [a] sketch'[17] rather than the faithful

rendition of a scene. Memory, notes and studies of his subjects were combined into his plates – executed under the more controlled climate of a studio. The etchings fizzled with the Scotsman's artistic DNA.

By the time he had issued his 'Third Palestine Set' in 1921, he was just thirty-seven years old. Later in the same year, he would pay another visit to Spain, from where such etchings as *Gerona* would originate. He had put on the weight that he had lost during his last months on the Palestine Front, and had settled back into domestic life in post-war London. From the comfort of his Holland Park surroundings, he had resumed his domestic creations, making a dry-point of Mollie Murray – *The Silk Dress* – in 1919. In this, Mollie is portrayed in a long evening ballgown – recalling Whistler's late-nineteenth-century plate, *Maud, Standing*. He also made a dry-point of Mollie's young daughter, Margot, whom he depicted as famous Russian ballerina Lydia Lopokova in *Margot as Lopokova*, in 1920. That year, he also created the classy dry-point *The Pianist*, in which Mollie and her husband, William, look on as Austrian pianist Benno Schoenberger plays a tune on McBey's Steinway in his first-floor drawing room. 'Never has the artist been so happy in rhythm and balance of design,' observed Hardie of McBey's musical number, 'or so quick and sure in rapid presentment of his subject, as in the rendering of this lamp-lit room, the frail head of the white-haired pianist, and the rapt interest of the two listeners.'[18]

These plates, and others like them, were both a depiction of individuals and a depiction of the social circle in which McBey now moved. McBey was, on the outside at least, a city-gent par excellence. His was now a life that was essentially free and easy, and his grand property at 1 Holland Park Avenue became a place of music, laughter, art and love affairs. For McBey, love affairs would always pervade his life and influence his art – and the 'Roaring Twenties' would see him at his sexual peak.

In 1920, he was forced to re-examine his associations with the Royal Society of Painter-Etchers and Engravers. But this time, it was McBey who held the position of strength. On 28 December, the Society wrote to the Scotsman apologising for their past failure to admit him into the body nine years earlier and inviting him to re-apply (with the guarantee of success) to remedy the situation. McBey's omission from their number as one of Britain's official war artists and one of the world's most celebrated printmakers was, on the face of it, unfathomable. McBey had, of course,

not been the only talented etcher to suffer a rebuff. English painter and etcher Sir Henry George Rushbury (1889–1968), who also became an official war artist, had tasted rejection from the Royal Society prior to the start of the First World War. Unlike Rushbury, who re-submitted himself for consideration and was elected an associate member in 1921, McBey declined. McBey had deliberated the offer, but on 4 January 1921, adopting a humble and self-effacing tone in refusal, he replied: 'I appreciate your generous letter to such an extent that I have the greatest difficulty in replying to it,' adding: 'after your Council's decision an attitude of independence was my only choice, and in this fate has been so kind to me that I feel very strongly I must continue in it.' McBey had, effectively, deemed this esteemed British institution surplus to his requirements. There was no trace of bitterness, just an accurate assessment of his own abilities and position. Now nearing forty, he had long carved his own path in life, and the Society was just another body with whom he would engage in his own way and under his own terms.

But why had the institution rejected him in the first place? Since McBey's time, two schools of thought have emerged. One says that McBey simply failed at his first attempt, and such was his prowess with the etching needle at this time that the Society's offer of full membership was simply a recognition of his current standing. Another, however, suggests elitism could have been at play. Although according to one writer and present Society member, the institute was unique in 'the fact that work by women and men was treated equally from the outset' and 'election was based on the quality of work regardless of gender and nationality',[19] the pre-war years in Britain were on the whole ones of exclusion. It was only after the 1918 Representation of the People Act came into force that millions of British women, along with a generation of working-class British men, including many who made up the Allied ranks on the battlefields of Europe and the Middle East, had a chance to vote for the first time. The Edwardian Council might have baulked at McBey's application in 1911 due to his background. A young, precociously talented, working-class Scotsman who was entirely self-taught as a printmaker, and who had only then recently left his boyhood home in Scotland's north-east for London's bright lights, might have been viewed with suspicion. Whatever the Council's motives, McBey had yet to reach

his creative peak in 1911, and it might be fairer to say that the Society's verdict simply reflected this fact.[20]

After he had rebuffed the advances of the Royal Society, his name was put forward for membership of the Royal Academy, but without his knowledge. Records show that his name gathered some heavyweight backers, such as etching great Sir Frank Short (1857–1945), who was then President of the Royal Society, and the very same individual who had written to McBey in 1920. Founded in 1768, the Royal Academy was the oldest, and most prestigious, fine arts institution in Britain. In July 1922, after his name secured six nominations, when a printmaker required only three, he was submitted to the General Assembly for consideration. The archives reveal his candidature, and, as in 1911, his failure, when two other etchers secured associate member status over him.[21]

Yet, McBey knew nothing about this, and, despite being nominated throughout the 1920s, he remained ignorant of his Royal Academy candidature. McBey would only get wind of his live nomination with the Academy in 1936 – two years after also politely turning down membership of The Royal Scottish Society of Painters in Water-Colours. He would hurriedly write to Frank Short asking for his name to be withdrawn. As before, he would do it with grace. 'I take this opportunity of thanking you and telling you how grateful I feel towards you for my original nomination and for renewing it after 7 years without a word to or from me,' he would write. 'I have not experienced very many kindnesses from members of our profession, and your generous act is therefore to me the more outstanding.'[22] The Academy had rejected a submission of his work back in 1913 (likely for an exhibition) and, by the time he had returned from the war, he had long deemed unnecessary any art establishment recognition.

He was now successful enough to enjoy the recognition that came with living the life of a London celebrity: 'when he is seen [taking] a walk in the West-End, paragraphs appear from the pens of the gossip-writers of the London papers.'[23] His social life was far from dull, and Lowell Thomas, the American filmmaker whom he had met in the Middle East, had now become a firm friend. Thomas had returned from the deserts of Arabia with a story to tell – that of Allenby and Lawrence's triumph over the Turkish Army, the latter with his band of Arab guerrillas. Frances Thomas, Lowell's wife, joined her husband for his London shows, then

called *With Allenby in Palestine*, which opened in the capital on 14 August 1919. Three days before, *The Times* had noted:
> Another novelty this week will be the use of the Royal Opera House, Covent Garden, as a lecture hall [...] Mr. Lowell Thomas [...] will lecture on Allenby's campaign, and his remarks will be illustrated by a series of moving and other pictures, many of which were taken from the air. He has recently been delivering the lecture in New York, where his stay had to be extended from one to ten weeks.

McBey attended the show, now titled *With Allenby in Palestine and Lawrence in Arabia*, on 2 October at Covent Garden, when Alder Anderson in *The Daily Telegraph* wrote that:
> if this illustrated travelogue of Mr. Lowell Thomas could be shown in every big centre throughout the country for the next year or two it would do more, I believe, to allay industrial unrest than any measure the most far-sighted and sagacious sociologist could devise. Though it has already been exhibited at Convent Garden over a hundred times, the big theatre continues to be packed twice a day. The whole demeanour of the audience and the rapt attention with which it follows the explanations of the pictures is most impressive.

Thomas would illustrate his newspaper articles on Lawrence with McBey's art from the Palestine Front. The Aberdeenshire man clearly found Thomas an intriguing figure. Writing after the war, the Scotsman recalled that his colleagues in the press corps 'were perturbed and suspicious of him' as the stentorian-voiced American 'had a habit of disappearing from the camp for long and unaccounted-for periods.'[24] McBey and the filmmaker, with their shared inclination to go off-piste, appeared to have an understanding, and the artist found the Thomases enjoyable company. Frances Thomas noted in her scantily-dated journal, 'One afternoon we had tea at James McBey's studio,' sometime around September 1919.
> He is Scotch, and his housekeeper is his old Scotch aunt. After tea he took us to his studio, on the third floor. It was a spacious room with enormous sky lights. Many portraits of great Generals were sitting about and he was working on the siege of Nebi Samwil.

Frances thought McBey 'one of the great recognised modern etchers', and made the insightful observation that 'Mr. McBey prefers to do portraits, but he says there is no money in that. He makes most of his money by his etchings.' Frances, who described McBey's encounter with Allenby on the Dead Sea in her diary, after hearing the artist himself relate the tale, elaborated on the 'vigorous' general's involvement in trying to extricate his sunken vehicle from the lake's salty marshes. Allenby had 'crawled under the car on his stomach, in all that slime, and dug grooves with hands, so the wheels could get a grip.'[25] McBey, we know, had ultimately succeeded in shepherding Allenby and the duke of Connaught to safety.

Both McBey and Lowell kept in touch during the rest of 1919. By December, the American showman and his wife were still in London. McBey dispatched a missive inviting the pair to a dance party at Holland Park Avenue three days before Christmas Day, which he was hosting with some friends. He must have received a letter back from Frances to the effect that Lowell's commercial success had worn him down, because the Scotsman in turn replied that he was 'sorry to hear your husband was not feeling so well, but these last few months must have entailed on him a tremendous strain, and the wonder is that he has kept it up so wonderfully.'[26]

McBey would meet with the real star of Lowell's show, T. E. Lawrence, again. The modest and self-effacing Arabist, who, quipped Lowell, 'had a genius for backing into the limelight', was becoming a nationwide hit when McBey bumped into him the following year. McBey spotted the pint-sized figure of Lawrence on a spring day in March or April 1920 while visiting the artist Augustus John's exhibition at the Alpine Club Gallery, off Conduit Street, London. Lawrence was stationary, just as he had been the day McBey captured him posed in flowing robes of white and gold some eighteen months before. 'I happened to see him standing alone in front of and regarding intently the portrait which Augustus John painted of him,'[27] recalled the artist much later. Lawrence was so taken with one of John's exhibited 1919 portraits of him that he repeatedly visited the show to see it. We should imagine him wearing a suit and clutching his hat as he viewed the portrait, which, like McBey's own painting, depicted him in traditional Arab dress. Lawrence's mind must have pitched like a

ship in a swell as he saw his likeness looking straight out of the canvas, his left hand in a resting position and a golden dagger fixed to his waist.

Frances Thomas painted a vivid picture of T. E. Lawrence as she saw him at their first meeting in London with Lowell. 'Colonel Lawrence was dressed in a grey suit and tan shoes and a grey hat,' she noted on 22 August 1919.

> He stands about five feet tall. He is fair with steel blue eyes. Eyes that pierce you. His face is not brown as you would expect one's face to be who had lived so long in the desert, but seems very strong and masterful. After several minutes he seemed not so bashful and was really very easy to talk to.[28]

Lawrence was an Oxford-educated enigma born in Wales to an Anglo-Irish father and Scottish mother. In the Alpine Club Gallery, McBey must have observed the former intelligence officer in similar attire and countenance to that described by Mrs Thomas, although in her description she had taken some five inches off Lawrence's real height. McBey's bluey-grey eyes would have flashed in recognition of Lawrence, who, conventionally suited and booted, little resembled the portrait he was carefully observing. 'I spoke to him and immediately knew he must have seen me before I had seen him, as his greeting was instantaneous,' recalled McBey in his 1954 letter to Lowell Thomas.

> We talked for a few minutes and he made the overture to dine with me at my house in Holland Park Avenue the following evening at 7 p.m. When the time arrived he had not put in an appearance by 9 p.m. so I went out to a friend's house. Next morning my Scottish housekeeper said he did turn up around 9.30 p.m. He told her he had come just after 7 p.m. but 'thought he heard voices' so went off for a couple of hours. About a week later I got a cryptic note from him with no address on it. I have never been able to find this note; I may have thrown it away but have no recollection of having done so. He was at that time a famous enigma, not, as he became later, a legend.[29]

Whether McBey saw this as a lost opportunity is unknown, and we can only now speculate on the conversations that never were. Might they have had a meeting of minds, these two prodigious outsiders, both illegitimate, both Victorian-born, with only five years between them? If it seems unlikely that they would have talked about these aspects of their

lives as figures who were, in reality, little acquainted, then they would almost certainly have discussed at length McBey's portrait of Lawrence and the conditions under which it was composed. Let us, for a moment, recreate the scene, and imagine what might have happened had they both dined together on that spring evening at 1 Holland Park Avenue.

At 7 p.m., Lawrence arrives at the door to McBey's home. He is not, as he appeared to be, spooked by any 'voices', and rings the bell. McBey's Scottish housekeeper answers and shows him inside, taking his hat, and perhaps some books he has under his arm. The etcher and painter, burly and full of artistic bonhomie, bounds down the stairs to greet him, holding out his hand, which Lawrence takes, but the Scotsman notices that the former guerrilla fighter's grip is 'loose' and 'unconvincing.'[30] Lawrence's gaze is initially directed towards McBey's feet; he is awkward and makes little small talk, before the Scot shows him upstairs into the drawing room. There, Lawrence relaxes, and, realising that no one else is about, starts to warm to the artist as McBey relates how pleasantly surprised he was to see him the previous day.

'The last time we saw each other was under completely different circumstances,' Lawrence says, a wistful smile flitting across his face, and at once McBey notices his strong and defined features.

The talk is of 3 October 1918 Damascus, when Lawrence sat for him and the exhausted Briton was bid emotional farewells by his battle-hardened Arab irregulars – but also, naturally, of art.

'I've sat for a lot of artists,' Lawrence says. 'You, Sir William Orpen, the sculptor Derwent Wood [1871–1926] and Augustus John, of course.'

'And you are very inclined towards John's,' replies McBey with a disarming laugh as he sweeps a large hand through his hair. 'Come on, let me show you my studio – it's on the third floor.'

Lawrence tells his host that he, too, was taken with art from an early age, and had 'sketched during bicycling tours of France, illustrated his college thesis with pen-and-ink drawings of medieval castles, and drawn and painted representations of artefacts excavated during his archaeological work at Carchemish, Syria.'[31] He even reveals to McBey that, in a 1909 letter to his mother from the Syrian city of Aleppo, he had expressed his 'wish' to be 'a real artist.'[32] When Lawrence finally leaves, at a little after 10 p.m., McBey knows that he has been in the presence of a man with deep wells of intellect, feeling and mystery; but Lawrence, too, is left with

the notion that to have possessed the artistic talent of McBey would have been to live a more agreeable life than the one he was living. Lawrence would later remark to his biographer, Robert Graves, that artists were 'the one class of human beings I'd like to belong to. I can salve the regret of not being an artist by watching artists work and providing them with a model.'[33]

McBey kept up his exposure in the press during the post-war years with aplomb. In 1922, for example, his sometimes dramatic, but always intriguing, tales of his travels around Europe and the Arabic-speaking world were published in *The Graphic*. They were letters written to Scottish journalist William Hutcheon and edited down into a series of observations that ran under the heading of 'An Artist's Wanderings by James McBey: The Brilliant Etcher as a Letter Writer.' On 27 January 1922, the 'London Letter' column of the *Aberdeen Daily Journal* announced to its readers that the 'final instalment of the finely-illustrated letters of Mr. James McBey describing his wanderings in Morocco, Holland, and Palestine' was concluding the next day. It continued:

> These letters [...] were written without thought of publication, and were as often as not accompanied by pen-and-ink drawings exuberantly alive. Mr. Hutcheon obtained the reluctant consent of Mr. McBey to their publication, and the result has justified his contention that Mr. McBey, the word-painter, is a serious rival to McBey, the etcher. Mr. Martin Hardie, a brother-etcher and writer and critic of distinction, says – 'Frankly, though I would be prepared to expect anything from McBey, I had no idea he could write like this.'

There was something about McBey that gave rise to acclaim of this nature. Socially popular? Yes. A bit of a maverick, who could surprise with his talents and intellect? Definitely. Someone who had risen to the top against the odds, and, instead of slavishly following tradition, had enjoyed deviating from it? Absolutely. He was unpredictable and would continue to be so.

Indeed, when, a year earlier in February 1921, he had put on his first exhibition of oil portraits at the Grosvenor Galleries on London's New Bond Street, the capital was clearly McBey's playground. He was 'one of the most discussed artists in London', his backstory as a humble bank clerk regularly reported by the press as the starting point in the story of

his meteoric rise to stardom. He was a 'brilliant' etcher and even 'the most promising portrait-painter in the world today.' He had a 'genius' that was reflected by the sale of his etchings, which were now 'fetching bigger and bigger prices every time any of them [came] into the auction room. Prints that five or six years ago were being sold by Colnaghi's for three, four or five guineas [were now] fetching anything up to sixty pounds.' He had a 'waiting list' of 'hundreds' for 'his new editions' and the clamour to own a 'McBey' had effected a run on his plates on both sides of the Scottish-English border.[34] *The Daily Graphic* even reported that in 1920 'his etchings alone must have brought him £10,000'[35] – though not all of the profit from his sales would in fact go to McBey directly.

During the post-war years, fresh portrait commissions also came his way. In 1921, Sir Harry Lauder sat for him. The highly successful Edinburgh-born entertainer was a global star, who, prior to the outbreak of war, had begun a tour of North America and Australasia. Following the death of his son, John, at the Western Front in 1916, he had thrown 'himself into the war effort, holding bond rallies [and] raising money for wounded and maimed soldiers.'[36] Photographs depicting McBey painting the Scottish troubadour, sporting his trademark tam o'shanter, offer a delightful glimpse into McBey's sessions with Sir Harry, who, knighted in 1919, was the first British entertainer to sell a million records. The portrait features Lauder holding his pipe and dressed in a kilt. One press report opined that the picture 'caught to a nicety the whimsical humour that lurks in Harry's eyes.'[37] Another report, in the *Aberdeen Daily Journal*, ventured to hope that McBey's effort was merely a shape of things to come. 'It shows how far Mr. McBey has gone in portraiture, and also how much further he must yet go and may be expected to go.'[38]

McBey's portrait of the entertainer generated such interest that even a member of the House of Lords dropped by Holland Park to admire it. It might seem twee to modern eyes that McBey was rubbing shoulders with Sir Harry Lauder, who also came from humble origins, working as a flax-spinner and coalminer before his success, but the performer was then the most famous Scotsman in the world. He was the Billy Connolly of his day and arguably even more famous. And what finer accolade for the Scottish artist than to be commissioned by a successful fellow countryman who was blazing a trail across the English-speaking world?

A year later, McBey's former employer, the North of Scotland Bank, approached him. The staff wanted to present James Hutcheon, one of the senior members of the institution, with a retirement gift – and the artist was commissioned to paint his portrait in April 1922. The retiree travelled to London to sit for McBey, and he completed an oil portrait that summer. During one sitting, the artist asked the bald and moustachioed banker why he had rarely engaged in conversation with his clerks. 'The reply, still tight-lipped, was "I did not want to show favouritism."'[39] On 29 June, McBey returned to Aberdeen to personally present the former general manager with the gift at the Palace Hotel. It turned out to be an entertaining evening – worthy of many column inches in the *Aberdeen Daily Journal*. Hutcheon, in his speech before the great and the good of the north-east, paid tribute to his 'portrait as a visible expression of your good wishes towards me, and of the skill of the artist, Mr. James McBey, whose work is well known over the whole world.' McBey himself was even invited to speak, and how he must have relished it. After another guest reminded the gathered diners of

> the cartoons which Mr. McBey in his banking days used to circulate round to the staff, those efforts culminating in a large cartoon, *The North Bank Band* [...] Mr. McBey, in acknowledging the toast, said that when he left the bank twelve years ago somebody told him that one day he would live to thank God for the eleven years he had been in the bank. He did not think much of the remark at the time, but he saw the wisdom of it now. (Laughter). In London, when asked where a boy should go for an art education, he suggested apprenticeship to a bank, preferably in Aberdeen, and said if he survived that he was capable of anything. (Laughter).[40]

McBey had, indeed, long proved himself capable of a great many things. After this period of revelling in his recognition in his home country of Britain, he once again resumed his travels. Two visits to Italy, his first in September 1924 and another the following year, widened further still his artistic horizons. McBey visited Venice with art dealer Duncan Macdonald, 'a sparrow-like Highlander, nervous, voluble and almost feminine in his mannerisms',[41] and found it hard to leave. 'Sketched from sandolo in canals but felt unsettled. No heart in it,' McBey recorded on his final full day, 16 October. 'Feel goodbye. Walked along to Dogana [...]

11.18 goodbye to Venice at night. Clear moonlight [...] Goodbye while looking.'[42] On his second trip to Venice, the so-called Floating City, in autumn 1925, he travelled with Hardie.

'Venice, with all its magnificence and its undying charm, its restfulness in the hush and stillness of the canals and waterways, is often harsh and glittering under a constant canopy of blue,' wrote Martin Hardie, recalling his time with the Scot.

> The painter is frustrated by his observance of all the clarity of detail in the fretted pillars and the traceries of myriad windows. It is at its best on the rare days that are grey, or in the soft opalescent atmosphere of the dawn. That was the atmosphere which McBey sought.[43]

Hardie marvelled at McBey's worth ethic as he watched him create his compositions, just as he had marvelled while watching McBey work in a Boulogne hotel room in 1916. Then, both were British officers and the world was at war. Now, McBey was plying his trade under an autumnal Venetian sky.

'Every morning, during a month which I spent in his company in the autumn of 1925, he was out at five a.m. to see whether the sun was rising in mist or cloud, or in a sky of blue,' an awe-inspired Hardie recorded later.

> Never have I known anyone with such untiring energy and passion for work. He began at dawn; he spent hours at the end of the Rialto or at a table under the colonnade of the Chioggia Café in the Piazzetta, making pen and ink notes of figures; or in a gondola on the canals or the Giudecca, making studies of shipping, of buildings and their reflections; at night he would be out again in his gondola, working on a copper plate by the light of three tallow candles in an old tin! Never has anyone been less dependent on the orthodox paraphernalia of his craft. Never was any artist more indefatigable. I have known a day's bag of an oil sketch, a brace of watercolours, several pen studies and an etching![44]

Venice, on the Adriatic Sea, clearly inspired McBey, as it had other greats before him. Italian painter Canaletto (1697–1768) found fame for his striking and meticulously detailed scenes of his birth city, while Whistler, commissioned by the Fine Art Society in London to do so, first

visited the former independent republic in 1879. Whistler arrived bankrupt after suing John Ruskin (1819–1900) for defamation over a review that the Victorian English art critic had written about one of his paintings, and he travelled to the city of canals and bridges to escape London, restore his morale and recoup his financial losses. German author Thomas Mann, a future Nobel Prize winner, also found the city in giving mood when he holidayed there in 1911, coming back with material for his semi-autobiographical novella, *Death in Venice* (1912). Now a man from a far corner of Scotland had added his name to this illustrious list of creatives inspired by Venice.

McBey's artistic interpretations of Venice, created once back in London, would not disappoint. Now in his forties, his three sets of Venetian plates proved his merit, which had been noted by art critics since he first appeared on Britain's biggest stage wide-eyed from Aberdeen. Again, he largely drew on his memory for his resulting etchings, many being made in his studio 'long after' his return from Italy, indicating that he had, once more, 'saturated himself in his theme.'[45]

His Venice trips also resulted in oils and coloured sketches which were exhibited in 1926 to great fanfare in London. A notable oil painting from his time in Venice is *Regatta on the Grand Canal, Venice*, a big and packed canvas bursting with people, colour and life – and 'a picture which calls for more than a glance in the passing.'[46] The press reported in April that McBey himself even dropped by to see how one of his shows was progressing, before making haste for Scotland to honour several portrait commissions. 'He is likely to be in Edinburgh for three weeks or so,' noted the report, 'and will be busily engaged with sitters all the time.'[47] Two years later, and following his 1926 record-busting sale in New York of *Dawn: The Camel Patrol Setting Out* (which was part of thirty-five McBey etchings sold, totalling $23,190 – in excess of $350,000 in current prices), some of his Venetian prints were purchased by Gustavus Mayer, a partner at Colnaghi's, for a handsome sum. 'Mayer came up unexpectedly and bought trials of first 8 Venice plates for £5,250,' he wrote in his journal on 10 February 1928 of a figure equivalent to more than £350,000 today. His Venetian plates were 'a consummation of his career as an etcher, [and] his last major achievement in the medium.'[48]

The etching profession was about to go through hard times, but for now, the market was in bloom, with tens of thousands of print impressions

being produced yearly. Many etchings were being sold for eye-watering prices on both sides of the Atlantic, with prices fluctuating on the basis of 'the reputation of its creator, its rarity and its subject matter.'[49] McBey knew he 'would lose "printing interest" in a plate after pulling some twenty or thirty impressions – "If I print another forty or so, it is only because collectors may want to possess them, but after seventy-six in all, I do not intend to go on".'[50] McBey, the celebrated heir to Rembrandt and Whistler, had long known how to maximise his value. By the late 1920s, he had well and truly broken into prohibition-era America, with a 1929 US Congressional report noting that 'etchings by D. Y. Cameron and James McBey [...] sell in this country for prices – $1,500 to $1,800 – as high if not higher than the works of our foremost American etchers.'[51]

One significant event in McBey's life during the 1920s happened without his knowledge. On 7 July 1927, his father died of heart complications in Wallington at the age of seventy-three, and it appears that the artist knew nothing of his passing. Yet, James McBey senior had not entirely been an absent father in the life of his successful son. It would take until McBey had entered adulthood before a proper relationship developed, but on that 'solemn' Sabbath day with his mother when McBey first met his father, a flicker of a relationship had begun. When, for instance, McBey wrote to him in December 1906 to inform him of his mother's sudden passing – and after keeping the true nature of her death a secret – his father had responded with a letter. 'I was surprised when I got your letter about your mother's death,' he wrote from his sizeable farmhouse in Warlingham, Surrey. 'I have no doubt but you and also your grandmother will feel it very much. It was so unexpected but we do not know which may be called next.'[52] And during his first visit to London one year later, on bank business, after accompanying the consignment of gold bullion to the Bank of England, 'he had met his father by appointment at East Croydon Station, and spent ten minutes with him, receiving the gift of a sovereign.'[53]

We do not know how James, now a very prosperous sheep farmer, reacted when his son finally told him of Annie's suicide. This was in May 1915, when both men had been in touch for less than two years, after a mutual acquaintance from Aberdeenshire had reconnected them. McBey travelled to his father's home of Beddlestead Farm on 6 December 1913, where he saw a man who, he noted in his diary, had visibly aged. He was

introduced to Scots-born Annie Hendry, his 'nice housekeeper', for the first time. James, we know, was a bachelor, and, on the face of it at least, was simply Miss Hendry's employer. As for the relationship between father and son, it endured – at least for a while. Surviving letters reveal a father more than willing to keep in contact with his only child, even visiting one of McBey's art exhibitions in London in 1914, later writing to him: 'I heard some people remarking how well they were done [...] I understand they are nearly all sold,'[54] signing off, as he always did, with 'yours faithfully.' He seemed a lonely figure – but, despite proclaiming to have no understanding of art, appeared proud of his son's achievements. 'The end came soon after the war. The older McBey was a rich man and had a will drawn up [...] McBey was named as [joint] executor with a legacy of £1,000.'[55] In mid-October 1923, McBey took receipt of the will from James with a covering note that was short but accommodating – 'If there is anything in it that you would like explained come down and we can talk it over.'[56] However, after reviewing the long and generous list of beneficiaries from his father's near £30,000 estate – including legatees now living in South Africa and America – the artist declined involvement, and contact ceased. On 21 October he noted: 'At 5 p.m. said goodbye to father after straight talk.' Following his death, James was buried in south-west London, nearly six hundred miles away from his birthplace of Echt, with no part of his fortune ever going his son's way. Perhaps because he blamed his father deep down for Annie's troubled and painful life, he had simply put principle before financial gain.

As memories of his last meeting with James faded with the passing of time, and he continued his artistic practice, McBey developed a new passion for sailing. As a native of Scotland's north-east, the white-tipped breakers of the North Sea and the pungent salt air remained an indelible memory. The 'angry' and crashing ocean had been the backdrop to his childhood by the coast. In his autobiography, he recalled the bravery of the lifeboatmen in his village, who frequently risked their lives to save distressed ships and their crew, particularly during winter. McBey had joined his grandmother in combing the shore for riches amid pieces of wreckage after a ship had foundered, pocketing a Bible and a cigar-box, which, he recalled, possessed 'an alluring aromatic odour the like of which I had never smelt.'[57]

Decades on, this son of Aberdeenshire would be in a position to purchase his own vessels. A trip to the Low Countries in early 1922 saw him pick up a Dutch flat-bottomed boat which he re-named *Esna* (perhaps as a nod towards his one-time married lover in Egypt). In the spring of 1925, he sold it, and bought a 'Baltic ex-revenue cutter', of 14 grt, which he called *Mavic*. In the former, he explored the likes of the Netherlands, with which by now he was more than familiar. As a novice sailor, he hired a Dutch skipper, from whom he was determined to learn the ropes. By the time he had moved on to the *Mavic*, he was a true salty sea dog.

The second boat became the subject of a privately printed book, *The Mavic's Log: Ramblings with Nautical Notes*, in which some of McBey's boating high jinks are recorded. Just how important sailing and all things maritime had become to the Scotsman by this time is amply illustrated by the book, published by Harold H. Kynett, then a soon-to-be friend, in 1951. The *Mavic* 'cruised the shores of the North Sea' between 1926 and 1928, carrying art-loving friends from England to the coastal reaches of Belgium and the Netherlands. 'His craft [...] was a comfortable plodder, the equivalent of marine amblers along the American coasts,'[58] and his 'continual entries in his diaries referring to sketching, painting and the making of etchings go on, but now against a nautical background.'[59] On 1 April 1926, one day before Good Friday, the *Mavic* was off the coast of Belgium, where McBey and his seafaring companions tucked into a meal 'of cold veal, bread and tea' after dropping 'anchor in 3 fathoms.'[60]

Martin Hardie and artist Arthur Baylis Allen (1889–1940) were among those who accompanied McBey during these artistic sojourns on the *Mavic*. Allen became his most steadfast sailing companion, McBey having first met him in wartime Cairo, where he was teaching art. In early April 1926, his cutter was cruising its way towards Zierikzee, a small, history-rich port city in the Netherlands. 'Allen was steering and keeping everyone right by his deep knowledge of charts and his numerous nautical instruments with which he delights to surround himself,' remarked McBey, then forty-two, on 4 April of a 'glorious day' with 'a spanking S.S.W. wind.' 'We sighted an enormous flock of seals basking on a shoal to starboard. They seemed all asleep.'[61] As the day grew overcast and blustery, McBey and his crew of amateur sailors 'went ashore to make a tour of [Zierikzee], but found it somewhat disappointing. Toward evening the

weather cleared and we crossed the canal. I made a hasty note of the sun setting behind the harbour windmill.'[62]

By late summer, the *Mavic* was in Belgium, where McBey moored his vessel in a dreary Ostend, in the Flanders region, before making a road trip. 'Took car to [Nieuwpoort] and Dunkirk,' McBey logged on 24 August.

> Recalled last time I had been to [Nieuwpoort] when, in the *Esna*, a squall having arisen, we ran before the wind across the shoal waters of Dunkirk. It was close, as the leeboards lifted on the banks but we got safely into harbour, though it had not been reclaimed since the war, and unexploded shells were lying about. Found Dunkirk very quaint, with the full rigged ships lying in the harbour.[63]

As the following month brought summer to a close, and with it that year's sailing, McBey, heavy with nostalgia, tied up his beloved vessel at a boat yard on the coast of south-east England. 'The *Mavic* looks very forlorn and there is a swelling in my throat,'[64] remarked the artist on Saturday 18 September.

McBey recorded in his nautical diary another journey in the *Mavic* two years later. By this time, he was now something of an old-hand at sailing, having been at it for six years. He had an ability to evoke the sights and sounds of his surrounds in written form. 'Clear sunset, still blowing hot breeze,' he noted on 15 July 1928 as a summer heat wave gripped Britain, where Pathé News that month filmed children paddling in the Thames at Greenwich.

> Engined up Erith Reach, intending if possible to make Greenwich, but the bare walls forming the banks on either side were most depressing, and this – to sail up the Thames – is the culminating point of my sailing, the point for which I had been making since I bought the *Esna*. Somehow I had expected more than those bevelled banks punctuated by factories.[65]

The days of the *Mavic* (and the *Esna*) were heady ones for McBey and his crew. During one of these sojourns, they came across Dutch etcher Marius Bauer (1867–1932) in Amsterdam – 'We decided he was quite unlike anything we had expected and certainly more like a Dutch banker than an artist.'[66] McBey rose early one morning to sketch a 'Fiery red sunrise',[67] and, as the *Mavic* bobbed up and down on the choppy North

Sea, 'at 4.30a.m. [...] served out cognac in egg cups so that all might drink prosperity to the new [London art] firm of A. Reid & Lefevre, Ltd.'[68]

For the rest of his life, McBey would be drawn to the sea. Whether creating art from his coastal adventures – 'Was he not born and bred among boats, so that for him, as he says, the unforgivable sin is to draw a boat badly?'[69] – later living on the north-western tip of Morocco, or as a passenger aboard a cruise liner, he would never stray too far away from the ocean. Another nautical moment in McBey's life had taken place back in spring 1923, when, as his work continued to bring him into contact with dealers, collectors and other monied figures, he was invited to lunch in London by wine and spirits merchant Francis Berry, an enthusiastic collector of etchings. He and his partner, Hugh Rudd, wanted help with the launch of a new Scotch whisky to sell abroad. McBey chose the name *Cutty Sark* – after a tea clipper built in Scotland in 1869. Naturally, McBey went on to design the label, too – reportedly on a napkin.[70] 'When Prohibition was established in America, "Berry Bros." products became in great demand in the Bahamas, a popular stop for smugglers'[71] – and the swashbuckler in McBey was no doubt tickled by the firm's plans to break into the US despite its nationwide ban on the production and consumption of alcohol. McBey purchased quantities of liquor, such as Montilla sherry, Madeira and, of course, *Cutty Sark* itself, from the firm.[72] The decision of Berry Bros. & Co. (today Berry Bros. & Rudd Ltd.) to involve the artist proved inspired. The whisky, with its nautical logo (albeit in revised form), is currently thriving under the ownership of French drinks giant La Martiniquaise-Bardinet.

The twenties had been a blast for the famous creative. But in between it all – the working, sailing and jet-setting – another part of his life had also been going at full throttle; a part that would soon lead to an unexpected event that would surprise all who knew him.

CHAPTER EIGHT

Love and marriage stateside

'Never delay kissing a pretty girl or opening a bottle of whisky.'

– Ernest Hemingway

McBey's first love was an Aberdeenshire girl named Polly Ritchie. From the age of five, he admired Polly, real name Mary Ann, from afar. Eleven months older than McBey, she was the daughter of John[1] and Charlotte Ritchie, proprietors of the Udny Arms Hotel on 50 Main Street, Newburgh, which frequently attracted guests looking to fish the waters of the Ythan.

As a child, he had longed to attend one of the Ritchie Christmas parties, but when an invitation finally came, his mother had forbidden him to go. It was, he recalled, a crushing experience, and 'for weeks [he] avoided meeting any of the Ritchie family lest they might expect some explanation.'[2]

On 26 December 1911, he reconnected with Polly 'after a lapse of 14 years'[3] on his first visit back to Newburgh after leaving for his new life in London several months earlier. By this time, she had not long wed a marine engineer. His schoolboy crush on Polly had been innocent, and he would remain in touch with her until she predeceased him in April 1959. When McBey returned from the Palestine Front in 1919, however, his past sexual liaisons were still fresh in his memory, and settling down was very far from his own mind. McBey's libido would soon cast him as a runaway train with most approaching tunnels conceivable points of entry.

He faced the 'Roaring Twenties' with every intention of maximising his own market share of that era's sexual revolution. Craving the intimacy of female companionship for sexual release may have been driven by his primal desires, but such intimacy also served to ward off the haunting spectre of loneliness which hung over him like the sword of Damocles. In an attempt to satisfy both his physical urges and a longing

for companionship, he began the post-war period by returning to his usual ways. He sought out the old crowd – Mrs Irene Salmond, whose husband had died in 1918, among others – but it was Mollie Murray, married to Dr William Murray, who really marked his return to civvy street.

Mollie was clearly a cut above. Her father-in-law, one-time MP Sir James, had often used her skills as a 'hostess for him in London at his political dinners.' She had 'travelled widely and with her taste and originality she must have seemed to McBey an immensely glamorous and sophisticated woman.'[4] His frequent 1919 diary entries of their rendezvous – such as 'Had walk with M.', 'M. afternoon' and 'M. tea' – were soon followed by ones of a sexual nature. In addition to their home in London, the Murrays also owned a cliffside holiday retreat in Kingsgate, a pretty hamlet located on the south-east coast of England, more than eighty miles from London. According to McBey's journal, this was where many of their intimate trysts took place. 'At Kingsgate. Morning M. Dull day,' he noted on 29 December. 'Set out from Kingsgate in car to Canterbury [...] Back in afternoon. All night M. [CODE – gave herself to me].' Theirs was an affair conducted with letters and snatched notes – 'Would you like a weekend in Kingsgate?' Mollie, who would often address him in her letter-headed missives as 'Snookie', wrote on one small piece of scrap paper. 'Put an X if you would on the back of this.'[5]

The years that followed saw the artist travel with Mollie (and her husband) to the likes of Spain (the same 1921 visit where he would conceive *Gerona*), where he attended a bullfight with her, even as other love interests emerged. He clearly thought nothing of moving between lovers as it pleased him. McBey's inclinations apparently did little to damage his relationship with the Murrays, both Dr Murray and his father, Sir James, and Mollie herself, who, even amid the heartbreak of losing her twelve-year-old son, Malcolm, to acute rheumatism and endocarditis in 1922, would remain a lifelong friend. He also kept up a touching correspondence with Mollie's schoolgirl daughter, Margot, who, clearly besotted with the famous Scottish artist, wrote to him from Northlands, a private boarding school for girls at Englefield Green, Surrey. 'I always watch the post on Wednesday or Thursday for your nice little envelope,'[6] she expressed in one excited missive, and 'I hope you have not been smoking to [sic] much I shall be very angry if you have,'[7] she wrote in another,

often addressing him as 'My dearest Mac' and ending with 'tons and tons' or 'heaps and heaps' of love and kisses.

In December 1920, a blast from the past came in relation to McBey's history with the married Isa Curtis in Egypt. She wrote to him with the alarming revelation that someone had outed their past affair to her husband. The arresting telegram in question – 'JAMES MCBEY IS YOUR WIFES [sic] LOVER A ROTTER' – had been sent to her husband's place of work in Esna, Isa wrote, and had on it a Chelsea postmark. 'It has been written, I am inclined to think, by someone close to you, as I fancy mine own enemies are all in Egypt, and the grudge is most likely against you,' opined Isa, adding that her husband, 'Will thinks it is possibly the work of a jealous woman.' She even refrained from signing the letter in case it should 'drop into enemy hands.'[8] Suspicions do exist about the sender, but there is nothing to indicate that McBey himself identified the informer.[9] To a man who knew inside and out his Bible, the sentiments expressed in Hosea 8:7 – 'For they have sown the wind, and they shall reap the whirlwind' – must have been too close for comfort. McBey and Isa were reunited on 10 June 1922, when McBey met a vacationing Mrs Curtis outside London's Temple Underground Station and took her to tea on Regent Street. As they looked into each other's eyes for the first time in four years, what feelings stirred can only be imagined. Two days later, she visited his home, where they 'went over [their] letters' and he 'persuaded her not to have them destroyed.'[10]

Several months before his brief reunion with Isa, he had met 'Tipi'. 'Tipi', whom McBey often referred to as 'Tips' in his diary, assumed the role of both subject and lover – 'Tipi came about 3 p.m. Had dinner. Then sketched her writing letter,' he wrote on 14 April. 'Tipi' is thought to be the lady featured in McBey's February 1923 pen and ink and watercolour, *The Kimono*, where a striking woman preens herself in front of a mirror.[11] 'Tipi', Mollie and other girlfriends were soon joined by Scottish artist Anne Finlay (1898–1963), who is first mentioned in McBey's diary on 1 November 1924. Finlay had moved to London two years earlier, having studied at Edinburgh College of Art. They both attended the Chelsea Arts Ball at the Royal Albert Hall on Hogmanay 1924 – where guests included Noel Coward and Ivor Novello – 'wearing costumes inspired by [Francisco] Goya [1746–1828] and his "Clothed Maja"',[12] before making love in the early hours of New Year's Day at his home.

He spent time with Finlay in Paris, and also Venice, during his successful autumn 1925 visit with Martin Hardie. An attractive 1920 oil on canvas portrait by Scottish painter Dorothy Johnstone (1892–1980) captures Finlay's allure: the sleek and bare-shouldered Edinburgh-born artist sits perched, panther-like, 'on a luxurious coat with a scarlet lining'[13] wearing bright red lipstick. Yet, despite her outward appeal, several other relationships would trump even hers.

During the post-war years, the razor-sharp aspiring novelist Eileen Arbuthnot Robertson also entered his life. McBey gave the young woman leave to use the *Esna*, moored seventy or so miles east of London at West Mersea, as a writer's retreat where she could work in peace. He became, as if it needed stated, a regular visitor. This act of generosity would lead to her 1928 debut novel, *Cullum*, which, published when she was just twenty-five years old, she would dedicate to McBey 'in affectionate recognition of his long, fruitless efforts to make me a credit to the Scottish race.'

The English-born E. Arnot Robertson, to give her her penname, was tall and slim, with a shock of bright red hair. She didn't go unnoticed by McBey, who persuaded her to sit for him anonymously in 1921. The resulting oil on canvas painting, *The Red-Haired Girl*, was exhibited at the Royal Academy two years later to rave reviews. Billy, as McBey would refer to her for the rest of his life, had a 'high fluttering voice' and burned 'like a flame.'[14] Like so many other women who met the artist, Robertson swiftly fell under his spell, with both coming to adore each other. Surviving photographs from around 1923 depict McBey, Billy and others carousing on the *Esna* in true bohemian style. In one shot the Scotsman, complete with yachting cap, cigarette and lapdog, sits between Billy and another young woman, both of whom lean into him, the sexual kingpin – and doesn't he know it. In April 1926, when Billy was twenty-three, and McBey forty-two, she fell pregnant, but soon miscarried. On the day she did, and still able to summon the wherewithal to display her trademark wit that would serve her so well as a novelist and broadcaster, she wrote to tell him. 'Darling Jimmie,' she scribbled hastily in pencil, heading up her letter with the word 'Bed', which she underlined, 'Today a little McBey passed painfully into the limbo of "Might have been" and so his potential mother is now in bed with an agonising pain just where

you would expect, as usual during the first few hours.' She added on page two:

> I want you to console me!! PLEASE come back soon, for the only man within reach who attracts me at the moment is married, and I so much prefer fornication to adultery. Don't you sweetheart? When I am a rich woman I shall have you kidnapped and taken to my private island and there I'll keep you locked up, and feed you exclusively on oysters and Château.[15]

Her taste for the outlandish was not solely confined to the written word: she was fond of playing practical jokes on the artist, such as stripping and lying naked on the chez lounge in the front hall of Holland Park in the hope of startling visitors and paying customers.[16]

In 1927, Billy tied the knot with Henry Turner, General Secretary of the Empire Press Union. She later described married life (and her hobby of sailing) as 'mentally inadequate as a whole-time occupation for any intelligent woman, but as healthy recreation they can't be bettered.'[17] Two years later, McBey was eyeing a visit to the United States, where his work had long been admired. Art dealer Duncan Macdonald first appeared to moot the possibility of an American tour that summer, and on 21 September 1929, the Scot booked a first-class ticket on the *Majestic* for £72. (With a bank balance of £1,340 – over £90,000 today – he could well afford the luxury.) On the morning of 15 October, he packed for his maiden voyage Stateside, noting that he had 'never felt less excited in my life' and, typically for McBey, also felt 'terribly alone.' He took the train from Waterloo to Southampton, where he and Macdonald, who had decided to accompany the artist after organising an exhibition of McBey's paintings at M. Knoedler & Co. in Chicago, 'Entered *Majestic* at docks. Amazing.' 'Sun shining through mist,' McBey scribbled from cabin A18 on the sixteenth as his luxury liner pushed out warm plumes of smoke and steam into the brisk open air. 'Strange those familiar Southampton sights.'

Six days later, the forty-five-year-old arrived under the breezy overcast skies of the Big Apple with his bulging suitcase of clothes, ties and bowties, his stash of tobacco, his 1929 American-centred diary (he possessed two diaries for this year), his etching gear, paints, brushes and canvas boards – and likely a photo or two of the women in his life. Like others, he was oblivious to the economic turmoil that was about to unfold, and on the

deck of the *Majestic*, he made a rapid sketch of the Manhattan skyline as his trans-Atlantic steamer edged towards the harbour (he would turn this sketch into an etching, *Approaching New York*, in 1934). From miles away, the metropolis had been a mere speck on the horizon – 'Saw N.Y. City in distance. Watched it as we got up,' he noted that morning – but, as tugboats piloted the behemoth of a vessel in to shore, the vertical feats of engineering that had been changing the city's vista from the late 1800s emerged like a ridge of jagged peaks. Steel hung from sky as skyscrapers soared above the Hudson River below, and McBey's eyes must have darted from one sight to another as a fresh autumnal breeze brought with it the smell of urban life from New York's streets.

Among the smoke-shrouded superstructures competing for his attention that forenoon would have been the Singer Building, the Metropolitan Life Insurance Company Tower and the Woolworth Building – and, of course, upon Bedloe's Island, the image of freedom itself in the shape of the Statue of Liberty. Also within sight would have been the shores of New Jersey, and the Brooklyn Bridge as the *Majestic* soon docked at the pier of the White Star Line company.

McBey made landfall that rainy Tuesday alongside celebrities such as operatic soprano Mary Garden, whose arrival even made the front page of *The Brooklyn Daily Times*. Under the sassy headline of 'Mary Garden Comes Home Short-Skirted and Tanned from Nude Bathing Habit', the paper revealed that she 'had come back to the United States [...] tanned from nude swimming in the Mediterranean, delighted about getting her weight down to 120 pounds and proudly flaunting a short-skirted costume.' She, interestingly, also hailed from Scotland's north-east but, just six years after her birth in Aberdeen in 1874, had emigrated to the US with her family, where they soon settled in the American Midwest. Garden knew America well; her fellow Scot did not. But McBey was no stranger to foreign adventures, and America was a feast for the senses. Ailing (and octogenarian) American inventor Thomas Edison was still making headlines. America's thirty-first (Republican) president, Herbert Hoover, was about to preside over financial calamity. Prohibition, which had outlawed the sale and importation of booze in 1920, had long become an absurdity, no more so than in New York itself. The Eighteenth Amendment:

> was a joke in most of urban America, but in New York it was an all-out farce. Seven thousand arrests for alcohol possession

or drinking in New York City between 1921 and 1923 (when enforcement was more or less openly abandoned) resulted in only seventeen convictions; observers estimated the number of illegal speak-easies, dives, and drugstores as somewhere between a monstrous 32,000 and an unbelievable 100,000 [...] Some people during Prohibition, playing on John Winthrop's famous words about the 'city on a hill', called New York the 'City on a Still.'[18]

While illicit alcohol was being sold and consumed nationwide, and the syphilitic bootlegging mobster Al 'Scarface' Capone was serving a short stretch in Philadelphia's Eastern State Penitentiary for carrying a concealed weapon, McBey set about his own business. The Scotsman had been a firm fixture of America's art scene long before his arrival. He had made his American debut in the autumn of 1914 after Knoedler Gallery held an exhibition of twenty-five of his works in New York. The 'Scotch etcher,' reported *The Brooklyn Daily Eagle* in October that year, possessed 'masterly skill' and a 'unity of expression' in his plates, which had included scenes from Morocco, Scotland and England. 'His blacks are velvety, and he shows, moreover, in his Moroccan etchings, strong dramatic feeling in his grouping of figures,'[19] it added. By the late 1920s, art columns the length and breadth of America included references to everything from McBey's eye-watering print sales to his time as an official British war artist. In June 1918, one US newspaper noted that 'Skilful artists of many countries have produced clever, even magnificent, pictures of the war and the soldier. Muirhead Bone, James McBey, Joseph Pennell, because of talent, dexterity, hard work, will leave for future generations truthful, even scientific, sketches of the world's war.'[20] And on 20 October 1929, while McBey was still aboard the *Majestic*, *The Cincinnati Enquirer* lauded him as one of the world's 'Big Three' printmakers along with Bone and D.Y.C. – 'all Scotsmen.' 'Cameron [...] has long had a deserved popularity – his plates are very fine,' it reported in its 'The Week in Art Circles' column. 'Bone is possibly the greatest living artist in black and white [...] James McBey, of Aberdeen origin, is perhaps the most popular living etcher.' Indeed, the same paper had earlier in the year called McBey 'a giant in his day. He is an artist whose power can encompass the whole keyboard [...] So spontaneous, so fresh are his interpretations, so

delightful his selections, that one often feels actual personal contact with his bitten line.'[21]

During the so-called 'Mad Decade' in the United States, art and culture were all the rage. After Wisconsin-born artist Georgia O'Keeffe (1887–1986) first held an exhibition of her work in 1916 New York, she became an unstoppable force.

> By the mid-1920s, O'Keeffe was recognised as one of America's most important and successful artists, known for her paintings of New York skyscrapers – an essentially American symbol of modernity – as well as her equally radical depictions of flowers.[22]

New Yorker Edward Hopper (1882–1967) was painting images of loss and alienation. Meanwhile, author F. Scott Fitzgerald described America's excesses. Kahlil Gibran (1883–1931), the ethereal Lebanese-born painter and poet, and author of the wildly popular 1923 book *The Prophet*, was living in New York in the latter stages of cirrhosis of the liver that would soon kill him.

It was somewhat surprising that it had taken the globe-trotting McBey until the autumn of 1929 to visit the US. At that time, screen idol Harold Lloyd was starring in his first 'talkie' – *Welcome Danger*. McBey and Macdonald were met off the *Majestic* by American Anna Lee Smyth 'and by the brothers Kuhn, two kind and elderly eccentrics who lived together and collected McBey's etchings.'[23] The reason for the Scotsman's sombre mood prior to his trans-Atlantic passage was almost certainly connected to Lee Smyth's close friend, Frances Gripper, who had been a latest lover of McBey's in London and had herself called time on their relationship in favour of returning to her fiancé in California, breaking the Aberdeenshire man's heart in the process.

McBey had first met Gripper on her twenty-sixth birthday, on 29 September 1928. The dark, wavy-haired pianist was a well-known teacher of music in Pasadena, California, and was engaged to Robert Oliver Schad, a curator of rare books at the Henry E. Huntington Library and Art Gallery in San Marino, Los Angeles County. She was attending London's Tobias Matthay Pianoforte School and likely chose to indulge in a last fling before she settled down to married life. She and McBey became involved, making Holland Park their love nest. No doubt drawn to the artist because of his flamboyant vocation and charm, perhaps in contrast to the bookish man she was about to marry, Gripper gave herself

completely to McBey, as evidenced by their many passionate encounters. 'This is the most heavenly wonderful position in the world,' she wrote in McBey's diary on 30 July 1929 during one love-making session. Surviving self-portraits of the pair, shot in his studio, also reveal the extent of their affections. Gripper, slim and with a long and graceful neck, and resplendent in a silk kimono, and McBey, dressed in a white shirt (with sleeves rolled up), a tie and trousers, are pictured kissing and canoodling, in various poses, delighting in each other's company. But perhaps they were aware that it was a relationship doomed to fail. McBey soon immortalised the Oregon-born American on canvas. His July 1929 portrait, Woman on a Sofa, in which 'a rich, red blanket slackens about [Gripper's] rounded form, its rich colours and exotic cloth turning her into a sumptuously wrapped gift',[24] also made clear that she had become his muse.

They spent time together in Scotland – his native country still proving a powerful draw after so many years away and despite so many bleak memories. Before doing so, they visited landmarks in England, such as King's Lynn and Lincoln Cathedral, where 'Heard service with F. [...] Felt much affected. Had not attended a service for many years.'[25] In York, he again felt overawed after visiting York Minster, and in Durham, he was suddenly confronted by his own mortality – not to mention their age gap – when Frances 'said I might soon be old. It gave me a shock.'[26] In Scotland, they took in the likes of Edinburgh Castle, the ramparts of Stirling Castle, where he had broken his journey south back in 1911, and the Wallace Monument, which they climbed.

They also later called on Newburgh, but, despite her writing in his diary declarations of love – 'I love you much more than I love anyone else in the world'[27] – he knew he was losing her. When he asked her to marry him, she refused, crying into a handkerchief. McBey had revelled in his roles of both lover and chaperone to Gripper's girlfriends, but in the early hours of 24 August 1929, he watched her leave his Holland Park home for the last time as she commenced her journey back to the US, accompanied by Lee Smyth. Before doing so, she again wrote in his diary – 'Good bye my darling' – time-stamping it at 5.05 a.m. that morning. McBey was hurt, recording his 'agony' and sleepless nights for days afterwards in his journal. 'You had made up your mind to marry Robert,' he later wrote to her, still seething.

You sailed in haste, crossed home and agreed to marry him all in three weeks. Now you don't expect me to believe that you, a very wide-awake American girl of twenty-seven, intend to marry a man (caring for another more) merely because he taps your pity by threatening suicide.[28]

Had this last point hit a raw nerve with McBey for obvious reasons? The forthcoming wedding was heralded in the *Pasadena Post* on 2 November – 'Musician Will Exchange Marriage Vows Tuesday.' McBey, who would still be in New York, would note the wedding, 5 November, in his diary, and, probably in a fit of pique, score it out. But, in the days following his arrival, he did not have to look far for distracting and exhilarating Stateside experiences. New York was bursting with multi-generational immigrants from the Middle East, Italy, Ireland and elsewhere and echoed to the voices of street peddlers on the Lower East Side, street preachers in Greenwich Village and children everywhere. In this rapidly growing urban centre of nearly seven million people, hatted pedestrians crowded the sidewalks, foods from the old country were consumed by people with exotic dialects and famous names sparkled from theatre billboards. Above all, the noise of construction boomed out across the city.[29]

Two days after McBey's arrival, however, economic disaster struck when Black Thursday shook the stock market on Wall Street. The market, bloated with borrowed money, nose-dived as Black Thursday was followed by Black Monday, culminating in Black Tuesday, 'the most devastating day in the history of the New York stock market [...] It combined all of the bad features of all of the bad days before.'[30] If McBey had spent two cents on *The New York Times* or three on *The Brooklyn Daily Eagle* during those crisis days, he would have read headlines proclaiming the end of the good times. He little knew it then, but events on Wall Street would also herald a slump in the market for etchings. Curiously, McBey mentions nothing of the Crash in his diary. He spent 24 October – Black Thursday – at New York's Metropolitan Museum of Art, having earlier booked himself into the Vanderbilt Suite at the Warwick Hotel. (The Warwick Hotel was built in 1926 by media tycoon William Randolph Hearst.) With Gripper still on his mind, he passed the time in New York meeting art dealers and collectors, securing commissions, and travelling with Lee Smyth. Smyth proved a timely distraction, taking him on a car ride across the borough of Brooklyn – and, as it appears from his diary, making herself sexually

available. McBey met Albert H. Wiggin, the bespectacled and (under the circumstances) beleaguered head of the Chase National Bank in New York. McBey revealed that he was, in fact, much affected by the scenes of financial panic in an interview with a London newspaper the following year.

> On the very day of the Crash, I lunched in [Wiggin's] office with Wiggin and George Davison, [president] of the Central Hanover [Bank and Trust Co.] – two of the financiers deeply involved in that crisis. For an hour and a quarter they talked prints with me, drawing on their immense knowledge of the subject, giving not the slightest indication of anxiety, and not even mentioning the crisis which might end their careers. Yet outside people were flinging themselves from windows, crowds were in a frenzy of fear and excitement, and, as I found on leaving, New York looked as if it were in the throes of an earthquake. It is an experience I shall never forget.[31]

McBey later dropped by Times Square – 'Liked it there,'[32] he noted in his diary – before heading west to Chicago. He arrived in the Windy City on 15 November at 9.40 a.m. In Chicago, where Capone had risen to prominence as its crime boss, he checked in to the Blackstone Hotel. At Knoedler, at 622 S. Michigan Avenue, he oversaw the hanging of twelve of his portraits, but, owing to the perilous state of affairs in the markets, the show was a disappointment. Still, he received favourable press, with the *Chicago Daily Tribune* commending his portrait of Sir Harry Lauder as 'full and running over with the comedian's irresistible personality. From the twinkling eyes to the stocky figure it is a priceless portrait, a capital piece of characterization.'[33] He also found time to mix with the city's art fraternity, was wined and dined, and lunched at the Tavern Club, which was a magnet for artists and media types.

McBey later headed back east to Cleveland, and, on 29 November, was in Philadelphia, where the city's Print Club, holding its Second International Exhibition of Prints, had organised an afternoon meet-and-greet with the artist. The event, advertised in *The Philadelphia Inquirer*, facilitated his meeting with wealthy American advertising executive, Harold H. Kynett – the very same man who would later privately publish McBey's nautical adventures on the *Mavic*. Kynett became a committed collector of the Aberdeenshire man's works – and a friend for life.

'I met James on his first trip to America,' recalled Kynett in *The Face of Change: Flippancies for the Future*, published in 1960.

> It is the custom of art dealers to parade at luncheon distinguished artists and [Philadelphian print dealer] Dick Sessler invited me to the luncheon he was giving to James. I have never seen a more obviously uncomfortable guest, politely but morosely silent. I shared his discomfort. When the interminable meal was over, I went up to him. 'Did this lunch bore you as much as it did me?' I asked. His eyes lighted. 'I am afraid it did,' he replied – and we were on the road to friendship.[34]

Kynett appeared to grasp something of McBey's complex persona from the beginning. The Philadelphian later asserted that, for as long as he knew the famous creative, 'He remained the quiet, attractive Scotsman that he was, concealing his idiosyncrasies stubbornly with a certain reticence, cloaked in a good-humoured conversational bent that shrank as the numbers about him increased.'[35]

In other words, McBey could be outwardly awkward and painfully shy. Indeed, Kynett's insight into his friend's character is revealing for so many reasons. For all his love affairs, glad-handing, travelling, working and fame, something of the bashful teenager sitting huddled behind his easel at John A. Hay's evening art class on Aberdeen's Union Street remained in the middle-aged aspects of James McBey. In 1929 Philadelphia, and surrounded by bombastic Americans eager to do his bidding, McBey's instinct might have been to retreat into the boy he once was.

That said, he had clearly perfected a temperament and countenance that found favour almost everywhere he went. His diaries reveal his countless meetings, appointments and commissions as he journeyed around a now Depression-hit America. He caught Giacomo Puccini's opera, *La Rondine*, in New York on Christmas Day 1929. Later, on 14 March the following year, he departed for Britain on the *Majestic*. He was seen off by a number of well-wishers, including Lee Smyth, who dispatched a wire with the words 'BON VOYAGE I LOVE YOU' which McBey received two days later as a Marconigram (time and date received – 03.26 a.m. on 16 March). The Marconigram was probably delivered to his cabin later that morning by a steward carrying the cable on a silver salver, or was maybe slipped quietly under his cabin door as he slept. Perhaps the artist cut the envelope's throat with a sterling silver opener before extracting

the message sheet (with the word MARCONIGRAM highlighted in bold red lettering). However he received the Marconigram, he would have no doubt loved the sentiment within as he was prone to bouts of despair.

Back home, he was still the artist about town. He bought himself a Buick, in which he had some interesting encounters – 'at Newcastle bus ran into me.'[36] He made another journey to Scotland, where he visited Newburgh, noting wistfully on 6 September: 'So strange to think of last time when I was with Frances a year ago.' Heading back south, he wrote on the eighteenth: 'Stopped at farm at 135th milestone for London in memory of F.' Despite yearning for Gripper (now Mrs Schad), he lived it up, taking in the thrilling Wimbledon semi-final between American Bill Tilden and Frenchman Jean Borotra (Tilden won by three sets to two in a topsy-turvy 0-6, 6-4, 4-6, 6-0, 7-5 battle of wits) and indulging his tried and tested method for warding off despondency – surrounding himself with adoring female company.

McBey was far from finished with the US, however, and he booked a return journey – on the *Aquitania* – picking up his visa (immigration no. 2617) on 29 September. He left southern England on 11 October, alone this time, before arriving in a New York thick with fog on the seventeenth. The Great Depression was now metastasising across the industrialised world – but, while US unemployment soared higher than a Manhattan skyscraper, opportunity was still knocking for McBey. Met off the *Aquitania* by Lee Smyth and the Kuhn brothers, as he had been one year earlier, he checked in to the Hotel Brevoort on New York's Lower 5th Avenue. From New York he travelled to New England, where 'He wandered up the east coast to Boston and back, particularly captivated by the little ports, to which he often returned.'[37]

Having agreed to several portrait commissions on his previous visit to Philadelphia, he returned to the city in November to make good on these agreements, accepting the offer of a studio. Subjects included Charles Copeland (a figure involved in the business and artistic communities in Delaware) and Lessing J. Rosenwald (a businessman, collector and philanthropist). McBey soon became the toast of Philadelphia. In contrast to the lightning crack of New York City, 'Philly' was smaller and lower key. Playing host to nearly two million residents, Philadelphia was no less impacted by immigration, with those of Scottish, Irish, Russian and German descent making up the many blue-collar families who called the

hard-working metropolis home.³⁸ McBey lodged at the family residence of J. Leonard ('Dick') Sessler, the prominent bibliophile and print expert. He remained newsworthy – *The Philadelphia Inquirer* from 30 November, noting that the artist 'is now in this city', featured his portrait of the very beautiful Mrs J. Leonard Sessler, one half of the couple with whom he was staying.

He also reconnected with Kynett, travelling with him to Valley Forge and visiting his home. It was a satisfying friendship. The American advertising supremo, full name Harold Havelock 'Doc' Kynett, was six years younger than the artist, and loved nothing more than fuelling McBey's passions, revelling in the Scotsman's 'magnificently argumentative mind.'³⁹

'When James discovered that I was collecting his work in preference to all others, he bloomed with friendly discourse,' remembered the thrice-married Kynett in his *The Face of Change* hardback. 'The normal course of events came after; James liked my home and we made sketching drives into the country, which is to say that he did the sketching and I did the driving.'⁴⁰

On 3 December, another life-altering detour began when he attended a dinner party hosted by a Philadelphia couple. There, he met a woman by the name of Marguerite Loeb, who had made the journey to her hometown from New York City, where she was living and working. She had travelled reluctantly, owing to the distance involved, and because the third was a Wednesday and not a weekend. At just twenty-five, she was tall, elegant and strikingly beautiful. McBey, on the cusp of turning forty-seven, remained 'a powerful, energetic man with an irrepressible sense of humour.'⁴¹ With the complexion of a porcelain doll, delicate cheekbones and an American drawl that belied her distinctly Philadelphian roots, the darkly alluring Marguerite instantly took the Scotsman's breath away. The feeling was mutual. McBey's diary entry was initially understated – 'Met Miss Loeb. Sat next to her at dinner.'

'At the dinner party I sat next to James,' recalled Marguerite decades later in a 1991 interview with *The Press and Journal*. 'He was a great raconteur and I was fascinated by him. He never lost his Scots accent. I used to say that he had thistles on his tongue. He had a beautiful voice.'⁴²

Marguerite's chocolatey brown eyes and McBey's bluey-grey must have met many times over dinner that winter's evening. McBey, a Scottish

oak of a man, had, we know, encountered (and seduced) many women in his time, and whether he instantly saw the willowy and Jewish-born Marguerite as marriage material rather than just another potential sexual conquest is difficult to say. Yet, beneath her stylish demeanour was substance altogether more intriguing.

This young woman, like McBey, sat smoking and laughing in between courses at the home of attorney Joseph Winokur and his wife, Beatrice. She had been born to Adolf Loeb and his wife, Hortense Huntsberry, in Philadelphia, the largest city in the Commonwealth of Pennsylvania, on 30 April 1905, while some 3,360 miles away an aspiring artist in Scotland's north-east was then twenty-one and supporting his elderly grandmother and ailing mother through his work as a bank clerk. Marguerite's origins couldn't have been more different to McBey's. Schooled in her birth city, she spent her formative years in Switzerland and at the Sorbonne in Paris. She also trained as a bookbinder in New York and at the French capital's École des Arts Décoratifs. Her father was a 'prominent' German-born Philadelphia tobacco merchant who, before suffering a fatal cardiac arrest on the golf course after completing eighteen holes at the Philmont Country Club on 25 October 1930 at just fifty-nine, was president of his late uncle's wholesale firm, K. Straus and Company Inc., 'one of the oldest tobacco houses in the country.'[43]

Marguerite had almost sent her father to an even earlier grave years before when she met and fell in love with Austrian artist Oskar Kokoschka (1886–1980) while studying at the Sorbonne. They had a brief love affair – but the Expressionist painter was some two decades her senior, and Adolf dispatched the family lawyer to bring Marguerite back to the United States, confiscating her passport into the bargain.[44] Surviving letters, however, reveal just how involved the twenty-year-old Marguerite had become with this hot-blooded polymath raised in Vienna.

From Kokoschka, straight-haired, clean-shaven and with a large, expressive face, there were romantic fits of pique:

'It would be egging you on to be dishonourable towards yourself, if I helped you to evade that telegram from your Papa,' he wrote to the young Miss Loeb from the Savoy Hotel, Paris, in the early summer of 1925. 'He thinks you ought not to see me even in the morning unless you spend the whole night with me, spend your whole life with me. He thinks

you [... must] preserve yourself, so that you can be a woman, when at last you find a man you really love!'[45]

There were also intimations of marriage:

'I love you so completely that I want to make you my wife, gladly and whenever you please,' Kokoschka wrote from the Grand Hotel Kronenhof-Bellavista in Pontresina, Switzerland, later that same summer. 'I have such complete confidence in you that I will voluntarily let you go away from me again [...] for as long a time as your parents think is necessary, so that they can be convinced that you have not made a mistake, and that you want to be united with me.'[46]

But a match between Oskar and Marguerite was not to be. Prior to meeting McBey, she was already familiar with the artist-adventurer's etchings, having worked for a short time at the Print Department of the Philadelphia Museum of Art after her forced return from France. In December 1930, the Loebs were still reeling from Adolf's sudden death, but any paternal obstacle to Marguerite's romantic liaisons was there no longer. Relationship between father and daughter had likely been volatile if the Kokoschka episode was anything to go by. Marguerite herself would later suggest that McBey would have fared little better in trying to gain Adolf's approval had he been alive at the time to give it.

'My father didn't mind me marrying someone who wasn't Jewish,' she said in the same 1991 interview. 'He didn't mind me marrying a Scotsman. But marrying an artist – that was the limit.'

Marguerite's life experiences over the 1920s had made her worldly-wise, talented and classy. Back in New York, McBey pursued his new love interest. She was at that time plying with vigour her unique trade at New York's 457 West 57th Street, where she 'executes de luxe book bindings that cost from $60 to $350, all made by hand with tools imported from Europe.'[47] On 15 January 1931, in a letter which gives two New York addresses – Harlow, McDonald & Co., 667 5th Ave. and the art studio of Ernest Roth (1879–1964) at 5 East 14th Street, where McBey had first ensconced himself on his maiden visit to New York in 1929 – he betrays his resolve to win Marguerite's affections, even noting that, at these two locations, he was available between 10 a.m. and 6 p.m. He also frequented the Hotel Brevoort, and, for good measure, notes his availability there between 11.30 p.m. and 8.15 a.m.

'I have phoned you twice or rather tried to,' he wrote somewhat pompously, addressing her formally as 'Miss Loeb'. 'The first time a male voice was most secretive as to your whereabouts, and the second time a female was by comparison most frank and informed me you would not return to New York till possibly Friday. I have every intention of trying again tomorrow.'

Another, undated, but probably written around the same time, and again addressed to 'Miss Loeb', delicately warns her not to get 'too embroiled with chance young men you may happen to speak to' and asks, 'Remember me to your mother', before signing off, 'With my kindest regards.'

There was great interest back home in McBey's American adventures. In February 1931, E. Arnot Robertson (or Billy) wrote to him in typical fashion.

> Very darling James, Many thanks for your last letter – even though the date of your return is as far off as the middle of March. I'm thankful there's some prospect of seeing you again; I was beginning to get definitely jealous of America and her famous hospitality, and was wondering whether you were going to be seduced by it by making the dam [sic] place your headquarters, for good and all [...] *Please* don't fix up to go back there next year; I hate your being out of London for so long.[48]

Mollie Murray, writing a year earlier to the artist in her uniquely gossipy style – and near-illegible hand that defined most, if not all, of her letters – had made no attempt to hide her own curiosity about his first US jaunt. 'Since your telegram on Jan. 1 no news from you except stock exchange and car technique!' she had said, adding: 'Are you spending the rest of your life in America? Have you found a suitable wife there? Or have you given up the idea of getting one?'[49]

Mollie, smarting at McBey's radio silence, would also keep abreast of his second visit – but even she would little realise how perceptive her earlier letter would be. At the end of January, McBey sailed to Bermuda to join Marguerite and Hortense for a fortnight's holiday on the North Atlantic Island territory (then popular with Americans looking to escape Prohibition). There, he was charm personified, attentive to the needs of both the recently bereaved Hortense, who, born in 1882, was more McBey's age, and Marguerite herself. Romance between the Scotsman

and the young Philadelphian blossomed. He sketched her, photographed her and, as revealed in code in his diaries, shared intimate moments with her, and many tender ones, before they consummated their relationship. On 11 February, on their voyage back to the US, where 'after the blue of Bermuda, these grey seas looked so northern and cold,'[50] he asked her to marry him. It was a 'maybe' – but ten days later, he asked again, and she accepted.

In contrast to his initial somewhat angsty missives in which McBey is clearly uncertain about Marguerite's feelings, subsequent letters are more personal, and, of course, peppered with cheery sketches. McBey's feelings towards her had, by this time, become all consuming. Now, he was addressing his new fiancée as 'Darling' and 'Sweetheart' and relaying amusing anecdotes. On an illustrated 27 February note in which he relates a curious tale involving a friend applying a poultice to his neck to soothe a boil he adds, once more looking for reassurance: 'Did you miss me on the journey down?' ending with 'My love to you.'

Marguerite 'understood and accepted'[51] that, even as his wife, she would take second place to McBey's passions as an artist. But, with a wedding to plan and action, a ring was required, and, while he made out the purchase to be a simple affair in his diary, the New York-based bookbinder was more revealing. 'Met James at 3.30 to buy wedding ring,' she wrote in her own diary. 'He so nervous and shy – gave me a wad of notes and made me go into Cartiers ALONE. I got one in spite of my self-consciousness while he paced the pavement biting his thumbs.'[52]

They were married on Friday 13 March at the sky-high Municipal Building, located at the intersection of Chambers and Centre streets in downtown Manhattan, with Dick Sessler acting as the groom's best man. It was a quiet affair, but with Marguerite standing at (give or take) 5'8 in height, they must have made for a striking couple. A photograph taken soon after their marriage shows them sitting side by side: McBey is dressed in a three piece suit, with a cigarette held loosely in his right hand, while his thick-set hair sits on a head cut like Aberdeen granite, which, when his face was animated, Marguerite later recalled, was akin 'to a Louis XIV sun, beaming with pleasure.'[53] Marguerite, seated to his right, and looking like a Native American princess, is slighter in appearance, her face more refined, her jet-black hair pulled back. There was over twenty years between them – but a remarkable married life lay before both.

He had found love and marriage Stateside, but why now and why Marguerite? Nearing fifty, and with his dizzying array of past (and present) lovers, McBey clearly sought the veneer of respectability that being married gave, not to mention a lifetime companion who could negate his periods of melancholic introspection and loneliness. This man of culture and success had at last tied the knot with a woman who was, in looks and accomplishments, herself unique and captivating. McBey was forever surprising those around him, but Marguerite's own charms should have rendered his sudden marriage less surprising than it turned out to be. That a mutual attraction between two beautiful people had resulted in a genuine whirlwind romance is beyond dispute, and if ever there was a perfect remedy for consigning Frances to history, this marriage was it. Yet, let us not forget that McBey could very well have married Mary Louise (Inglis) years before, had it not been for the protestations of her overbearing mother, or Frances herself had she not decided to return to – and wed – her fiancé in Pasadena.

In this sense, then, it was third time lucky for the Scotsman, but to imagine that McBey went into married life with Marguerite with the intention to stay faithful and leave behind his past behaviour would be to misunderstand a character trait now ingrained. McBey moved in very libertarian circles, and his attitude to relationships was cavalier – indulging, we know, in love affairs with both single and married women. He had a chequered history in this regard – and whether he admitted it to himself or not, echoes of his father's past actions were present in his own. He was – and would forever be – a womaniser. Did his mother's problematic ways – with her pernicious brand of indifference – and his own illegitimacy make him seek out the affections of women who could give him the attention that he appeared to lack as a child? Or was his conduct simply due to his being freed from the rigidity of his Protestant roots? More likely, the truth lies somewhere in between. In the years to come, no one would know the artist more intimately than Marguerite herself, and she would later have her own opinions about her husband's childhood as it related to many aspects of his character.

McBey's sexual adventuring would continue even after his marriage, and echo behaviour indulged in by many other creatives at the time. Take Augustus John; the Welsh-born painter and printmaker, who, in 1897, suffered a serious head injury whilst diving into the sea that caused a

change in his personality and, according to critics, markedly altered his artistic style, was widely known for his wayward love life. Despite marrying in secret fellow artist Ida Nettleship (1877–1907) in 1901, the restless John soon began an affair with Dorelia McNeill, resulting in her later moving into the marital home, where, amid this menage a trois, an illegitimate child was born. Pablo Picasso was another kindred spirit: the Spanish artist had two wives and four children with three women during his long, frenetic and often ugly life, with multiple other sexual liaisons in between. In terms of philandering, McBey was joining the ranks of John and Picasso, but also Sir William Orpen and Anders Zorn, to name but a few. McBey's free-spirited ways in matters of sex needed little encouragement in a profession then rife with brazen misogyny.

The new Mr and Mrs McBey boarded the England-bound *Olympic* the same day as their nuptials, arriving in Southampton on 20 March, and soon after at Holland Park itself. It is not clear how much Marguerite knew of her new husband's past or indeed what she herself expected (initially at any rate) from her marriage to McBey, but her own romantic history had made it clear that she was no shrinking violet in affairs of the heart. It seems reasonable to assume that only after she had arrived in London with McBey did the nature of some or all of his most recent relationships come to light, by which time she would have had a greater sense of the man she had wed.

After his split from Gripper, not twelve months before his marriage to Marguerite, McBey had another pregnant girlfriend on his hands. Fay Woods had spent three tumultuous years being courted by McBey while he pursued other relationships, Gripper included. Miss Woods was a freelance journalist, and wannabe novelist, who first approached McBey on 25 March 1927 requesting an interview for an article on etching. She returned on 5 April, and the Scotsman's diary revealed that they kissed – '3 in all' – after which a liaison began. Woods was just twenty and looked like the quintessential English debutante. Her artist lover had long been a human-Venus-fly-trap where women were concerned, and he saw her as willing prey.

As already indicated, we should picture McBey's life at this time to be one of revolving doors. Fay Woods took her place among his medley of women, and on 1 June, they had sex for the first time. Clearly, Fay felt compelled to see McBey, who obliged her as and when his diary allowed;

and when the Scotsman later that year began recording his sporadic sexual encounters with another young woman by the name of Fay (Taylor), his frenetic sex life became wilder still. But the young journalist's behaviour must have aroused the suspicion of her solicitor father, because even he became involved in Fay's love affair, visiting Holland Park Avenue – 'R. Woods came round, and discussed Fay's coming to studio,'[54] the artist noted in December 1927. Mr Woods kept up a correspondence with McBey, likely with his daughter's reputation in mind. Fay almost certainly knew her lover was a far from faithful companion. The earnest Woods, like Isa Curtis and Billy Turner before her, also fell pregnant with his child (in May 1930), prompting, it appears, McBey to pay for her to get a termination at a London nursing home.[55]

When she told McBey on 10 September 1930 that she was to be engaged, thereby ending things, he expressed no regret. Theirs had been a tempestuous relationship – 'Fay Woods came 8 but we fought over letter she wanted me to destroy. Feel disappointed and old, and disillusioned,' he recorded on 30 September 1927 – and he had repeatedly resisted her desperate appeals to marry. Indeed, her letters to him had often been intense – 'You don't want a wife only a lover'[56] and 'I feel in love with you – as you are – selfishness and all – you big brute'[57] – as well as tender – 'I shall never forget you last night – the very gentleness of you [...] A kind, fond smile on your face [...] that I shall capture again and again in my darkest moments.'[58] While she would marry Robert Martin, the heir to the Bob Martin petcare company, in March 1932, her debut novel – a hackneyed effort that was nevertheless reviewed in papers as far afield as *The Sydney Morning Herald* and which was dedicated to her then fiancé Robert – would reveal just how much her life had been touched by the artist. Published just a year before she wed, and called *Burnt White* (1931), the story was a thinly veiled pastiche of aspects of McBey and his life. 'This story is of one Michael Moray, a young man of humble birth and exceptional ability who makes a favourable impression on the managing director of a bank and welcomes the offer of a clerkship [...]'[59] noted one press review. And the 'unreliable young man' and 'young rake'[60] in the story? One James Ewan McBean – a Scotsman, naturally.

Marriage had now left McBey on a par with many of his one-time love interests, such as Billy, Mary Louise, who had wed second lieutenant Sydney Eric Gillett in January 1917, and Phyllis, who had married

divorcee land agent and surveyor George Langley-Taylor in August 1922. It is easy to see why Marguerite had decided to settle down with McBey, having found in him a way to enhance a life already well lived. His looks, vocation and accomplishments meant he stood out as a man apart, and despite his philandering ways, he enjoyed lavishing attention (and a genuine care) on the opposite sex as well as receiving affection from women. Moreover, his intellect made him 'a consistent library patron when it came to developing his capabilities', and 'he discussed religion in the hair-splitting fashion of the Covenanter';[61] he was (and would continue to be) himself the subject of portraits by fellow artists, such as Gerald Leslie Brockhurst (1890–1978), was a committed theatre goer, music lover and avid film buff, and had 'a passion for precious stones',[62] purchasing in Jerusalem, for example, during the First World War, an intaglio – 'an elongated oval of spinach green'[63] – which he had fitted into a Roman ring and wore for years afterwards on the ring finger of his left hand. His desires ran deep – but his infidelities would soon become a defining aspect of his marriage to Marguerite.

CHAPTER NINE

Paradise

'The world is three days: As for yesterday, it has vanished along with all that was in it. As for tomorrow, you may never see it. As for today, it is yours, so work on it.'

– Hasan Al-Basri (642–728)

1 Holland Park Avenue, for so long McBey's bachelor pad, was now his marital home. It had seen its fair share of drama since the artist first purchased the property as a decommissioned war artist returned from the Middle East twelve years before. Women had come and gone (as the notches on his bedpost could testify), hearts had been broken (his included) and art had been made. In love affairs he was an expert, but he was a bricks-and-mortar man too.

From the moment he entered Holland Park Avenue in 1919, he had grand designs – and soon:

> devoted himself to restoring and improving it. He levelled the ground between it and the street, built a high wall and made a 'Dutch' garden. He found for it antique doweled floorboards and put in eighteenth century pine panelling. Gradually, over the years, he collected piece after piece to furnish and embellish it, lavishing on it most of the money he earned, and all his knowledge, imagination and ingenuity.[1]

McBey must have waxed lyrical about his London home as Marguerite and he made their way to England on the *Olympic*, where a clearly loved-up Marguerite hung on his every word. 'Dearest Mother – I have such a lot to tell you,' she wrote breathlessly aboard ship on the *Olympic*'s fancy stationery on 18 March.

> I just wish we could have a few hours together but just wait – It won't be much more than a month and we can walk into Kensington Gardens […] and talk and talk and talk […] James is a darling – the sweetest man you could ever fancy. And I'm frightfully hard in love […] What with one thing and another I

have had a very strenuous trip. On Monday night the weather turned bad. The boat slowly and laboriously ascended mountains to pause and tremble at the heights before dashing into the very bowels of the earth. I felt as if I were on some dreadful apparatus at an amusement park that simply could not be turned off [...] There seems to be a lot that I have forgotten such as 'how divine and what a darling he looks in pyjamas' but perhaps it is just restraint plus writers' cramp. It has all been lovely and I am 'glad I came'. So is James and if he is at all nervous about London he is hiding it well. I will be anxious for your first letter. Lots of love darling and a fat kiss, Marguerite.[2]

When Marguerite first caught sight of Holland Park, as their taxi from the station pulled up outside, she must have taken her new husband's hand and squeezed it in delight. But it was otherwise to be an inauspicious start for the new couple, who had journeyed from southern England by train after their vessel had docked at Southampton. Marrying in secret was a sure-fire way to shock and surprise his many friends and acquaintances. When Patrick Finneron, his butler, met them both at Waterloo, he accompanied the couple back home, where Jeanie, his wife and McBey's housekeeper, 'turned white [...] and disappeared into her quarters until next day.'[3] The Finnerons had waited on the Scotsman for seven years, and Marguerite's appearance would cause Jeanie to nurse a grudge for months afterwards. 'Mrs. Finneron [...] upset – not a pleasant homecoming at all,' he scratched into his diary on 20 March. 'Unpacked and went to bed early.'

McBey's unpublished biography, written initially by English author Rupert Croft-Cooke after the artist's death, but later partially re-written by Marguerite herself, mentions that McBey 'seemed quite incapable of understanding the social aspects'[4] of his bringing a hitherto unheard-of (American) wife back to England. But it seems more likely that this man of the world knew full well the confusion that would ensue – and took great delight in it. He introduced his beautiful bride to his friends, each of whom were taken aback by the news. Martin Hardie's wife, Agnes, wrote to her son: 'this I am sure he feels is the biggest "leg-pulling" stunt that he has ever brought off!'[5] His male friends were no doubt bowled over by Marguerite's good looks. Some of the ladies were, on the other

hand, put out, such as Malcolm Salaman's wife, Annie, who was 'upset I hadn't told her.'[6]

But Marguerite, in another letter to her mother, shortly after her arrival, betrayed no hint of discomfort in her new surroundings:

'Darling, it's a funny thing, I have been thinking so much of you this week and James has been talking such a lot about you,' she wrote to Hortense on 30 March, posting it to the ocean liner, *Paris,* in New York, from where Mrs Loeb would sail to London on 10 April to stay at Holland Park. 'He took me over to the Dutch Garden so as I should know where it was to show it to you and Sunday last we drove out into the country to spend the day with a writer friend of his and her husband and we went via Burnham Beeches and the country was exquisite and he said I must bring you there! I can hardly wait until you come. I shall be so glad to see you! I know my way about quite well now [...] I am so busy working on my room and you will have to help me with the living room when you come – it is the only one in the house that looks unlived in and I am waiting for you cause I know you will enjoy shopping around auction rooms here in London [...] The place is very lively with Bach religious music now so near Easter – all the passions and Handel's *Messiah*. I guess we'll stay in London as James hasn't mentioned going anywhere. He is straightening and putting order to his old papers of which he has a large collection. I help him a bit and I am learning a lot – also about old frames. The Finnerons are really darlings and can't do enuff [sic] for me. I've met quite a few of James' friends and each in turn is dumbstruck at his really being married. Oodles of love and a big kiss, Marguerite.'[7]

When the media got wind of the match the following month after Duncan Macdonald informed the press, McBey's marital status quickly became public knowledge.

'Mr. James McBey, the distinguished Scottish artist, who, it is revealed, was recently married in the United States, has arrived in London with his bride [...] a native of Philadelphia,' Dundee's *The Evening Telegraph* told its readers on 14 April. 'Mrs. McBey is also an artist, and recently held a successful show of book bindings in New York. The news of his wedding

came as a great surprise to his friends, who had long regarded him as a confirmed bachelor.'

Eight days later, London's The Evening Standard hailed 'The New York Love Story of a London Artist', in which the Scotsman was quoted on page two:

> Our marriage was not exactly a secret [...] though both Miss Loeb and myself wished to keep the ceremony quiet. Only a few personal friends were present, including my wife's mother, her brother and her cousin, Mr. Paul Hahn. The best man was Mr. Leonard Sessler, an art dealer, of Philadelphia, and a personal friend of mine. It was he who introduced me to Miss Loeb at a dinner. But even he did not know we were to be married until a few hours before the actual ceremony.

It is hard not to think of McBey as the cock of the walk at this time, strutting with his exotic wife by his side. In the days and weeks following their return from the US, it was all catch-ups – with Billy and Henry Turner featuring often – cinema trips and whisky and sodas. On 30 April, Marguerite turned twenty-six and received the gift of a 'big ring'[8] from her husband. He also 'arranged the loveliest dinner party with caviar, birthday cake and all the exotic delicacies you could think of including two bottles of Sauerkraut juice with their necks tied up with pink ribbon and some kind of rare Chinese fruit.'[9] Later, on 29 June, he and Marguerite, along with the Turners, attended the summer dance at the Chelsea Arts Club. After Hortense (and Marguerite's seventeen-year-old brother, Arthur) arrived in London, the McBeys and Loebs decamped to France, where the Scotsman sketched, bought antiques and made a pilgrimage to Vincent van Gogh's grave in Auvers-sur-Oise, on the outskirts of Paris.

In October, McBey and Marguerite made for Scotland in his Buick, taking in Inverclyde, Glasgow and the arresting Rest and Be Thankful Mountain Road in Argyllshire, where they lunched. The ramparts of Stirling Castle followed, where he likely regaled Marguerite with tales of his 'turning point' as they looked out across the town from their vantage point of Castle Hill. In his native land, and with his wife an ever-present companion, he golfed and sketched his way towards the north – encouraging Marguerite to pursue her own love of art with the watercolours and sketchbook he had earlier purchased for her – as his birthplace pulled him ever closer, like a needle to the pole. 'To Foveran,' wrote McBey in

his diary on 11 November 1931. 'Showed M. churchyard [...] Stopped for two minutes [Armistice Day] silence.'

'Two generations of my family are buried here – seven in all,' McBey might have said to Marguerite as they stood over the Gillespie family gravestone in Foveran Kirkyard with the bare autumn trees shivering around them. 'But how I miss my granny – Mary was the best of us.'

The sights of his childhood, and the memories – both painful and warm – were interspersed with visits to old friends, such as Alice Macdonell and James Hutcheon. In Aberdeen, he likely drove past Union Grove's grey granite tenements, pointing out to Marguerite number forty-two as inquisitive Aberdonians caught sight of his beloved Buick's 'black fabric body and yellow disc wheels.'[10] They would have driven along the routes and past surrounding thoroughfares he had once roamed daily. Did he show her the very part of Union Street where, cycling his way to the police station after his mother's suicide in the dead of night, a scarpering black cat had struck his front wheel causing him to lose control and crash? And did he proudly walk her past his first art studio on Justice Mill Lane, and take her to the building where his dreary days as a bank clerk had begun?

They returned to Holland Park on 30 November – St. Andrew's Day – and on 23 December, McBey celebrated his forty-eighth birthday. Marguerite's classy ways soon became part of their homelife as she continued to advance her bookbinding career and found a way to win over Mrs Finneron. She immersed herself in her husband's creative obsessions. But, by the year's end, and according to his diary, there were signs that he was again up to his old tricks, and Marguerite, whose 'experience of the British climate had been restricted to two summer visits, in 1922 and 1926',[11] was not taking to the rigours of an English winter. She had been plagued for months by viral bugs and longed for more temperate surroundings. Marguerite later remembered:

> Every morning as I scanned the sky, looking for a small break in the clouds and beheld only a thick, low, grey blanket I said to whomever was about, 'Do you think it will clear today?' No one had the courage to tell me the truth which I with time found out for myself. When it did clear, it was almost worse, for then I saw that even when the sun does shine, during the winter, it is very weak and has not the strength to stay up long. James

> understood my depression and promised to take me to Spain
> [...] where he could paint and we could explore the coast to see
> if we could find a place in the sun – a warm sun.¹²

Marguerite would revisit her husband's birthplace (with her mother) in July 1932. McBey would later write to her of it: 'there is a strange fascination about the place, in spite of its melancholy (at least it is melancholy to me, but this may be on account of its associations). There certainly is a peace which one might search the world for and not get.'¹³ In late August, Marguerite's dreams of sunnier climes came true when she and McBey set off for the Iberian Peninsula. 'They took a leisurely route, down the west coast of France, through Bordeaux and into Spain, via San Sebastian, Burgos, Madrid, Toledo and finally [...] Seville, where [McBey] had rented a studio.'¹⁴ Before they reached the Andalusian city, McBey fell foul of the rules against sketching fortifications without a permit, and was instructed to report to the civil governor in Vitoria-Gasteiz, located in Spain's Basque Country. Spain was a stickler for bureaucracy, and he and Marguerite were often asked to present their credentials to the authorities as they travelled. 'On a lonely road in Aragon, [I was] asked for my car papers,' McBey recalled.

> He unfolded them and gravely perused them, holding them
> upside down. He then informed me that they were quite in
> order and returned them to me with an impressive salute.
> After that experience, I always handed my papers upside down
> when they were asked for. The papers were invariably in 'good
> order.'¹⁵

This was the Scotsman's third visit to Spain – and 'in Seville he concentrated once more on bullfighting, making sketches and finished watercolours of the matadors, toreadors and the magnificent black bulls'¹⁶ – but further south and across the Straits of Gibraltar, lay a land McBey longed to revisit.

'When, after months of adventure, the car finally reached Algeciras on the south coast of Spain, James asked me if I would like to see Morocco,' recalled Marguerite of their trip there on 20 September when they sailed from Tarifa. 'We left the car behind and crossed for a few days.'¹⁷

Morocco must have ebbed and flowed in his mind like a tide since his last visit there with James Kerr-Lawson over the winter of 1912–1913. Some two decades had passed since McBey had sailed 'into the quieter

waters off Ceuta, then South for another fifteen miles or so'[18] before heading to Tetouan by mule. McBey was now a rich man, with a new wife, when back then he had been of moderate means and a bachelor. Just as much had changed within his own life, so it was in the life of Morocco.

As McBey had earlier predicted, this North African country on the Atlantic and Mediterranean coasts would be subject to European change of profound proportions. Tetouan – once distinctly Moroccan in ambience and appearance – had now become a melded version of East and West. The city had been the capital of the Spanish protectorate of northern Morocco since 1913, and its 'old Soko, the Moorish market-place outside the city walls, had been transformed into a Spanish-style town square, complete with palm trees and bandstand.'[19] In order to recapture something of the fading sights and sounds of old Morocco, they travelled some eighty miles south-west to Alcazarquivir (locally called al-Kasr al-Kabir) and then Asilah, a fortified seaside town on the Atlantic, where they tried (unsuccessfully) to purchase a property. Tangier followed, and had she been alive, then they might have called in on artist Helen Russell Wilson, who had sketched with McBey in 1913 and lived on the Old Mountain Road. She had passed away in 1924, in the year that Tangier had transitioned into an international zone after Britain, France and Spain had agreed on its permanent neutrality in December 1923. McBey roused his wife at 4.30 a.m. as she slept soundly at their hotel eager to explore the port city, before they headed back to Europe the same day. In the pitch black, they prowled the empty streets as silently as cats and 'saw day-break from a bit of land looking across the Straits of Gibraltar to Spain.'[20]

Oddly, McBey left blank his diary for 1933, though that year would turn out to be one of the most significant of his life. Save for making a hurried pencil-sketch of a picture frame framing the image of an unidentified man on one of the pages, the artist was either weary of documenting his life or was too preoccupied with things to make keeping a journal a priority. The McBeys were a couple on a mission – and after travelling back to Holland Park Avenue in late 1932, they returned to Morocco the next spring, intent on buying a place to live. They made for Tangier – then well on its way to becoming the den of vice and iniquity that would make it a byword for notoriety in later years – where the sights were

seductive and rich and where the Straits shimmered under a warm North African sun. Just two miles west of the city, they found their paradise: a small ramshackle house originally built by Sidi Al-Hadj Abd al-Salam – the cherif of Wazzan – for his English wife, Emily Keene, whom he had married in great splendour in Tangier in 1873. The building was buried deep in dense garden atop a hillside, but the artist and his wife saw there its potential as their new home.

'The day after we had been shown the cherifa's garden, James said he would like to go to the adjoining hill which looked down onto it for a picnic,' recalled Marguerite later:

> In this way we might see it again without giving the impression that we were too keen – a thing to be avoided at all costs. The day was splendid, the view across the water to Spain and then through the Straits of Gibraltar was the most beautiful I had ever seen. There was a serenity and a tranquillity as yet unknown to me [...] 'I think I'd like to see what is down there,' said James, so we explored the property like a wild park which extended to the sea. We passed into a dark and quiet shade on this day of brilliant sunshine, treading black earth in a world of hushed silence.[21]

Marguerite was lithe, graceful and elegant, and her forty-nine-year-old husband was imposing and outwardly unflappable. With the artist likely leading the way, they 'traversed groves of giant cedars [and] large, twisted acacias emitting the sweet scent of their yellow blossoms.'[22] Deeper into the undergrowth they ventured, leaving an excited medley of Scottish and American voices in their wake, until the ocean was in sight; and soon 'the whole coast of Northern Africa to its most north-westerly point lay before'[23] them. McBey 'loved it immediately and decided to make it his own'[24] buying the house and garden, and later the adjacent land of thirty acres. The house they called Jalobey – a playful, and Arabic-sounding, corruption of James and Loeb – and the land Cherifian Rocks after the cherif who had once owned the estate decades before.

In December 1933, McBey turned fifty. Perhaps the looming nature of this milestone was the reason the artist decided against keeping a 1933 diary. We know from Marguerite's own recollections that he was 'sad at being 50'[25] – but at least he was spending it in Morocco, where he and his wife were now renovating their 'picturesque ruin'[26] of a house.

The half-century-old McBey was still handsome, if a little jowly. He wore round-rimmed spectacles on a brooding face upon which his cleft chin remained proud. His frame had expanded somewhat over the years, but he carried it well and kept himself active by way of his jet-setting lifestyle. For formal occasions – events or studio photographs – he would often slick, or at least comb, back his fairly thick (if now receding) hair, but at other times, it sat on the top of his head, wind-swept and interesting. He was a 'devout adherent of stale New Zealand cheddar' and 'had a yearning for baked potatoes and vanilla ice [...] the two foods over which he was fussy [...] Similarly, he was devoted to sleep. His ability to concentrate on sleep surpassed belief.'[27] As earlier indicated, he retained a roving eye – and the onset of his fifties would do little to quell his urges.

Wilhelmina Greenhill (1899–1977) was part of the art scene in London and had studied in Italy and at the Chelsea Art School. On 16 January 1934, Mina (as she was known) arrived in Tangier on the steamship *Mooltan*. She proved a willing sketching partner for the Scotsman – and (soon) a sexual one. Mina was exactly McBey's type – slim and much younger (a full sixteen years). She was not as beautiful as Marguerite (very few women were), and juggling a wife in her late twenties and a thirty-four-year-old lover was an audacious move, but perhaps he was on a quest to reclaim his youth. Back in London, Marguerite encouraged them both to weekend in the Cotswolds, where his first revealing diary entry on the matter (he resumes his diary keeping from April 1934) is from 30 June – in code and written from right to left, as if in a bid to conceal it further – 'Mina slept with me.' Clearly, Marguerite knew well her husband's peccadillos – and her tacit approval of their relationship was surely her attempt to accommodate him and keep him onside. But it couldn't have been easy for her so early into their marriage, particularly when other wayward aspects to their union began to emerge. As Marguerite's own recollections make clear, there was seldom harmony in their marriage. The celebrated artist and charmer was not an easy man to live with and always acted according to his own terms. The picture Marguerite paints is of a husband with little tolerance: 'James cross because I showed I was tired. "If I am tired go to bed"' and 'nagged me about posture and feet in front of friends. Apologised. Hard work blamed.'[28] McBey even denied his wife the prospect of having children, because of his own complex persona.

'J. was v. sweet and went into the matter thoroughly from his point of view,' Marguerite recollected of her desire to be a parent – and his steadfast refusal:

> He gave up a first-hand intensity between himself and his work when he married. He knew he was doing it and chose to in order to avoid that awful ache of loneliness which nawed [sic] at him constantly. He *wanted* a companion. If I had a child he would have to give me up but he would be willing to if I really wanted one [...] He [as a child] was made but so unwelcome [and] suffered so that he thinks it unfair to bring anyone else into the world to be subjected to the same thing.[29]

McBey's contention that he didn't want to be a father because of his own emotionally stunted childhood clearly has substance – and it is arguably to his credit that he wished to remain childless because he had not the emotional resolve nor inclination to give a child fatherly love. In essence, he did not want any child of his to feel as he had as an illegitimate; cast out and alone. Yet, that is where any sympathy for the artist begins to wane. By his reasoning, he had partly sacrificed his first love – his work – by marrying and would have to sacrifice it further if they started a family. But reading between the lines, it seems clear that he just couldn't bear to share Marguerite with anyone else. As she recalled of another domestic episode – 'James says he only loves me when I am dependent on him and need him. When I'm independent it's a game like chess.'[30]

McBey's former lover, Fay Woods, had similarly been wise to the artist's conflicted attitude to independence several years before: 'It is curious that you are so independent and yet as I have come to know you – so dependent,'[31] she had written him, making an observation that must have stung.

Marguerite would never bear a child – but, in years to come, she would find ways to assert her own role in the marriage. For now, though, they made it work – and McBey's paradise of Jalobey became something of a surrogate child for Marguerite. They became devoted to their place in the sun – with a pond of 'sacred goldfish', views of Spain and, when they finalised the purchase of Cherifian Rocks, their own private beach. While Marguerite spent the summer of 1934 with her brother in Jalobey, the artist travelled once more to Scotland's windy north-east coast.

McBey was going to the University of Aberdeen to receive an honorary degree of Doctor of Laws (LLD), an unusual move for this somewhat anti-establishment figure, who had plotted his course of independence years earlier. It was the morning of Monday 9 July when the Scotsman attended the university's Mitchell Hall, Marischal College, to be conferred by Professor A. Mackenzie Stuart on the instructions of Principal Sir George Adam Smith. Again, there was no gloating in his diary – just a mention that he 'Got car washed' before heading to 'Mitchell Hall where got degree of LLD.' He was honoured alongside another high flier, Professor Harold Arthur Prichard, one of the twentieth century's leading Oxford philosophers. The artist had been unable to attend the spring graduation on 4 April because he had been overseas – but he must have taken great pride in the honour. One shot depicts him with four university dons after the ceremony, probably before he was due to lunch at the Elphinstone Hall buildings. He stands to the right in the picture, steely and brooding, with the build of a retired rugby player who could still do some damage.

The Aberdeen press reported on the summer ceremony, which included the graduation of 174 students, some of whose happy faces were splashed across page three of *The Press and Journal*.

'It had been said of the North-East of Scotland that it was not a region productive of great artistic activity – that its artists and poets were few,' said Professor Mackenzie Stuart,' ran the 10 July report of the printmaker's investiture.

> They welcomed Mr. James McBey there with gratitude, for he had taken that reproach from them. He came with a reputation widely acclaimed as one of the greatest etchers of his or any age. His most famous plates, in their masterly purity of line, provoked comparison of those with Rembrandt. In the years since he left the ledgers of The North of Scotland Bank for the bitten line, he had delighted and amazed the world with the vitality and range of his work. He could interpret with an equal imaginative power the deserts of Egypt and the turbulent seas of his native coast. But his etchings, however diverse in subject, had always that delicate reticence, that economy of effort at once vigorous and rhythmic, which had made his contributions to art so individual and personal.

Fine words indeed – but why had McBey chosen to accept this distinction when he had shunned (and would shun) others of a more artistic nature? It was a significant award from the city of his youth for one, and it was an educational honour he likely thought he deserved, having left school at just fifteen. Perhaps he allowed himself this one treat in the hope that it would lay the ghosts of his forgettable schooldays to rest – and perhaps it did.

The newly decorated doctor of laws was back in Tangier two months later. On 18 September, Hortense joined him as they docked at the port city, where Marguerite, sporting a big hat, met them off the *Dempo*. Marguerite then drove them to Jalobey, where McBey had added a studio in which to work in peace. 'Saw carpet hanging over studio window [… Jalobey] looked so clean and white,' he wrote that day. In the afternoon, all three boarded the *Dempo* as it continued east. They sailed up the Spanish coast, and after pausing at Marseilles, where they briefly disembarked, continued through the Strait of Messina, passing Crete before landing at Port Said on the twenty-fifth. Fifteen years had elapsed since McBey was last in the Middle East – and the memories ('Kept thinking of 1919, 4 Feb.' he scribbled later that day) hit him as potently as the muggy Egyptian air.

The Arab region had undergone huge changes since the end of the First World War. Egypt had long ceased to be a British protectorate, having become an independent state in 1922 – albeit one with continued British interference. Fuad I, formerly Ahmad Fuad Pasha, was now Egypt's king, soon to be followed – in 1936 – by his son, the self-indulgent and corpulent Farouk I, who would be overthrown sixteen years later by the hurricane that was Gamel Abdel Nasser (and his Free Officers). In the Levant, Mandatory Palestine was under British jurisdiction – and not until 1948 would the State of Israel be established, sparking the first Arab-Israeli War. Lebanon – cobbled together from the Maronite-Druze-dominated mountains and the Muslim-heavy Mediterranean coast – was now a distinct Republic under a French mandate, and Syria a separate national entity which too sat uneasily under Gallic rule.

And what of the First World War's Middle Eastern protagonists with whom McBey had engaged and whom he had painted during his official role as a war artist? Emir Feisal, having failed in his bid to become ruler of a great Arab Kingdom, had, as consolation, been handed the

throne of a newly created Iraq by the British in 1921. The one-time Arab Revolt leader, who had sat squirming on a loose doorknob while the artist immortalised him on canvas in war-torn Damascus, had died in 1933, and was replaced by his son, Ghazi bin Faisal, who would be killed six years later in a car accident. A fatal accident would also take the life of forty-six-year-old T. E. Lawrence (then going by the name of T. E. Shaw) after he was thrown from his Brough Superior SS100 motorbike in Dorset, close to his cottage, Clouds Hill, in the spring of 1935. As for General 'the Bull' Allenby, now 1st Viscount Allenby, he was enjoying his retirement, but would succumb to a ruptured cerebral aneurysm at his home in Kensington one year later at the age of seventy-five.

As McBey's lungs filled with the heavy scents of Port Said for the first time since 1919, his initial thoughts were likely less about the region's geo-politics and more about Isa Curtis. If, as Billy Turner later told Mrs McBey, Marguerite and Isa 'were the only two women James really loved',[32] then it is probable that Mrs Curtis was an enduring memory, brought to the surface by old sights and sounds. Leaving the morals of their affair aside, who could blame him for remembering her now? Theirs had been a passionate relationship which had resulted in a (short-lived) child, and he could have been forgiven for half-expecting her to meet him dockside. Yet, Isa was almost certainly not in Egypt but in southeast England, where she and her retired husband now lived in Kent, and where her own memories of her one-time lover were surely as intoxicating and profound.

From Port Said at the northern end of the Suez Canal, they journeyed to Kantara and then at 11.30 p.m. caught the night train to Jerusalem, arriving at 9.30 a.m. After pushing through the dark desert landscape, McBey revelled in the mid-morning splendour offered by the Holy City. There he was reunited with his old friend from the American Colony, John D. Whiting. Over the following days, he revisited the Holy Land's iconic sites – such as Herod's Gate, The Wailing Wall and Bethlehem – sketching as he went and noting it all down in his diary with typical precision. 'Lunch. Then taxi to Jericho and Dead Sea,' he wrote on 29 September. 'Had swim. Then drunk at cafe. Gramophone and loudspeaker! Home at dusk.'

McBey, Marguerite and Hortense left Jerusalem for Lebanon on 4 October. 'Saw Nablus and Jenin. Nazareth. Arrived at Haifa and left

baggage at Hotel Nassar,' recalled the artist that day. 'Held up at French customs. Arrived Beyrouth 2 p.m.' Lebanon, as revealed by an official census taken two years earlier, was then marginally dominated by Christian Maronites (at fifty-three per cent of the population), followed by Muslims (at thirty-nine per cent) and other faiths, largely the Druzes, at eight per cent. It was, at this time, seen as a safe haven for the Middle East's Christian communities looking for a home – and a Western protector. 'The original idea that served as a basis for the establishment of the Lebanese state was to make it into a refuge for all the Christians of the Orient and an abode of undivided fidelity to France,'[33] wrote Elias Peter Hoayek, the Maronite patriarch, to the French minister of foreign affairs in 1926. It would be this kind of partisan thinking that would bring the country's myriad sects into bloody conflict as an independent state.

McBey's personal interest in Lebanon was for the eminently sketchable ancient sites. He returned to the history-rich town of Baalbek, featuring such towering wonders as the Roman ruins of the Temples of Bacchus and Jupiter. On the seventh, McBey, Marguerite and Hortense left Lebanon from Beirut, and headed south down the Mediterranean coast to Acre, where they 'sketched and explored.' They revisited Haifa on the same day and on the eighth, departed once more for Egypt. 'Took taxi to station but wise detour due to streets being lit up in memory of [King] Feisal,' he noted.

The Scotsman retraced his war steps in Egypt thoroughly on this visit, but the journey lacked the dramatic edge of his 1917–19 commission. Marguerite's contention – 'I don't like travelling in this style, no sketching or anything, just tourists. Very dull and I won't do it again'[34] – was McBey's opinion also, and they were glad to get back to their haven in Morocco on 25 October.

McBey and Marguerite had worked closely together during their Middle Eastern travels. While McBey had sketched, his wife had photographed. This approach gave the artist another source from which to convert his hurried drawings into studio-based oils and watercolours, and the practice became a way they often collaborated in later years.[35]

McBey had now become used to sharing Marguerite with her mother, Hortense. An accomplished pianist, Mrs Loeb was at this time fifty-two years old. She was, as earlier suggested, more the Scotsman's age, and onlookers might have thought that it was they who were husband and

wife – and Marguerite their daughter. Like McBey, the widow was a woman with family intrigues. Hortense, born in Mount Vernon, Ohio, was the daughter of Lawrence E. Huntsberry, assistant to the Secretary of the Knox Mutual Insurance Company, and Caroline (also known as Lena or Lina) Oppenheimer. She never knew her father, who, shortly after his marriage, attempted to kill himself with a .38 Smith and Wesson. Injured, but not fatally, he was later 'judged insane' and spent the rest of his life in various facilities. It appears that Hortense had little idea of her father's fate or whereabouts. 'She adored her mother,' noted Marguerite, 'and told me she never asked her for fear of hurting her.'[36]

In the midst of his role as husband, son-in-law, adventurer and philanderer, however, McBey was an artist first and foremost. As a committed adherent to the Protestant work ethic, he laboured at his artistic work every day like it would be his last. He remained one of the greatest printmakers – if not the greatest – of his time, but the etching market had long been in decline – the Wall Street Crash, which he had viewed first hand, having seen to that. During the boom times of the 1920s, 'there had been mobilized a public comprising two types of print buyers: the amateur d'estampes, who responded to the aesthetic appeal of the original print, and the speculator, driven by publicity surrounding the more spectacular sales.'[36] Treating prints as a speculators' market, thereby inflating their price, were the very people – stockbrokers, bankers and businessmen – who would lose their fortunes in the Crash. McBey's art was still highly valued, and in January 1935, his enduring masterpiece, *Dawn: The Camel Patrol Setting Out*, fetched $1,450 (some $29,600 in modern prices) at the American Art Association Galleries, New York – much to the ire, no doubt, of some of the world's less celebrated etchers. English printmaker William P. Robins (1882–1959), perhaps envious of his rival's fame and fortune, 'felt that McBey, as much as any dealer, was responsible for "ruining the market" with the outrageously high prices he had charged for his prints.'[37] The Scot, wise to the diminishing returns of a medium which – as he once confided to James Greig of the *Morning Post* – had seen him lionised by many patrons 'as a sort of mild Messiah',[38] began to focus his energies on watercolours and oils, for which he had long been critically acclaimed.

But it is hard not to see 1930s McBey as an artist past his headlining best. If Rembrandt and Whistler were the all-time king-emperors of

original printmaking, then McBey was arguably their successor; but as a middle-aged artist in a post-printmaking world, he was seen by some to be resting on his laurels. Picasso, *The Observer* remarked, was an artist who thrived on 'the almost infinite variety of his invention', and who composed 'remarkable productions, marked by clarity of design, brilliance of colour, vitality, and what might be called [...] an aristophanic imagination.'[39] The Spanish-born pioneer of Cubism was 'the most extraordinary artist of the day', but 'even in revolutionary times' the Scotsman was content 'to live peaceably under a king', added the same article, damning McBey with faint praise. He was, it continued, an individual who had opted 'to stick to the old regime, taking his Nature as he selects her, and keeping his eyes open.' But an exchange between McBey and young wannabe artist Anthony Lousada (1907–1994) in the summer of 1930 had revealed him to be a very contented creative during this period of flux.

'We used to talk a lot about the painters we admired, and certainly I would never have had such a passionate and lasting love for the Rembrandt landscape drawings but for his indoctrination,' recalled Lousada of McBey, writing sometime during the late 1960s.

> But I was puzzled and one day, unconscious of the daring, I said: 'When one looks at a painter like Picasso one realises that he is constantly exploring something new, something which no one has done before. Don't you ever feel that you want to do this or are you content to work within the older tradition?' I suppose this was impertinent, but somehow it did not seem to me to be so and James looked hard at me with a slow amused look and then said: 'Well Anthony you see I think that, wonderful though he was, Rembrandt only hit the highest note on a few occasions. If I could do that, say, once, I think that all my working in this way would be justified!'[40]

In essence, McBey had already proved himself, and he felt little need to deviate from his own ethos for the sake of it. The artist who chose 'to live peaceably under a king' was still relevant, globally fêted and prolific. During this period, he painted sublime portraits, many naturally with a Moroccan flair. There was his striking 1936 oil of his wife, Marguerite, and another of Emily Keene, the English-born cherifa of Wazzan. Her marriage to the cherif, who died in 1891, had become the stuff of legend,

and McBey, who painted 'this large woman with a kindly face'[41] at her Tangier home in December 1934, when she was then in her mid-eighties, found her intriguing company. 'I think Mr. McBey's manipulation of the brush is splendid,'[42] she would say of her portrait, which she later permitted to be exhibited in London. But the Scotsman was also much drawn to the everyday citizens of Morocco, painting some of his most beautiful arrangements of 'market women, beggars and street performers [who] were to become the subject of some of his finest paintings.'[43]

In London during this decade, he was also busy in his studio at Holland Park. In 1934, Scottish politician, writer and adventurer R. B. Cunninghame Graham sat for McBey. The artist painted a portrait of the handsome and dandy personality, visibly frail at eighty-two, who, during his sitting, constantly chatted about his travels in South America (where he would die two years later in Buenos Aires). In the spring of 1935, it was hung at the RA, much to the delight of the octogenarian. 'My dear McBey,' he wrote on 3 May 1935. 'THE picture looked splendid in the Academy this afternoon and was admired. Being hung rather high shows it off.'[44] Multi-talented British writer E. V. Lucas was also captured by the artist. Like many others, Lucas thought McBey the double of Beethoven, referring to him often as 'Beet'.[45] He was also quite taken with Marguerite, his one condition of his sitting being that she be present in the studio so he could look at her while McBey painted. Indeed, Lucas' little ditties were often the source of wry amusement, such as one he wrote to the American while she holidayed with her mother in Cornwall:

O Marguerite, it would be sweet, if we could meet, all indiscreet, without old Beet, but Cornwall's far too far away, and here in London I must stay amid the heat, and think how sweet, t'would be to be all indiscreet, with Marguerite, and NO OLD BEET.[46]

Morocco remained McBey's focus. In December 1936, he purchased the property of Dar Ben Zina, Marrakesh, several hundred miles south of Tangier. Marrakesh had proved a great escape for the couple during the winter – when Tangier was often in the grip of harsh weather blowing in off the Straits of Gibraltar. The dilapidated Dar Ben Zina (Arabic for 'the house of the son of the beautiful one') fast became another project. By this point, they had made many friends in Morocco, such as Moulay Larbi el Alaoui, a relative of the Sultan of Morocco, Mohammed V. The

Paris-educated Alaoui, whom McBey also painted, lived in Marrakesh, where he was the Khalifa of the Pasha there. Thomas Corbett – the 2nd Baron Rowallan – whose family the artist had started painting in 1926 (he would complete the last of his nine portraits of the Rowallan family in 1951), did not live in Morocco but joined the Scotsman in 1936 at his suggestion for a Moroccan road trip. McBey had earlier traded in his Buick for an open-top 1923 Rolls-Royce – 'a real skidder'[47] – in which both men

> travelled the mysterious road from Tangier to Marrakesh, and over the Atlas Mountains. The Rolls was piled with provisions and bedding, for there were no air-conditioned hotels with restaurants and private bathrooms for weary travellers [...] We laughed at the same jokes, and I tried to copy his broad Aberdonian accent which no amount of success would make him discard.[48]

On Rowallan's return home, he received a November 1936-dated letter from McBey in which the artist laid bare his latest exploits. The aristocratic Rowallan later reminisced that McBey had a 'personality [...] the sparkle and impact of granite' and that his 'friendship was as solid as that rock.'[49] The kaid of Chichaoua, he wrote, had invited him to his kasbah in the Atlas Mountains to be present at a relative's wedding. His thirteen-year-old Rolls almost melted in the onrushing 'hot wind'[50] during the trek, but he made it to the citadel after more than twelve hours of hard driving.

'The Kaid's black slaves were famous,' he wrote to Rowallan on the very day he returned from his trip,

> and even the Sultan desired one in vain. Only once before had the Kaid entertained a European in his kasbah – [writer and journalist] Walter Harris in 1895! Now don't you wish you were there? We were the only Europeans who had been allowed to fraternise with the slave girls. We had a great time. Acrobats, dancers and musicians, all 7000 feet up. Cold at night but hot in the sun.[51]

McBey's insatiable love for the dramatic was matched only by his prodigious artistic output. Morocco would remain his and Marguerite's paradise – but soon another sizeable event, not of their choosing, would rock their painstakingly carved-out world.

CHAPTER TEN

A war to forget

'Why do old men wake so early? Is it to have one longer day?'

– Ernest Hemingway, *The Old Man and the Sea* (1952).

McBey's propensity to collect had become something of an art form in itself. He was enticed by the myriad riches of antique show rooms – which he haunted like the ghost at a séance. He was drawn to purchasing vintage blank paper, 'in ever increasing quantities, until his collection became the best and largest of its kind in the world.'[1]

He had earlier remarked of this paper-collecting habit:

> My practice is to print my etchings and dry-points on old paper only, because it yields a quality to the impression – irrespective of the etching quality – so far superior to any a modern paper can yield that the trouble and time spent in stalking the steadily diminishing quantity of genuinely old paper now available are more than compensated for. Modern attempts to imitate the surface and the colour have not been successful. The skin of old paper has become soft and velvety, due to the action of time on the surface size, while the strength of the actual paper itself has not been impaired. It has thus the advantage for printing of a soft-sized paper, without the disadvantage of its lack of cohesion.[2]

He also treasured other, more personal, keepsakes. As a child of Victorian Britain, it was perhaps unsurprising that he had a fascination for the strange and the macabre. Sometime after his mother's death, perhaps as she lay sallow and stiff in the dark and dank parlour at 42 Union Grove, he had removed a shank of her hair to keep as a memento. Not a delicate curl – but a large shank, brown with specks of grey. Later this was tied in a neat ribbon and placed inside an envelope on which he wrote: 'Lock of mother's hair and notices about funeral and deaths.'[3] A part of Annie Gillespie will forever remain immortalised in that yellow-stained envelope, 'so escaping from the idea of death.'[4] He retained, too,

the penknife (light brown in colour and crudely inscribed with his initials) that he had used to cut loose his mother's lifeless body, and which he had also likely used to cut that tuft of hair from her head. His own extracted teeth, newspaper clippings, hair shavings from girlfriends, you name it; he kept them all.

Most of these items he stored at his house in London. But by the start of 1937, McBey owned three residences, Dar Ben Zina being his latest acquisition. With this purchase, it seemed as if he was now collecting houses as well as objects such was his property portfolio. Marrakesh was a 'city of the plain with its red mud walls and houses lying wide open under a vivid blue sky, the Atlas Mountains, snowy, a white wall to the South.'[5] After Dar Ben Zina – derelict, but with 'beautiful and noble proportions'[6] – was lovingly restored to its former place in the sun, Marrakesh became his and Marguerite's winter wonderland. They had achieved the restoration by employing local contractors who took their orders from the artist in a comically circuitous fashion. McBey articulated his instructions in his distinctive Aberdeenshire tongue to the multi-lingual Marguerite; she then translated this into French to Moulay Larbi el Alaoui (whose idea it had been to purchase the property), who then passed on the instructions to the workmen in Arabic.

'The mason and plumber always unfortunately had some ideas and objections of their own which they voiced at great length to [el Alaoui], which he translated to me and which I relayed to my husband,' remembered Marguerite later. 'This went back and forth for hours at a time.'[7]

There were other moments of amusement. 'One Friday, the chief mason examined his watch at length before asking McBey if he could have the afternoon off. 'Do you expect to be paid for the time?' McBey asked. 'Yes, indeed,' replied the mason. 'Well, then, I think I am entitled to know where you are going.' Without hesitation he replied: 'Monsieur, I am going to the mosque to thank Allah for sending you here.'[8]

McBey's experiences with Jalobey had made him wise to the ways of Moroccan culture, craftsmanship and bureaucracy, and soon Dar Ben Zina was restored, becoming another crowning glory for him.

The late 1930s continued to see him at his tireless best as both artist and jetsetter. At the start of 1937, he returned to London for work, then took a trip to Scotland, where he painted, fished and golfed with Lord Rowallan, or Billy as he preferred to call him. His relationship with

Marguerite remained plagued by disquiet. His reliance on his young wife as his artistic aide, translator and most of all his companion, conflicted with the liberation he often craved. 'James complains [of] never being alone with his friends (I feel the same),'[9] Marguerite recollected of a heated exchange with her husband in March. His own sexual desires, of course, were fervent at this time. He may have been a philanderer even before his marriage to Marguerite, but it is hard not to see his extra-marital affairs as a defiant show of independence from his wife. There had been Mina Greenhill – with whom he would have another sexual liaison in London in June – and others, such as Clémence Bonnet-Matthews and Lisbeth Simpson, would also fall for the ageing lothario during the late 1930s.

McBey and his wife first met Bonnet-Matthews in late-1936 Morocco. Born in Tangier in November 1909 – almost exactly three years before the artist himself made his first visit to the North African state – Bonnet-Matthews was of French-Moroccan descent and was visually glamorous. Her distinctive features, dark wavy hair and pencil-thin eyebrows were often offset by red lipstick which she was fond of wearing on cupid bow lips. In 1937, McBey captured her on canvas wearing a bright red high-collared blouse with buttons, and holding a cigarette elegantly elevated in her right hand in the manner of a matinee screen idol.

She was a fourth-generation 'Tangerine', was (or had once been) married to Fernando Nunes da Silva Araujo[10] and was mother to Ana Gabriela, to whom she had given birth in 1930. Neither Fernando nor Ana were an obstacle to the relationship between the artist and the Moroccan-born free spirit. McBey diarised the evolution of their relationship in typically finite detail. It began in the autumn of 1937 as she sat for him. A sexual encounter with her on 19 October had him proudly declare them lovers. The reason for his joy was because at nearly fifty-four, he was a full quarter of a century older. Moreover, she was sexually adventurous – '[CODE – Clem suggested kissing me all over].'[11] She also took to teaching him the Tango. On 1 November, her twenty-eighth birthday, he gifted her her portrait together with a 'small bottle of scent.' During his relationship with Clémence, he remained a social animal, mingling not only with Marguerite, but with her holidaying mother, Hortense, and with Billy Turner, who also dropped by Tangier for a winter break, before

taking off to Dar Ben Zina with his wife on 1 December. A week later, his lover joined him in Marrakesh, where his affair resumed.

But as Marguerite's own revelations make clear, she too was sleeping with Clémence. She had not only been privy to her husband's promiscuity in this regard, but was content to turn her marriage into a menage a trois and explore her own sexuality in the process (if she hadn't already with other women). The three sometimes quarrelled with each other in the manner of a polyamorous marriage: '10 p.m. C. went over all my faults,' noted McBey. 'Began to lose patience and went to my own bed [...] Went to Cl. room and slept with Marguerite',[12] and 'Clémence [...] came and cried on terrace,' recalled Marguerite. 'Said she thinks James is tiring of her – dramatic.'[13]

Marguerite's bisexuality was likely part of her nature long before her husband's infidelities – but it's possible that her fulsome embrace of it was hastened by McBey's own behaviour. Theirs was now an open marriage, but the artist was still highly dependent on his wife day-to-day due to his own personal demons. His mistress admitted as much to Marguerite: 'Clémence told me that J. had said in Tangier he could not get on without me and had to do all he could to keep me,'[14] the American recalled of a conversation with Clémence in 1938.

In early 1938, Herbert Paton, Ann (Nan) Simpson and her sister, Elizabeth (Lisbeth), arrived in Morocco on the *Dempo*. Fifty-five-year-old Herbert was an ex-colleague from the bank in Aberdeen, and had long been in London working as a successful businessman. He had reconnected with McBey seven years earlier after reading about his marriage in the newspapers, and lived in Woldingham, Surrey, ostensibly with Nan as his wife and Lisbeth as his secretary. However, not everything was as it seemed. If McBey's life was complicated, so too was Herbert's, who appeared to carry on the pretence of being married to Nan when the truth was otherwise. In fact, he had married Aberdonian Nellie Bisset Esson[15] in 1910 – with whom he would remain legally wed until the end of his life. He now seemed to be enjoying his own menage a trois with Nan and Lisbeth in south-east England. McBey and Marguerite had visited their spacious home and garden in Surrey from the start of their marriage, and it was Lisbeth on 20 December 1931 with whom the ever-amorous artist appeared to have his first (recorded) extra-marital sexual encounter.[16]

McBey and Marguerite had returned to Tangier from Marrakesh at the start of February 1938. On the eighth, the Aberdeenshire man rose early – as he so often did to make the most of the day ahead – and went down to meet the arrival of Paton and the Simpson sisters before dawn broke. He would often light a large bonfire 'near the cliffs of the lower property' as a 'welcome signal'[17] to friends who were arriving by sea – and had he done so on this occasion, the snapping flames would have made for an especially visible spectacle in the gloom of early morning. The trio – travelling first-class – would have had a very comfortable voyage from Southampton, relaxing in the main lounge with its beautifully carved timbers and living it up in the smoke room and bar. It was a pleasant Tuesday morning when McBey drew up quayside in his Rolls Royce Silver Ghost, his distinctive face likely eliciting beaming smiles from the group as they caught sight of him. The holidaymakers were not planning on being in Tangier for a long time, but they were planning to have a good time – and probably knew that the artist and his wife were kindred spirits.

Within days, and as McBey continued to court Clémence, he was intimate with Lisbeth; in fact, only two days separated the liaisons – 14 February with the former and the sixteenth with the latter. Lisbeth, also from Scotland's north-east, was forty years old. Photographs suggest she was not as naturally beautiful as Marguerite or Clémence – or as young – but the letters between them in subsequent years demonstrate that McBey found in her a committed friend and confidant.

These encounters were just how he lived life, but, as Marguerite later revealed, their marriage was in trouble, commenting 'SEX must have been the trouble between us really.'[18] Whether it was a lack of sexual intimacy between them as husband and wife or McBey's promiscuities that were the main point of friction is not clear – but when the couple decamped to London in mid-March, Clémence joined them. When she returned to Morocco on the *Narkunda* on 27 May, however, the Scot was left bereft. 'Felt lost in studio,' he coded in his diary later that evening, adding the next day: 'Feel lonely Clémence being gone. 1st time we have been alone since a year.'

It is clear that he had married Marguerite primarily to ward off the spasms of solitude which had dogged him since his early days in London. By 1938, he had long taken her companionship for granted, but she was still a necessary presence. In truth, McBey was, despite his God-given

talents as an artist, an insecure middle-aged man who craved constant female adoration at heart, and Clémence had been his bright new shiny toy. But, Marguerite, functioning as his typist, hostess to his friends and lovers, and even his hairdresser, remained by his side. Their lives throughout 1938 and 1939 continued to revolve around their exotic travels together (and independently), to London, Tangier, Marrakesh, Agadir and the South of France, to where on 12 August 1939, McBey saw off his wife and Hortense from London's Victoria Station on holiday.

McBey's love affairs had been almost relentless – Clémence in Morocco, Lisbeth in Morocco and at Holland Park Avenue, or H.P.A. as he termed his London home in his diary, and other, more opportunistic seductions, such as his 23 August 1939 London liaison with sixty-two-year-old Annie Salaman (whose octogenarian husband, Malcolm, was now an invalid), with whom he had recorded one sexual encounter twelve years before. But at the end of that summer, the prospect of another world war threatened to curtail these affairs. 'State of tension. Seems like war,' he wrote on 29 August from London, adding two days later: 'Things look very black.' On 3 September, war began. 'Plenty rain during night,' he wrote that forenoon as he sat by the wireless – a cigarette or cigar likely in hand – anticipating Prime Minister Neville Chamberlain's address. 'Beautiful morning. At 11.13 (I wrote this) waiting Chamberlain's announcement. Beautiful sunny morning […] He begins from 10 Downing St. At war with Germany.'

The days following Britain's declaration of war propelled the McBeys into self-preservation mode – but the artist remained naïvely (and unusually) hopeful, writing to Hortense on the eighth:

> When I saw you off that day at [London] Victoria [Station] I did not think there would be war so soon. I saw by your letter to Marguerite that you had a very wonderful landing at Tangier. I do hope that the war will not affect you out there. I don't see why it should as Spain is now at peace internally and is to remain neutral in the present war, as is Italy,

he penned, little suspecting that Spain's neutrality would largely align it with Hitler's Germany, and that Mussolini's Italy would actively join the war on the side of the Nazis in June 1940.

> I see also the Italian liners are sailing to New York as usual, so you will not feel you cannot get away if you want to […] Sailing

permits are now required for anyone going abroad, and regulations etc change from day to day, but in a little Marguerite and I will try to get to Tangier.

Yet, two days later, McBey felt the need to evoke his faith – and confide his private guilt over his many infidelities – in writing, scribbling in code in his journal: 'God help me. I promise never again abuse.' He even 'resolved to give up [H.P.A.] and live very simply from now.'[19] The house, with its 'substantial dining room, panelled in 18th century wainscot and furnished with robust late-17th century Spanish chairs and a sturdy Flemish oak dining table,' its 'elegant' north-facing drawing room as well as its 'great T-shaped studio (with a storeroom)',[20] would in fact not be relinquished by either of the McBeys until more than six decades later. On 23 October, he and Marguerite boarded the New York-bound *Statendam* at 2 p.m., where he observed the presence of 'many Germans (Jews).' Before the break of dawn on the thirty-first, they docked beneath the Big Apple's soaring skyscrapers, which poked through the grey autumnal clouds in the falling rain.

The fifty-five-year-old had intended to travel back to Morocco that autumn but was persuaded by his wife to visit the States, where, as a US citizen, her passport was impounded by Immigration on account of the war. McBey's artistic career was required to take secondary importance for the first time since 1916 – when he had been commissioned by the War Office to report to the AP&SS in France during the First World War. But he had long known what was coming: 'I wonder when I shall print my next etching,' he noted weeks earlier as he got his affairs in order. 'The last print I took must have been the prayer at Marrakesh, with the Atlas.'[21]

Up until the outbreak of war, he had been a powerhouse of art production. At Colnaghi's in the spring of 1937, he had exhibited a range of his Moroccan oil paintings, such as *Sirocco*, *Tichka Pass: High Atlas* and a portrait of Moulay Larbi el Alaoui as well as those with a link to his birthplace – not least *Portrait of a Hero,* in which he depicts John Innes, the former 'coxswain of the Newburgh lifeboat during McBey's youth [who] had been decorated for bravery.'[22] A portrait of his wife also adorned the show, where his new style of painting – 'flatter and more tempera-like, his colours clearer [...] he showed he could use the sheer beauty of line

as effectively in a painting as in his etchings'[23] – was hailed by some and slated by others:

The Sketch was among those who praised him, describing the show's opening to its readers:

> A good come-back to the galleries is James McBey, at Colnaghi's. He has not shown his paintings for about ten years, so it is pleasant again to meet his sure touch, atmospheric truth and flair for colour. The Private View was crowded. Mrs. McBey, who is a very attractive lithe American, wore a fur cape. Gina Malo, whose fine natural-looking portrait is hanging there, wore a black fur coat with a little black skull cap on the back of her head. A U.S.A. friend had cabled over buying the portrait for a present to Gina on her marriage to Romney Brent ... Mrs. Chou, subject of a lovely portrait by McBey, arrived in a long lavender velvet Chinese dress and no hat. Lords Gainford and Hampton were early arrivals. Mr. Martin Hardie, of the South Kensington Museum, came with his wife; and Lady Walston, [printmaker] Mr. C. R. W. Nevinson, and Mrs. McOstrich were other viewers. For half the year, the McBeys revel in the sunshine and colour of Tangier, where they have a house. The other half is spent in London. About a quarter of the paintings were sold the first day – all those I wanted myself had gone before I arrived.[24]

His mastery of tone, exemplified in other creations such as *Acrobats Marrakesh*, in which the painting's viewers are effectively part of the pictured audience, and *Beggar and Child*, gave his North African works dazzling quality. Both of these paintings had relied on Marguerite's photographs to achieve the end result. Morocco, with its wide-open spaces, thronged marketplaces and intoxicating mix of colours, had, for McBey the artist, long been another mistress; and nothing, not even the vast, rich and divergent tracts of the fifty-state US republic, would compete.

But now, McBey was in the US, and there he would stay for the duration of the war. The artist, erroneously described as a merchant in the *Statendam* passenger manifest, arrived in 1939 America with an uncertainty about the future alongside travelling teachers, students and housewives. He had just seventy pounds in his pocket – the most he was allowed to bring into the country. He was at least familiar with the States and its

traditions – and the art scene remained familiar with him, particularly in his overwhelmingly recognised role of printmaker.

Indeed, in Washington, D.C.'s *The Sunday Star* earlier that year, art critic Leila Mechlin had joyously heralded the publication of McBey's 1934-conceived *Manhattan*, 'a view of Manhattan looking down the East River from a point of vantage well upstream.' She informed readers the published etching was 'distributed in a limited edition by the American College Society of Print Collectors.' She wrote:

> James McBey is one of those few fortunate artists who has not had to wait for acclaim until too late to enjoy it [...] It is interesting to know that this skilful and accomplished etcher prints himself every proof that he signs, to which may be in part ascribed the uniformly high quality of each impression. In other words, McBey recognizes, notwithstanding his genius and good luck, that the production of a work of art involves infinite painstaking, and he does not begrudge it. Only thus are works of lasting merit created. But how encouraging to know that even in this day of haste and carelessness such devotion to the ideal of the perfect actually brings reward![25]

His early days in the country seemed to pass by with relative ease. He dined out, met up with old friends, including Dick Sessler, attended cocktail parties and in November completed his first portrait commission. At the Museum of Modern Art, New York, on the fifteenth of that month, McBey attended the opening of Picasso's exhibition, *Picasso: Forty Years of His Art*, where the Scotsman observed a 'big crowd.' Two days later, he and Marguerite were gifted a Ford by Arthur Loeb, which they used to drive the 100-plus miles from New York to Hortense's home at 6417 Wissahickon Avenue, Philadelphia. There, he continued to socialise, going to a showing of James Stewart's *Mr. Smith Goes to Washington* and talking over with friends his wish to sell 1 Holland Park Avenue. His mother-in-law, having earlier returned from Tangier, 'offered him the large ex-nursery on the top floor [of her house] as a studio',[26] where he did his best to make art from the various Philadelphian landmarks. But he loathed not having a place to call his own. 'We feel like refugees here,' he would later write, 'thankful to have a shelter.'[27]

On 23 December, the émigré turned fifty-six years old. The United Kingdom's younger artistic guns – such as Eric Ravilious (1903–1942),

John Piper (1903–1992) and Richard Eurich (1903–1992) – would largely take on the mantle of official British war artists during the Second World War – but at least one newspaper lamented McBey's loss to the Allied campaign.

'Australian troops are again in the Middle East, strengthening that valuable link in the Empire's defence line,' wrote the author of the literary section of Australia's *The Age* early on in the war.

> This time they will be without the virile, rugged pencil of James McBey to record their activities. The British Government could hardly have chosen a better official artist to depict the wild skirmishes and battles between Briton and Turk in the sands of Egypt and Palestine. James McBey has in his art a quality of stark simplicity admirably suited to the bare, treeless deserts of the Middle East; nor does he lack the strength necessary to draw men tough and wiry after strenuous, sun-baked days [...] Whilst in the East James McBey found time to draw the Australian soldiers who formed such a large and important part of the troops stationed there. And it is hard to find a more striking tribute to our manhood than in these vigorous facile sketches. His hardy Scottish upbringing had made him a superb realist and such drawings as that of Sergeant Jim Liddy are masterpieces in their strength of tone and character.[28]

His 'hardy Scottish upbringing' had, actually, provided mixed blessings, but had no doubt contributed to his ability to document the First World War; yet it would be a war to forget in terms of his artistic contribution to this next global conflict. While he had been largely privy to the events of the First World War through his posting in France in 1916 – and his commission on the Palestine Front from 1917 – he, like other civilians, would have to get his Second World War news from radio and the press.

In the spring of 1940, and after returning north following a brief visit with Arthur at his home in Brevard, North Carolina, where he made some quick sketches of a seven-year-old African American girl called Vessie Owens,[29] which he later turned into an oil on canvas portrait, McBey wrote to Herbert Paton: 'We climbed at 8 a.m. on the morning of the 10th May and paused at a "parking look-out" at 4.30 p.m.,' he wrote of his and Marguerite's car journey up the Skyline Drive in Virginia.

This I'll never forget as long as I live. There was utter silence. Marguerite had a small radio, and while I made a sketch, she put it on a stone and tuned in. A small European voice whispered from the radio that Hitler had invaded Holland, and Brussels was being bombed. We just sat speechless, for many long minutes gazing sadly at the pleasant land bathed in sunshine, three thousand feet beneath, and then silently coasted down. It was only when we reached the zone of brooks and flowering shrubs that I said to Marguerite, 'This is the end.' I hope I was wrong.[30]

The artist's fatalism was understandable: most of those hostile to fascist Germany – and its fanaticism – feared the onward march of Nazi jackboots. McBey was rarely prone to bouts of hubris when the going got tough. 'Personally I like to know the skipper of the ship on which I sail is a pessimist,'[31] he had written years earlier. But in fearing the Nazi advance, he was simply expressing the concern of millions of anti-fascists worldwide.

McBey travelled to the Cuban capital, Havana, in June so he could sketch and return to the United States as a legal alien, as he was obliged to renew his immigrant's visa every few months. Havana had already captured the heart of US novelist Ernest Hemingway, who later that year purchased Finca Vigía, a hilltop villa ten miles east of the coastal city. Havana would soon become a 'port of call' for 'hot-blooded [US] sailors'[32] after America's entry into the war at the end of 1941. McBey's travels there proved far from straightforward: when he arrived in the capital on the seventeenth with Marguerite, it took multiple photographs, a medical examination and countless trips to and from the US Legation before he was finally granted a permit to sketch on the afternoon of the nineteenth. He celebrated by purchasing a pocketbook holder made from crocodile skin and a Panama hat, and returned to Miami – from where he had left – on the *Florida* alongside Cuban and Soviet-born passengers on 24 June. That day, newsboys proclaimed the end of France, which had surrendered to the Nazis two days earlier.

The Aberdeenshire man was still finding a market for his various creations, and his old American friend, H. H. Kynett, among others, remained an avid fan of his work. McBey was also continuing his portrait commissions – in February 1940, he had charged $1,000 for a portrait of

a Mrs Starr in New York – and would complete many other such compositions by the war's end in 1945, billing patrons as high as $2,500 (give or take, $40,000 today). Portraits were money-spinners for sure – but painting veteran industry executives such as M. Albert Linton and Cecil F. Shallcross proved, artistically at least, a hollow experience.[33]

Yet, his output ensured he remained a newsworthy figure throughout this time. *The Brooklyn Daily Eagle* of 15 November 1940 featured a story of both him and Marguerite under the headline 'Famous Etcher Finds Harbor View Superb', in which Mrs McBey did most of the talking.

'Brooklyn's view of New York harbor is superb, avows James McBey, internationally-known etcher, and is surpassed only by the view of the Strait of Gibraltar from his mountainside home in Tangiers,' ran the piece, below a photograph of the couple and on the same page as a large advert for furs (including 'Black Dyed Persian Paws', 'Natural Skunk Jackets' and 'Silver-Tipped Let-Out Raccoons') and stories about New York crime – 'Gun Blazing, Ex-Convict Killed by Cops after "Kiss of Death"'.

> Mr. McBey, Scottish-born artist who made the official drawings for the British Government on the [Middle] Eastern Front during the World War, is visiting here this week with his pretty young American wife. They are guests of Immigration Commissioner Rudolph Reimer. In Commissioner Reimer's eighth-floor apartment at Montague Terrace, 2 Montague St., the genial grey-haired artist sat before a window in the library, gazing at the skyline of Lower Manhattan, and making preliminary drawings for an etching of the scene. Clad in a bright Scotch plaid dressing gown, Mr. McBey chatted with his wife, the former Marguerite Low [sic] of Philadelphia, and the interviewer as he worked. Commissioner Reimer, who owns a collection of Mr. McBey's prints, plans to submit [McBey's] completed etching of the Brooklyn harbor view to the Port of New York Authority for inclusion in its forthcoming 20th annual report. 'The scene lends itself admirably to my medium,' Mr. McBey said. 'Its grandeur resolves into sharply-contrasting shadings, which I shall attempt to capture in basic lines.' 'It is a wonderful view,' added tall, brunette, Mrs. McBey [...] Mrs. McBey, although not an artist herself, is an ardent admirer of her husband's work. Her avocation before her marriage was bookbinding: now her hobby

is photography, which serves as a complement to Mr. McBey's activities [...] 'We left London after two months of blackouts,' Mrs. McBey recounted. 'The fun, as our hardy neighbours call it, had not yet started. When last we heard, our town house still was unscathed by bombs, although an incendiary bomb – a dud – fell in our back yard. Our butler, who removed it, wrote us about it [...] ' Mrs. McBey thinks Great Britain is putting up 'a marvelous fight', and both she and her husband were pleased to find this country so 'ardently pro-British.' During the interview Mr. McBey used snuff from a supply he buys at the same Haymarket shop which more than 150 years ago served King George III.

While on the wrong side of fifty-five, McBey's charisma still caused many news stories to remark on his persona, as well as his art.

'A sturdily built man, his head crowned with gray and accented by the black outline of shell-rimmed glasses, McBey speaks with a burr, which, though dulled by long years of foreign travel and residence, underlines his Scotch background,' purred another story three months later. 'He enjoys working in America, liking particularly those sections where the sea and rivers are. New York and Maine have absorbed most of his attention.' It added: 'McBey is at a loss to explain the special collector-appeal of his *Dawn Patrol* (at auction it regularly brings between $1,500 and $2,200), and is not sure that it is his best plate.'[34]

There were several events which shaped the life of McBey during his years in the US. When Gustavus Mayer, one of Colnaghi's directors, declared himself bankrupt at the end of 1940, McBey the following year agreed to take back hundreds of his own etchings in settlement of a debt owed to the artist by the London art dealers. While Herbert Paton dealt with the matter on his behalf, and with the entire US at his beck and call, the Scotsman set out with Marguerite westwards on a road trip from Philadelphia on the morning of 23 September 1941. 'Off for California @ 8.45 a.m. [...] About 6 p.m. through Pittsburgh. Factories scaling. Plenty traffic [...] Skirted Ohio,' he noted that day. He crossed the Mississippi River three days later, and after sunrise, his car's odometer was displaying one thousand miles. Nebraska was followed by Colorado, Utah and then the Grand Canyon in Arizona, as Marguerite snapped away on her camera. On 4 October, he left Las Vegas and crossed the Mojave Desert

in the shadow of the Sierra Nevada mountains as dust from his Ford fired out in all directions, its windows rattled and the 'gas meter played high jinks.' He had well passed the peak of his fitness and smoked with a Humphrey Bogart-like zeal, but retained a zest for life, and his two-thousand-five-hundred-plus miles from east to west must have evoked his car journeys in the Middle East during the First World War.

The next day, he was in Los Angeles County in southern California – and on 15 October, he reunited with Frances Schad (née Gripper) for the first time since she walked out of his life during those hours before daybreak in August 1929. The artist's former lover – with whom McBey had once shared an intimate dinner at a French restaurant called La Mère Catherine during a romantic getaway in Paris in June 1929 – was now a respectable mother to nine-year-old Jasper and three-year-old Catherine. She was still married to Robert and had weeks earlier celebrated her thirty-ninth birthday. McBey attended her buffet party on the eighteenth (Robert must have been thrilled), when, as he wrote in code in his diary that day, he 'kissed her gently' before penning: 'Strange reunion after 12 years and 2 months' – not that he was counting.

Los Angeles he found 'a dreadful place.' Writing to Minnie Rennie, the sister of his long-time Aberdonian friend, Henry, he described the City of Angels as 'sprawling over an area from Newburgh to Stonehaven back to Banchory, all of brightly painted wooden houses made to last five to seven years. You feel a heavy shower would wash the whole place away.'[35] He much preferred San Francisco – and when the 'rain [and] heavy fog' over the Pacific city lifted, the metropolis was 'breath-taking in her loveliness. With the exception of that prospect from the mountain in Tangier I have seen nothing like it in all my wanderings.'[36] Like he did at many places he came to love, McBey decided to ensconce himself and Marguerite in a property, leasing a flat on Russian Hill overlooking San Francisco Bay, Golden Gate Bridge and Marin County. The property also overlooked Alcatraz, where Capone, after a stretch of more than four years, had been released two years earlier, and the likes of George 'Machine Gun' Kelly and Alvin 'Creepy' Karpis were still serving time. He explored the city on sketching tours, repeatedly drawn to areas in and around the waterfront.

Marguerite, all too aware of her husband's fear of being alone, decided against attending the wedding of her brother, Arthur, in Chicago on 12 November. Shades of McBey's vulnerabilities had already come to the

fore when, having arrived in California, he was made guest of honour at a California Arts Club dinner. He had asked that he not have to make a speech, but found himself having to do just that after speakers praised his name to the Californian hilltops. It was, as he recalled in a letter to H. H. Kynett, a painful experience, and his address to the assembled audience was restricted to just a few awkward words of thanks.[37]

On 7 December, the hitherto neutral US had a shock awakening at Pearl Harbor. For McBey, the day began as a 'Beautiful warm sunny day', followed by a nice alfresco lunch later with friends. 'Returning we stopped to buy oysters at stall. Man in next car sat at his radio. We heard Japs had bombed Hawaii. Very serious.'[38] The next day, he added: 'We noticed the bridge was not lit over the Golden Gate. Then M. noticed no cars were running. It was our first black-out since England 25 months ago. It was so strange to be back in that atmosphere.'[39]

They left San Francisco on New Year's Day 1942, planning a leisurely return back east. America was now at war, and on high alert. Just how alert the artist experienced first-hand when he and Marguerite were accosted in Santa Barbara harbour by naval officers who did not take kindly to his sketching. They were promptly arrested, strip-searched and thrown in jail; Marguerite with an inebriated prostitute and McBey with three drunkards. It was a humiliating experience that only ended when an FBI agent came to their rescue. The FBI agent was a Mr Donald Daughters, about whom McBey later wrote a letter of commendation to the Bureau's director, J. Edgar Hoover, from whom he received a reply. But the whole affair left a sour taste.[40]

He and Marguerite made it to the more familiar surroundings of Philadelphia by February. Later that spring, a pain in her side saw Marguerite diagnosed with a fibroid growth and a grumbling appendix. Just months afterwards, McBey arrived at another turning point when he threw in his lot with America by becoming a naturalised citizen. On 12 August, he went to Philadelphia's District Court – 'Signed at table, 120 of us, at 10.14, took oath of allegiance,' he wrote. His 'Petition for Naturalisation' included his vitals: his complexion was noted as 'ruddy', his eyes and hair 'grey', his height '5 feet 11 inches' and his weight a not too problematic '182 pounds' or thirteen stone. He had, however, suffered a slight health scare just several weeks earlier when Marguerite took him to see a doctor about pains in his chest, which, according to his

wife's own notes, turned out to be just 'false angina' due to his decades-long smoking habit.[41]

The day before his naturalisation, he had diarised his mixed feelings about trading in the old world for the new: 'Possibly my last day as British subject. Feel I am cutting last bonds with Newburgh.' Newburgh, in the tiny coastal Parish of Foveran, was where his Victorian childhood was bent and shaped like a white-hot horseshoe forged at his uncle's smithy. The place where his troubled mother's world began to darken and where his grandmother had tended to their home, and where his passion for art was ignited like a newly-lit Christmas tree, still tugged at his heart in this, the autumn of his life. Wherever he went, he took his Aberdeenshire roots with him – in his thoughts about the world, in his faith and in his accent. He wore, too, his Scottishness like a badge of honour, particularly as it related to his own belief about England – and the English.

'Combine the financial genius of the Jew, the thrift of the French, the energy and politeness of the American, and the imagination of the Arab, and you will find – a Scotsman,' he wrote some years earlier.

> No wonder he commands respect, and is, perhaps, a puzzle!
> It is from within the range of his own philosophy that the Englishman tries to 'place' the Scot. That is why he fails – and the Scotsman smiles because he has the better of the joke, though the Englishman does not know it.

And suggesting the English were the culpable party for the existence of Britain's class structure, he added, with a nod to Scotland's national bard, Robert Burns: 'When a Scot meets a person, it does not occur to him that the stranger may be placed above or below him socially. He prefers to regard him in any case as an equal. Burns expressed that for all time.'[42] Just months before his naturalisation, he had written: 'In the 28 years I lived in England, I can recall meeting only two Englishmen whom I would have trusted like I would the average Scotsman.'[43]

McBey's letters and diaries had revealed a man little given to overt statements of British patriotism (his First World War years 'had left him very cynical about [British] military abilities'[44]), so his assuming US citizenship was not such a wrench. In any case, he was eleven years married to an American and since 1929 had fostered strong working ties with the country, most of all New York and Philadelphia. At breakfast on 19

August, he received his citizenship papers. 'Feel glad. Feel I have ceased to be a serf and am now a shareholder,' he wrote in his diary that day.

By the time of McBey's naturalisation, his brother-in-law, Arthur, was on active service. At 5'10 and 200 pounds, the strapping twenty-eight-year-old, sporting a visible scar on the left side of his neck from an operation, had left to join the Army on 30 July 1942. Many other of McBey's friends and lovers outside the States were living their own war too. He had retained the Finnerons, his domestic servants at H.P.A. – which proved a financial drain. Clémence in Tangier had been beside herself with worry after her numerous letters to McBey and Marguerite appeared to go astray, and when the artist did receive her 'last try' in a note dated May 1942, he read her heartfelt expressions of grief over this 'new world – a cruel, crazy world.'[45] As for Herbert and the Simpson sisters, tragedy struck when Nan committed suicide at their home on 4 July that year by placing her head in the gas oven 'while the balance of her mind was disturbed.'[46] When McBey received word from Herbert later that month, he replied instantly.

'We were both terribly shocked when we got your letter of the 9th,' he wrote in pencil on the twenty-eighth. 'Today and even after 5 sad hours we find it impossible to realize that Nan is gone [...] I can feel for you, Herbert, and for Elizabeth, too, as my own mother died under very tragic circumstances, which I shall never forget [...] I feel very shaken. I was so fond of Nan.'[47]

In mid-August, a still traumatised Herbert wrote another missive to McBey and Marguerite.

'It was all so unexpected and indeed so terribly unnecessary,' he elaborated. 'Nan had not been herself since the earlier months of the year, and latterly she got so thin and so depressed – over the turn of the war news (she always feared invasion), over the death of [an] old friend [...]'[48]

To what extent the trio's clandestine domestic arrangements had impacted Nan is unknown, but her death must have played on McBey's mind throughout the hot and clammy summer as he travelled back and forth between Philadelphia and New York on business. In New York, he leased a studio for one month at 7 MacDougal Alley, Greenwich Village. In August, he was likely soaking a shirt through each day with sweat as he worked behind his canvas board; and in October, buoyed up by his commissions, he leased a larger space in the Alley at number eleven.

'We have taken a studio in MacDougal Alley,' he wrote home to England,

> a little cull de sac in Greenwich Village just where Fifth Avenue begins. Greenwich Village is the Chelsea of New York and MacDougal Alley used to be the mews of the big houses in Washington Square. Although we rent the whole house, it consists of only a studio and a room below with bath and kitchenette. The studio is a converted hayloft and the downstairs, a converted stable.[49]

The two gas street lamps in the Alley were ordered to be extinguished due to wartime blackout regulations in February 1942. These were the only two left in New York City from a time when stables and carriage houses lined this now very bohemian backstreet. Bohemian artists who have resided on MacDougal Alley include American sculptress Gertrude Vanderbilt Whitney (1875–1942), who opened her first studio at 19 MacDougal Alley in 1907; in 1942, and after spending six months voluntarily in a Japanese internment camp, Japanese American artist Isamu Noguchi (1904–1988) moved into number thirty-three; and between 1949–1950, Wyoming-born painting great Jackson Pollock (1912–1956) would stay at number nine. McBey's own place, at number eleven, had even once belonged to the creator of Washington, D.C.'s Lincoln Memorial statue, sculptor Daniel Chester French (1850–1931), between 1909–1912.

But, despite his portrait commissions giving him financial security, and his newly-won US citizenship a feeling of belonging there, his aching for Morocco remained all-consuming. His thoughts about Scotland also gave him 'a choking nostalgia.'[50] 'This Alley is so quiet that no hooting or noises are present to prevent me projecting myself amongst the thyme and bent and heather,' he wrote in early 1943. 'Yet I have been so sad every time I have returned.'[51]

All the while, he committed to his work with the same level of Calvinist vigour that had produced works which brought him international acclaim decades before. When a potential client asked McBey if he could 'make something of his wife', the artist replied:

Making something of Mrs. S. means for me, not just painting on canvas a map of her features so that the result bears a resemblance to her, but much more, maybe, God willing, a masterpiece. I have not painted

a masterpiece yet, but the hope will be stilled only when I can no longer hold a brush.⁵²

Guests came and went from number eleven. This often included being invited to sample McBey's Scots porridge for breakfast, styled, naturally, on his grandmother's recipe. But he was unhappy, as was Marguerite, who saw in him a restiveness that was only sated by thoughts of his return to Tangier. McBey would find some semblance of stability at MacDougal Alley, and, up until the end of the conflict, he and Marguerite did their best to maintain a relationship that for some years now had rarely been a contented one, amid the extra strains of war. There had long been no physical intimacy between them, and Marguerite craved a sex life again.

When McBey turned sixty on 23 December 1943, the shadows of his past surrounded him once more: 'My birthday. So I am sixty. Feel very old whenever I think of the tragedy at old mill, Foveran 60 years ago. Somehow this forenoon I kept thinking of it. That strange mess-up.'

Facing the onset of old age – by the standards of the 1940s at least – he looked for meaning more and more in his Presbyterian roots. When work accidently spilled over into the Sabbath, for example, he felt obliged to note the event in his diary: 'Worked till 12.30,' he wrote on Saturday 4 November 1944. 'Hope God will give me a special dispensation for half-an-hour on Sunday.'

In wartime America he made many lasting friends. One such individual was Spanish literature professor Pedro Villa Fernandez – a native of Oviedo, Spain, who had entered the lives of McBey and his wife in late 1942. The New York University academic was small – at no more than 5'6 – but possessed a mighty intellect and dashing looks. He was married to New Yorker Claire and had an adopted daughter, Hélène, who had been the product of an affair between his brother, Antonio, and an American woman. At the outbreak of war, he continued his teaching at NYU, but in 1941, the US War Office called on his services as a propogandist. He broadcast first from New York and later from Algiers, followed by Rabat, in Morocco, where he took charge of the radio station there, beaming out to Spain and Latin America. He returned to the States before the war's end after he developed a stomach ulcer.⁵³ The Fernandez family lived in a rented apartment on Washington Square South – just several minutes' walk from MacDougal Alley, which itself runs parallel to both Washington Square North and West 8th Street.

'He and my father were very congenial,' remembers his daughter, Hélène, then just a child, and today a widow in her late eighties. 'James was visually a powerful-looking man with springing white hair – I guess all that parch when he was a little boy made him into a healthy older man.'[54]

In the latter stages of the war, McBey and Marguerite visited Pedro at his very sketchable summer home in Killingworth, Connecticut, located between the Connecticut River and the Long Island Sound. Marguerite had already earlier established a 'very intense friendship'[55] with the outspoken naturalised American, taking Spanish classes under his tutelage at NYU four times a week and joining him for coffee. By 1945, McBey was truly at loggerheads with his wife. She was spending more and more time with the near fifty-year-old Pedro, and he was spending time with a Virginia Moore. Marguerite made plain her disdain of Virginia, confessing to her husband that 'her presence irritated' her.[56] But as Mrs McBey herself noted, the bonds between Marguerite and McBey remained clear for all to see: 'Pedro thinks J. and I will never separate – too much in common. And we think the same.'[57]

By the time the Allies had secured victory over the Nazis in Europe in May 1945, and over Japan several months later, McBey had lived in America for six long years. He had kept himself artistically relevant through exhibitions of his work past and present (such as his retrospective 1943 show of his etchings at the Smithsonian American National Museum) and as the sporadic subject of press reports. One such report, in a 1945 edition of *The Boston Daily Globe*, acclaimed the Boston Public Library's collection of McBey plates, despite the near complete collapse of the print market. 'Only Goya has rivaled these etchings,'[58] the paper breathlessly opined in the same month (September) that Japan formally signed terms of surrender aboard the USS *Missouri*.

At MacDougal Alley, he had also managed to indulge some hobbies, such as the restoration and rigging of a six-foot-plus-long French model ship from c. 1725, which he had purchased at auction at the Parke-Bernet Galleries for under $200, and which he worked on in his studio with characteristic zeal. (The completed model is today in storage at the Mystic Seaport Museum in Connecticut.) But McBey's life in exile from his Moroccan paradise had been predictably fraught, and – unable to indulge

his thirst for international travel and exploration during the war years – he had increasingly become conscious of his own mortality.

'Tomorrow will be my birthday,' he had diarised before turning sixty-one. 'So little time left.'[59]

CHAPTER ELEVEN

'Why can't I see the sun rise?'

'Not how long, but how well you have lived is the main thing.'
– Lucius Annaeus Seneca (c. 4 BC–65 AD)

The engines roared, the propellers turned and the interior rattled like an old tin can as the early-morning Trans World Airlines (TWA) flight from New York to Lisbon prepared to take off from LaGuardia Airport. McBey sat buckled up in his seat anticipating his first plane ride on 9 May 1946, the day when King Emmanuel III of Italy would abdicate his throne.

Beside him, as ever, was Marguerite, still beautiful at forty-one, although jaded by her wartime experiences in America, and not quite as love-struck with her now sixty-two-year-old husband as she had been during their whirlwind romance (and wedding) fifteen years before. Still, she was there, as dedicated to McBey the man as she was to the artist, despite the sexual tensions, her frustrations over their cramped living conditions at MacDougal Alley and her husband's moods.

McBey had longed for the war to end so he could return to his Moroccan idyll – and, following 'months of vain promises, uncertainty and delay',[1] he was offered a TWA flight on 8 May. He bid farewell to Pedro at LaGuardia and after many hours of waiting, started the first phase of his days-long journey to Tangier with a flight to New England.

'The sun rose a red ball half-way between N.Y. and Boston,' he wrote.

> Landed at Boston [...] Calm. Flew above clouds [...] then descended through them, very bumpy to Gander, Newfoundland. Austere place – lunch in big hut – long delay. 8.10 GMT we are off. Long night – shaved at 4.30. At 5.10 [...] passed through dense scudding clouds. Came down [Ireland's] Shannon Airport 5.50 a.m. Beautiful airport – flowers – flat country and misty distance [...] At 2 p.m. over the north of Spain – brown earth, little yellow tracks, patches of green. Came round at entrance of Tagus and landed at [Lisbon] at 5.45 GMT.[2]

He was one of the first passengers to experience the TWA's new New York to Lisbon service. In the Portuguese capital, located on the north bank of the River Tagus on the Atlantic coast, he and Marguerite found lodgings at the Hotel Florida. There, in a letter dated Saturday 11 May, he found time to write to Pedro, who had accepted an invitation to visit him and his wife at Jalobey.

'I cannot believe that only yesterday morning we were in Ireland,' he wrote on the hotel's headed stationery in a long and boisterous missive which detailed his following seventy-two hours in Lisbon – and which also revealed his obvious excitement at his imminent return to Tangier.

> Yesterday afternoon we landed here at 4 p.m. and years seemed to have passed since then. At the airfield was assembled the entire population of Lisbon, civil as well as military [...] We got a room here, clean, with bath [...] Lisbon is so clean and spacious compared with New York or Philadelphia, but so noisy. The Portuguese must have been something in his heyday [...] Yesterday it rained. Today it rained – a constant drizzle (and my last act on American soil was to leave my umbrella with you).

Perhaps it was the artist's frustrations at his enforced four-day layover in Lisbon (and general jetlag) which meant he let slip unsavoury comments about the locals, whom he described to Pedro as being 'endowed with an inborn ingratiating slipperiness.' 'Can you speak Portuguese, Pedro?' he wrote to his fellow naturalised American. 'You'll find it easy. You fill your mouth with an oil – olive, castor or what have you, and, speaking Spanish, what then comes through the lubricant is Portuguese.'[3]

McBey and Marguerite boarded 'the small weekly aeroplane which made the journey to Tangier in ninety minutes'[4] on 15 May. The artist's mind must have been a blur of excited thoughts and emotions as his plane flew over mainland Portugal and the Gulf of Cadiz before its descent into northern Morocco. During his time in the States, he had, other than his work and the enduring stresses and strains of his personal life, enjoyed many strokes of serendipity; from meeting a New York cop whose sister had been born in Aberdeen, to purchasing at auction in the Big Apple a Victorian sewing table, which he recognised as belonging to his grandmother. McBey was arriving with endless tales of his colourful life in the US (despite his own misgivings about his time in the country), and to his many friends in Tangier who had remained holed up in Morocco for the

entire war, his and Marguerite's return must have seemed like manna from heaven.

McBey's Tangier-born lover, Clémence, was there to meet them both – a 'wonderful welcome'[5] – after which they lunched and then checked in to the El Minzah Hotel. The Scotsman had been desperate to see Jalobey and travelled there that same day. 'Very overgrown after 7 years,' he noted, remarking, too, that his loyal domestic servant, Shaib, 'looked dirty.' 'Mirrors etc. broken. Telescope in pieces. M. and I walked to Socco Chico by full moon. It is good to be back again. Thank you God.'[6]

It had been so long since he had last seen Jalobey. It had also been so long since he had last heard the ghostly call to prayer echo through the warm Tangier air; since he had gazed at the city's intense sky, which presided over the market-places, shifting colours, crooked passageways, golden sands and hardy post-war inhabitants like an all-seeing eye. It had been so long since he had smelled the mingled scents of brewed coffee, mint tea and hookah, and watched old men with rough faces play cards, dominoes and backgammon at the tiny cafes. It really had been so long since he had last called this place between the two seas home. More adventures lay in wait – but Morocco would hold him in the palm of its hand for the rest of his life.[7]

However, as friends of the Scot would relate, 'this land of much prayer'[8] had not emerged unscathed from the war. After the Nazi occupation of France in June 1940, Morocco had come under the control of the Vichy regime. Its North African neighbours of Algeria and Tunisia had also been forced to submit to Nazi-collaborationist Vichy France, which soon passed its own anti-Jewish statutes. Morocco's two-hundred-and-forty-thousand-strong Jewish population, while not sent to Nazi death camps in Europe, did find themselves the target of Nazi oppression.

> Under wartime rationing, Jews [in Morocco] received less to eat than Europeans or Muslims, and a 1941 edict gave Jews living in European neighbourhoods one month to move back into the mellahs, or Jewish quarters, where overcrowding accelerated the spread of disease.[9]

> Early 1940s Tangier itself became a hotbed of intrigue and was especially a mart for 'intelligence' [...] Shabby little men with names like Pinto, Gonzales or Benmoussa haunted the foyers of belligerent consulates and furtively handed each other

slips of paper in the Place de France or the Petit Socco; one at least, a Portuguese, would make his way every Friday from the British legation to the German, from the French to the Italian, collecting his wages from each.[10]

In Operation Torch, on 8 November 1942, a combined Anglo-American taskforce launched its military invasion of Morocco and Tunisia in a bid to 'disrupt collaborationist Vichy French control of northwest Africa'[11] among other strategic objectives. The success of Torch liberated Morocco from the grip of the Vichy French Government and enabled the January 1943 Casablanca Conference, where American president Franklin D. Roosevelt and British prime minister Winston Churchill met to discuss the continuation of the Allied war effort.

By the time of McBey's arrival, the war had been over for the best part of a year, and Moroccans were now agitating for independence from their pre-war European masters. Single-minded as ever, McBey quickly set about his own priorities, beginning with the restoration of Jalobey. Despite damage to the house and the wider grounds in the shape of a pond full of dead goldfish as a result of a contaminated water supply, Jalobey's survival contrasted with other properties in Tangier which 'had been stolen away, stone by stone'[12] during wartime. McBey and Marguerite moved back in on 27 May after ten days clearing the weeds, dust and detritus. His hired Arab workmen were still 'cutting trees [and] repairing [the] brick pergola',[13] but the house was habitable.

'FIRST NIGHT SPENT AT JALOBEY – beautiful with clouds,' he noted in his diary later that spring evening.

> Got lamps from Arab all fixed more or less. Got suitcases and off to Jalobey. M. holding lamps on her knees [...] Night fell gradually – very calm – nothing but dull hum of sea – very dark – very bright stars – occasionally the croaking of a frog. This is what I have thought of so often for seven long years. I am so glad that it is granted me to be here again. God, I thank You.[14]

Although McBey might have been caught-up in his own concerns, he was not oblivious to the more profound post-war transformations in Tangier, which he would note in a letter eight weeks later.

'There is little outward change in Tangier since we saw it, exactly seven years ago,' he would write.

17. Marguerite and McBey pictured together shortly after they wed. The Scotsman and Marguerite had a volatile marriage during which the artist was often unfaithful.

18. McBey on holiday with Marguerite (left) and her mother, Hortense (right), in 1931 in Concarneau, France. McBey had a relatively amicable relationship with his mother-in-law, and the three often holidayed together.

19. McBey's 1934 etching, *Approaching New York*. Based on his rapid sketch of the Manhattan skyline from the deck of his ocean liner, *Majestic*, on 22 October 1929 as it edged into harbour just days before the Wall Street Crash.

20. McBey's brilliantly vibrant 1936 oil painting, *Acrobats Marrakesh*, for which he made use of photographs taken by his wife, Marguerite.

21. McBey at work in New York in 1944. He had a powerful work ethic. On Saturday 4 November 1944, the artist wrote in his diary: 'Worked till 12.30, hope God will give me special dispensation for half-an-hour on Sunday.'

22. El Foolk, the second house that McBey bought in Tangier, after Jalobey. McBey sought a more adaptable home than Jalobey and found it in El Foolk. Many alterations were made. El Foolk sits on the Old Mountain Road overlooking the Straits of Gibraltar.

23. Interior of El Foolk, Tangier. On the right-hand wall are two of the artist's paintings: McBey's 1952 self-portrait (in the foreground); and his 1950 portrait of Marguerite (in the background).

24. McBey's 1950 portrait of his wife Marguerite, in Tangier, in which the American cuts a relaxed and exotically styled figure. After the high drama of the 1930s and 1940s, the 1950s were a more settled time for the couple.

25. McBey portraying himself as the quintessential artist in 1952. He was fond of self-portraits and of sitting for fellow creatives, such as sculptor Benno Schotz (1891–1984), who made a bronze bust of him in the mid-1920s.

26. *Zohra* is McBey's portrait of his young domestic servant of that same name. It remains an enduring Moroccan masterpiece, widely known as the 'Moroccan *Mona Lisa*', with eyes that follow you from every angle.

27. Spanish literature professor Pedro Fernandez, with whom McBey became good friends. Fernandez was married to New Yorker Claire. The artist's wife, Marguerite, also had an 'intense friendship' with Fernandez.

28. In 1956, Marguerite's nieces (Barbara, Joan and Kathleen Loeb, daughters of Marguerite's brother, Arthur) arrived in Tangier with their parents for an extended visit. Pictured left to right are McBey, Joan, Barbara Ogilvie (a Scottish friend of McBey's), Barbara, Kathleen and the girls' mother, Kitty (standing).

29. McBey and Marguerite looking through his large Zeiss telescope at El Foolk, Tangier, in 1959, the year of his death. He would often use it to study, from his home, ships passing through the Straits of Gibraltar.

JAMES McBEY
PAINTER ETCHER
BORN 23 DEC 1883
DIED 1 DEC 1959
أحب المغرب

30. McBey's grave and headstone. On 12 September 1948, at the height of their estrangement, McBey had written to his wife, Marguerite: 'If anything should happen, and if it be possible without much trouble, I should like to stay in the lower property, on the high bit, just beneath the Cherifian Garden. It is still, to me, a heaven down there.'

31. Lady Caroline Duff, Marguerite's lover after McBey's death. Lady Caroline was the bisexual wife of Sir Michael Duff, who was also bisexual. Lady Caroline was staying with David Herbert in Tangier when she met Marguerite. Lady Caroline is understood to have told Herbert: 'I have found my Waterloo.'

32. The widowed Marguerite with her Tangier friend, David Herbert, in the mid/late 1970s. Herbert 'commanded' the social world of Tangier, according to Lady Caroline Duff's son Charles.

There is, though, a new hard core of refugees from Middle Europe who have cornered the gasoline, sugar, metal, cement, drinks, etc., so that most things are three times as expensive as they were in 1939. Gasoline oil and flour are rationed – a farce, as the black market is tolerated with good humour.[15]

Ever the former Aberdonian bank clerk, the artist would add:

The Spanish shops will accept only pesetas which fluctuate every quarter of an hour. At the present moment – 11 a.m. – they are 25.40 to the US dollar. The French shops including the British Post Office, will accept only the French Moroccan franc, which, since we arrived two months ago, has risen from 310 to 220 to the US dollar. What or who causes the fluctuations here is a mystery as Tangier is a black market exchange. The sidewalks of what used to be the principal street are lined with moneychangers, each with his little collapsible counter in front of him and a blackboard behind. On this is chalked what he is prepared to give, exactly like bookies at a racecourse. The £ sterling is way down about $3.40.[16]

Pedro arrived in Tangier from the States on 5 June. He was accompanied by sixty-six-year-old MacDougal Alley resident Elizabeth (Betty) Shoop, and McBey drove out to the airfield to meet them. Clearly still tickled by his recent experience as a first-time commercial airline passenger, he noted in his diary that day: 'It was uncanny to see the aeroplane come like a speck out of the blue.'[17]

All appeared to be well until 26 June, when McBey, still obsessively focused on trying to put Jalobey into working order, found Marguerite in Pedro's room. 'Upset. Fevered. To bed,'[18] he penned dramatically. It remains unclear what McBey actually witnessed, but when the Spanish-born academic left Jalobey to see out the rest of his visit at the El Minzah Hotel, the artist recorded in his diary: 'All a misunderstanding. Am so sorry.'[19] McBey's marriage to Marguerite had long been indiscreet, unhappy and mistrustful, but they continued their travels, back to America that autumn via Lisbon, London the following spring, and a solo Marguerite to the US that summer. The Scotsman might have resumed his affair with Lisbeth – and indeed, she had joined them in December 1946 in New York – but when his wife travelled Stateside on 20 June 1947, he felt that familiar crushing solitude. 'Very sad and lonely,'[20] he wrote

after seeing her off at London's Sloane Street, adding the following day: 'Felt lonely all day.' But in early September, Marguerite returned, and they both left shortly thereafter for Tangier. This time, they were joined by McBey's extra-marital flame, Mollie Murray (now a widow after the death of her doctor husband, William, in 1946), the artist again not content with the company and attention of just his wife. As at New York's MacDougal Alley, three was a crowd at Jalobey, where 'this summer paradise seemed even smaller.'[21]

Matters between McBey and Marguerite had reached an impasse by the following year. McBey, having severed ties with Colnaghi's some years before, had no London dealer, and felt artistically untethered in the post-war era. Marguerite had become the butt of his frustrations, and the Scotsman, who had earlier noted a 'terrible row with [Marguerite]' which had left his 'dream [...] in ruins',[22] was exasperated by his wife's apparent thin-skinned propensity to take the slightest comment as criticism. Neither party would give ground. In May 1948, Marguerite told her mother that she was leaving her husband,[23] and on 26 June, she did just that.

They both rose early that sunny Saturday morning – long before Shaib sounded the bell for breakfast at 6 a.m. At 7.15 a.m., McBey, who had known for weeks his wife's intentions, kissed her goodbye before she left for the airport to make the long trek back to the United States. There were no hysterics or drama, but as the artist stared forlornly at the blue skies, waiting for her plane to fly overhead to Lisbon, where she would catch her Pan American Airways flight to New York via Boston, his mind 'kept thinking of things I might have said to mend matters.'[24] Marguerite had wanted a 'communion with the human heart'[25] and, for years, had found it not with her husband.

Newly free, she arranged to holiday in Cuba with Pedro, who had a year earlier swapped his academic position at NYU for a role at the University of Florida, where he would retire in 1966. Correspondence between the estranged couple did continue, but it was strained and often far from privately played out. When, in early July, McBey saw Hortense at the local post office clutching a letter, he enquired after Marguerite. Hortense vacationed in Tangier more often than her son-in-law might have wished, but he had heard next to nothing from Marguerite since her departure.

'It did gall me a bit to have to ask this of her, but I have swallowed a lot of pride in my day, and its effect, although poisonous, is not lethal,' he wrote his wife in a letter dated 9 July. 'With smug satisfaction she tapped the unopened letter in her hand and said, "This is from Marguerite. I am going now to the beach and I shall open it and read it when I get there." Without a word, I turned and left her.'

McBey confided his marriage difficulties to H. H. Kynett and even Pedro himself, with each offering their own advice and take on the matter. The artist was not averse to spilling out his angst to both in letters, as he did to Marguerite herself, who contacted him from Havana on 17 July.

'I was too upset at the tremendous upheaval that had taken place in our lives and you had intimated that you didn't want any hypocrisy,' she wrote in reply to two letters received from McBey.

> Of course you must understand that instinctively I still see life through your eyes [...] but I feel that to go through all that terrible agony of leaving you and to write you as if all were well between us would make things worse for you – more confusing and bewildering and for me just more deception and wishful thinking.

Theirs had been a far from conventional marriage – but their grievances were very conventional in nature. McBey reiterated his complaints for good measure on 25 July.

'You have not yet got beyond thinking of the *effects* which are unpleasant for you,' he declared self-righteously. 'You still choose to ignore the *causes*, which irritate me, and start the whole cycle.'

'It all boils down to this: certain things, small in themselves, but trying if persisted in,' he continued, at which point Marguerite, on reading the letter herself, might have rolled her eyes.

> Like driving on the wrong side of a blind corner, bawling at the servants, neglect at household jobs which other men's wives take as a matter of course, being always behind time and so in a nervous, ill-tempered, hurried jitter, do irritate me, and so far as I can see, always will, and would any man.

On 15 August, Marguerite had her say:

> I received your letter [...] and I must say that if it were true that I had consistently persisted in doing those things you so carefully list, it might have irritated any man if he were subjected to my

company 24 hours a day. But there is no excuse either before God or before a court of law for cruelty and your invitation manifested itself along those lines.

And so it went on – McBey addressing his wife as 'Marguerite dear' and she him as 'James dear' – each missive a masterclass in passive-aggressive postal ping-pong. But the Scotsman was struggling in her absence, even noting in his diary that he had been forced to visit a barber's shop for the first time in seventeen years, having relied always on his wife to cut his hair. Marguerite 'had made herself indispensable to him and he was lost without her',[26] and he couldn't help but involve her in his work – and his day-to-day life. However, Marguerite had resolved to make a fresh start, and soon set up home at their leased New York studio in Greenwich Village. A tunnel-visioned McBey joined her at 11 MacDougal Alley in October – despite taking receipt of a cable at Holland Park Avenue from Marguerite in which she urged him not to come to New York – sending her fleeing to her brother's home in North Carolina. Ultimately, their (non-conformist) bonds of marriage, though often stretched to breaking point, were forever destined to revert to their original shape. Her return to the bohemian surroundings of the Alley on 30 November signalled her readiness for a rapprochement. Marguerite's actions had been a clear shot across the bows – but 'she was back and they never separated again.'[27]

McBey, his marriage now saved, ended 1948 by making a start on his commissioned portrait of US judge Arthur T. Vanderbilt, then newly appointed to the role of Chief Justice of the New Jersey Supreme Court. But during his post-war relationship struggles with Marguerite, he had embarked on a very different project. Throughout the early to mid-1930s, he had been encouraged by G. P. Putnam's Sons to write his memoirs. He had been greatly flattered by their interest – but after toying with the London arm of the American publishing house with vague and amusing promises to write, he let the notion slide. However, over the last months of 1947 – during many weeks 'of torrential downpour, frayed nerves and unhappiness'[28] – he had begun to unburden his memories.

'Rain all day and without ceasing,' he noted in his diary from Jalobey on 3 December 1947. 'Marguerite and Mollie [Murray] sewed curtains at gazebo. I stayed and wrote of Annie's death.'

He completed the first draft of his autobiography at the beginning of 1948 and posted the manuscript to H. H. Kynett in the United States. On 19 February, the Philadelphian responded.

'I have read the 180 pages of manuscript twice [...]' he remarked of the work, which had been typed up by Marguerite after he had written it out in pencil. 'But the one thing I want to get across to you is that the material is splendid, and you should, by all means, proceed with your recollections.'

The advertising supremo, clearly flattered that he had been asked to review his friend's effort, and fancying himself as something of an author, having published his own privately-printed works, gladly assumed the mantle of mentor – but quickly overwhelmed the artist with literary criticism.

'In an effort to avoid pricking your sensitive skin, I have knuckled under too deeply to escape the brutal bluntness which I am told is a distinguishing characteristic,' he wrote pretentiously on 13 April. 'With this apologia I shall endeavour to extricate my dripping mind from the slough of ambiguity.'

McBey, while an accomplished writer, lacked the confidence to proceed further. In the face of Kynett's suggestions to tone down 'the bitterness and harshness'[29] of the manuscript, the artist, more comfortable with that which had brought him fame and fortune, set aside his memoirs – never to return.

He would never realise the publication of his autobiography during his lifetime, but there were many other projects to occupy him. He had tired of Jalobey – despite his initial commitment to its restoration – and longed to replace it with another, more adaptable, home in Tangier in which he could live out the rest of his days. He found such a place in El Foolk – that very same residence which he had visited in 1913 and which had once belonged to the late artist Helen Russell Wilson. Just days after Marguerite had made good on her pledge to separate from McBey by flying to the States, the crestfallen artist had received word from Lisbeth that she was purchasing El Foolk. It turned out to be a co-ordinated bid at a 'tax dodge'.[30] Lisbeth did not intend to keep El Foolk for herself, but purchased it for McBey. Lisbeth wrote, 'Good luck and my blessing' under McBey's diary entry for 3 June 1949, and that day handed over the keys to the Scot, who began work on El Foolk with typical gusto.

McBey's latest property acquisition – another example of his excessive good fortune – would be his last. El Foolk sat on the Old Mountain Road overlooking the Straits of Gibraltar. With McBey's finest and most enduring legacy being, of course, his art, El Foolk would also become an impressive part of his legacy. In page after page of his diary, he noted the renovations to El Foolk with boyish glee as he sketched and photographed the changes, and invited friends from the town to come and admire his vision.

'About 18 men arrived at El Foolk and they started [...] to dig the foundations [...]' he wrote on 1 August. 'They all seem to work well together [...] They cut down the Mimosa where the library will be.'

There were significant milestones: on 6 November, he was able to lock the front doors of El Foolk for the first time. Not even the sporadic heavy rain of winter could forestall his military-like advance, as Moroccan masons, carpenters and general dogsbodies executed McBey's will with alacrity. On 18 December, the artist's work in progress reached another milestone when he spent the night.

'I went up to El Foolk at night and slept there for 1st time,' he wrote. 'Very comfortable. [CODE – Thank you God]. Slept well. 7.15 a.m.'

On 30 December, he and Marguerite moved all their essentials from Jalobey to El Foolk.

'Bright moon,' he noted. 'Writing this at 10.45. At last am comfortable in Tangier. [CODE – I thank God].'

And on Hogmanay, they bedded down for the night at El Foolk as a couple.

'It is strange after all these years to have a place for everything,' he remarked on New Year's Day 1950.

It was now a new decade, and the sixty-six-year-old artist had long been one of northern Morocco's most recognisable and celebrated foreign luminaries. His post-war diaries of meet-ups read like a who's who guide to mid-twentieth-century Tangier: Englishwoman Joan Kingsmill, long-time resident Lady Scott, who had first visited Tangier during the era of the Boer War when it was a mere fishing village; Scottish medic Dr G. W. Fraser Anderson; Captain F. H. Mellor, author of the 1939 book, *Morocco Awakes*, who lived on the Jews River; Ruth Maxwell, social columnist for the *Tangier Gazette*; and many other expats besides. McBey's old crowd from England – Mollie Murray, Lisbeth Simpson and Herbert Paton

– often visited, as well as Hortense, who would continue to shuttle between the US and Tangier into the 1950s.

Surviving letters reveal that both McBey and Marguerite deeply valued their long-distance relationships (and correspondence) with the likes of Lisbeth, Herbert and, of course, Pedro. Between Marguerite and her husband's lover Lisbeth, there was genuine abiding affection: 'Darling, I just want to thank you for again being you,' Mrs McBey would write Miss Simpson in the spring of 1952 after Patrick Finneron, the butler at H.P.A., died, and Lisbeth looked after his widow following the funeral. 'It seems often to me that you are the balm giving element in our crazy old world – making life and all the sorrows so much easier to bear with your sympathy and understanding.'[31]

As McBey approached seventy, he sought more to reclaim his past. He hosted Aberdeenshire-born Polly Keith (née Ritchie) at El Foolk in April 1952, after earlier issuing her an invite. Polly had, we know, been the artist's first boyhood crush, and he paid for her passage to Morocco. She socialised with McBey's Tangier friends and wandered its marketplaces before heading home in May.

But art, above all else, sustained McBey during this – his last – decade. He had ended the 1940s with an exhibition of his work at New York's American British Art Center. At that exhibition, he had shown 'pages from his sketchbooks', 'sixty watercolour notes and drawings done during his travels in America and North Africa.'[32] In the early 1950s, however, he would execute some of his finest creations, inspired into something of a renaissance by Tangier – this 'basin that holds you, a timeless place [where] the days slide by less noticed than foam in a waterfall.'[33] In 1950 came his sumptuous portrait of a mid-forties Marguerite, in which she is captured sitting at a table, right hand on her hip, her left jauntily hanging over the top of the chair. She wears a fabulous handwoven wicker hat, red headscarf, dark glasses, salmon-coloured blouse – and a cool expression. Two years later, he depicted himself as the consummate artist, complete with a paint brush and palette in his left and right hand respectively, an open-neck shirt, tanned sports jacket, moody expression, and shock of silver hair.

In 1952, he also created his enduring Moroccan masterpiece, *Zohra*, a portrait of his young domestic servant.

'Painted Zora [sic] band round head and hair and blocked in purple gown,' he noted on 7 May.

'Painted gown of Zora [sic] in forenoon pale purple,' he added a day later.

These casual remarks would little do justice to the showstopper it became. Tangier-born Zohra Zefri was just a teenager when McBey caught her on canvas by painting her over a three-month period in thirty-to-forty-five-minute bursts on any given day.[34] By the time the sixty-eight-year-old had signed and dated his work, he had elicited the woman behind the girl, teasing out her naturally arresting features into a portrait for the ages.

'Zohra gets more beautiful every day,' Marguerite had observed in an April 1952 letter to Lisbeth, 'and now I'm dressing her up fancy to wait at table [...] when we have guests and everyone is smitten.'[35]

Indeed, 'smitten' is what many visitors to the Tangier American Legation Museum are left feeling after they catch a glimpse of the hypnotic oil on canvas work, measuring (its seventeenth-century Spanish frame included) 28.5 x 31.5 inches and today hanging in the museum's Zankat Gallery alongside several other of McBey's great works. The artist painted eyes that follow you from every angle, and not for nothing is *Zohra* widely known as the 'Moroccan *Mona Lisa*'.

When, in 1953, he turned seventy, he noted the milestone in his diary. 'It is 2.45 a.m. I am seventy years old today. I try to visualise the night of 23 Dec. 1883 at Newmill, Foveran. Annie's photo as a girl of 2 or so hangs in my bedroom. For 35 years I have not had anxieties. [CODE – I thank you God help me].'

In Tangier, the ageing artist felt close to God. But, as the diary entry on his birthday made clear, he remained troubled by his past, fearing that he might at any time encounter someone from his hometown cognisant of his illegitimacy. Once, in Tangier, he had even felt compelled to show 'a list of famous people who were illegitimate'[36] to his British painter friend, Phyllis Pearsall (1906–1996), so desperate was he to 'normalise' his upbringing. But McBey was in good company. Internationally-administered Tangier – this 'utopia of dangerous, unknown pleasures'[37] to where many (especially homosexual) British and American creatives had flocked to live out their deepest desires without fear of retribution

– harboured secrets and lies as easily it did the tides which lapped its sugar-soft sands.

McBey carried age-old baggage for sure, but he still retained his ability to be jovial. He had long been partial to pranks involving 'impersonation and disguise'[38] – but there had been genuine acts of kindness, too. During a sea voyage, for instance, one of the artist's fellow passengers had told him that her own inhibitions had made her more wallflower than social butterfly. 'Suddenly and mysteriously she found herself being sought after by a dozen men. She was danced off her feet, entertained at the bar, flattered and pursued.'[39] At El Foolk, he enjoyed holding rapt small audiences with his tales of high jinks, adventure and happenstance, his Aberdeenshire accent as unmistakeably lilting as it was when he shuttled between banks as a young Edwardian-era clerk.

During the 1950s, he continued to treasure his friendships, such as with Billy Turner, who since 1951 was Lady Turner on account of her husband, Henry, being knighted. (The couple had adopted in 1939 a baby boy whom they had named Gordon.) McBey would soon be forced to say goodbye to a number of people with whom he had shared a great many memories. On 20 January 1952, Martin Hardie passed away, as did McBey's H.P.A. butler, Patrick Finneron, later that year. On 10 July 1957, he would lose his dear friend, Herbert Paton, to stomach cancer at St. Thomas' Home, Lambeth. In the autumn of 1955, a major bereavement came when Hortense died on board the *Andrea Doria* as she sailed for America after another stay in Tangier. She had been carrying thirty-three drawings back to the United States on behalf of her son-in-law to H. H. Kynett, art collector, and McBey's friend, when she expired as she lay sleeping in her cabin.

McBey had recalled his final – almost prescient – moments with the seventy-three-year-old Hortense on 7 November as she 'came up and said goodbye at the top of the stairs outside the door leading to the study. There seemed to be tears in her eyes but she said nothing.'[40] Two days later, the artist had watched – through his prized Zeiss telescope – his mother-in-law's ship as it traversed the Straits of Gibraltar. On the fourteenth, his brother-in-law, Arthur, telephoned with news of her passing.

Arthur wrote to Marguerite on 17 November, beginning his missive, 'Darling: I don't know where to start, so I'll just begin and stumble!' '[The doctor] fixed the time of death at 6.30 a.m.,' he wrote. 'He told me her

eyes were closed, and that she had passed on in her sleep. I'm so glad it went that way.'[41]

Hortense's death would not be the end of McBey's link with Marguerite's side of the family. The following summer, Arthur, his wife Kitty, and their three daughters – Barbara at twelve, Joan at nine and Kathleen at six – arrived from the US for an extended visit with McBey and Marguerite.

'James had a great sense of humour,' remembers North Carolinian Joan Dickson (née Loeb).

> He sent Whisky, their dog, off to fetch Mohammed, the cook, when meals were over. We were astounded when James licked his ice cream bowl to the last drop. He had made and painted a papier mâché replica of a large dog poop which looked exactly like the real thing to fool his guests. He had a fake beard for Mohammed, which he would wear for one course and then appear without it for the next.[42]

'James painted our portraits that summer,' she adds,

> and my biggest memory was trying to sit still and maintain the same pose for what seemed like an eternity. I do remember watching him and being astounded that he could take his paints and put them on a canvas which was set on an easel to create an exact image/replica that looked just like us. I remember the preliminary outline/shape of my face; first, the eyes, nose and mouth in the beginning, then the hair before any detail. Watching him mix the paints and getting the colours that he wanted on his palette that he then transferred to the canvas via a small brush – maybe a larger one for the background and larger areas – that turned into us. A miracle. I was in awe. It was fascinating to watch him hold his paint brush up at arm's length and 'eye' his subject to measure perspective. I remember the smells of oil paint and cleaner [...] I think I remember we sat for our portraits during the early part of the day, before lunch, perhaps [...] Barbara and I had our ears pierced that summer and James designed and made a pair of gold hoops with a tiny seed pearl for me [...] James commanded a formidable presence. I might have been intimidated had I been older, but I loved everything about him and Marguerite.[43]

Indeed, the childless McBey appeared to take quite a shine to the Loeb girls – and Joan in particular.

'I am drinking in every moment with them so that I have plenty of cud to chew after they leave,' wrote Marguerite to her brother, Arthur, after he had cut his own holiday short to return to the US.

> They are really all enchanting – each in their own way [...] Joan has really charmed James and I feel there is a kind of bond between them – probably she senses his admiration of her and she is reacting like a 100% woman that she is. She comes up every evening before bedtime to have a few games of Chinese checkers with him which he adores as you know [...] I really believe he did not want to get involved in painting 3 portraits but when he got down to it he was completely carried away. I've rarely seen anything that has come so well and easily. I only wish you were here to see them.[44]

McBey might have been in the winter of his life – but he retained his fondness for travel. Scotland, so long a place of conflicted pilgrimage for the artist, remained a compelling destination. In the summer of 1951, he had journeyed to his homeland, visiting Rowallan Castle – the Kilmarnock home of his friend, Lord Rowallan, from 1945 Chief Scout of the British Commonwealth and Empire. On 24 August, he had wandered the grounds of Rowallan's grand property, noting that 'Scotland seems so melancholy now.' The next month, he had gravitated to Foveran, visiting its graveyard and checking in with old friends. Eight years later, he returned, after his and Marguerite's travels across America's southern states in 1958, which had also included a visit to Pedro Fernandez at Gainesville, Florida.

He had spent his seventy-fifth birthday in New York despite some years earlier having given up MacDougal Alley. There, on Hogmanay, he wrote in his diary: 'It is now 11.59. Thank you God for 1958. I cannot expect 1959 to be so good.' Perhaps – because somewhere deep down he knew that time was against him – he felt the pull of his Caledonian roots now like never before. He called on Mains of Foveran and again visited Foveran Kirkyard. It was a cold March day in Aberdeenshire when he drew up outside the grounds of the church. Leaving Marguerite in the car (she had no doubt seen enough of the time-worn markers of the dead on previous visits), he entered the churchyard gates before turning

left and walking the few short paces to where his family's lichen-covered headstone rose from the dew-covered earth. He had long made his peace with God, and indeed his coded diary entries had – for some years now – related less to sex and women, and more to the Almighty Himself. Yet there, within earshot of the spring-chilled waters of Foveran Burn, he maybe, just maybe, made his peace with his past too.

During that time, his childhood friend, and first love, Polly Keith, lay dying in Aberdeen's Woodend Hospital, 'in bed in a room with 9 others. Her hair was cropped. Very sad [...] Kissed her goodbye.'[45]

It was only when he returned to Tangier that he learned of Polly's death from bladder cancer.

'Very sad at the news my oldest friend has passed on,' he noted in his diary on 21 April after discovering she had died eleven days earlier. 'Now only John Loutit[46] is left of all my closest contemporaries.'

The spring, summer and autumn of 1959, however, proved just as hectic as previous years as he continued his art and general lust for life. In September, a BBC producer approached McBey for his recollections of his old American friend, Lowell Thomas, then still in good health. Thomas was, unbeknown to him, about to appear on the US edition of *This is Your Life*, and the BBC's Leslie Jackson had been asked by his American counterparts to probe the ageing film-maker's former associate on the Palestine Front for his war-time remembrances, even exploring whether the veteran artist might be prepared to fly to Hollywood itself to participate in the programme (all expenses paid). But McBey declined the latter. He had, he responded to Jackson, two prior engagements, including a date with Lord Rowallan, then recently installed as the new governor of Tasmania, who was passing through Gibraltar on his way to assuming his new role on the Australian island.

'I liked immensely *This is Your Life* on the T.V. screen when I was in the U.S. and I am very fond of Lowell Thomas, so it will be painful to me to miss this one as we have no television yet in this part of the world,' he wrote to Jackson from Tangier on 19 September. 'Would it be possible for you to arrange to have a tape sent me of this event? Then, at least, I could hear what took place.'

Tangier, for three years now part of an independent Moroccan state following the country's severing of ties with France in March 1956 and the disestablishment of the city's status as an international zone later that

year, was on the cusp of a new decade. On Saturday 14 November 1959, McBey rose alone before sunrise, he and Marguerite having long slept in separate bedrooms. A south-westerly wind had yet to disperse the grey clouds of early morning, but he felt energised by the coming of a new day. In the forenoon, he bid two Europe-bound friends goodbye at the quay, drove to the garage of another friend – mechanic Leslie John Legg – to fix a flat tyre, and then 'stuck down' a completed canvas portrait of Tangier resident Kathy Ryan. In the afternoon, he lunched with British socialite and writer David Herbert, who had moved to Tangier in 1946; Leo Cyr, the US consul-general to Tangier; the consul-general's wife, Kitty; and French media tycoon Charles de Breteuil.

'L. thinks Tangier will shrink to a village, and not become a Freeport,' wrote the artist in his diary. 'Felt cold and depressed after lunch.'

That day's entry would be his last. On the sixteenth, he developed a chill, a cough on the nineteenth, and a fever on the twentieth. As her husband's seventy-five-year-old body was gripped by illness, Marguerite documented his final stages of life.

21 November: 'Anderson came and gave him second penicillin shot [...] James had v. high temperature in night [...] [Molly] Huusko does not leave him,' she wrote in her journal, name-checking McBey's Aberdeen-educated physician – a one-time medical missionary – who had diagnosed bronchitis, and his nurse-cum-masseuse respectively. 'James asked date of his chill. Says it is v. important – 16th Nov. – for his diary.'

22 November: 'I went in to see James about 6. At 6.30 sat him on side of bed and gave him a wash. Suddenly he seemed limp [...] Anderson came [...] noticed that J. could not grasp him with the left hand and told me it was a stroke [...] I spent most of day trembling which I could not control.'

23 November: 'J. wheezing, high temperature, exhausted with every cough. Anderson gave him [more] penicillin [...] He now has congestion in lungs (pneumonia) which in conjunction with the cerebral haemorrhage is very difficult to cure.'

24 November: 'J. changed to side position and much more comfortable. Head clear. God helped me today.'

25 November: 'Wonderful [...] clear day. Blackbird singing in the garden. James lying side. I outside. Nothing could go wrong on a day like this.'

26 November: 'James does not seem better today. I feel depressed [...] Huusko seems jealous and touchy and dictatorial.'
27 November: 'James has to be turned every 3 or 4 hours. V. difficult and he hates it [...] Rose 3 times to help Huusko but couldn't sleep after and I feel spent.'
28 November: 'Most strenuous day. Anderson said J. should have oxygen [...] Also arranged [...] hole in floor for tube. Feel rather hysterical.'
29 November: 'J. in oxygen tent all nite [sic] and this made a great change – made him feel much better [...] J. speaking very lucidly [...] J. said to Batoul [his Moroccan nurse]: "Je ne suis sur de guerir ma main"[47] [I'm not sure my hand will heal]. Does not mention to me or Huusko.'[48]

On 30 November, McBey awoke to the dawning of a new day but did not feel refreshed. 'Why can't I see the sun rise?'[49] he asked Marguerite, as storms raged outside and the rain clattered on the roof of El Foolk like an Aberdeenshire winter. He grew weaker but took to sketching 'in the air with his stub of pencil'[50] as death struggled to extinguish a flame that had burned bright and true for more than seven decades.

On the morning of Tuesday 1 December, he stood, as it were, at the foot of another uncharted canvas. When he failed to properly cough up some loose phlegm, his body gave way – his 'last look into my eyes,' lamented his wife, 'must have seen panic and terror.'[51] He died at 11.45 a.m. leaving 'a stone in my chest,'[52] a drained Marguerite would record. He was just twenty-two days shy of his seventy-sixth birthday.

In his Tangier bedroom hung not only the photo of his mother as a little girl, but also Sir Jacob Astley's prayer delivered on the eve of the English Civil War's Battle of Edgehill in 1642 – 'O Lord! Thou knowest how busy I must be this day; if I forget thee, do not thou forget me'[53] – and a portion of the Ordnance Survey map featuring the Parish of Foveran where he had been born three quarters of a century before.[54] The man who had for decades struggled with his past had ended his days surrounded by it.

CHAPTER TWELVE

'He is still taking complete charge of my life'

'I am no bird; and no net ensnares me: I am a free human being with an independent will.'

– Charlotte Brontë, *Jane Eyre* (1847)

The king was dead. But the queen was very much alive. Marguerite was fifty-four years old – and now a widow.

'Crept in early to have a last look at James,' recorded the American on 2 December. 'V. handsome and at peace [...] Am happy for him that illness is over and no more discomfort.'[1]

She wrote to her late husband's friend, Lord Rowallan, now Governor of Tasmania, to tell him the news, at the same time as graciously paying tribute to his and McBey's decades-long friendship. (In his own memoirs, Lord Rowallan wrote that he feared his meeting with McBey at Gibraltar might be their last.)

'James was so very fond of you [...] and I am happy that he had that time with you at Rowallan and Gibraltar so recently,' she penned that December.

> He always enjoyed being with you. I cannot realise he has gone – El Foolk and Tangier are still so full of him and I hope will be always. An amusing drawing I haven't seen for years slips to the floor and I'm laughing with him. I have so much to be thankful for. James seemed in perfect health and had just finished an excellent portrait. He got a chill which developed into acute bronchitis. The doctor asked him what he did when he got the chill. 'Well, I took the only medicine prescribed in Scotland [...] exercise. I spent the morning chopping wood.' This was complicated by a cerebral haemorrhage and then pneumonia. He remained in his room from which he loved to see the sun rise over the Straits. He died after 12 days of illness.[2]

She wrote to Lord Rowallan after a more fraught letter to Arthur and his wife, Kitty, in which she had chronicled McBey's illness, death and subsequent memorial service. The service, in its beautiful simplicity, would surely have elicited his grandmother's approval. Marguerite had dated her note 7 December, but clearly still reeling from the previous six days, absent-mindedly scribbled in the year as '57, before trying (meekly) to correct it.

'I hope this telegram was not too much of a shock,' she penned on yellow notepaper classily adorned with her Tangier address and PO Box number.

> I must say, I can't remember at what stage I wrote you [...] He was lucid and witty to the last – wanting to paint his Moorish nurse. He had a Moorish one, Spanish one and Huusko – everyone did everything possible and I thank God it's like this – no mention of James as an invalid and no suffering or limited physical activity, which he never would have supported I think. I have been a woman of iron and all say they admire me. I am sad but inside I'm happy if it had to be that it was like this,

adding, too, that all of their friends, such as the Cyrs, David Herbert and Tangier's British consul-general, Bryce Nairn, and his wife Margaret,

> have been with me constantly as has Huusko – watching over me like hawks and getting everything done as if on oiled tracks. James lay in the studio, flowers banked on the windows – coffin closed, just natural (light) mahogany on which only a bunch of heather and his palette and 3 brushes. There was a very nice little ceremony in the studio – just old friends – at the base cemetery there must have been over 100 people while the casket was put into a temporary vault – all of which [sic] came to shake hands with me afterwards. Someone said it was not sad.³

Leslie John Legg and another friend 'are having built on Cherifian Rocks (the lower property) a grave to which the coffin will be moved when the weather is better,' she continued.

> I hope to have [former US diplomat] Hooker [Doolittle] [...] to say a few words and get 2 pipers over from Gib. to play. Legg has been magnificent, everyone has, and my heart is overflowing with gratitude. I only wish James could know how very much he was loved here and the amount of goodness in the world. I'll

live a long time on the love that has been lavished on me during the last week [...] The house is full of James and full of peace and I act with great calm and serenity for the first time in many years. Love to you both, Marguerite.[4]

Marguerite, who had clearly chosen not to divulge the somewhat traumatic end to McBey's life in either of these two letters, had known for eleven years of his wish to be buried on Cherifian Rocks. On 12 September 1948, at the height of their estrangement, the artist had written to her: 'If anything should happen, and if it be possible without much trouble, I should like to stay in the lower property, on the high bit, just beneath the Cherifian Garden. It is still, to me, a heaven down there.'

The Scot had, we know, been conscious of his own mortality for some time. At the back of his 1959 diary – after pages with all the names and addresses of his friends and former lovers – was a list of people buried at Foveran Kirkyard, together with the dates of their deaths and the age at which they had passed. He had recorded the details on his final visit to his birthplace: 'John Ritchie, 28 Feb. 1941, 90', 'Mary Gillespie, 28 Nov. 1915, 95', 'Anne Gillespie, 12 Dec. 1906, 45', and so on, perhaps attempting to gauge something of his own potential life expectancy. As a young Aberdonian bank clerk, he could have little imagined that he would end his days in Morocco – let alone be buried in its soil. But Marguerite and their mutual friends made good on their commitment, and under a gravestone inscribed (in Arabic) with the words 'He Loved Morocco', he was laid to rest on Cherifian Rocks, where he remains at eternal peace today.

News of the Scotsman's death was spread across the continents by the world's press. *The New York Times*, the illustrious pages of which he had graced over the decades, paid tribute to the creative, as did *The Times* of London, which remarked that his life

> provides one more example of the grit and pertinacity, allied to great talent, so often found in the sons of Scotland; for, born obscurely in the far north, receiving no encouragement or training in art, he used hand and brain to such good effect that by the age of 30 or thereabouts he was internationally famous as an etcher. To-day his name has, for the time being, largely dropped out of fashionable art talk; but at the height of the boom in contemporary etchings, some 30 or 40 years ago, he was among the few most eagerly collected artists.[5]

The Philadelphia Inquirer also featured a worthy homage, given his and Marguerite's links to the city, as did New York's *Newsday*, both reminding readers of the late artist's feats and local connections. *The Guardian* lamented his passing by recalling McBey's first trip to London as a bank clerk with the gold bullion. 'He told the story one night to the Scots Club in Fleet Street [...]' the newspaper remarked on 7 December. 'McBey did not forget the Scots Club in Fleet Street, for he painted in tartan the club mascot, an old tobacconist Highlander about four feet high with a swivelled arm, operated by a string, which afterwards saluted several Premiers at club meetings.' Scotland, too, honoured their most extraordinary progeny, mourning his death and celebrating his life with the highest praise. The Granite City's *Evening Express* naturally marked the passing of this famous son of the north-east, as did Edinburgh's *Scotsman*, which split its glowing obituary into several subheadings.

McBey had been a globally-renowned portrait painter, but the free fall of the etching market – in which he had been regarded as a bona fide genius – combined with his life of blissful exile in North Africa meant many other press tributes were limited to the snappy repetitive reports off the wires. Had he passed away in London prematurely in the 1920s, then it is likely his death would have multiplied the column inches in a lament to a virtuoso creative cut down in his prime. But he had certainly made his mark on history – and Marguerite would soon make sure that as many people as possible would know of her late husband's unique contribution to the modern art world.

Right now, however, Marguerite was too busy taking stock. In the minutes, hours and days following McBey's death, she had been surrounded by her expat friends all eager to help, as her letter to Arthur and Kitty made clear. McBey's strong-willed Finnish-born masseuse, Huusko, made Marguerite soup (as she had often done for the Scotsman himself) and gave her a massage in attempt to soothe her tensions – and there were countless international cables with expressions of condolence. But as her letter to her brother and sister-in-law also indicated, something about her husband's death was liberating – 'I act with great calm and serenity for the first time in many years.' Of course she was relieved that he was in no more pain and distress, but there was a release for her too; his passing was empowering even.

'Spent morning in bedroom,' she had scribbled in her diary on 4 December. 'Quiet, quite peace and calm [...] Wonderful feeling being free and no pull inside to get back always.'[6]

Two days later, she had confided in her journal: 'I only hope I can live now to enjoy this new wonderful freedom and calm.'[7]

And on the seventh: 'Determined to rest. Heart thumping sometimes and I so want to live and enjoy my new-found freedom. This house is calm and peaceful and full of James but with all tension snapped.'[8]

Marguerite, realising that McBey's death had freed her from the suffocating worry of an ailing or bedridden husband, was already anticipating a future without him, and it was filled with possibilities.

McBey had dominated their lives together, both as a man and a famous artist, even from their days as a courting couple. Marguerite had long given up pursuing her own creative ambitions in order to dedicate herself fully to his needs and wants. Yet, despite her 'new found freedom', Marguerite's longing to emerge from her chrysalis proved almost impossible to do at first. She would eventually live the remainder of her (long) life according to her own rules, but, in the wake of McBey's passing, the late artist's domineering shadow remained as potent in death as it did in life. 'He is still taking complete charge of my life,' she would confide in a notebook.[9]

In the aftermath of her bereavement, Marguerite felt compelled to keep both hands on the tiller of McBey's legacy. In June 1960, the American announced that she would meet the cost of a room at Aberdeen Art Gallery, and on 18 April 1961, the James McBey Memorial Room was officially opened, with Marguerite present. A month later, Foveran Parish Church conducted a memorial service where a bronze plaque, gifted by Marguerite, was unveiled in loving memory of the parish's local hero.

'Genius, we are told, consists in an infinite capacity for taking pains,' went part of the dedication as read by the Rev. John Tennant.

> James McBey precisely and triumphantly fits this description. But genius in a man is not evident at his birth. It must be nurtured and developed by his natural surroundings and by the people among whom his lot is cast [...A]ll conspired to make McBey the great painter and etcher he became, and the typical Aberdeenshire Scot he remained to the end.[10]

During the same year, Marguerite donated more than a hundred and forty of her late husband's works to the Cummer Museum of Art & Gardens in Jacksonville, Florida, after the intervention of the artist's Philadelphian confidant, H. H. Kynett. He had shown 'The H. H. Kynett Collection of Etchings by James McBey' at Aberdeen Art Gallery in March 1960 and remained protective of his friend's memory.

'Under no circumstances would I submit the manuscript which James wrote some years ago,' he opined in a letter to Marguerite on 27 March 1961. McBey had written to Kynett in April 1948 to explain his unwillingness to elaborate in his autobiographical writings on why he had kept his mother's suicide a secret: 'I suppose I [McBey] didn't convey at all the mean almost triumphant malice which would have been Aberdeen's attitude.' Kynett said of the biographical material,

> It is bleak and stark and does not disclose the real James at all. It would give anyone attempting to write a biography a completely distorted picture, because all it does is to disclose James' bitterness which was buried very deeply in the magnificent phases of his character. I think it would be a great mistake to bring this out in the open, and it should be buried, probably permanently. Any real biography of James should be concerned with his art and his existence once he had found himself and developed the characteristics that made him what he was.

Despite McBey's Scottish and British roots, and Marguerite's American ones, Tangier, for her, remained home. The North African port 'was a vibrant, exciting, beautiful city',[11] and she was not about to retreat into her shell. It was a haven for American and British members of the literati, many of whom, as revealed earlier, revelled in the city's reputation as a refuge for same-sex relationships. By the 1960s, 'Tangier was as gay a city, in every sense of the word, as it had ever been,'[12] wrote one-time Tangier-resident Dennis Dewsnap in his autobiographical work, *What's Sex Got To Do With It?* (2004).

Even during McBey's time as one of Tangier's foreign elder statesmen, American author William Burroughs had written – in a Tangier hotel room – his drug-fuelled surrealist novel, *Naked Lunch* (1959), which, interspersed with explicit language and homosexual sex, would fall foul of US obscenity laws. Other famous figures, including Tennessee Williams, Truman Capote, Gore Vidal, Joe Orton and other gay and bisexual

creatives, would also find the city fertile ground in which to explore their sexuality unencumbered. In this environment, a widowed Marguerite would likewise find herself free to pursue her own passions as she consolidated her colourful social scene, mixing with the likes of David Herbert, second son of the 15th earl of Pembroke; American author Paul Bowles, author of novel *The Sheltering Sky* (1949); and his writer wife, Jane; all Tangier residents – and all gay.

Indeed, according to a friend who knew Marguerite well, the widow and Molly Huusko became involved after McBey's passing.[13] But it was another woman who became the greatest love of Marguerite's life following the death of her husband. It was Easter 1964 when Lady Caroline Duff and her adopted teenage son, Charles Duff, arrived in Tangier for a two-week visit. Lady Caroline was the bisexual wife of Sir Michael Duff, also bisexual. Theirs was a marriage of convenience, and Lady Caroline's real partner had been English actress and playwright Audry Carten. Audry was an alcoholic, and, by the turn of the 1960s, according to Charles Duff's memoirs, she was suffering from 'early senility'.[14] Both Charles and his mother were staying with David Herbert, Lady Caroline's cousin and Charles' godfather, when Marguerite and the English aristocrat struck up a relationship. Lady Caroline, worn down by her duties of care to Audry, was immediately taken with Marguerite, then in her late fifties, but still stunning with her swarthy looks and jet-black hair – often resembling 'an Aztec princess or a Pharaoh's consort'.[15] Eight years younger than Marguerite, Lady Caroline is understood to have told Herbert: 'I have found my Waterloo.'[16]

'Caroline was really very ready for a [new] relationship,' says Charles, also claiming that his mother and father were living a 'nightmare marriage'. 'And also very ready for a relationship where she could leave London, where Audry was, and North Wales, where Michael Duff lived.'[17]

Marguerite was already friends with Veronica Tennant, Sir Michael's sister and another member of Tangier's expat community, when the 5'7 Lady Caroline entered her life. Their love blossomed as Lady Caroline spent more time in Tangier and Marguerite gave her new romantic interest gifts, such as a crocodile skin handbag. The American must have seemed to Lady Caroline heaven-sent. Marguerite, having travelled widely for years with her late artist husband, was a practiced traveller, able to show Lady Caroline the world. Marguerite took the Englishwoman on her first

visit to the United States, where she gave Lady Caroline a guided tour of the very same haunts (New York, Philadelphia and North Carolina) that had, for decades, been such a familiar part of her life with McBey. As their relationship deepened, they made intrepid journeys to other parts of the globe – such as Europe, India and East Africa – and across the 1960s and into the 1970s, they would make the most out of what Herbert called their 'amitié amoureuse'.[18]

The skilled bookbinder, embracing her freedom more and more with the passing of the 1960s, also explored her own (hitherto suppressed) talent for art. She took to sketching as she travelled the world with Lady Caroline, often converting her studies into finished watercolours. But she also involved Lady Caroline in her loving attempts to tell McBey's extraordinary story by way of a biography. By this time, the American had largely thrown off the shackles of her previous life, but she remained determined to immortalise her dead spouse in the world of literature – not just art.

She had, we know, been somewhat consumed by McBey's legacy in the aftermath of the Scotsman's death, and, in the very early years of her widowhood, the artist's diaries and letters remained close at hand as she made plans to make publishable the entirety of his life. She had sought the counsel of H. H. Kynett, who, in another letter to her in 1963, remained of the view that his friend's own account 'was too brutally frank.'[19] She also discussed with British publisher Rupert Hart-Davis the possibility of employing the services of British writer, and Tangier resident, Rupert Croft-Cooke. In 1953, the prolific Croft-Cooke had been arrested at his English home for 'gross indecency' with two naval ratings, for which he had been given a nine-month prison sentence. Following this, and in 1954, Croft-Cooke had left to join the thriving gay scene in Tangier – but would become jaded with life there.

'It had been an intolerable summer in Tangier,' he would write in the late 1960s, shortly before his permanent return to England. 'The Anglo-American colony, which has grown large and vociferous, sizzled with rumour, intrigue and violence.'[20]

By the end of 1962, however, he had agreed with Marguerite to ghost write her late husband's biography, receiving six months later as part payment $1,500. At the outset, in a letter to Hart-Davis in December 1962, the widow had admitted to being 'a bit frightened to proceed'[21] with it all,

but embraced Croft-Cooke's involvement when he signed on the dotted line. Yet, by 1968, both Marguerite and Lady Caroline had assumed control over Croft-Cooke's manuscript – which had begun where McBey himself had ended in 1911 – after the agreement was amicably annulled. Marguerite had clearly long disregarded the tiresome objections of H. H. Kynett, and sought publication.

But they were to be met with disappointment. In April 1969, Jamie Hamilton, chairman of Hamish Hamilton Ltd. publishers in London, wrote (an albeit cheery) letter of rejection in response to Marguerite and Lady Caroline's overtures. Reflecting just how much Lady Caroline had become involved in attempting to get published the totality of McBey's autobiographical work and Croft-Cooke's initial effort, later partially re-written by the couple themselves, the missive was addressed to Lady Caroline herself.

While Hamilton couched his rebuff in deferential terms, his response – 'Had James McBey survived and been able to finish his autobiography it might well have been worth publishing' but 'the fact must be faced that while McBey's name is still known to earlier admirers like myself [...] the general public is not so well informed' – must have been galling. This would not be the end of the matter, and Marguerite would triumph yet, but Hamilton's suggestion that the 'second-half'[22] of the book hadn't done justice to McBey's own account was surely as much of an indictment of the somewhat cautious nature of the Croft-Cooke-originated manuscript as of McBey's alleged lack of vogue.

Marguerite's life during the 1960s was dominated by her conflicting attempts to free herself from McBey while trying to honour his memory at the same time. But Marguerite also established herself as an artist in her own right over the decade, culminating in her first exhibition of paintings in Tangier in 1970. The 'Swinging Sixties' would, too, provide her with a serendipitous launchpad from which to reinforce her reputation as one of expatriate Tangier's leading lights. Opportunity came when the Tangier Port Company needed to quarry stone from Cherifian Rocks to help expand the city's quayside. In return, Marguerite received a $20,000 settlement which she used to construct a Sea House.

'Returned Tangier from London,' she wrote on 13 October 1962 in her self-bound 'Sea House' journal. 'Found Sea House built on platform. Perfect situation.'[23]

Seventeen days later, the 'cement table and benches and walls' were being built, but it would take until Monday 12 August the following year before Marguerite's project was given its long-awaited christening,[24] and meanwhile she travelled to the likes of Egypt, Syria, Lebanon and Switzerland.

'First party,' wrote the fifty-eight-year-old trend setter later that day almost breathlessly. 'After 1 week of severe wind – a perfect calm and beautiful day [...] Set table with "Blue Sea and Stones" tablecloth [...] David [Herbert] down early to put down matting. Place looked superb.'[25]

Ten guests came that day, including Herbert, director of Knoll International France Yves Vidal, and French interior designer François Catroux. They ate like God's chosen ones – salade niçoise, pinchitos of lamb and liver, a cheese board and melon, figs and grapes – while they shared stories and admired the view across the Straits.[26]

Marguerite's Sea House gatherings, particularly her summer parties, would soon become legendary events. 'She would welcome penniless teenage artists if they were beautiful and reject duchesses if she thought they were boring.'[27] When Lady Caroline arrived on the scene, she, too, joined the get-togethers. Lunches at the Sea House included the likes of Paul Bowles, American writer John Hopkins, who, in 1997, would publish his memoirs of his life in the city, *The Tangier Diaries: 1962–1979*, and Alabama-born Joseph A. McPhillips, who, in 1962, moved to Tangier to take up his role as an English teacher at the American School of Tangier (from 1972, he would assume the role of headteacher). Tessa Codrington, who had been coming to Tangier since the age of nine and would soon make her name as a society photographer, would also negotiate the steep descent to where the Sea House sat perched on the edge of the rocks. There, after a lunch of grilled sardines washed down with wine, guests would often leap into the ocean, swim, sunbathe and repeat as the Tangier sun beat down on their semi-naked bodies; and Marguerite watched, stylishly dressed, the doyenne of all she surveyed.

During the years, she kept detailed notes of her visits to the Sea House – 2 May 1964: 'After cocktails at El Foolk, (8 people), David [Herbert] and I were to have lunch at Sea House [...] Conversation concentrated on gossip. Glorious day and I felt it was a desecration'; and 5 May 1964: 'Lunch with David [Herbert and British photographer] Cecil Beaton.

Cold and David chilled swimming.' She also often recorded the state of the weather (as McBey had been inclined to do) and the waves.[28]

While the American was able to fully realise her adventurous spirit in later life, she was, naturally, unable to stop the march of time taking away those she loved. In 1959, it had, of course, been her husband, but, on 5 December 1968, her beloved brother, Arthur, died at a North Carolina community hospital of bronchopneumonia, having suffered for eight months from a terminal glioblastoma brain tumour. While staying with Marguerite in Morocco in the autumn of 1975, Lady Caroline herself would be taken ill, forcing her return to London for tests. There, she would be diagnosed with pancreatic cancer, dying on 18 March 1976, estranged from her son, Charles, whom she had inexplicably disowned a year earlier. Marguerite had been present in London, but did not stay for the funeral, travelling back to Tangier after hosting a dinner several days after Lady Caroline's death at her H.P.A. home, where Charles and his father had a drunken row as their own relationship deteriorated.

By the 1970s, some of McBey's former lovers had also passed away. Billy Turner in 1961 of, according to her death certificate, an accidental overdose of barbiturates (which her son, Gordon, claims was a deliberate act) five months after her husband, Sir Henry, had tragically drowned in the Thames. Artist Anne Finlay died of breast cancer in 1963, and Isa Curtis of heart failure in 1966.

Marguerite was just one month shy of her seventy-first birthday by the time of Lady Caroline's death. In Tangier, which was a hotbed of idle gossip and chit-chat, she was admired as a serious and intelligent woman, and respected for her fresh watercolours, and the exhibitions which she had held. She would continue to hold shows, at such places as London's Portmeirion Gallery (October–November 1975) and, of course, Aberdeen Art Gallery, where around seventy of her portraits and landscapes, primarily of Morocco, were shown between November and December of 1975. During this time, visiting creatives to Tangier, such as Spanish artist Rafael Cidoncha (1952–), who became a close friend of the widow from the mid-1970s until her death, often gravitated to Marguerite, drawn by her clear devotion to and passion for art.

'Marguerite wasn't really in the sort of silly, chattering, superficial social world of Tangier, which David Herbert commanded,' opines Charles Duff.

She had periods where she was quite reclusive, where she had friends to stay, and she didn't go out and when she worked and painted. She made forays into that social world – and would have wonderful dinner parties in James' studio at El Foolk surrounded by easels and paintings propped up against the wall – but the people weren't superficial, but were writers like Paul Bowles and [1961 Pulitzer Prize winner] Sanche de Gramont.[29]

But ask today for people's immediate recollections of Marguerite, and the answer is invariably her style, her dress-sense and her effortless air of sophistication, all of which McBey had fallen in love with decades earlier, and which continued to infuse her character even into old age. El Foolk, where she hosted her friends and confidants, was her main home, but she also liked to spend time at H.P.A., which she kept almost exactly 'as it was during the years of McBey's greatest fame' and where the past made 'the present, the roar of traffic beyond the wall, irrelevant and unreal.'[30]

'She handled her personal finances there, shopped for clothes, saw plays and visited museums,' recalls her niece, Kathleen, of her aunt's London visits.

She seemed to always be on the cutting edge and 'in the know.'
In the late 60s and early 70s after the play, *Hair: The American Tribal Love-Rock Musical*, came to the stage, Marguerite had the soundtrack which I listened to in Tangier on a record player.[31]

In the late 1970s, she managed at last to have published an account of McBey's life. It came about after Oxford University Press' Nicolas Barker 'happened on the manuscript of the McBey memoir'[32] after he had caught sight of it in amongst a set of the late artist's antique paper which Marguerite had offered to Harvard University, and which Barker had been asked to examine. Barker immediately saw the work as 'a small masterpiece'[33] and collaborated with Marguerite to publish *The Early Life of James McBey* under the auspices of Oxford University Press in 1977.

'I always thought James' unfinished autobiography should be published,' she would write in her planned introduction to McBey's unpublished biography. 'After his death I felt this even more strongly and the idea gave me no peace.'[34]

'When Marguerite McBey hit seventy,' wrote John Hopkins, 'she levelled off. Nobody can explain it, but she just stopped getting older.'[35] This flattering view echoed that of many who knew her, but, like others

of a certain age, she would in fact find her growing maturity something of a burden. When the steep decline that led to her Sea House became too much for her aged bones, she would take in the mint and pine-infused aromas of the surrounding eucalyptus trees, as well as the yellow broom, rock roses, mimosas and other growing vegetation, from astride a donkey.

But she remained a person who was largely interested in what came next; her next dinner party, trip or adventure. She rarely dwelled in the past, unlike McBey, who had been perennially inclined to reflect and brood. She continued to keep her nieces – Barbara, Joan and Kathleen – close, even as they themselves established their own lives, and she delighted in her aromatic garden where she grew flowers, fruit and vegetables. Yet, she craved companionship, and after Lady Caroline's death, found it with another Tangier resident, Nancy Eastman, a full thirty-three years younger than herself. She was the Maine-born wife of Harland Eastman, Tangier's American consul-general between 1975–1979. Nancy had long lived an itinerant life as a diplomat's wife, so when Harland retired in 1979 and returned to the US, the expat mother remained in Tangier, where, settled, she continued her career as head librarian at its American School. In Tangier, Nancy and Marguerite became close during the 1980s and the 1990s, and the ageing Philadelphian's notes reveal that they spent time together on some of the most important days of the year.

'Today is Easter Sunday,' wrote Marguerite on 15 April 1990, just fifteen days shy of her eighty-fifth birthday.

> I phoned Nancy and proposed we do something to set this day apart. She said she'd think it over and phone me back. She did and suggested this walk on Cherifian Rocks. For more than a whole year I have not been near the place. Today I walked down with cane and a helping hand of Nancy – saw James' grave and [...] the Eucalyptus grove [...] It was glorious [...] Breeze from the N. – sun and cloudless sky and a great serenity about it all. I feel great![36]

She gladly retained her ties through her husband to Scotland's northeast. She remained respected there for her deft handling of McBey's priceless legacy and her own independence of thought and creation. In August 1991, she travelled to the Granite City to formally open a *McBey and the Sea* exhibition, dedicated to her now long-dead spouse, at Aberdeen Art

Gallery to coincide with the visit to the city of the Tall Ships Race. There, she sketched the Tall Ships from a tower block office, telling a local newspaper: '[McBey] had a tough time in Scotland, but he wasn't ruined for life. He was very human. He liked frankness and sincerity. He hated anyone smarmy.'[37]

After McBey's death, she maintained her ability to provide interesting copy for the press – featuring, for instance, in a 1967 edition of *The New York Times* ('International Set in Tangier Stays Aloof'), a 1970 edition of *The Sydney Morning Herald* ('Morocco is Gold, Silk, Jewels, Age and Beauty') and a 1984 edition of *The Sunday Telegraph* ('Why a Present of Paints and Brushes Revealed a Rare Gift') where she had spoken of her reluctance to forge her own artistic career during her marriage: 'I gave up my bookbinding, and even though he gave me paints and brushes and urged me to use them, I never did. I thought that one painter in the family was enough.'[38]

In April 1995, she celebrated her ninetieth birthday in Tangier with her nieces and Nancy, who had long made herself indispensable to Marguerite. But when Nancy's health began to falter, Marguerite's life in Tangier became uncertain, and both decamped to H.P.A. Her nieces were compelled to fill the void left by Nancy when she was forced to return in 1997 to the US, where she sadly died one year later. Marguerite was back in Tangier, via Canada, where her niece, Barbara, resided, in the spring of 1998. There, several months later, she suffered a stroke, before suffering another in December while in London. The last impaired her speech, and she never spoke again.

During her final months at H.P.A., under the care of its housekeeper, Jean Cragg, and her husband, Douglas, she was bedridden. Paul Bowles was of frail health in Tangier, and David Herbert had died there in 1995. Marguerite passed away on 21 October 1999 in the house which McBey had bought a full eighty years before, and which she had largely kept as a shrine to his memory. She was ninety-four.

As a tribute to a long and glamorous life, which had seen its fair share of tragedies, challenges and hardships, the American's death was marked by colourful press obituaries, such as those in *The Daily Telegraph* and *The Guardian*. Both London-based broadsheets remarked on her past love affair with Oskar Kokoschka. *The Guardian* included as its featured image of her McBey's 1950 oil on canvas work, and stated: 'As recently as 1998

she was photographed by Bruce Weber for *Vanity Fair*, and *Hello!* magazine dubbed her "the doyenne of Morocco-based artists."'[39]

She was cremated eight days after her death in the East Chapel at the West London Crematorium, after which a reception was held at H.P.A., all organised by her nieces. In the year 2000, Barbara, Joan and Kathleen attended a memorial service for their aunt in Tangier (where Bowles had died just a month after Marguerite herself) where they scattered her ashes in the waters she had known so well.

In words resonant in tone to those written by Marguerite or McBey himself, Barbara later recalled their pilgrimage: 'Katie, Joan and I went to Tangier in May 2000 – along with our husbands. I carried Marguerite's ashes with me. One day, the six of us walked down to her Sea House on the Straits of Gibraltar. It was late afternoon – the sea was calm and lit by the sun. We scattered her ashes into the water and they glittered like silver. It was a peaceful and moving moment.'[40]

Afterword

In the first half of 2000, Marguerite's nieces, faced with three wills and two lawyers, cleared out 1 Holland Park Avenue and El Foolk following the death of their legendary aunt. Marguerite had earlier donated many of McBey's works to Aberdeen Art Gallery, and to the American School of Tangier, Cherifian Rocks. It proved an exacting – but also wonderfully illuminating – experience. Not every artwork created by the Scotsman had survived, however, Marguerite having destroyed in 1961 two of his oil paintings (both of women), and, under the instructions of H. H. Kynett, some female nudes sketched in watercolour. In truth, though Marguerite's death was more recent, it was her larger-than-life husband who continued to haunt the halls, walls and studios of Holland Park Avenue and El Foolk. The Aberdeenshire man had been dead for more than forty years, but many matters centred on him in death, as they had in life.

'The London house was full of his papers,' remembers Barbara, who made good on Marguerite's request to burn an envelope marked 'Destroy After My Death', the contents of which will likely remain a mystery.

> James had kept everything – receipts for things he bought – art he sold. But his presence was very much a part of both houses, the furnishings – and the art. We were definitely aware that Marguerite had dedicated her life and energy to him while alive and to his art, and protecting and enhancing his reputation after his death. He was always a presence in those houses and in Marguerite's life.[1]

For any successful creative, it is the creations themselves which naturally assume the mantle of 'legacy' after death, and McBey created much and wasted little. Who could fail to be stirred by his internationally acclaimed plates such as *Dawn: The Camel Patrol Setting Out*, *Night in Ely Cathedral* and *Grimnessesluis*. Or by his globally feted oil on canvas works, such as the paintings of T. E. Lawrence, Clémence Bonnet-Matthews and Zohra, the former still a prized possession of the Imperial War Museums,

and the latter two – including the 'Moroccan *Mona Lisa*' – to this day hanging at the Tangier American Legation Museum in Morocco.

He remains a powerful draw for art collectors worldwide. In September 2020, McBey's 1914 oil on canvas work, *Portrait of Dacie*, was sold at Christie's in London for £25,000 GBP.[2] In December 2021, his 1933-dated *Marguerite Sleeping*, another oil on canvas portrait, realised a price of $46,740 USD at American-based auction house Brunk.[3] At the same US auction, a single impression of his 1926 Venetian plate, *Santa Maria della Fava*, fetched $2,560 USD.[4] McBey's war-time etchings continue to be among his most valuable prints, however, with many achieving sale or auction prices of $1,000 USD-plus. For his legions of admirers on both sides of the Atlantic, he remains one of the world's most underrated artists, who may again be globally celebrated. The homes he procured – in London and on the Old Mountain Road in Tangier – remain as prominent today as they did when McBey first purchased them. The distinguished H.P.A. – which McBey bought in 1919, and which played host to some of his greatest creations and many of his love affairs – was sold in March 2000 for £2,875,000 GBP (and is today worth close to eleven million GBP).[5] Indeed, such had been the impact of H.P.A. on many who crossed its threshold throughout the decades that one former colleague from McBey's war posting in France was moved to write to *The Times* following the artist's death:

'The last occasion I saw James McBey was sometime in the 1920s, in his studio in Holland Park, where he entertained my wife and me to a magnificent Scottish tea,' went the 10 December 1959 letter, in which the author recalled the Scot's 'wonderful luminous eyes'.

> I remember the tea, the fine furniture, the blazing fire, the Louis XIV curtains which he and I had bought in Rouen, and his dramatic arrangement of his fine collection of Rembrandt prints; they covered one whole wall of the studio and were its only mural decoration; the other walls were bare.

El Foolk was purchased by erudite British art dealer, collector and decorator Christopher Gibbs, who 'later built a ravishing Neoclassical villa in the neighbouring gardens.'[6] In 2018, the iconic Gibbs 'died like a king of yore [...] in his beloved Tangier',[7] as McBey himself did fifty-nine years earlier.

McBey's extraordinary life was lived in an almost nomadic state of in-betweenness.[8] A life which he documented in the art he produced, and which became his one true constant. He was an enigma – perhaps even to himself – and it is this element of the man that was largely the inspiration for this book. As his biographer, I found myself party to the artist's day-to-day life as I waded through page after page of diary. There is something simultaneously peculiar and moving about reading journal entries of an individual in their original hand as they unwittingly approach the hour of their death. And so it was reading the diaries of James McBey, who retained his belief in God, and maintained many of the relationships he had forged over his spectacular life to the very end.

Tracing the descendants of those who knew McBey proved one of the most electrifying aspects of my research. Not content to simply accept the Scotsman's own perspective on his various love interests, I determined to find out more about the women themselves. Not every woman with whom McBey enjoyed short- or long-term relationships appears in this account. I was able to give a fuller picture of those who do after some online detective work and not a little luck brought me the way of their living relatives. For example, Frances Gripper's life was revealed to me by her granddaughter, Leslie, Fay Woods' by her granddaughter, Georgina, and E. Arnot Robertson's by her adopted son, Gordon (who, as a little boy, himself remembered meeting the Aberdeenshire creative after the Second World War). Each interaction was, in its own way, illuminating, and in the case of Leslie, conducted between my home in Scotland and hers in California. Leslie even possessed some McBey-related memorabilia from her long-dead grandmother, including a menu (on which McBey had doodled, naturally) from a Paris restaurant where both the artist, who was traversing continents decades before international travel became commonplace, and Frances had dined in 1929.

The global pandemic proved, from a research point of view, a double-edged sword: it made visiting museums and libraries at the height of lockdown impossible, but communicating with people who were working from home (and, like most of us, craving the outside world) often simpler. As restrictions eased, the many experts with whom I had been discussing McBey's life were able to access their own work-place records, and I too was able to visit the artist's Aberdeen-based archives. Suddenly,

his life story could pour on to my page like water off granite, and I was relieved to finally make good on my project.

Intriguingly, McBey's widow claimed to be

> amazed at the completeness of the materials pertaining to his life [...] He had a strong sense of destiny, and something in him, perhaps that longing for immortality common to artists, was responsible [...] for his obsessive notion that even the smallest things connected with his life should be preserved. This is my explanation for the vast collection of letters, telegrams, documents, newspaper clippings and photographs [...] as well as such varied mementos as [...] bits of girl's hair kept in envelopes and labelled in cypher [...] [T]he numerous entries in the early diaries concerning women, tend to produce a one-sided portrait of James. It is more than likely that in his early relations with women his notes approximate bearings taken in an uncharted sea by a lone navigator, carefully recorded in case he should become grounded.[9]

Perhaps this is the case. But perhaps these impulses had actually been driven by an urge to tell a different tale; that which not only sought to counter memories of bleak beginnings, but which also endeavoured to prove – to the world, and to himself most of all – that he had loved and had been loved in return.

Endnotes

This biography has relied on various sources, such as interviews and books, but most particularly McBey's diaries and associated letters, all of which (unless otherwise stated) I have extracted from Aberdeen Archives, Gallery & Museums (AAGM). Where the source is revealed (or clear) in the text – such as dated diary entries and newspapers – I have often not repeated the attribution in the notes. Indeed, McBey's diary entries are the backbone to much of this work – and are often denoted in the text by such terms as 'he noted' or 'he wrote'. Where such terms refer to a letter instead, this will be made clear in the text or in the notes. Marguerite McBey's unpublished biography of her then-late husband (initially written by Rupert Croft-Cooke – but later partially revised by Marguerite herself – and held by AAGM) has also provided a framework to this biography.

It is also important to point out that for the chapters on McBey's early life, I have referred to and often referenced his 1883–1911 autobiography, *The Early Life of James McBey*, but have endeavoured to fill in gaps in his narrative and even correct aspects of his written account where obvious errors were spotted.

ABBREVIATIONS

AAGM = Aberdeen Archives, Gallery & Museums
AAWJM = 'An Artist's Wanderings by James McBey: The Brilliant Etcher as a Letter Writer', *The Graphic*, 1922
AG = Annie Gillespie
EAR = E. Arnot Robertson
EDP = Martin Hardie (ed.), *Etchings and Drypoints from 1902 to 1924 by James McBey* (P. & D. Colnaghi & Co., 1925)
FW = Fay Woods
GG = George Gillespie
IC = Isa Curtis

JM = James McBey
JMAD = James McBey's army diary
JMD = James McBey's diary
JMUB = James McBey's unpublished biography
JMS = James McBey (senior)
LT = Lowell Thomas
MLI = Mary Louise Inglis
MM = Marguerite McBey
MMu = Mollie Murray
TELJM = *The Early Life of James McBey: An Autobiography* (Canongate Classics, 1993). (First published by Oxford University Press, 1977)

FOREWORD

1 'James McBey Talking' from AAGM.
2 Opinion as expressed by esteemed printmaker Edward Twohig, head of art at Marlborough College.

CHAPTER ONE

1 Sir Ronald Storrs, *Lawrence of Arabia: Zionism and Palestine* (Penguin, 1940), p. 26. (The contents of this book were originally published in *Orientations* – Ivor Nicholson and Watson – in 1937.)
2 Accepted manuscript of a book chapter from Michael J. K. Walsh and Andrekos Varnava (eds.), *The Great War and the British Empire: Culture and Society* (Routledge, 2017), p. 18.
3 James Barr, *Setting the Desert on Fire: T. E. Lawrence and Britain's Secret War in Arabia, 1916–1918* (Bloomsbury, 2006), p. 291.
4 Michael Asher, *Lawrence: The Uncrowned King of Arabia* (Penguin, 1999), p. 338.
5 Liddell Hart, *T. E. LAWRENCE: In Arabia and After* (Jonathan Cape, 1934), p. 360.
6 Michael Korda, *Hero: The Life & Legend of Lawrence of Arabia* (Harper Perennial, 2011), p. 440.
7 Ibid.
8 Ibid.
9 Michael Asher, *Lawrence: The Uncrowned King of Arabia* (Penguin, 1999), p. 337.

10 Charles Masterman was McBey's superior at the Ministry of Information.

11 TELJM, p. 115.

12 James Barr, *Setting the Desert on Fire: T. E. Lawrence and Britain's Secret War in Arabia, 1916–1918* (Bloomsbury, 2006), p. 213.

13 Rory Miller (ed.), *Britain, Palestine and Empire: The Mandate Years* (Routledge, 2016), p. 92.

14 JMD, 12 January 1918, AAGM.

15 Ibid.

16 'Holy Land Bible Illustrators', *Sacred Art Pilgrim.* http://sacredartpilgrim.com/schools/view/43. (Accessed 21 October 2021).

17 TELJM, p. 4.

18 William Hole, *The Life of Jesus of Nazareth: Eighty Pictures* (Eyre & Spottiswoode, 1908), prefatory note.

19 JMD, 15 January 1918, AAGM.

20 James Barr, *Setting the Desert on Fire: T. E. Lawrence and Britain's Secret War in Arabia, 1916–1918* (Bloomsbury, 2006), p. 213.

21 Harry Pirie-Gordon (ed.), *A Brief Record of the Advance of the Egyptian Expeditionary Force Under the Command of General Sir Edmund H. H. Allenby, G.C.B., G.C.M.G.* (1919), p. 14.

22 James Barr, *Setting the Desert on Fire: T. E. Lawrence and Britain's Secret War in Arabia, 1916–1918* (Bloomsbury, 2006), p. 214.

23 Ibid., p. 221.

24 Ibid., p. 215.

25 Peter Rees, *The Other Anzacs: The Extraordinary Story of Our World War I Nurses* (Allen & Unwin, 2009), p. 7.

26 John Keay, *Sowing the Wind: The Mismanagement of the Middle East 1900–1960* (John Murray, 2004), p. 105.

27 Peter Rees, *The Other Anzacs: The Extraordinary Story of Our World War I Nurses* (Allen & Unwin, 2009), p. 7.

28 John Presland, *Deedes Bey: A Study of Sir Wyndham Deedes, 1883–1923* (Macmillan, 1942), p. 237.

29 Lawrence James, *The Golden Warrior: The Life and Legend of Lawrence of Arabia* (Weidenfeld & Nicolson, 1991), p. 87.

30 JMD, 2 February 1918, AAGM.

31 Ibid.
32 Ibid.
33 IC to JM, 22 January 1918, AAGM.
34 IC to JM, 28 January 1918, AAGM.
35 JMD, 19 February 1918, AAGM.
36 JMD, 25 February 1918, AAGM.
37 JMD, 2 March 1918, AAGM.
38 JMUB, p. 82–83, AAGM.
39 JMD, 23 March 1918, AAGM.
40 James Barr, *Setting the Desert on Fire: T. E. Lawrence and Britain's Secret War in Arabia, 1916–1918* (Bloomsbury, 2006), p. 229.
41 IC to JM, 4 April 1918, AAGM.
42 JMD, 11 April 1918, AAGM.
43 JMD, 13 April 1918, AAGM.
44 AAWJM, *The Graphic*, 28 January 1922.
45 Gregory A. Daddis, *Armageddon's Lost Lessons: Combined Arms Operations in Allenby's Palestine Campaign* (Air University Press, 2005), p. 15.
46 Anthony Bluett, *With Our Army in Palestine* (Andrew Melrose Ltd., 1919), p. 247–248.
47 Hector Dinning, *By-ways on Service: Notes from an Australian Journal* (Constable and Company, Ltd., 1918), p. 40.
48 IC to JM, 9 March 1918, AAGM.
49 Ibid.
50 IC to JM, 9 February 1918, AAGM.
51 T. E. Lawrence, *Revolt in the Desert* (Jonathan Cape, 1927), p. 168.
52 Archibald Wavell, *Allenby: A Study in Greatness* (Oxford University Press, 1941), p. 234.
53 JMD, 8 August 1918, AAGM.
54 JMD, 22 August 1918, AAGM.
55 Harry Pirie-Gordon (ed.), *A Brief Record of the Advance of the Egyptian Expeditionary Force Under the Command of General Sir Edmund H. H. Allenby, G.C.B., G.C.M.G.* (1919), p. 228.
56 JMD, 19 September 1918, AAGM.

57 'Palestine Campaign', *NZHistory*, https://nzhistory.govt.nz/war/palestine-campaign/battle-of-megiddo, 20 December 2012. (Accessed 28 October 2021).

58 James Barr, *Setting the Desert on Fire: T. E. Lawrence and Britain's Secret War in Arabia, 1916–1918'* (Bloomsbury, 2006), p. 279.

59 Arthur Grenfell Wauchope (ed.), *A History of the Black Watch [Royal Highlanders] in the Great War, 1914–1918* (Medici Society Ltd., 1925), p. 283.

60 Names of the war dead were sourced from the Commonwealth War Graves Commission.

61 *A Punjabi, Arsuf*, Imperial War Museums, https://www.iwm.org.uk/collections/item/object/18053. (Accessed 28 October 2021).

62 *A Punjab Sentry, Arsuf*, Imperial War Museums, https://www.iwm.org.uk/collections/item/object/18052. (Accessed 28 October 2021).

63 Accepted manuscript of a book chapter from Michael J. K. Walsh and Andrekos Varnava (eds.), *The Great War and the British Empire: Culture and Society* (Routledge, 2017), p. 16.

64 Ibid., p. 17.

65 Charles Crutchley, *Machine Gunner 1914–18: Personal Experiences of The Machine Gun Corps* (Pen & Sword Military, 2013), p. 224.

66 Lowell Thomas, *Good Evening Everybody: From Cripple Creek to Samarkand* (William Morrow and Company Inc., 1976), p. 134. (All quoted passages appear on this page.)

67 Ibid. (Harold Jeapes began his working life as a professional jockey. Thus, Lowell Thomas' quip about him being a 'gnome of a man' likely refers to him being of small stature.)

68 Ibid.

69 Walter Russell Mead, *Foreign Affairs*, November/December 2017.

70 William Thomas Massey, *The Observer*, 6 October 1918.

71 JM to LT, 9 March 1954, Lowell Thomas Papers, Archives & Special Collections, Marist College, USA.

72 Ibid.

73 T. E. Lawrence, *Seven Pillars of Wisdom* (Wordsworth Editions, 1997), p. 76. (Privately printed, 1926; first published for general circulation, 1935.)

74 JMUB, p. 86, AAGM.

75 JMUB, p. 86–87, AAGM.

76 Ibid.

77 Kenneth Hare, *London's Latin Quarter* (John Lane, 1926), p. 137–138.

78 Meirion and Susie Harries, *The War Artists* (Published by Michael Joseph in association with The Imperial War Museum and The Tate Gallery, 1983), p. 27.

CHAPTER TWO

1 Graeme Morton & Trevor Griffiths (eds.), *A History of Everyday Life in Scotland, 1800 to 1900* (Edinburgh University Press, 2010), p. 256.

2 TELJM, p. 1.

3 Ibid.

4 TELJM, p. 1–2.

5 Ibid., p. 3.

6 Ibid.

7 Ibid.

8 The author is indebted to Malcolm Nicolson, emeritus professor of the history of medicine (economic and social history) at the University of Glasgow, for this information.

9 *Aberdeen Tram Routes, Doric Columns*, 'The History & Heritage of the City of Aberdeen'. https://doriccolumns.wordpress.com/welcome/aberdeen-city/tram-routes/. (Accessed 30 October 2021).

10 Dr Lindsey Fitzharris, 'Houses of death: the horror of life in a Victorian hospital', Penguin Random House, 26 October 2018. https://www.penguin.co.uk/articles/2018/oct/houses-of-death-life-in-a-victorian-hospital-lindsey-fitzharris.html. (Accessed 30 October 2021).

11 The author is indebted to Malcolm Nicolson, emeritus professor of the history of medicine (economic and social history) at the University of Glasgow, for this information.

12 Obituary of Sir James Mackenzie Davidson, *BMJ*, 12 April 1919. https://www.bmj.com/content/1/3041/468.1. (Accessed 30 October 2021).

13 The author is indebted to Malcolm Nicolson, emeritus professor of the history of medicine (economic and social history) at the University of Glasgow, for this information.

14 TELJM, p. 3.

15 Admittance records of Aberdeen Royal Infirmary, NHS Grampian Archives. (The author is indebted to Fiona Musk, NHS Grampian archivist, for sourcing this information.)

16 The author is indebted to Dr Andrew Blaikie, ophthalmologist, NHS Fife, and senior lecturer at the University of St. Andrews, for this information.

17 George Andreas Berry, *Diseases of the Eye: A Practical Treatise for Students of Ophthalmology* (Lea Brothers and Co., 1889), p. 130.

18 TELJM, p. 3.

19 Ibid., p. 4–5.

20 Ibid., p. 7.

21 Ibid., p. 5.

22 Andrew Drummond and James Bulloch, *The Church in Late Victorian Scotland, 1874–1900* (The Saint Andrew Press, 1978), p. 23.

23 TELJM, p. 7.

24 Graeme Morton & Trevor Griffiths (eds.), *A History of Everyday Life in Scotland, 1800 to 1900* (Edinburgh University Press, 2010), p. 123.

25 Andrew Drummond and James Bulloch, *The Church in Late Victorian Scotland, 1874–1900* (The Saint Andrew Press, 1978), p. 23.

26 James McBey, 'My First Prints were made on the Household Mangle', *The Aberdeen Press and Journal*, 30 January 1933.

27 TELJM, p. 8.

28 Some commentators on James McBey's young life have suggested that he was born into poverty. This is incorrect. He and his working-class family lived simply and modestly during his formative years – but were never destitute.

29 TELJM, p. 7.

30 Ibid.

31 Ibid.

32 Charles Catto, 'Newburgh, James McBey and Cutty Sark Whisky', *Foveran Community Newsletter*, December 2011. (This paragraph is based on Catto's findings, as is the quote.)

33 There is evidence to suggest that Alexander dies of heart failure in Grong Grong, New South Wales, in 1905. As for the suggestion that the family knew Alexander was living abroad, this is indicated firstly by the 1888 death notice of his father, William Gillespie, which includes the line – 'Australian and American

papers please copy'; and, secondly, by a 1907 draft letter written by JM to his uncle, George. In it, McBey writes that after his grandmother made a new will, 'I explained to her that Alexander's share would merely go into chancery and remain there probably forever.' (Source: AAGM).

34 William Gillespie's will makes clear that James McBey (senior) from the Mains of Foveran was among those who still owed money (in his case, £2. 2s. 9d) to the deceased.

35 David Dobson, *Scotland and the Flemish People*, The University of St Andrews, 13 November 2015. https://flemish.wp.st-andrews.ac.uk/2015/11/13/migration-from-scotland-before-1700/. (Accessed 1 November 2021).

36 Interview with Dr Malcolm Kinnear, consultant psychiatrist with NHS Scotland, and treasurer of 'The Scottish Society of the History of Medicine'. 'It's certainly possible,' he said, 'that she had postnatal depression, and this can lead to a chronic depressive state [...] There is no suggestion at all that she [was suffering from] disturbed behaviour, bizarre beliefs, nonsensical speech, grandiosity, extreme religiosity which might suggest bipolar disorder or schizophrenia.'

37 Graeme Morton & Trevor Griffiths (eds.), *A History of Everyday Life in Scotland, 1800 to 1900* (Edinburgh University Press, 2010), p. 94.

38 Callum G. Brown, *Religion and the Demographic Revolution: Women and Secularisation in Canada, Ireland, UK and USA Since the 1960s* (The Boydell Press, 2012), p. 154.

39 The author is indebted to sociologist Andrew Blaikie, emeritus professor at the University of Aberdeen, for this information.

40 Lynn Abrams, *The Making of Modern Woman: Europe 1789–1918* (Routledge, 2014), p. 11.

41 *Foveran Kirk Session – Minutes 1874–1917*, National Records of Scotland, General Register House, Edinburgh.

42 Graeme Morton & Trevor Griffiths (eds.), *A History of Everyday Life in Scotland, 1800 to 1900* (Edinburgh University Press, 2010), p. 129.

43 TELJM, p. 6–7. (However, on this point, sociologist Andrew Blaikie, emeritus professor at the University of Aberdeen, told this author that 'this was the Scottish convention until well into the twentieth century, at least in that, say, Annie Smith married to John Brown would continue to be known locally as

Annie Smith anyway. What's odd is that his friend should think this unusual and, by extension, that McBey should care.')

44 Michael Asher, *Lawrence: The Uncrowned King of Arabia* (Penguin, 1999), p. 11.

45 William Boyd, Lawrence of Arabia: a man in flight from himself, *The Guardian*, 29 April 2016. https://www.theguardian.com/stage/2016/apr/29/lawrence-after-arabia-hampstead-theatre-london. (Accessed 22 November 2021).

46 Quote from Jane Gillespie's 1892 will, sourced from 'ScotlandsPeople.' https://www.scotlandspeople.gov.uk/. (Accessed 29 April 2022).

47 Christian Watt (author) and David Fraser (ed.), *The Christian Watt Papers: An Extraordinary Life* (Birlinn Ltd, 2012), p. 7.

48 Simon Forder, *The Castle Guy*, Knockhall Castle, https://thecastleguy.co.uk/castle/knockhall-castle/. (Accessed 1 November 2021).

49 TELJM, p. 14.

50 James McBey, 'My First Prints were made on the Household Mangle', *The Aberdeen Press and Journal*, 30 January 1933.

51 TELJM, p. 16.

52 Ibid., p. 18.

53 James McBey, 'My First Prints were made on the Household Mangle', *The Aberdeen Press and Journal*, 30 January 1933.

54 TELJM, p. 19.

CHAPTER THREE

1 Donald MacDonald, *Gum Boughs and Wattle Bloom, Gathered on Australian Hills and Plains* (Cassell and Company, Ltd., 1887), p. 136. (While this book – and quote – concerns Australia, it seems reasonable to assume that village blacksmiths elsewhere – including in Foveran – took on the same social function.)

2 TELJM, p. 14.

3 Ibid.

4 Ibid.

5 Ian Maxwell, *Tracing Your Scottish Ancestors: A Guide for Family Historians* (Pen & Sword, 2018), p. 72.

6 Helen Louise Young, *The small rural school and community relations in Scotland, 1872–2000: an interdisciplinary history*, (University of Stirling, PhD History, July 2016).

7 TELJM, p. 14.

8 Ibid., p. 18.

9 Ibid., p. 15.

10 Ibid., p. 16.

11 Correspondence from Leslie Tait, Foveran School Board, to James McBey, Early Paper Ephemera, AAGM, https://emuseum.aberdeencity.gov.uk/objects/136964/correspondence-from-leslie-tait-foveran-school-board-to-ja. (Accessed 2 November 2021).

12 TELJM, p. 19.

13 *Slater's Royal National Commercial Directory of Scotland* (1878), p. 282.

14 JMS to JM, 19 December 1898, AAGM.

15 TELJM, p. 21.

16 James McBey, 'My First Prints were made on the Household Mangle', *The Aberdeen Press and Journal*, 30 January 1933.

17 TELJM, p. 22.

18 Ibid.

19 William Hamish Fraser and Clive Howard Lee (eds.), *Aberdeen, 1800–2000: A New History* (Tuckwell Press, 2000), p. 25.

20 Malcolm Archibald, *Fishermen, Randies and Fraudsters: Crime in the 19th Century Aberdeen and the North East* (Black and White Publishing, 2014), p. 234–235.

21 TELJM, p. 23.

22 Ibid.

23 JM to AG, 16 March 1899, AAGM.

24 TELJM, p. 31.

25 Ibid.

26 TELJM, p. 32.

27 Prize List Session 1900–1 and Government Awards Session 1900–1, Robert Gordon's College. (The author is indebted to archivist Tom Cumming for sourcing this information.)

28 TELJM, p. 36.

29 Ibid.

30 Portrait of McBey's Mother, AAGM. https://emuseum.aberdeencity.gov.uk/objects/118124/portrait-of-mcbeys-mother-early-photographs--sketches. (Accessed 3 November 2021).

31 TELJM, p. 37.

32 TELJM, p. 39.

33 EDP, introduction.

34 The author is indebted to esteemed printmaker Edward Twohig, head of art at Marlborough College, for this information.

35 'The Etching Revival in Britain', *The Saturday Gallery*, 28 September 2017, https://www.saturdaygalleryart.com/articles/archives/09-2017. (Accessed 3 November 2021).

36 Etching with one's back towards the subject was (and remains) common practice, because, according to Jennifer Melville, art historian, 'the printing process reverses the image so by looking through a mirror you re-reverse it.'

37 James McBey, 'My First Prints were made on the Household Mangle', *The Aberdeen Press and Journal*, 30 January 1933.

38 TELJM, p. 43.

39 AG to JM, date unknown, AAGM.

40 Ibid.

41 The author is indebted to Dr Andrew Blaikie, ophthalmologist, NHS Fife, and senior lecturer at the University of St. Andrews, and Dr Daniel M. Albert, professor of ophthalmology, OHSU, Casey Eye Institute, for this information.

CHAPTER FOUR

1 TELJM, p. 35.

2 Ibid., p. 51.

3 Ibid., p. 35.

4 Ibid., p. 34.

5 Ibid., p. 51.

6 Diane Morgan, *The Granite Mile: The Story of Aberdeen's Union Street* (Black and White Publishing, 2010), p. 70.

7 TELJM, p. 51.

8 John W. Sawkins and Robert Mochrie, 'Competition and Participation in Religious Markets: Evidence from Victorian Scotland', *Review of Social Economy*, February 2008, p. 2.

9 TELJM, p. 51.

10 Ibid., p. 71.

11 Ibid., p. 64.

12 Ibid.

13 Robert Shiels, 'The Investigation of Suicide in Victorian and Edwardian Scotland', *Dundee Student Law Review*, Vol. 5(1+2), No.4, p. 5.

14 Ibid., p. 17.

15 TELJM, p. 67.

16 Ibid., p. 71.

17 Letter from William Williams to JM, 20 December 1906, AAGM.

18 TELJM, p. 75.

19 Ibid.

20 TELJM, p. 85–86.

21 Ibid., p. 86–87.

22 Kenneth Hare, *London's Latin Quarter* (John Lane, 1926), p. 135.

23 Luke McKernan, 'Diverting Time: London's Cinemas and Their Audiences, 1906–1914', *The London Journal*, 18 Jul 2013, p. 125. https://www.tandfonline.com/doi/pdf/10.1179/174963207X205707. (Accessed 4 November 2021).

24 TELJM, p. 90.

25 The Correspondence of James McNeill Whistler, 1855–1903, edited by Margaret F. MacDonald, Patricia de Montfort and Nigel Thorp; including The Correspondence of Anna McNeill Whistler, 1855–1880, edited by Georgia Toutziari. (On-line edition, University of Glasgow. Accessed 29 April 2022).

26 TELJM, p. 90.

27 Ibid.

28 For a complete history of the portrait's travels, visit https://www.whistlerpaintings.gla.ac.uk/catalogue/exhibitions/display/?eid=&mid=y101&xml=his

29 'The Theft That Made The "Mona Lisa" A Masterpiece', *NPR*, 30 July, 2011, https://www.npr.org/2011/07/30/138800110/the-theft-that-made-the-mona-lisa-a-masterpiece. (Accessed 4 November 2021).

30 Ibid.

31 *The tumultuous history of the Mona Lisa*, Un Jour de Plus à Paris, https://www.unjourdeplusaparis.com/en/paris-culture/histoire-de-la-joconde. (Accessed 4 November 2021).

32 The author is indebted to art historian Jill Marriner for identifying these works.

33 TELJM, p. 92.

34 Ibid., p. 76.

35 The author is indebted to Jacqueline Spear of The Northern Arts Club for sourcing this information.

36 The author is indebted to Jennifer Melville, art historian, for this suggestion.

37 JM's second visit to London occurred on 28 June 1909. Both his first visit (in 1907) and this subsequent visit are briefly recorded in JM's 1909 diary – but (retrospectively) written by another's hand. Why 'Ironside' (a banking associate of JM's) writes this account in JM's diary is unclear – but it states that G. B. Esslemont, MP for Aberdeen South between 1907 and 1917, facilitated JM's (and his colleague's) visit to the House of Commons.

38 TELJM, p. 96.

39 Ibid., p. 97.

40 EDP, introduction. (The quote is credited to Sir Frederick Wedmore.)

41 TELJM, p. 97.

42 Ibid.

43 TELJM, p. 98.

44 Ibid.

45 Ibid.

46 Ibid.

47 TELJM, p. 99.

48 Ibid., p. 100.

49 John U. Higinbotham, *Three Weeks in Holland and Belgium* (The Reilly & Britton Co., 1908), p. 61.

50 Ibid.

51 Ibid., p. 62.

52 Ibid.

53 Nina Lübbren, *Rural artists' colonies in Europe 1870–1910* (Rutgers University Press, 2001), p. 175.

54 John U. Higinbotham, *Three Weeks in Holland and Belgium* (The Reilly & Britton Co., 1908), p. 79.

55 Ibid.

56 Promotional Material for Hotel Spaander, Volendam, AAGM. https://emuseum.aberdeencity.gov.uk/objects/137584/promotional-material-for-hotel-spaander-volendam-letters-a. (Accessed 5 November 2021).

57 The author is indebted to Evert Schilder, art expert at the hotel, for sourcing these hotel guest records.

58 Vose Galleries, https://www.vosegalleries.com/artists/melbourne-h-hardwick. (Accessed 5 November 2021).

59 The author is indebted to Evert Schilder, art expert at the hotel, for sourcing JM's hotel guest book record from August 1910.

60 The author is indebted to Evert Schilder, art expert at the hotel, for sourcing JM's composition.

61 EDP, introduction.

62 Letter from Alida to JM, 1910 (month unknown – but likely September), AAGM.

63 Letter from Alida to JM, 24 October 1910, AAGM.

64 JM's 1910 diary features several references to Alida during his stay in the Netherlands, not least a 17 August entry when he writes: '12 morning till 2 [CODE – Alida].' Exactly one year later (17 August 1911), while travelling in Spain, he writes in code: 'Anniversary of Alida's sleep'. Indeed, during his time at the Hotel Spaander, he even notes having 'quarrelled' with Alida, suggesting that any 'relationship' was somewhat fiery (which would explain the content of her letters). JM's artistic practices were inadvertently influenced by Alida when, one day at the hotel, he asked to borrow a pencil, but having run out, she instead loaned him her fountain pen, which he discovered gave him a better line.

65 Letter from Alida to JM, 1910 (month unknown – but likely September), AAGM.

66 TELJM, p. 104.

CHAPTER FIVE

1 TELJM, p. 56.

2 Rose from Jeannie Gordon, AAGM, https://emuseum.aberdeencity.gov.uk/objects/137632/rose-from-jeannie-gordon-letters-and-memorabilia-belonging. (Accessed 8 November 2021).

3 TELJM, p. 77.

4 GG to JM, 3 January 1907, AAGM.

5 TELJM, p. 105.

6 *The Impact of Recent Immigration on the London Economy*, London School of Economics and Political Science, July 2007, p. 10. http://eprints.lse.ac.uk/23536/1/Gordon_the_Impact_of_Recent_Immigration_On_The_London_Economy_author.pdf (Accessed 4 May 2022).

7 Katrine Helene Andersen, 'A Revolt of the Masses: Culture and Modernity in Early 20th Century Spain: From Bullfights to Football Games', *CALL: Irish Journal for Culture, Arts, Literature and Language* (2017), p. 1.

8 Jennifer Melville, *Manhattan to Marrakech: The Art and Lives of James and Marguerite McBey* (Aberdeen City Council, 2001), p. 4.

9 Katrine Helene Andersen, 'A Revolt of the Masses: Culture and Modernity in Early 20th Century Spain: From Bullfights to Football Games', *CALL: Irish Journal for Culture, Arts, Literature and Language* (2017), p. 7.

10 'Spanish Bull Fights, How the Dangerous National Sport is Carried on', *The Irish News and Belfast Morning News*, 11 August 1910.

11 TELJM, p. 107.

12 Ibid., p. 109.

13 Ibid., p. 61.

14 David Young Cameron, National Galleries of Scotland, https://www.nationalgalleries.org/art-and-artists/features/david-young-cameron. (Accessed 8 November 2021).

15 The author is indebted to Peter Trowles for sourcing his brief 1986 exhibition catalogue of Muirhead Bone, *Muirhead Bone – Portrait of the Artist*, in which this quote exists. (The exhibition was held at the Crawford Centre for the Arts, St. Andrews.)

16 JMD, 16 February 1912, AAGM.

17 EDP, introduction.

18 Ibid.

19 Ibid.

20 Jennifer Melville, *James McBey's Morocco* (HarperCollins, 1991), p. 11.

21 *The Times*, 3 May 1939. (Sourced from the archives of the National Gallery of Canada/Musée des beaux-arts du Canada.)

22 Jennifer Melville, *James McBey's Morocco* (HarperCollins, 1991), p. 11.

23 Ibid.

24 Ibid.

25 Ibid.

26 'An Aberdeen Artist's Adventures', *Aberdeen Daily Journal*, 18 March 1913.

27 Lawrence Harris, *With Mulai Hafid at Fez: Behind the Scenes in Morocco* (Smith, Elder & Co., 1909), introduction.

28 'French Morocco (1912–1956)', University of Central Arkansas, https://uca.edu/politicalscience/dadm-project/middle-eastnorth-africapersian-gulf-region/francemorocco-1930-1956/. (Accessed 8 November 2021).

29 Ibid.

30 Herbert Adams Gibbons, *An Introduction To World Politics* (The Century Co., 1922), p. 479.

31 'An Aberdeen Artist's Adventures', *Aberdeen Daily Journal*, 18 March 1913.

32 Ibid.

33 All quotes/information from JMUB, p. 23-24, AAGM.

34 'An Aberdeen Artist's Adventures', *Aberdeen Daily Journal*, 18 March 1913. (The author has left JM's archaic spelling of 'Tetuan' as is in his quotes, but has spelled the city 'Tetouan' elsewhere.)

35 JMUB, p. 24, AAGM.

36 All quotes/information from 'An Aberdeen Artist's Adventures', *Aberdeen Daily Journal*, 18 March 1913.

37 All quotes/information from AAWJM, *The Graphic*, 7 January 1922.

38 Eustace Reynolds-Ball, *Mediterranean Winter Resorts* (K. Paul, Trench, Trubner & Co., Ltd., 1914), p. 414.

39 AAWJM, *The Graphic*, 7 January 1922.

40 Ibid.

41 Ibid.

42 Jennifer Melville, *James McBey's Morocco* (HarperCollins, 1991), p. 13.

43 AAWJM, *The Graphic*, 7 January 1922.

44 Robert Kerr, *Morocco After Twenty-five Years* (Murray and Evenden, Ltd., 1912), p. 4.

45 JMUB, p. 27, AAGM.

46 Ibid.

47 AAWJM, *The Graphic*, 7 January 1922.

48 Ibid.

49 JM's use of the word 'Riff' (also 'Rif') is used to denote those 'Berber peoples occupying a part of north-eastern Morocco known as the Rif'. (Source: *Encyclopaedia Britannica*.)

50 JMUB, p. 32, AAGM.

51 All quotes/information from 'An Aberdeen Artist's Adventures', *Aberdeen Daily Journal*, 18 March 1913.

52 Jennifer Melville, *James McBey's Morocco* (HarperCollins, 1991), p. 18-20.

53 JMUB, p. 31, AAGM.

54 JMUB, p. 33, AAGM.

55 JM adds in his diary of this observation – 'not the above but this, 4.12 p.m. ... [CODE – Praise God].'

56 Jennifer Melville, *James McBey's Morocco* (HarperCollins, 1991), p. 20.

57 Ibid.

58 'An Aberdeen Artist's Adventures', *Aberdeen Daily Journal*, 18 March 1913.

59 Ibid. (All quotes/information from this except Reuters press report.)

60 Ibid.

61 Robert Kerr, *Morocco After Twenty-five Years* (Murray and Evenden, Ltd., 1912), p. 4.

62 Obituary of Helen Russell Wilson, *The Architects' Journal*, 5 November 1924.

63 JMD, 2 February 1913, AAGM.

64 JMUB, p. 39, AAGM.

65 JMD, 8 February 1913, AAGM.

66 Jennifer Melville, *James McBey's Morocco* (HarperCollins, 1991), p. 17.

67 Ibid., p. 25.

68 Malcolm C. Salaman (ed.), *Fine Prints of the Year – An Annual Review of Contemporary Etching and Engraving* (Halton & Truscott Smith Ltd., 1924), p. 4.

69 Jennifer Melville, *James McBey's Morocco* (HarperCollins, 1991), p. 17.

70 EDP, introduction.

CHAPTER SIX

1 JMUB, p. 8, AAGM.

2 JMD, 4 July 1912, AAGM.

3 JMUB, p. 15, AAGM.

4 Jerry White, *London in the Twentieth Century: A City and Its People* (The Bodley Head, 2016), p. 312.

5 EDP, introduction.

6 AAWJM, *The Graphic*, 21 January 1922.

7 TELJM, introduction.

8 JMUB, p. 1, AAGM.

9 The author is indebted to esteemed printmaker Edward Twohig, head of art at Marlborough College, for supplying this list of essential printmaking equipment.

10 'Grace's Guide', 1912 Obituary, 20 June 2015. https://www.gracesguide.co.uk/James_Charles_Inglis. (Accessed 10 November 2021).

11 Martin Hardie and Charles Carter (eds.), *The Etchings and Dry-Points of James McBey (1883–1959)*, (Alan Wofsy Fine Arts, 1997), introduction.

12 Robert Speaight, *William Rothenstein: The Portrait of an Artist in his Time* (Eyre & Spottiswoode, 1962), p. 267.

13 JMUB, p. 47, AAGM.

14 JMD, 20 October 1914, AAGM.

15 JMD, 23 October 1914, AAGM.

16 JMUB, p. 42, AAGM.

17 Portrait of James McBey's Grandmother, AAGM. https://emuseum.aberdeencity.gov.uk/objects/118129/portrait-of-james-mcbeys-grandmother-early-photographs--s. (Accessed 11 November 2021).

18 JM to GG, 12 January 1916. (The author is indebted to Jenny Wilks and her brother, Alan Wilks – distant relatives of GG – for providing a copy of this letter.) As an interesting aside, GG was likely responsible for carrying out work at Balmoral Castle, the Aberdeenshire holiday home of the Royal Family, after the First World War. According to the little official information available, the blacksmith was responsible for making the castle's main entrance gates and/or the gates to the South Garden.

19 JMD, 22 October 1914, AAGM.

20 Ann-Marie Foster, *Ephemera and the First World War*, British Library, 11 November 2016. https://www.bl.uk/world-war-one/articles/ephemera-and-the-first-world-war. (Accessed 11 November 2021).

21 Ibid.

22 TELJM, p. 113.

23 EDP, introduction.

24 Ibid.

25 JMUB, p. 57, AAGM.

26 Ibid.

27 Ibid.

28 JMUB, p. 58, AAGM.

29 The author's use of the phrase 'rebel printmaker' to describe JM's antics at the time was inspired by Edward Twohig's 2018 work, *Print REbels*.

30 TELJM, p. 57.

31 EDP, introduction.

32 Ibid.

33 'Imperial War Museum: A Memorial Exhibition of Drawings by James McBey,' AAGM. https://emuseum.aberdeencity.gov.uk/objects/141900/imperial-war-museum-a-memorial-exihbition-of-drawings-by-ja?ctx=86e0e9090c598a21e59527934e63e3d2dd0f0cd7&idx=1. (Accessed 12 November 2021).

34 Meirion and Susie Harries, *The War Artists* (Published by Michael Joseph in association with The Imperial War Museum and The Tate Gallery, 1983), p. 24.

35 *Drawing of the Battle of the Somme* by Muirhead Bone, British Library, https://www.bl.uk/collection-items/battle-of-somme-mbone. (Accessed 12 November 2021).

36 JMD, 1 July 1917, AAGM.

37 JMD, 11 July 1917, AAGM.

38 JMD, 12 July 1917, AAGM.

39 Martin Hardie and Charles Carter (eds.), *The Etchings and Dry-Points of James McBey (1883–1959)*, (Alan Wofsy Fine Arts, 1997), introduction.

40 Jennifer Melville, *Manhattan to Marrakech: The Art and Lives of James and Marguerite McBey* (Aberdeen City Council, 2001), p. 6.

41 This record was beaten by D.Y.C. in April 1926 for his print, *Ben Ledi*.

42 The author is indebted to Simon Aitken, a distant relative of Isa's, for helping him piece together her identity and background. (Isa's letters also corroborate the author's findings.)

43 The author is indebted to Eugene Rogan, professor of Modern Middle Eastern History at St. Antony's College, University of Oxford, for his expert

suppositions surrounding Esna during WWI and the importance of William's role as an engineer during this period.

44 *The London Gazette*, 24 August 1920. https://www.thegazette.co.uk/London/issue/32028/page/8709/data.pdf. (Accessed 13 November 2021).

45 *The Camel Corps: A Night March To Beersheba*, Imperial War Museums, https://www.iwm.org.uk/collections/item/object/18136. (Accessed 13 November 2021).

46 AAWJM, *The Graphic*, 28 January 1922.

47 Ibid.

48 Meirion and Susie Harries, *The War Artists* (Published by Michael Joseph in association with The Imperial War Museum and The Tate Gallery, 1983), p. 25.

49 JMD, 8 November 1917, AAGM.

50 On 17 October 1917 he writes in his diary: 'Got letter at noon from Mrs. C. [CODE – A terrible blow].'

51 Bertha Spafford Vester, *Our Jerusalem* (Doubleday & Company, Inc., 1950), p. 261.

52 AAWJM, *The Graphic*, 28 January 1922. (The surrender of Jerusalem had a comic edge to it. Its mayor, holding a white flag and the keys to the city's gates, was several times rebuffed as he tried in vain to find an Allied official to whom to surrender. Although he eventually found a divisional commander who felt equal to the occasion, there was a tragic postscript: the bracing winter air left the mayor with a chill, and he died three weeks later of pneumonia.)

53 *The Manchester Guardian*, 13 December 1917. (This edition of the paper also features on the same page as the letter a sketch by JM – *Convalescents* – a scene of six convalescing soldiers on a sandy beach at Mahemdia, Sinai.)

54 Shari Ann Cohn, *Scottish tradition of second sight and other psychic experiences in families*, 11 July 1996. https://era.ed.ac.uk/handle/1842/9674. (Accessed 13 November 2021).

55 Hector Dinning, *Nile to Aleppo: With the Light-Horse in the Middle-East* (George Allen & Unwin Ltd., 1920), p. 40. (Dinning's book was illustrated by JM.)

56 JMD, 2 November 1918, AAGM.

57 Hector Dinning, *Nile to Aleppo: With the Light-Horse in the Middle-East* (George Allen & Unwin Ltd., 1920), p. 58. (Dinning's book was illustrated by JM.)

58 Gilbert Spencer, *Gilbert Spencer, R.A.: Memoirs of a Painter* (Chatto & Windus, 1974), p. 57.

59 Hector Dinning, *Nile to Aleppo: With the Light-Horse in the Middle-East* (George Allen & Unwin Ltd., 1920), p. 59. (Dinning's book was illustrated by JM.)

60 Meirion and Susie Harries, *The War Artists* (Published by Michael Joseph in association with The Imperial War Museum and The Tate Gallery, 1983,) p. 27.

61 James McBey 1917–1928, Imperial War Museums. https://www.iwm.org.uk/collections/item/object/1050000119. (Accessed 14 November 2021).

62 IC to JM, 2 February 1919, AAGM.

CHAPTER SEVEN

1 Info and quotes from TELJM, p. 62–63.

2 JMAD, 4 February 1919, AAGM. (This letter from IC is very likely the letter that is mentioned at the end of chapter six.)

3 JMAD, 9 February 1919, AAGM.

4 JMAD, 14 February 1919, AAGM.

5 JMAD, 15 February 1919, AAGM.

6 Meirion and Susie Harries, *The War Artists* (Published by Michael Joseph in association with The Imperial War Museum and The Tate Gallery, 1983,) p. 24.

7 The author is indebted to art historian Jill Marriner for this suggestion.

8 Advert, *Pall Mall Gazette*, 22 March 1919.

9 Dudley Barker, *The Man of Principle: A View of John Galsworthy* (London House & Maxwell, 1963), p. 69.

10 James Gindin, *John Galsworthy's Life and Art: An Alien's Fortress* (Ann Arbor: The University of Michigan Press, 1987), p. 48.

11 Meirion and Susie Harries, *The War Artists* (Published by Michael Joseph in association with The Imperial War Museum and The Tate Gallery, 1983), p. 28.

12 TELJM, p. 117.

13 JMUB, p. 90, AAGM.

14 TELJM, p. 117.

15 'Men You Know', *The Bailie*, 23 March 1921, AAGM.

16 EDP, introduction.

17 Ibid.

18 Ibid.

19 Edward Twohig, *Print REbels* (Royal Society of Painter-Printmakers, 2018), p. 95.

20 The author is indebted to Edward Twohig, Joe Winkelman and Jonathan Black for their contrasting opinions on this point, which helped to inform this analysis.

21 The author is indebted to Mark Pomeroy, archivist at the Royal Academy of Arts, for sourcing this information.

22 JM to Sir Frank Short, 21 February 1936, AAGM. (Although he writes to Short asking for his name to be withdrawn, he asks in the same letter whether he has to, in actual fact, contact the RA's secretary in order for his wishes to be carried out.)

23 'London Letter' column, *Aberdeen Daily Journal*, 4 August 1922.

24 JMUB, p. 74, AAGM..

25 Diary of Frances Thomas, Lowell Thomas Papers, Archives & Special Collections, Marist College, USA. (Her reference to JM's 'housekeeper' as 'his old Scotch aunt' is likely a reference to Jim Reid's mother, Mary Jane Torn Reid, who appeared to take on that role during this time. Indeed, the 'UK, British Army World War I Medal Rolls Index Cards, 1914–1920 for J T Reid' has as Jim's address for any correspondence 1 Holland Park Avenue.)

26 JM to Frances Thomas, 14 December 1919, Lowell Thomas Papers, Archives & Special Collections, Marist College, USA.

27 JM to LT, 9 March 1954, Lowell Thomas Papers, Archives & Special Collections, Marist College, USA.

28 Diary of Frances Thomas, Lowell Thomas Papers, Archives & Special Collections, Marist College, USA.

29 JM to LT, 9 March 1954, Lowell Thomas Papers, Archives & Special Collections, Marist College, USA.

30 Diary of Frances Thomas, Lowell Thomas Papers, Archives & Special Collections, Marist College, USA. (The author has based JM's imaginary meeting with Lawrence at Holland Park on some of Frances Thomas' impressions of him when she and her husband, Lowell, hosted the former intelligence officer at their apartment in London.)

31 Charles Grosvenor, *Lawrence of Arabia: soldier, writer – and artist?*, 29 January 2018. https://artuk.org/discover/stories/lawrence-of-arabia-soldier-writer-and-artist. (Accessed 15 November 2021).

32 Ibid.

33 Ibid.

34 Quotes and info from 'Men You Know', *The Bailie*, 23 March 1921, AAGM.

35 'The Artist Bank Clerk', *The Daily Graphic*, 6 October 1921.

36 James Marturano, *An Archive Of All Things Sir Harry Lauder*, July 2019. http://www.sirharrylauder.com. (Accessed 16 November 2021).

37 *The Courier*, 20 April 1923.

38 *Aberdeen Daily Journal*, 29 April 1922.

39 TELJM, p. 118.

40 *Aberdeen Daily Journal*, 30 June 1922.

41 Jennifer Melville, *Manhattan to Marrakech: The Art and Lives of James and Marguerite McBey* (Aberdeen City Council, 2001), p. 11.

42 'Goodbye while looking' was JM's way of committing a place or person to memory in the hope of seeing it or them again.

43 Charles Carter (ed.), *Etchings and Dry Points from 1924 by James McBey (1883– 1959): A Supplement to the Catalogue by Martin Hardie* (Aberdeen Art Gallery, 1962), introduction.

44 Ibid.

45 Ibid.

46 *Aberdeen Press and Journal*, 17 April 1926.

47 Ibid., 14 April 1926.

48 Charles Carter (ed.), *Etchings and Dry Points from 1924 by James McBey (1883– 1959): A Supplement to the Catalogue by Martin Hardie* (Aberdeen Art Gallery, 1962), introduction.

49 Gladys Engel Lang, *Etched in Memory: The Building and Survival of Artistic Reputation* (Chapel Hill: University of North Carolina Press, 1990), p. 74.

50 Ibid., p. 75.

51 *Tariff Readjustment – 1929* (Committee on Ways and Means, United States Congress), p. 9679.

52 JMS to JM, 27 December 1906, AAGM.

53 JMUB, p. 52, AAGM.

54 JMS to JM, 11 February 1914, AAGM.

55 JMUB, p. 54, AAGM.

56 JMS to JM, 17 October 1923, AAGM.

57 TELJM, p. 13.

58 Harold H. Kynett, *The Mavic's Log: Ramblings with Nautical Notes* (privately printed, 1951), p. 13.

59 TELJM, p. 118.

60 Harold H. Kynett, *The Mavic's Log: Ramblings with Nautical Notes* (privately printed, 1951), p. 17.

61 Ibid., p. 23.

62 Ibid.

63 Ibid., p. 73.

64 Ibid., p. 107.

65 Ibid., p. 141.

66 Ibid., p. 25.

67 Ibid., p. 121.

68 Ibid., p. 24.

69 Malcolm Salaman, 'James McBey's Water-Colours', *The Studio: An Illustrated Magazine of Fine and Applied Art*, 14 February 1914.

70 Ronnie Cox, *Liquid history: Cutty Sark*, 31 October 2017. https://blog.bbr.com/2017/10/31/liquid-history-cutty-sark/. (Accessed 17 November 2021).

71 *History of Berry Bros. & Rudd*, Berry Bros. & Rudd. https://www.bbr.com/about/history. (Accessed 17 November 2021).

72 The author is indebted to Ronnie Cox, (retired) Brands Heritage Director, Spirits, Berry Bros. & Rudd Ltd., for this information. JM's purchase of some *Cutty Sark* in September 1923, as recorded in the firm's official ledger, 'is the earliest record that I have found of *Cutty Sark* anywhere in the company,' noted Cox.

CHAPTER EIGHT

1 John Ritchie was the 'mutual acquaintance from Aberdeenshire' mentioned in Chapter Seven who facilitated JM's and JMS's reconciliation. (JM remained in touch with many of his friends and relatives in the Scottish north-east despite his life in London – such as 'his relatives the Reids, his friends the Stewarts of Macduff, Mrs. Macdonell, the Ritchies [...] Edith Rae, the Rennies and James Torn Reid his second cousin, who was frequently his companion in London.' (Source: JMUB, p. 51).

2 TELJM, p. 9.

3 JMD, 26 December 1911, AAGM.

4 JMUB, p. 8, AAGM.

5 MMu to JM, undated, AAGM.

6 Margot Murray to JM, 6 April 1924, AAGM.

7 Margot Murray to JM, 9 October c.1921, AAGM.

8 IC to JM, 23 December 1920, AAGM.

9 MM in her 'Who's Who' of people in JM's life (written with a view to publishing a biography of her husband) suggests that the culprit could have been Jim Reid.

10 JMD, 12 June, 1922.

11 Barnebys auction, 25 February 2021. https://www.barnebys.co.uk/auctions/lot/james-mcbey-scottish-1883-1959-the-kimono-the-kimono-h9usocfakd. (Accessed 19 November).

12 Jennifer Melville, *Manhattan to Marrakech: The Art and Lives of James and Marguerite McBey* (Aberdeen City Council, 2001), p. 11.

13 Duncan Macmillan, 'Dorothy Johnstone and her contemporaries', *Art UK*, 27 April 2020. https://artuk.org/discover/stories/dorothy-johnstone-and-her-contemporaries. (Accessed 19 November 2021).

14 JMUB, p. 98, AAGM.

15 EAR to JM, 20 April 1926, AAGM.

16 The author is indebted to EAR's son, Gordon Turner, for sharing this anecdote.

17 Isabelle Keating, 'Marriage Just One of the Hobbies of this Rebellious Redhead', *The Brooklyn Daily Eagle*, 21 March 1934.

18 Robin Waterfield, *Prophet: The Life and Times of Kahlil Gibran* (Allen Lane, 1998), p. 248.

19 *The Brooklyn Daily Eagle*, 17 October 1914.

20 Bessie Laub, 'The Art Corner', *The Courier-Journal*, 2 June 1918.

21 Mary L. Alexander, 'The Week in Art Circles', *The Cincinnati Enquirer*, 31 March 1929.

22 Georgia O'Keeffe Museum. https://www.okeeffemuseum.org/about-georgia-okeeffe/. (Accessed 20 November 2021).

23 JMUB, p. 120, AAGM.

24 *Woman on a Sofa*, AAGM. https://emuseum.aberdeencity.gov.uk/objects/11007/woman-on-a-sofa. (Accessed 20 November 2021).

25 JMD, 3 May 1929, AAGM.
26 JMD, 4 May 1929, AAGM.
27 JMD, 28 June 1929, AAGM.
28 JMUB, p. 119, AAGM.
29 Descriptions of the sights and sounds of NYC from 'The Sounds Of New York City, Circa 1920', *NPR*, 22 October 2013. https://www.npr.org/sections/thetwo-way/2013/10/22/239870539/the-sounds-of-new-york-city-circa-1920. (Accessed 20 November 2021).
30 John Kenneth Galbraith (Selected and Edited by Andrea D. Williams), *The Essential Galbraith* (A Mariner Original/Houghton Mifflin Company, 2001), p. 295.
31 JMUB, p. 122, AAGM. (Despite JM's contention of people throwing themselves from windows following the Wall Street Crash, 'A 1980s study suggested stories of widespread suicides of bankers in 1929 was [a] myth.') (Source: BBC).
32 JMD, 6 November 1929, AAGM.
33 Eleanor Jewett, *Chicago Daily Tribune*, 15 November 1929.
34 Harold H. Kynett, *The Face of Change: Flippancies for the Future* (privately printed, 1960), p. 163.
35 Ibid.
36 JMD, 4 September 1930.
37 TELJM, p. 122.
38 The author is indebted to Barry Moreno, librarian and historian at the Statue of Liberty National Monument, for his insight into Depression-era America (including NYC and Philadelphia).
39 Harold H. Kynett, *The Face of Change: Flippancies for the Future* (privately printed, 1960), p. 163.
40 Ibid.
41 TELJM, p. 122.
42 Ian Sutherland, 'Strokes of Genius', *The Press and Journal*, 7 August 1991.
43 *The Philadelphia Inquirer*, 26 October 1930.
44 The author is indebted to Barbara Kehler, Marguerite's niece, for this information.
45 Olda Kokoschka and Alfred Marnau (eds.), *Oskar Kokoschka Letters 1905–1976* (Thames and Hudson Ltd., 1992), p. 110.

46 Ibid., p. 116.

47 Helen Josephy and Mary Margaret McBride, *New York is Everybody's Town* (The Knickerbocker Press, 1931), p. 180.

48 EAR to JM, 21 February 1931, AAGM.

49 MMu to JM, 29 January 1930, AAGM.

50 JMD, 11 February 1931, AAGM.

51 JMUB, p. 135, AAGM.

52 Ibid.

53 Jennifer Melville, *Manhattan to Marrakech: The Art and Lives of James and Marguerite McBey* (Aberdeen City Council, 2001), p. 18.

54 JMD, 19 December 1927, AAGM.

55 MM's brief notes on her husband's love letters suggest that FW terminated her pregnancy: '22 May 1930 – Fay is pregnant. She made all arrangements. Nursing home – Welbeck Street, £24, £50, £25. J. paid.' JM's diary entries also mention her pregnancy – such as 'I was in the car Fay told me she was still [CODE – pregnant]' (5 June 1930). Abortion was (save for some medical exceptions) illegal in Britain until 1967, but, as British women's rights activist Dorothy Thurtle told the Inter-Departmental Committee on Abortion (report published 1939), it was not a challenge 'for any woman of moderate means to find a medical man willing to relieve her of an unwelcome pregnancy regardless of the state of her health.' (Source: *Abortion in England 1900–1967* by Barbara Brookes, p. 124).

56 MM's notes on JM's love letters – from FW to JM, October 1927, AAGM.

57 Ibid., 15 July 1928.

58 Ibid., 20 July 1929.

59 *The Barrier Miner*, 13 June 1931.

60 Fay Woods, *Burnt White* (Cassell and Company, Ltd., 1931), p. 303.

61 Harold H. Kynett, *The Face of Change: Flippancies for the Future* (privately printed, 1960), p. 161.

62 Hector Dinning, *Nile to Aleppo: With the Light-Horse in the Middle-East* (George Allen & Unwin Ltd., 1920), p. 59. (Dinning's book was illustrated by JM.)

63 JMUB, p. 80, AAGM.

CHAPTER NINE

1 JMUB, p. 90, AAGM.

2 The author is indebted to Barbara Kehler for providing a copy of this letter.

3 JMUB, p. 136, AAGM.

4 Ibid.

5 Jennifer Melville, *Manhattan to Marrakech: The Art and Lives of James and Marguerite McBey* (Aberdeen City Council, 2001), p. 20.

6 JMD, 30 March 1931, AAGM.

7 The author is indebted to Barbara Kehler for providing a copy of this letter.

8 JMD, 30 April 1931, AAGM.

9 The author is indebted to Barbara Kehler for providing a copy of this letter, in which these words are found.

10 Letter from Anthony Lousada to MM, late 1960s, AAGM.

11 Jennifer Melville, *James McBey's Morocco* (HarperCollins, 1991), p. 34.

12 Ibid., p. 34–37.

13 Jennifer Melville, *Manhattan to Marrakech: The Art and Lives of James and Marguerite McBey* (Aberdeen City Council, 2001), p. 25.

14 Ibid.

15 JMUB, p. 142, AAGM.

16 Jennifer Melville, *Manhattan to Marrakech: The Art and Lives of James and Marguerite McBey* (Aberdeen City Council, 2001), p.25.

17 Jennifer Melville, *James McBey's Morocco* (HarperCollins, 1991), p. 37.

18 Quotes from JMUB, p. 24, AAGM.

19 Jennifer Melville, *James McBey's Morocco* (HarperCollins, 1991), p. 37.

20 JMUB, p. 149, AAGM.

21 Jennifer Melville, *James McBey's Morocco* (HarperCollins, 1991), p. 40.

22 Ibid.

23 Ibid.

24 Ibid.

25 MM's 1933 Diary Precis, AAGM.

26 Jennifer Melville, *James McBey's Morocco* (HarperCollins, 1991), p. 41.

27 Harold H. Kynett, *The Face of Change: Flippancies for the Future* (privately printed, 1960), p. 165–167.

28 MM's 1933 Diary Precis, AAGM.

29 MM's 1935 Diary Precis, AAGM.

30 MM's 1934 Diary Precis, AAGM.

31 'Letters to James McBey', AAGM.

32 MM's 'Who's Who', AAGM.

33 Amos Bershad, 'The World's Most Dangerous Census', *The Nation*, 17 October 2019.

34 MM's 1934 Diary Precis, AAGM.

35 Jennifer Melville, *Manhattan to Marrakech: The Art and Lives of James and Marguerite McBey* (Aberdeen City Council, 2001), p. 29–30.

36 Gladys Engel Lang and Kurt Lang, *Etched in Memory: The Building and Survival of Artistic Reputation* (University of Illinois Press, 2001), p. 77.

37 Ibid., p. 78.

38 Ibid., p. 243.

39 Jan Gordon, Art and Artists, *The Observer*, 11 April 1937.

40 Letter from Anthony Lousada to MM, late 1960s, AAGM.

41 JMUB, p. 158, AAGM.

42 Ibid., p. 158–159.

43 Jennifer Melville, *Manhattan to Marrakech: The Art and Lives of James and Marguerite McBey* (Aberdeen City Council, 2001), p. 31.

44 JMUB, p. 172, AAGM.

45 Ibid., p. 170.

46 Ibid., p. 170–171.

47 Lord Rowallan, *Rowallan: The Autobiography of Lord Rowallan* (Dundurn Press, first published 1976 by Paul Harris Publishing), p. 59.

48 Ibid., p. 59–60.

49 Ibid., p. 60.

50 Ibid.

51 Ibid., p. 61.

CHAPTER TEN

1 TELJM, p. 124.

2 Malcolm C. Salaman (ed.), *Fine Prints of the Year*, (Halton & Truscott Smith Ltd., 1924), p. 4.

3 AAGM.

4 Robert Kunciov (ed.), *Mr. Godey's Ladies*, (The Pyne Press, 1971), p. 105.

5 Draft article by MM on the purchase of Dar Ben Zina, AAGM.

6 Ibid.

7 Ibid.

8 Jennifer Melville, *James McBey's Morocco* (HarperCollins, 1991), p. 56.

9 MM's 1937 Diary Precis, AAGM.

10 Clémence appeared to have married Fernando, but whether they were still married at this time is unclear.

11 JMD, 29 October 1937, AAGM.

12 JMD, 4 January 1938, AAGM.

13 MM's 1938 Diary Precis, AAGM.

14 Ibid.

15 On her passing in 1960, she is named on her death certificate as Helen Bisset Paton, 'Widow of Herbert Paton'.

16 'To Patons for day. [CODE – Felt] Lisbeth.' JMD, 20 December 1931, AAGM.

17 JMUB, p. 155, AAGM.

18 MM's 1938 Diary Precis, AAGM.

19 JMD, 11 September 1939, AAGM.

20 'At Home with his Pictures', *Country Life*, 7 March 2002.

21 JMD, 3 October 1939, AAGM.

22 JMUB, p. 186, AAGM.

23 Ibid.

24 *The Sketch*, 14 April 1937.

25 Leila Mechlin, 'James McBey's *Manhattan* Goes to Several Museums', *The Sunday Star*, 28 May 1939.

26 JMUB, p.194, AAGM.

27 Ibid., p. 194–195.

28 'James McBey – Etcher, Literary Section', *The Age*, 2 November 1940.

29 The author is indebted to the sister of Vessie Owens, Nancy Williams, Vessie's childhood friend, Carl Mooney, Jr., and Joan Dickson for bringing the Vessie Owens story to light.

30 JMUB, p. 195–196, AAGM.

31 JM letter to a Mr Campbell, 13 September 1933. (The author is indebted to Joan Dickson for providing a copy of this letter.)

32 Peter Moruzzi, *Havana: Before Castro, When Cuba was a Tropical Playground*, (Gibbs Smith, Publisher, 2008), p. 127.

33 All information, names and prices in this paragraph come from JM's book of US portraits, AAGM.

34 'James McBey, Famous Scot, Etches America', *The Art Digest*, 15 February 1941, p. 24.

35 Jennifer Melville, *Manhattan to Marrakech: The Art and Lives of James and Marguerite McBey* (Aberdeen City Council, 2001), p. 51.

36 Ibid.

37 JMUB, p. 205–206, AAGM.

38 JMD, 7 December 1941, AAGM.

39 Ibid., 8 December 1941.

40 JMUB, p. 209–215, AAGM.

41 MM's 1942 Diary Precis, AAGM.

42 JM, 'The Scot Seen by Himself', *Daily Herald*, 25 January 1932, AAGM.

43 Letter from JM to Duncan Macdonald, 27 March 1942, AAGM.

44 Jennifer Melville, *Manhattan to Marrakech: The Art and Lives of James and Marguerite McBey* (Aberdeen City Council, 2001), p. 55.

45 Letter from Clémence Bonnet-Matthews to JM, 21 May 1942, AAGM.

46 As taken from her death certificate.

47 JM to Herbert Paton, 28 July 1942, AAGM.

48 Herbert Paton to JM and MM, 17 August 1942, AAGM.

49 JMUB, p. 217, AAGM.

50 Jennifer Melville, *Manhattan to Marrakech: The Art and Lives of James and Marguerite McBey* (Aberdeen City Council, 2001), p. 57.

51 Ibid.

52 JMUB, p. 219–220, AAGM.

53 The author is indebted to Peter R. Bullen and Hélène Bullen for information about Pedro. Information about him also comes from http://ufdcimages.uflib.ufl.edu/UF/00/00/59/21/00001/UF32.pdf. (Accessed 6 May 2022).

54 Interview with author.

55 MM's 1944 Diary Precis, AAGM.

56 MM's 1945 Diary Precis, AAGM.

57 Ibid.

58 A. J. Philpott, 'McBey Collection of Etchings is Feature', *The Boston Daily Globe*, 14 September 1945.

59 JMD, 22 December 1944, AAGM.

CHAPTER ELEVEN

1 JMUB, p. 228, AAGM.

2 Ibid., p. 228–229.

3 Letter from JM to Pedro Fernandez, 11 May 1946, AAGM.

4 JMUB, p. 229, AAGM.

5 MM's 1946 Diary Precis, AAGM.

6 Ibid.

7 Inspired by http://www.paulbowles.org/tangier.html. (Accessed 11 May 2022).

8 AAWJM, *The Graphic*, 7 January 1922.

9 Gershom Gorenberg, 'Holocaust in the Middle East', *History Extra*, 22 November, 2021, https://www.historyextra.com/period/second-world-war/holocaust-middle-east-morocco-iraq/. (Accessed 23 March 2022).

10 Iain Finlayson, *Tangier: City of the Dream* (Flamingo, 1993), p. 64-65.

11 'Remembering Operation Torch: Allied Forces Land in North Africa during World War II,' *American Battle Monuments Commission*, 8 November, 2017, https://www.abmc.gov/news-events/news/remembering-operation-torch-allied-forces-land-north-africa-during-world-war-ii. (Accessed 23 March 2022).

12 Iain Finlayson, *Tangier: City of the Dream* (Flamingo, 1993), p. 67.

13 Jennifer Melville, *James McBey's Morocco* (HarperCollins, 1991), p. 74.

14 Ibid.

15 Iain Finlayson, *Tangier: City of the Dream* (Flamingo, 1993), p. 67.

16 Ibid.

17 MM's 1946 Diary Precis, AAGM.

18 Ibid.

19 Ibid.

20 JMD, 20 June 1947, AGGM.

21 JMUB, p. 235, AAGM.

22 JMD, 2 November 1947, AAGM.

23 MM's 1948 Diary Precis, AAGM.

24 JMD, 26 June 1948, AAGM.

25 JMUB, p. 237, AAGM.

26 Ibid., p. 238.

27 Ibid., p. 239.

28 Ibid., p. 235.

29 Letter from Harold H. Kynett to JM, 13 April 1948, AAGM.

30 Jennifer Melville, *Manhattan to Marrakech: The Art and Lives of James and Marguerite McBey* (Aberdeen City Council, 2001), p. 65.

31 Letter from MM to Lisbeth Simpson, 20 April 1952, AAGM.

32 JMUB, p. 239, AAGM.

33 Truman Capote, Tangier, *Vogue*, 1 April 1950.

34 The author is indebted to Aziz Zefri for speaking to his mother and eliciting this information. (According to Aziz, Zohra's real age is unclear. While her official year of birth is 1939, it is thought that she was in fact born in 1935.)

35 Letter from MM to Lisbeth Simpson, 20 April 1952, AAGM.

36 MM's 16 May 1968 interview with Phyllis Pearsall, AAGM. (According to JM's records, and MM's own notes, JM also carried on an affair with Phyllis during the 1950s.)

37 Richard Hamilton, 'How Morocco became a haven for gay Westerners in the 1950s,' *BBC online*, 12 October 2014, https://www.bbc.co.uk/news/magazine-29566539. (Accessed 24 March 2022).

38 JMUB, p. 188, AAGM.

39 JMUB, p. 190, AAGM.

40 JMD, 7 November 1955, AAGM.

41 The author is indebted to Joan Dickson for providing a copy of this letter.

42 Interview with author.

43 Ibid.

44 The author is indebted to Joan Dickson for providing a copy of this letter.

45 JMD, 3 March 1959, AAGM.

46 John Loutit was the son of the Rev. J. S. Loutit of Foveran Parish Church.

47 Should be: 'Je ne suis pas sûr de guérir ma main'. The author is indebted to Claire McClelland for her help with this translation.

48 The author is indebted to Joan Dickson for providing a copy of MM's diary of JM's illness and death.

49 Ibid.

50 JMUB, p. 253, AAGM.

51 The author is indebted to Joan Dickson for providing a copy of MM's diary of JM's illness and death.

52 Ibid.

53 Jennifer Melville, *James McBey's Morocco* (HarperCollins, 1991), p. 78. (Although Melville's text mentions the Battle of Newbury, it was in fact the Battle of Edgehill.)

54 TELJM, p. 127

CHAPTER TWELVE

1 The author is indebted to Joan Dickson for providing a copy of MM's diary of JM's illness and death.

2 Lord Rowallan, *Rowallan: The Autobiography of Lord Rowallan* (Dundurn Press, first published 1976 by Paul Harris Publishing), p. 62.

3 The author is indebted to Joan Dickson for providing a copy of this letter.

4 Ibid.

5 JM obituary, *The Times*, 3 December 1959.

6 The author is indebted to Joan Dickson for providing a copy of MM's diary of JM's illness and death.

7 Ibid.

8 Ibid.

9 Jennifer Melville, *Manhattan to Marrakech: The Art and Lives of James and Marguerite McBey* (Aberdeen City Council, 2001), p. 68.

10 Foveran Parish Church Dedication Service booklet, 28 May 1961. (The author is indebted to Charles Catto for providing a copy of this booklet.)

11 Tessa Codrington, *Spirits of Tangier* (Arcadia Books, 2008), p. 131.

12 Ibid.

13 This information comes from Charles Duff, one of MM's most intimate friends.

14 Charles Duff, *Charley's Woods* (Zuleika, 2017), p. 142.

15 Ibid., p. 171.

16 Ibid., p. 142.

17 Interview with author.

18 The author is indebted to Charles Duff for sharing this information.

19 Letter from Harold H. Kynett to MM, 17 January 1963, AAGM.

20 Rupert Croft-Cooke, *The Ghost of June* (W. H. Allen, 1968), p. 12.
21 Letter from MM to Rupert Hart-Davis, 3 December 1962, AAGM.
22 Letter from Hamish Hamilton to Lady Caroline Duff, 16 April 1969, AAGM.
23 The author is indebted to Joan Dickson for sharing a copy of MM's Sea House diary entries.
24 Ibid.
25 Ibid.
26 Ibid.
27 Tessa Codrington, *Spirits of Tangier* (Arcadia Books, 2008), p. 98.
28 The author is indebted to Joan Dickson for sharing a copy of MM's Sea House diary entries.
29 Interview with author.
30 Rupert Croft-Cooke, *The Ghost of June* (W. H. Allen, 1968), p. 54–55.
31 Interview with author.
32 TELJM, introduction.
33 Ibid.
34 MM's unpublished introduction to JMUB, AAGM.
35 John Hopkins, *The Tangier Diaries, 1962–1979* (Arcadia Books Ltd., 1997), p. 212.
36 The author is indebted to Joan Dickson for sharing a copy of MM's Sea House diary entries.
37 Ian Sutherland, 'Strokes of Genius', *Press and Journal*, 7 August 1991.
38 Adrian Woodhouse, 'Why a Present of Paints and Brushes Revealed a Rare Gift', *Telegraph Sunday Magazine*, 26 August 1984.
39 Gary Pulsifer, MM's obituary, *The Guardian*, 23 October 1999.
40 Interview with author.

AFTERWORD

1 Interview with author.
2 Price realised includes buyer's premium.
3 Ibid.
4 Ibid.
5 Information from The Move Market.
6 Obituary of Christopher Gibbs, *Vogue*, 31 July 2018, Hamish Bowles.

7 Ibid.

8 The author is grateful to Griffin Coe, from AAGM, for this suggestion.

9 MM's introduction to unpublished biography, AAGM. (The passage from 'The numerous entries' to 'grounded' had been scored out by MM, but the author has decided to retain this sentence as it reveals her initial thoughts.)

Bibliography

ARCHIVES

Aberdeen Archives, Gallery and Museums
https://emuseum.aberdeencity.gov.uk/collections
British Newspaper Archive
https://www.britishnewspaperarchive.co.uk
The Commonwealth War Graves Commission
https://www.cwgc.org
Correspondence of James McNeill Whistler
https://whistler.arts.gla.ac.uk/
Georgia O'Keeffe Museum
https://www.okeeffemuseum.org
Imperial War Museums
https://www.iwm.org.uk/
Internet Archive
https://archive.org
James McBey Talking
https://soundcloud.com/abdnartmuseums/james-mcbey-talking/s-I3kNjkz98iM?utm_source=clipboard&utm_medium=text&utm_campaign=social_sharing
Lowell Thomas Travelogues https://archives.marist.edu/lttravelogues/Lowell%20Thomas/lowellthomas2.html
NHS Grampian Archives
https://www.scottisharchives.org.uk/archives-map/nhs-grampian-archives/
Scotland's People
www.scotlandspeople.gov.uk
Tangier American Legation Museum
https://legation.org

BOOKS

Archibald, Malcolm, *Fishermen, Randies and Fraudsters: Crime in the 19th Century Aberdeen and the North East* (Black and White Publishing, 2014).
Asher, Michael, *Lawrence: The Uncrowned King of Arabia* (Penguin, 1999).
Barker, Dudley, *The Man of Principle: A View of John Galsworthy* (London House & Maxwell, 1963).
Barker, Nicolas (ed.), *The Early Life of James McBey: An Autobiography* (Canongate Classics, 1993).
Barr, James, *Setting the Desert on Fire: T. E. Lawrence and Britain's Secret War in Arabia, 1916–1918* (Bloomsbury, 2006).
Carter, Charles (ed.), *Etchings and Dry Points from 1924 by James McBey (1883–1959): A Supplement to the Catalogue by Martin Hardie* (Aberdeen Art Gallery, 1962).
Codrington, Tessa, *Spirits of Tangier* (Arcadia Books, 2008).
Croft-Cooke, Rupert, *The Ghost of June* (W. H. Allen, 1968).
Dinning, Hector, *Nile to Aleppo: With the Light-Horse in the Middle-East* (George Allen & Unwin Ltd., 1920).
Duff, Charles, *Charley's Woods* (Zuleika, 2017).
Fraser, David (ed.), *The Christian Watt Papers: An Extraordinary Life* (Birlinn Ltd., 2012).
Fraser, W. Hamish and Lee, Clive H. (eds.), *Aberdeen, 1800–2000: A New History* (Tuckwell Press, 2000).
Hare, Kenneth, *London's Latin Quarter* (John Lane, 1926).
Harries, Meirion and Susie, *The War Artists* (Michael Joseph,1983).
Harris, Lawrence, *With Mulai Hafid at Fez: Behind the Scenes in Morocco* (Smith, Elder & Co., 1909).
Higinbotham, John U., *Three Weeks in Holland and Belgium* (The Reilly & Britton Co., 1908).
Keay, John, *Sowing the Wind: The Mismanagement of the Middle East 1900–1960* (John Murray, 2004).
Kerr, Robert, *Morocco after Twenty-Five Years* (Murray and Evenden Ltd.,1912).
Kokoschka, Olda and Marnau, Alfred (eds.), *Oskar Kokoschka Letters 1905–1976* (Thames and Hudson Ltd., 1992).

Korda, Michael, *Hero: The Life & Legend of Lawrence of Arabia* (Harper Perennial, 2011).

Kynett, Harold H., *The Face of Change: Flippancies for the Future* (privately printed, 1960).

Kynett, Harold H., *The Mavic's Log: Ramblings with Nautical Notes* (privately printed, 1951).

Lang, Gladys Engel and Kurt, *Etched in Memory: The Building and Survival of Artistic Reputation* (University of Illinois Press, 2001).

Lawrence, T. E., *Seven Pillars of Wisdom* (Wordsworth Editions, 1997).

Melville, Jennifer, *James McBey's Morocco* (Harper Collins, 1991).

Melville, Jennifer, *Manhattan to Marrakech: The Art and Lives of James and Marguerite McBey* (Aberdeen City Council, 2001).

Morgan, Diane, *The Granite Mile: The Story of Aberdeen's Union Street* (Black and White Publishing, 2010).

Morton, Graeme and Griffiths, Trevor (eds.), *A History of Everyday Life in Scotland, 1800 to 1900* (Edinburgh University Press, 2010).

Rogan, Eugene, *The Fall of the Ottomans: The Great War in the Middle East, 1914–1920* (Penguin, 2016).

Speaight, Robert, *William Rothenstein: The Portrait of an Artist in his Time* (Eyre & Spottiswoode, 1962).

Spencer, Gilbert, *Gilbert Spencer, R.A.: Memoirs of a Painter* (Chatto & Windus, 1974).

Thomas, Lowell, *Good Evening Everybody: From Cripple Creek to Samarkand* (William Morrow and Company Inc., 1976).

Twohig, Edward, *Print REbels* (Royal Society of Painter – Printmakers, 2018).

Vester, Bertha Spafford, *Our Jerusalem* (Doubleday & Company Inc., 1950).

Waterfield, Robin, *Prophet: The Life and Times of Kahlil Gibran* (Penguin,1998).

White, Jerry, *London in the Twentieth Century: A City and its People* (Bodley Head, 2016).

WEBSITES

Aberdeen Tram Routes
https://doriccolumns.wordpress.com/welcome/aberdeen-city/tram-routes/

Battle of Megiddo – Palestine campaign
https://nzhistory.govt.nz/war/palestine-campaign/battle-of-megiddo

Dorothy Johnstone and her contemporaries
https://artuk.org/discover/stories/dorothy-johnstone-and-her-contemporaries

The Etching Revival in Britain
https://www.saturdaygalleryart.com/articles/the-etching-revival-in-britain

Lawrence of Arabia: soldier, writer – and artist?
https://artuk.org/discover/stories/lawrence-of-arabia-soldier-writer-and-artist?

Liquid history: *Cutty Sark*
https://blog.bbr.com/2017/10/31/liquid-history-cutty-sark/

The Sounds Of New York City, Circa 1920
https://www.npr.org/sections/thetwo-way/2013/10/22/239870539/the-sounds-of-new-york-city-circa-1920?t=1653644079542

The Theft That Made The *Mona Lisa* A Masterpiece
https://www.npr.org/2011/07/30/138800110/the-theft-that-made-the-mona-lisa-a-masterpiece?t=1646406932191

Index

A. Reid & Lefevre, Ltd 137
Aberdeen 23, 24, 35–6, 42–3, 57
 Union Street 11, 48, 51, 53
 see also under McBey
Aberdeen Art Gallery 221, 222, 227, 229–30
Aberdeen Artists Society 46, 63
Aberdeen Daily Journal on McBey 78, 94, 128, 129, 130
Alaoui, Moulay Larbi el 176–7, 179
 McBey picture of 184
Aldington, Richard 119
Allan, Phyllis 107–8, 118
 marries George Langley Taylor 159
Allen, Arthur Baylis 135
Allenby, Lady Adelaide 12,
Allenby, Sir Edmund 2, 4, 9–11, 113, 125
 books about 16, 123–4
 commands EEF 6, 10, 108, 111
 in Damascus 15, 17
 in Jerusalem 112
 and McBey 2, 6, 12, 16, 112, 114, 125
 as 1st Viscount Allenby 172
 retirement and death 172
American Art Association Galleries, New York 174
American British Art Center, New York 209
American College Society of Print Collectors 186
American Colony, Holy Land 5, 6, 172
American School of Tangier 226, 229, 233
Anderson, Alder 124
Anderson, Dr G. W. Fraser 208, 215
Anderson, W. B. 28
Arab Irregular Cavalry 2–3, 14
Arab Revolt 1, 2
 and capture of Damascus 46–7

Army Printing and Stationery Services (AP&SS) 104
 McBey and 104, 105

Barker, Nicolas 228
Batoul (nurse) 216, 218,
Battle of Megiddo 13, 15, 16
Bauer, Marius 136
Beaton, Cecil 226–7
Berry Brothers (Berry Bros. & Rudd Ltd) 137
Berry, Francis 137
Bewicke, W. S. 89
Bishop, Henry 87
Bone, Muirhead 79–80, 109, 144
Bonnet-Matthews, Clémence 180, 194, 201
 daughter Ana Gabriela Bonnet da Silva Aruajo 180
Borotra, Jean 150
Bowles, Jane 223
Bowles, Paul 223, 226, 230
 The Sheltering Sky 223
 death 231
Bowyer, Henry, Mayor of Southampton 83–4
Brent, Romney 185
Brockhurst, Gerald Leslie 159
Brookins, Walter 66
Bryce, Alexander Joshua Caleb 83, 94
Bryce, Maude 94
Burdett, Sir Henry 70
Burroughs, William, *Naked Lunch* 222

Cameron, David Young 79, 133
Canaletto 131
Capone, Al 'Scarface' 144, 191
Capote, Truman, 222
Carten, Audry 223

Catroux, François 226
Chamberlain, Neville 183
Chauvel, Lieutenant General Sir Harry 17
Chelsea Art School 168
Chelsea Arts Club 75, 76, 80, 163
Cherifian Rocks (land, Tangier) 167, 169, 229
 McBey's burial at 218–19
 quarrying at 225
Chou, Mrs 185
Christians, Miss Jeanne 94
Church of Scotland 54
Churchill, Winston 202
Cidoncha, Rafael 227
Colnaghi and Obach, Messrs P. & D. 95, 102,
 becomes Colnaghi 120
 McBey and 102, 113, 129, 184, 185
 McBey severs ties with 204
Connaught, Duke of 9
Copeland, Charles 150
Corbett, Thomas, 2nd Baron Rowallan 177,
 180, 213, 214, 217, 218
 Governor of Tasmania 217
Coward, Noel 140
Cragg, Douglas 230
Cragg, Jean 230
Crawhall, Joseph 8
Croft-Cooke, Rupert 160, 224–5
 ghost-writes McBey's biography 224–5
Cummer Museum of Art & Gardens,
 Jacksonville, Florida, US 222
Curtis, Isa (née Isabella Hempseed) 8, 10, 11,
 110–11, 112, 140
Curtis, William Henry 110
Cutty Sark (whisky) 137
Cyr, Leo 215, 218

da Silva Araujo, Fernando Nunes 180
 daughter Ana Gabriela Bonnet da Silva
 Aruajo 180
Da Vinci, Leonardo 61–2
 Mona Lisa 61, 62
Damascus 2, 3, 4, 10, 16–17
 Allies taking of, WWI 113

Dar Ben Zina, Marrakesh 176
 McBey at 178, 179, 181
Daughters, Donald 192
Davidson, George 81, 120
Davidson, James Mackenzie 24
Davison, George 148
de Breteuil, Charles 215
Deedes, Wyndham 7
Delon, Madame 70
Desert Mounted Corps 17
Dewsnap, Dennis *What's Sex Got to Do With
 It?* 222
Dickson (née Loeb), Joan 212, 213, 229, 231
Dinning, Hector 113
 (book) *Nile to Aleppo: With the Light-Horse in
 the Middle East* 113–14
Disruption of 1843 54
Dodgson, Campbell 107
Doolittle, Hooker 218
Duff, Charles 223, 227–8
Duff, Lady Caroline 223–4, 226
 death 227, 229
Duff, Sir Michael 223
Dugdale, Thomas 109
Duncan, Janet 56

Eastman, Harland 229
Eastman, Nancy 229, 230
 death 230
Edinburgh School of Art 79
Edison, Thomas 143
Egypt 171
Egyptian Expeditionary Force (EEF) 2, 3–4,
111
 conquest of Jericho 9
 McBey as war artist 2, 3, 107
El Foolk, Tangier (McBey residence) 207–8,
226, 233
 bought by Christopher Gibbs 234
Esna (boat) 135, 136, 141
Esna Barrage 110
Esson, Nellie Bisset 181, 182
etching and prints, market in 1920s, 132–3

decline in market 174, 220
Eurich, Richard 187

Farouk I 171
Feisal, Emir Sherif 2, 17, 18, 171
 made King of Iraq 171-2
 painted by McBey 18-19
Ferguson, Fergus 15, 16
Fernandez, Antonio 196
Fernandez, Claire 196
Fernandez, Hélène 196, 197
Fernandez, Pedro Villa 196, 197, 199, 203, 204, 205, 209, 213
Findlater, Andrew 39
Fine Art Society 121
Finlay, Anne 140-1, death 227
Finneron, Jeanie 161, 164, 194, 209
Finneron, Patrick 161, 194
 death 209, 211
First Battalion Seaforth Highlanders 13
Fitzgerald, F. Scott 145
Foveran, Scotland 22, 23, 29
 McBey and 21, 22, 28, 55, 163-4, 213
 McBey memorial service 221
 Parish Church 26, 31
 Parish of Foveran 22, 23, 193, 216
 see also Mains of Foveran
Foveran Burn 56, 82, 214
Foveran Kirkyard 54, 56, 73, 103, 125, 164, 213-14, 219
Foveran Links 27
France 85, 109, 166, 188
 Decolonisation of Tangier 214
 Lawrence in 127
 McBey in 61-2, 86, 104, 105, 106, 107, 163, 165, 183, 187
 Vichy regime 201-2
Free Church of Scotland 54
French, Daniel Chester 195
Fuad I (Ahmad Fuad Pasha) 171
Full, Louisa Ann 101

Galsworth, John 119

Garden, Mary 143
George Davidson Ltd 71
George, Dorothea St John 19
Georges-Picot, François 17
Ghazi bin Faisal (Iraq) 172
Gibbs, Christopher 234
Gibran, Kahlil 145, *The Prophet* 145
Gillespie, Alexander (uncle) 28-30, 37
Gillespie, Annie (mother) 21, 22, 23, 27-8, 29-30, 41, 73
 censured for conceiving an illegitimate child 31-2
 and McBey 33, 34, 36, 41, 42, 45, 51,
 McBey paints 47-8
 photographs of 45-6, 48
 sight problems 22, 23-5, 38, 45, 47
 at Union Grove 43, 46
 death 51-2, 54-6, 116
 funeral 56
 estate 74
Gillespie, George (uncle) 23, 26-7, 37-8, 74
 helps McBey with etching press 50
 McBey dispute with 103
Gillespie, Helen (wife of George) 37
Gillespie, Jane (aunt) 22, 29
 death 32-3
Gillespie, John 66, 103
Gillespie, Maggie 74, 103
Gillespie, Mary (aunt) 56
Gillespie, Mary (grandmother, née Torn) 6, 22, 26, 28, 54-6, 62, 66, 72
 and Annie's death 54-5
 and McBey 25, 33, 36, 42-3, 45-6, 56, 75, 82
 McBey's painting of 46-7, 66
 sketch of 103
 death 102-3, 219
Gillespie, William (grandfather) 21, 22
 family 28, 29
Gillespie, William (uncle) 27, 62, 67, 74, 102-3
Gillett, Second Lieutenant Sydney Eric 158
Glasgow School of Art 79
Gordon Highlanders 75
Gordon, Jeannie 73

Goupil Gallery, London 77, 78, 80, 81
 McBey leaves 95
G.P. Putnam's Sons 206
Graf, Urs *Girl Bathing Her Feet* 49
Graham, R. B. Cunninghame 176
De Gramont, Sanche 228
Graves, Robert 128
Gray's School of Art, Aberdeen 46, 53
Greenhill, Wilhelmina (Mina) 168, 180
Greig, James 78, 174
Gripper, Frances *see* Mrs Schad
Gripper, Leslie 235
Groppi, Giacomo 110
Grosvenor Galleries, London 128

Hackett, Jon 83
Hahn, Mr Paul 163
Hair: The American Tribal Love-Rock Musical 228
Hamilton, Jamie 225
Hamish Hamilton Ltd 225
Hardie, Agnes 161, 185
Hardie, Martin 82, 118, 121, 161
 Etchings and Drypoints from 1902 to 1924 by James McBey 80
 and McBey 80, 82, 92, 94, 104, 120, 121, 131, 135, 141, 185
 alerts McBey to 1 Holland Park Avenue 118
 travels with McBey 131, 135, 141
 death 211
Hardwick, Melbourne H 70
Hare, Kenneth 19
 London's Latin Quarter 19, 59
Harlow, McDonald & Co, New York 153
Harris, Lawrence 84
 With Mulai Hafid at Fez: Behind the Scenes in Morocco 84
Harris, Walter 177
Hart-Davis, Rupert 224
Havana, Cuba,
 McBey in 188
Hay, John A. 48, 149

Hearst, William Randolph 147
Helmholtz, Hermann von 24
Hemingway, Ernest 188
Hempseed, Mary 110
Hempseed, Richardson 110
Hendry, Annie 41, 134
Herbert, David 215, 218, 223, 224, 226, 230
Higinbotham, John U. 68–70
 Three Weeks in Holland and Belgium 68
Hoayek, Elias Peter, Maronite Patriarch 173
Hoffman, Harry L. 70
Hole, William 5–6
Holland Park Avenue (HPA) 118, 119–20, 121, 125, 126–7, 137, 164, 183, 184
 Inglises 95, 96, 98, 100, 101
 as McBey marital home 160
 McBey considers selling HPA 186
 see also under James McBey
Hoover, Herbert 143
Hoover, J. Edgar 192
Hopkins, John *The Tangier Diaries 1962–1979* 226
Hopper, Edward 145
Hotel Spaander 69–70
Huntsberry (née Oppenheimer), Caroline (Lena, Lina) 174
Huntsberry, Hortense (neé Loeb) 152, 163, 172–4, 180, 186
 at Holland Park Avenue 162
 and McBey 154, 171, 180, 183, 204–5, 209, 211
 and Marguerite McBey 162
 death 211–12
Huntsberry, Lawrence E. 174
Hutcheon, James 130, 164
Hutcheon, William and McBey 4, 10, 80, 86–7, 89, 94–5, 111, 128
Huusko, Molly 215, 216, 218, 220
 and Marguerite McBey 223

illegitimacy in Victorian Britain 30–1
Imperial Camel Corps (ICC) 109
Inglis, Lady Louisa Anne 95, 97, 98, 99, 100–1

Inglis, Miss Mary Louise 95, 96–7, 99
　McBey's relationship with 95–6, 98, 99, 100, 156
　relationship ends 101–2
　marries Second Lieutenant Sydney Eric Gillett 158
Inglis, Sir James Charles 95, 100–1
Innes, John 42
Israel, State of 171

Jackson, Leslie 214
Jaffa
　Allied entry into WWI 112
　McBey in 9, 10
Jaffrey, Mary 95, 97, 99
Jaffrey, Thomas 95
Jalobey (house, Tangier) 167, 169, 171, 201, 202, 203
James Stephen & Sons 35, 40
Jeapes (Jeap), Harold 15, 16
Jerusalem 4
Jerusalem, Allies taking of 112–13
John, Augustus 125, 156–7
Johnstone, Dorothy 141

K. Strauss and Company Inc 152
Kamp, Jan 68
Kamp, Mrs 69
Karpis, Alvin 'Creepy' 191
Keene, Emily 167, 175
Keith (née Ritchie), Polly 209, 214
Kelly, George 'Machine Gun' 191
Kennedy, Edward Guthrie 60
Kerr-Lawson, James 81–2, 83, 85, 87, 88, 165
　art 86, 88
Kerr-Lawson, Jessie 81
Kerr-Lawson, William 81
Kingsmill, Joan 208
Knockhall Castle 34
Knoedler Gallery 144, 148
Knoll International France 226
Koehler, S.R. 49
Kokoschka, Oskar 152–3

Kuhn, brothers 145, 150
Kynett, Harold H. 135, 148–9, 151
　and McBey 188, 192, 205, 207, 211, 222
　and Marguerite McBey 224, 233
　destruction of McBey's art 233
　The Face of Change: Flippancies for the Future 149, 151

La Martiniquaise-Bardinet 137
Lalanne, Maxime, 49
　A Treatise on Etching 48–9
Langley Taylor, George 159
Larsson, Edith 5
Lauder, Sir Harry 129, 148
Lauder, John 129
Lavery, Sir John 83
Lawrence, T. E. (T. E. Shaw) 1–3, 125–6
　encounters with McBey 1–2, 17–18, 125–7
　illegitimacy of 32
　in Damascus 4, 17
　in Jerusalem 112myth of Lawrence of Arabia 3, 15–16
　painted by McBey 1, 2, 3, 17–18, 19, 125, 233
　painted by Orpen 109
　regret at not being an artist 128
　suspicion of traitor in Arab contingent 7
　views of post-Ottoman world 3
　death 172
Lebanon 171, 173
　McBey in 113, 172–3
　Marguerite McBey in 226
Lee Smyth, Anna 145, 146, 147–8, 150
Legg, Leslie John 215
Leiter, Friedrich 70
Lever, David 63
Linton, Albert 189
Lloyd George, David 65, 93, 108, 118
Lloyd, Harold 145
　Welcome Danger 145
Loeb, Adolf 152, 153
Loeb, Arthur 163, 186, 191, 211, 212, 213, 218
　military service 194

death 227
Loeb, Barbara 212, 229, 230, 231
Loeb, Kathleen 212, 228, 229
Loeb, Kitty 212, 218
Loeb, Marguerite, *see under* Marguerite McBey
London McBey in 58–9, 73, 74–6, 133
 cholera epidemic in 77
Lousada, Anthony 175
Loutit, Rev J. S. 31, 32
Lucas, E. V. 176
Lumsden, Martha (neé Quegan) 110
Lumsden, Richard 110

Macdonald, Duncan 130, 142, 162
Macdonell, Alice E. 78, 164
Macdonell, William R. 78
Mackenzie, Alexander 35
Mackenzie, Nellie 34–5, 96
Mains of Foveran 29, 31, 213
Malo, Gina 185
Mann, Thomas 132
 Death in Venice 132
Martin, Robert 158
Massey, William Thomas 15, 16, 17
 Allenby's Final Triumph 16
Masterman, Charles 4, 111–12
Matisse, Henri 84
Mavic (boat) 135, 136, 148
Maxwell, Ruth 208
Mayer, Gustavus 132, 190
McBey, James (father) 27–8, 29, 30, 41
 censured for conceiving an illegitimate child 31
 McBey and 41, 133
 death of 133
 and Annie's death 133–4
McBey, James
 and Aberdeen 35–6, 42–3
 in Acre 173
 and Phyllis Allan 107–8, 118
 absence of marital intimacy 196
 accepts etchings from Mayer's bankruptcy 190

 acquires antique blank paper 69, 79, 178
 activities in Boulogne 104–5
 advice on carrying revolvers 84
 affairs 117, 121, 138–9
 at Army Printing and Stationery Service 104, 105
 arrives in Egypt 108
 art at Tangier American Legation Museum 210
 art at the Louvre 61–62
 artistic training 40, 46
 artwork early WWI 104–5
 attends bullfights 76–7, 139, 165
 attends *Picasso: Forty Years of His Art* 186
 attends show *With Allenby in Palestine and Lawrence in Arabia* 124
 attitude towards etchings 133
 auction results 233–4
 autobiographical material 222
 becomes naturalised US citizen 192, 193–4
 in Baalbek 113, 173
 in Belgium 136
 in Bermuda 154
 bicycle accident 164
 biography ghost-written 224–5
 birth 21, 29–30
 Clémence Bonnet-Matthews 182, 183, 201
 burial 218–19
 California Arts Club dinner 192
 called up WWI 103–4
 and Catholicism 105–6
 change in style 184–5
 and changing art market 174–5
 childhood 21ff
 clerking job at North of Scotland Bank 40, 41–6, 57, 65, 130
 as collector 178
 considerations of the past 210–11
 and Isa Curtis 8, 10, 11–12, 110–11,112, 115, 139, 172
 at Damascus 17
 at Dar Ben Zina 178, 179, 181
 Dead Sea 9

death 216, 217–18
death of father 133–4
declines parenthood 168–9
desire for Morocco 195
Diamond Street Aberdeen exhibition 78
diary 112, 139, 147, 151, 172, 190, 193, 196, 199, 202, 203, 208, 214
 starts diary 65
 diary unpursued 166
and Hector Dinning 113–14
discovers water-colours 91–2
dispute with uncle over estate 103
draws Isa 110
(autobiography), *The Early Life of James McBey* 21, 22, 25, 58
earnings from art 50–1
earns stripes 113
in Edinburgh 50–1
education 38–40
as EEF war artist 3–6, 12-13, 19
and El Foolk residence 207–8, 209, 211, 216
encouraged to write memoirs 206–7
escorts gold to London 58–9, 133
exhibitions 197
and fall of Gaza 111–12
and fall of Jerusalem 112
and father 41, 133
and Feisal 18–19
feelings of loneliness 82
and Fernandez family 196–7
and Pedro Fernandez 205
final illness 215–16
flowers and other mementos 89
in France 61–2, 86, 104, 105, 106, 107, 163, 165, 183, 187
in Gaza 111
Glasgow exhibition 81
grandmother's death 102–3
at Gray's School of Art, Aberdeen 46, 5
at Great Sphinx 11
and Wilhelmina Greenhill 168
and Frances Gripper (Mrs Schad) 145–7, 157, 190

and Martin Hardie 80, 82, 92, 94, 104, 120, 121, 131, 135, 141, 185
 alerted by Martin Hardie to 1 Holland Park Avenue 118
 travels with Martin Hardie 131, 135, 141
health issues 192–3
Hermon: Cavalry Moving on Damascus 2
Holland Park Avenue (HPA) Chapter 7 118, 119–20, 121, 125, 126–7, 129, 137, 142, 157, 183, 184, 233
 improvements 160
 and love life 142, 146, 158, 183
 as marital home 160, 164, 166
 studio 176, 234
 cleared 233
 sold 234
and Hortense Huntsberry 154, 171, 180, 183, 204–5, 209, 211
 Hortense's death 211–12
impact of Great Crash 147–8
impact of illegitimacy 31–2, 33
in Holy Land 8–9, 10, 11
interest in art begins 34–5, 41–2
interest in etching 48–50
intimations of mortality 197–8, 219
Jalobey acquired 167, 202, 204
in Jaffa 9
James McBey Memorial Room, Aberdeen Art Gallery 221, 233
in Jerusalem and Holy Land 16–17, 117, 172
joins Chelsea Arts Club 75–6
Jordan Valley 10
keepsakes 178–9
and Polly Keith 209, 214
at Kingsgate 139
Knoedler Gallery 144
and Harold H. Kynett 148–9, 205, 207
and T. E. Lawrence 1–2, 17–18, 124, 125–8
learns the tango 180
learns to ride horses 111
leaves bank 66
leaves Middle East 117
in Lebanon 172–3

legacy 221, 222, 233
letters 83–4, 85, 86–7, 88, 91
and Loeb family 212–13
and Marguerite Loeb 151–3, 154
in London 59–60, 62
London exhibition 77
and Los Angeles 191
MacDougal Alley, Greenwich Village, New York 194–5, 213
and Nellie Mackenzie 34–5, 96
marriage 155–6, 158–9, 162
 marriage proposal to Marguerite Loeb 155–6, 182–3
 reactions to marriage 161–3
 marital unharmonies 168–9
 (book) *The Mavic's Log: Ramblings with Nautical Notes* 135
McBey and the Sea exhibition 229
meets John D. Whiting 113
memoirs 22, 59
memorial service 221
Messrs P. & D. Colnaghi and Obach (agents) 95, 102, 184, 185
Middle East drawings 114–15
in Morocco 137, 165–6, 180
in Nablus 14
in New York 213
in Portugal 200
in Sinai Desert 109
Luxor 8
'Miss Lumsden, Eva Whitehouse and Susie' 65
model ship restoration 197
Moroccan art 92, 94
Morocco 83, 85, 176, 177, 185, 201
and mother Annie Gillespie 33, 34, 36, 41, 42, 45, 51
and mother's visual problems 24, 25
and mother's death 54–5, 56–7, 58
visits Annie's grave 81
see also Annie Gillespie
moves from Foveran to Newburgh 22–3
moves to Crown Street 71

moves to Hampstead 98–9
moves to London 71, 72, 73, 74–5
and Mollie Murray 121, 139, 154, 204, 208
name mis-spelled McBee 79
newspaper reaction to death 219–20,
newspapers on 170, 175
1920 success 128–9
official war artist with EEF 107, 108
on changes in Tangier 203
open marriage 180–1
opportunity to go to Ceylon 73
on Palestine Front 1–2,
philandering 156, 159, 180, 183
and photography 173
photographs of 58, 66
pigments used 96
plaques to 54
pleurisy 65
possible employment 38
post-WWI situation 118
pranks 211, 212
and Presbyterianism 25
printing press 49, 50, 75, 81, 97, 99, 197
propaganda for US War Office 196
purchase of Napoléon Bonaparte's death mask 53
purchase of Rembrandt etchings 97
purchases Dar Ben Zina 176
has quinsy 12, 105
reaches 50 167–8
receives China hen as payment 89
receives honorary degree 170–1
rejected by Royal Society of Painter-Etchers and Engravers 80, 81, 121–3,
relationship with Mary Louise Inglise 95–6, 98, 99, 100, 156
 relationship ends 101–2
religious encounters 146
reminisces 45
return from Palestine Front 138
returns to Britain, posting to Egypt March 1917 107
returns to Scotland 71

returns to UK 115, 149–50
returns to US 147–8
reviews of McBey's art 186, 189
reviews of work 78–9
Eileen Arbuthnot Robertson 141–2, 154
Royal Academy 122
sees Puccinni's *La Rondine* 149
Annie Salaman 183
and separation from Marguerite 204–6
short-sightedness 74
sketches Harfleur 106
sketching trip to Carmarthen, Wales 77
and Lisbeth Simpson 181, 183, 203, 207
and Lee Smyth 145, 146, 147–8
and Alida Spaander 70, 71
in Spain 76–7, 81, 121, 139, 165, 183
starts as freelance artist 67
studio Justice Mill Lane Aberdeen 116
success 80–1
and Suez Canal 109
and 'Suzie' 77
takes up sailing 134–6
takes up watercolours 102
taste for motion pictures 60
tastes 168
Fay Taylor 158
The Quai Gambetta Boulogne 104
'Tipi' (lover) 140–1
in Tangier 18, 83, 89, 90, 91 166–7, 171, 182, 196, 199–200, 204, 208, 210–9, 214
 residence in 167, 185, 201, 202, 216
 returns home 91
see also Jalobey, El Foolk
at Tetouan 86-8, 90
 attitudes of locals 87–8
and Lowell Thomas 123, 125, 126, 214
travels 183, 203–4, 207
 with James Kerr Lawson 81–9
 North Africa 171–2
 round Scotland 163–4, 213
 UK 146, 150
 US 142–5, 150, 184
at Union Grove 45, 50, 54–6, 57, 62, 116–17
at Union Street 57, 63, 65, 71, 149, 164
unauthorised sketching 165
and unrest in North Africa 89–90
US newspaper reviews of 144–5
in US during WWII 185ff
use of prostitutes 94
views George V's coronation 80
views towards 16
visits Baalbek and other cities 113
visit to Cairo 7, 8
visits Cuba 188
visits Foveran Kirkyard 213–12
visit to Memphis 7
visits Museo Nacional del Prado, Spain 76
visits Netherlands 67–72, 94–5
visits Paris 60–61
visits Sandwich, Kent 81–2
visits Spain 121, 165
visits the Somme on sketching tour 106
visits Venice 130–2
as war artist 2, 3, 12, 14, 107, 108, 118, 121, 144, 171
watches *Mr Smith Goes to Washington* 186
Wharfedale studio 96
and Whistler's art 61
Fay Woods 157–8, 169
and World War I Chapter 1, 101
and World War II 183–4
wins first art prize 34, 40
writings in *The Graphic* 128

Etchings 91, 178
 1588 82
Approaching New York 143
Beggars 91
The Crucifix, Boulogne 104
Dawn: The Camel Patrol Setting Out 109, 120, 132, 174, 190, 233
Door of a Café, Tetuan 94
Ebbesfleet 82
The Foveran Burn 82
France at her Furnaces 106
Gerona 121, 139

Grimnessesluis 94, 233
Gunsmiths, Tetuan 91
Hermon: Cavalry Moving on Damascus 120
Hoorn Cheesemarket 71
Jews Buying Fish, Tetuan 94
The Lion Brewery 102
Manhattan 186
Margot as Lopokova 121
The Mill, Zaandijk 71
Night in Ely Cathedral 233
A Norman Port 104
Old Torry 51, 79
Omval 80
The Ovation to the Matador 79
'First Palestine Set' 109, 120
'Second Palestine Set' 120
'Third Palestine Set' 120, 121
The Pianist 121
The Pool, Sea and Rain 102
Santa Maria della Fava 234
The Shower 82
The Silk Dress 121
The Skylark 82
Spring 1917 106
The Story-Teller 91
The Sussex 104–5
Tetuan no 2 91
The Grain Market, Tetuan 94
etchings, value of 234, 235–6
A View in Wales 80
A Volendam Girl 79
Zero: A Sixty-five Pounder Opening Fire 13, 106

Paintings
 portraits by and of 159
 Acrobats Marrakesh 185
 The Allies Entering Jerusalem, 11th December 1917 112
 (sketch) *The Arrival in Port* 108
 Beggar and Child 185
 The Long Patrol (series), *Breakfast, Strange Signals, Noon, Bivouacs, Nightfall* 120
 Marguerite Sleeping 234

(cartoon) *The North Bank Band* 130
Portrait of Dacie 234
The Red-Haired Girl 141
Regatta on the Grand Canal, Venice 132
Sirocco 184
The Star of the Nativity: in the Church of the Nativity at Bethlehem, where the silver star marks the birthplace of Jesus 6
Tichka Pass: High Atlas 184
Tul Keram: A Retreating Turkish Column Bombed and Machine-Gunned by Airmen in the Defile at Tul Keram 13–14
The Wells at Samaria: Indian Troops Fetching Water during the Advance 14
Woman on a Sofa 146

Portraits: 14, 48, 71, 150, 175–76, 184, 188–9, 195–6
 Sir Edmund Allenby 12, 114
 Clémence Bonnet-Matthews 233
 family portraits 212
 Annie Gillespie 47–8
 John Innes: *Portrait of a Hero* 184
 Sir Harry Lauder 129, 148
 T. E. Lawrence 1, 2, 3, 17–18, 19, 125, 233
 Kathy Ryan 215
 Marguerite (wife) *see under* Marguerite McBey
 Margret Gillespie grandmother 46–7
 Arthur T. Vanderbilt 206
 Zohra Zefri: *Zohra* 209–10, 23
 see also under particular terms

McBey (née Loeb), Marguerite 151–3, 160, 209
 in Acre 173
 autonomy as artist 225, 227, 230
 (book) *The Early Life of James McBey* 228
 absence of marital intimacy 196
 ageing 228–9
 bisexuality of 181, 222–4
 bookbinding 164, 189, 224
 and Clémence Bonnet-Matthews 180–1
 in Canada 230

construction of Sea House 225–6, 229
and Lady Caroline Duff 223–4, 226
and Nancy Eastman 229, 230
with Pedro Fernandez 204, 207
at El Foolk 228
and English winter 164
at Holland Park Avenue 157, 160–1, 227, 228, 230, 233
 considers selling HPA 186
and Molly Huusko 223
in Jalobey 202
in Jerusalem 172
in Lebanon 172–3
letter to mother 162
marriage 155–7, 158–9, 162, 163
 marriage proposal 155–6, 182–3
 reactions to marriage 161–3
 marital unharmonies 168–9
 separation 204–6
McBey portrait of 175
leaves McBey 204
life after McBey 220ff
and McBey legacy 221, 224, 225, 229
and McBey's death 216, 217, 218
medical problems 192
visits Morocco 165–6
and parenthood 168–9
photography 173, 190
in Portugal 200
and the press 230
in Scotland 165
and Lisbeth Simpson 180, 181, 182, 183, 203, 209, 210
in Spain with McBey 164–5
in Tangier 166–7, 171, 176, 180–1, 182, 222–4, 225, 227, 229–30
 home in Tangier 223
as translator for McBey 179–80
travels 224, 226
trip with McBey round Scotland 163–4
in US during WWII 184ff
returns to US 203, 204
rewrites McBey's biography 161

US passport impounded in US 184
death 230–1
cremation 231
memorial service 231
McBey, James Wyllie 29
McBey, Martha (neé Stephen) 29
McConachie, John 28
McCosh, James 26
McNeill, Dorelia 157
McOstrich, Mrs 185
McPhillips, Joseph A. 226
Meiklejohn, Private Thomas 13
Mellor, Captain F. H. 208
 Morocco Awakes 208
Melville, Arthur 83
Miller (William, acting British vice-consul) 87, 89, 84
Mohammed (cook) 212
Mohammed Ali-el-Mauyed El Aden 19
Mohammed V, Sultan of Morocco 176
Monet, Oscar-Claude 60
Moore, Virginia 197
Morocco 83, 84
 European intervention in 166
 French-Spanish division of 85
 Treaty of Fez 84
 under Vichy France regime 201
 Operation Torch 202
 Casablanca Conference (1942) 202
 independence movement 202
Munro, Annie 28
Murray, General Sir Archibald 108, 111
Murray, Gilbert 119
Murray Sir James 92, 93–4, 139
Murray, Malcolm 139
Murray, Margot 121, 139–40
Murray, Mollie 121, 139, 154, 204, 208
Murray, William 121, 139
 death 204
Mystic Seaport Museum, US 197

Nairn, Bryce 218
Nairn, Margaret 218

Nasser, Gamel Abdel 171
Nebi Samwil 5, 9, 124
Nettleship, Ida 157
Nevinson, C. R. W. 185
Newburgh village 27
Noguchi, Isamu 195
North of Scotland Bank 49, 57, 65, 130
 McBey and 40, 41–6, 50
Northern Arts Club (NAC), Aberdeen 63
Novello, Ivor 140

O'Keeffe, Georgia 145
'Order of the Paint Box' 87
Orpen, Sir William 1, 109, 157
Orton, Joe 222
Ottoman Empire 2, 21
 bounty on Lawrence of Arabia 7
 Ottoman Army 4, 6, 7, 13, 16, 112
 WWI armistice 2, 113
Owens, Vessie 187
Oxford University Press 228

Palestine Front, McBey and 1, 16, 108, 109, 115, 117, 214
 McBey's art of 120, 124
Palestine Mandate 171
Parke-Bernet Galleries 197
Paton, Herbert 181, 182, 187, 190, 194, 208
 death 211
Pearl Harbor 192
Pearsall, Phyllis 210
Pennell, Joseph 119, 144
Pettie, John 64
Picasso, Pablo 157, 174,
Picasso: Forty Years of His Art 186
Piper, John 187
Plain of Esdraelon 14–15
Pollock, Jackson 195
Portmeirion Gallery, London 227
Pound, Ezra 119
Prichard, Professor Harold Arthur 170
Print Club, Philadelphia 148

Raphael, Sir Herbert and Lady 99, 102
Ravilious, Eric 186
Reid, James Torn 100, 105
Reimer, Rudolph 189
Rembrandt 67, 97, 175
 David in Prayer 97
 The Night Watch 69
 McBey and 35, 68, 69, 85, 94, 97, 174, 175, 234
Rennie, Henry J. 53–4
Rennie, Minnie 191
Ritchie, Charlotte 138
Ritchie, John 138
Ritchie, Polly (Mary Ann) 138
Roberts, Lionel 83
Robertson, Eileen Arbuthnot (E. Arnot Robertson, 'Billy') 141–2, 154, 163, 172, 180, 211, 235
 (book) *Cullum* 141
 marries Henry Turner 142
 taste for practical jokes 142
 dies 227
Robins, William P. 174
Roosevelt, Franklin D. 202
Rosenwald, Lessing J. 150
Roth, Ernest 153
Rothenstein, Alice 98
Rothenstein, William 97–8
Rowallan, Lord *see* Thomas Corbett
Royal Glasgow Institute 79
Royal Scottish Academy 51, 79
Royal Scottish Society of Painters in Water-Colours, The 123
Royal Society 122
Royal Society of Painter-Etchers and Engravers 80, 81, 121–3
Rudd, Hugh 137
Rushbury, Sir Henry George 122
Ruskin, John 132
Ryan, Kathy 215

Salaman, Annie 162
Salaman, Malcolm Charles 99

Salmond, Irene Foster 101, 107, 139
Salmond, Dr James Laing 100, 139
Saunders, Mr (agent) 44
Sargent, John Singer 14
Sauter, Blanche Lilian (née Galsworthy) 119
Sauter, Georg 119
Sauter, Rudolf 119
Schad, Catherine 191
Schad, Frances (née Gripper) 145–7, 150
 marriage 147
 and McBey 190, 235
Schad, Jasper 191
Schad, Robert Oliver 145, 147, 191
Schneider Munition Works 1006
Schoenberger, Benno 121
Schupp, Matthew 74
Schupp, Mrs Paulina 74
Scott, Lady 208
Sea House 225–6, 229, 231
Second Battalion Black Watch 13
Sessler, J. Leonard 'Dick' 149, 151, 155, 186
Shaib (guide, Tetouan) 87, 201 204
Shallcross, Cecil F. 189
Shepheard's Hotel, Cairo 7
Shoop, Elizabeth (Betty) 203
Short, Sir Frank 123
Sidi Al-Hadj Abd al-Salam 167, 175
Simpson, Ann (Nan) 181, 182, death 194
Simpson, Lisbeth 180, 181, 203, 207, 208
 intended purchase of El Foolk 207
 and McBey 180, 181, 182, 183, 203, 209, 211
 and Marguerite Loeb/McBey 209, 210
 and Herbert Paton 181
Sinai Desert, McBey in 109
Sinclair of Newburgh, Lord 34
Slade School of Art 98
Smart, Charles Ion 76
Smart, Douglas Ion 76, 77
Smeaton, Private James 13
Smith, Lieutenant Campbell Lindsay 75, 118
Smith, Principal Sir George Adam 170
Smithsonian American National Museum, McBey artwork at 197

Spaander, Alida 70, 71, 95
Spaander, Leendert 70
Spain
 bullfighting in 76–7, 139
 during WWII 183
 McBey in 76–7, 81, 121, 139, 165, 183
 situation in 76
 Treaty of Madrid 85
Spencer, Gilbert 114
St Nicholas Kirkyard 53
Starr, Mrs 189
Stewart, James 186
Stirling, Walter Francis 2, 3
Storrs, Sir Ronald 1
Stuart, Professor A. Mackenzie 170
Sykes, Sir Mark 17
 The Caliphs' Last Heritage 17
Sykes-Picot Agreement 17

Tangier 90, 91, 165, 180, 194, 208, 214–15, 226, 229, 231
 as international fleshpot 166, 210–11, 222–3, 224
 as international zone 166, 214–15
 McBey in 18, 83, 89, 90, 91 166–8, 171, 182, 185, 196, 199–200
 McBey's residence in 167, 201, 202
 Marguerite McBey in 176, 180–1, 182, 222–4, 225, 227, 229–30
 during WWII 183–4, 201
 post-WWII transformation 202–3, 214–15
Tangier American Legation Museum 210, 234
Tangier Gazette 208
Tangier Port Company 225
Tavern Club, Chicago 148
Tay Bridge disaster 25–6
Taylor, Fay 158
Tennant, Rev John 221
Tennant, Veronica 223
Tetouan, Morocco 85, 86–8, 89, 90, 166
Thomas, Frances 123, 124–5, 126
Thomas, Lowell 15–16, 18, 61, 123
 autobiography, *Good Evening Everybody:*

From Cripple Creek to Samarkand 15
and McBey 123, 125, 126, 214
 With Allenby in Palestine and Lawrence in Arabia 16, 123–4,
Thomson, Rev William 68
Tilden, Bill 150
'Tipi' (McBey's lover) 140
Torn, John 40, 47
Trans World Airlines (TWA) 199–200
Treaty of Madrid (France, Spain) 85
Troubetzkoy, Prince Pierre 119
Tul Keram 14
Turner, Gordon 211, 227, 235
Turner, Henry 142, 163, 211
 death 227
Twain, Mark 119
Umm el Kelab 4
United Free Church of Scotland 54
United Presbyterian Church 54
United States 138ff, 204, 224
 attack on Pearl Harbor 192
 'Mad Decade' in 145
 McBey in 142ff, 188
 Prohibition in 133, 137, 143–4, 154
 US War Office 196

Vanderbilt, Arthur T. 203
Velázquez, Diego 76
Vester, Bertha Spafford 112
 (book) *Our Jerusalem* 112
Victoria, Queen, death of 46
Vidal, Gore 222
Vidal, Yves 226

Wall Street Crash 174, 204
Walston, Lady 185
war artists 108–9, 187
 McBey as war artist 2, 3, 12, 14, 107, 108, 118, 121, 144, 171
 Royal Society of Painter-Etchers and Engravers, and war artists 121–2
Watt, Robert 63
Welldon, J.E.C. 113

Whisky (dog) 212
Whistler, James Abbott McNeil 49, 60, 61, 75, 121–2
 Arrangement in Grey and Black: Portrait of the Painter's Mother 61
Whistler, William McNeill 61, 119
White, John Forbes 78
Whiting, John D. 6, 117, 172
Whitney, Gertrude Vanderbilt 195
Wiggin, Albert H. 148
Williams, Tennessee 222
Wilson, Helen Russell 90–1, 207, 166
Wilson, Inspector George 55
Winokur, Joseph and Beatrice 152
Woods, Georgina 235
Woods, Miss Fay 157–8, 169 235
 (book) *Burnt White* 158
Woods, R. 158
World War I, Ottoman Front 2, 10
 Western Front 2, 10
 German Spring Offensive 10
 Palestine Front 15
 outbreak of 100
 British Expeditionary Force Base Stationery Depot/Army Printing and Stationery Services 104
 end 117–18
World War II 183, 197
 Operation Torch 202
 see also specific entries

Yuill, George Skelton 64–5
Yuill, William 63–5

Zefri, Zohra 210
Zorn, Anders 80, 15